KB006053

KOREAN WAR

IN COLOR

KOREAN WAR IN COLOR

A Correspondent's Retrospective on a Forgotten War

Photographs by **John Rich**

Seoul Selection

KOREAN WAR IN COLOR
A Correspondent's Retrospective on a Forgotten War

Photographs by **John Rich**

Published by **Seoul Selection**
B1 Korean Publishers Association Bldg., 105-2 Sagan-dong,
Jongno-gu, Seoul 110-190, Korea
Tel: 82-2-734-9567
Fax: 82-2-734-9562
E-mail: publisher@seoulselection.com
Website: www.seoulselection.com

ISBN: 978-89-91913-64-6 06910

Printed in the Republic of Korea

Contents

Forewords

The moment I saw war correspondent John Rich's color photographs of the Korean War, I could feel my heart race. It was as though I had gone back in time sixty years to that very time and place. As far as I am aware, the technology for developing color photographs did not exist in Korea back then. If you took color pictures, the only way to see them was to send the film to Hawaii and have it developed there with US Army equipment.

The appalling devastation visited on the streets of the Republic of Korea's capital city of Seoul and the villages in the countryside; the United Nations troops; the war orphans standing in front of thatched houses, still holding onto their bright smiles—in every picture, one can sense the ever-curious eye of Mr. Rich, nimbly shifting the angle of his Nikon to capture the moment.

Today, those children in the picture are already in their seventies or thereabouts; I, too, have suddenly found myself at the age of ninety. The name of the "Republic of Korea" has assumed a history of pride and glory rather than shame, ranked now among the world's great powers. While this is certainly a wondrous blessing from God, it is more than just the so-called "Miracle on the Han River"—it is a miracle of 20th century world history and a great triumph of liberal democracy.

This stunning victory was made possible by the noble sacrifice of countless troops who transcended nationality for the sake of world peace and the defense of freedom. These young men came to a foreign land—"Korea," a name some did not even know—and shed their noble blood there. Because of this, I can venture to say that every one of the nameless UN troops who appear in this collection is a true hero.

Sixty years have passed since then, but the cruel scars of the three-year, one-month Korean War still linger deeply in the hearts of UN veterans in the US and other nations, and in the hearts of the family members of those who perished. As we mark the sixtieth anniversary of the outbreak of the Korea War, we the people of the Republic of Korea humbly express our recognition and respect to those troops and their families. This nation owes them a great debt. Now the Republic of Korea must repay that debt to them.

Korean War in Color provides all of us with vivid memories of that day, and it forces us to contemplate what remains for us to do today. Once again, I wish to express my deepest appreciation to Mr. Rich, the man who so stunningly retrieved those distant memories of the Korean War, and my most enthusiastic praise for his passionate journalistic spirit.

"Let's Go Together! *Katchi Kapshida!*"

<div align="right">

Paik Sun-yup

General, Republic of Korea Army, Retired
Korean War commander & Korea's first four-star general

</div>

I offer my sincerest congratulations on the publication of journalist John Rich's *Korean War in Color*. It is particularly meaningful that this vivid photographic record by Mr. Rich, a man who reported on the war from beginning to end, is having its timely publication in 2010, the 60th anniversary of the outbreak of the Korean War.

These days, people who experienced and can recall the Korean War sixty years ago represent a small minority of South Koreans. The Korean War is thus becoming a "forgotten war" throughout the world—even in South Korea, the very nation involved in that war. At a time like this, these photographs, which capture the scene of that war with the characteristic eye of an outstanding journalist, could literally be called a "living record of history." Mr. Rich's photographs also possess an artistry that goes beyond the level of a mere precise record. It was a truly ghastly war, but he has lifted the photographs in this book into the territory of art as they capture the human faces of the leaders, citizens and children—and, especially, the soldiers—who experienced the war. I wish to pay my respects to Mr. Rich, who is both a great journalist and an artist.

The 60th anniversary of the start of the Korean War is being met by South Koreans with both a sense of appreciation and one of hope. I would like to express my endless gratitude to all of the patriots who guarded our liberty and independence by guiding this war to victory, and to the allied forces from 16 nations, including the US, who fought with us and for us in the foreign and far-flung territory of the Korean Peninsula. All of us must work together so that the true meaning of the freedom that we joined forces to preserve is carried on forever in this land. Once again, I offer a prayer of thanks to all of those who gave their lives in the Korean War.

I am certain that the publication of *Korean War in Color* will be an occasion for just this kind of appreciation and reflection.

<div align="right">

Lee Hong-koo

Former Prime Minister & Co-Chairman,
60th Anniversary of the Korean War Commemoration Committee

</div>

Forewords

The successful defense of the Republic of Korea by the United Nations was attained through the joint efforts of the United States, the Republic of Korea, and twenty other countries. The courageous and unsparing acts of countless individuals from these countries laid the foundation for the Republic of Korea to take its first steps toward developing into the prosperous, democratic and free society it is today.

In between filing stories as a war correspondent from 1950 to 1953, John Rich crisscrossed the Korean Peninsula and snapped photographs of a people ravaged by a loss of everything but determination, and of allies prepared to give the ultimate sacrifice for their future.

Tucked away in a chest for nearly fifty years, Mr. Rich's pictures give a breathtaking glimpse not only into the military aspects of this grueling conflict, but also into the ordinary lives of Koreans and the hardships they experienced. The vibrant photographs, the largest known collection of color photographs of the Korean War, also provide viewers with a realistic view of the war that black and white images could not achieve.

The US Embassy in Seoul recognizes the significance of Mr. Rich's photographs and will support a public photo exhibit during this 60th anniversary year of the Korean War. The exhibit, which opens May 4, 2010, at the Blue House before beginning a nationwide tour, reinforces the sincere friendship and strong alliance between the United States and the Republic of Korea.

Kathleen Stephens
US Ambassador to the Republic of Korea

The Republic of Korea, our United Nations Allies, and the United States have successfully deterred aggression on the Korean Peninsula for nearly 57 years. John Rich's photographs remind us why we have put forth this great effort to keep the peace. His work chronicles three years of loss, devastation, and dislocation. Mr. Rich's photographs show us the human side of war in a way that no other media can.

The long decades of armistice have let our Korean friends and allies build a strong, free, and prosperous nation and grow into one of our most important and valuable alliances. As the latest in a line of United Nations Commanders stretching back to General of the Army Douglas MacArthur, I am proud of the contributions that the soldiers, sailors, airmen, marines, and civilians of the United Nations Command have made in defending Korea. We remain here to ensure that their sacrifice was not in vain and that the tragedy captured in John Rich's work is never repeated.

These photographs will be of benefit to anyone interested in the history of Korea. They illustrate the human side of war in a way that the written word alone cannot, and will serve as a valuable companion to any history of the Korean War. It is therefore with great pleasure that I await the upcoming nationwide public exhibit of these photographs. This exhibit is a welcome addition to the events commemorating the 60th anniversary of the Korean War. I fully support the US Embassy and the Ministry of Culture, Sports and Tourism in this worthy endeavor.

<div style="text-align: right">

Walter L. Sharp

General, US Army
Commander, UNC/CFC/USFK

</div>

Prologue

One day in Japan in late spring of 1950, I had heard my name called as I entered the Tokyo Foreign Correspondents Club. Three *Life* photographers were sitting in the lobby—David Douglas Duncan, Horace Bristol and Carl Mydans, as I recall. They all knew that I spoke Japanese. "Hey Rich, we need you," one of them said, "Our English-speaking Japanese colleague has just left on appointment. We've got to go visit a camera company. It's called Nikon." I had heard about it vaguely and agreed to go. On the way over they told me about their amazing find. They had been at the plant and couldn't believe how good the Japanese lenses were. They had taken a few Nikon lenses to their Time-Life Magazine office on Tokyo's Ginza and done "bench tests" on them. They found that the Japanese lenses were superior to the German lenses they had been using.

While at the Nikon plant, we met the president of the company and in the following weeks had more meetings and dinners. The upshot was that these *Life* photographers got rid of their German Zeiss and Leica lenses and replaced them with Nikon lenses.

The story I heard was that back in the late 1920s and '30s Japan had hired German technicians to come and teach them the craft of lens making. As in many other fields, the Japanese tried to learn everything the Germans knew, and then went on to improve on it.

For my work as interpreter, I acquired a Nikon camera. David, Horace and Carl gave me a quick course in photography, and I loaded the camera with Kodachrome color film. I remember Dave Duncan's instructions to me. They were simply "move in." Within a month or two, the Korean War broke out, and I headed for Korea equipped with my new Nikon camera, loaded with Kodachrome film, slung over my shoulder. My main job was to report for the International News Service, but when I saw something I would snap it for my own interest. Nobody else professionally was using color film to record this war, neither magazines like *Time*, *Life*, *Newsweek* nor the wire services like AP, UPI, and the INS.

In those days, a roll of Kodachrome came with a tiny string sack with a tag on it for mailing to Kodak in Rochester, New York. Once it had been developed, it was sent back in a small cardboard box filled with color transparencies. I would hold them up to the light and have

a look, then put them away in their boxes. As the war went on, my pile of film grew until, eventually, I put them all in a tin-lined Japanese tea chest. This was fortunate, because after 50 years of expatriate life in Paris, Berlin, Tokyo and Hong Kong, they had all survived in excellent shape.

In Maine, I met a retired physicist, Jack Kennelly, who had begun a new life in photography. He had been a teenager during the Korean War and followed the war closely, making him sort of a Korean War buff. He was amazed when he saw my collection of photos of the war in color. Technology, of course, had made great strides, and he put them in CD form to prevent any deterioration. At his suggestion, I had them all copyrighted.

Since I had changed my affiliations early in the war from INS to NBC News, I spent more time in Korea covering the fighting than any other American correspondent. A few decades back I was in Korea, and I showed a few of my photos to a Korean newsman, who was amazed. He exclaimed, "We've never seen our war in color!" I lent him a few of the photos and his newspaper, the *Chosun Ilbo*, ran them on the front page.

As I kept snapping pictures during my more than three years of covering the war, from the Pusan (Busan) Perimeter and the Chosin (Changjin) Reservoir and during the long Korean armistice talks, the collection represents a unique and remarkable color view of the whole conflict.

It's my hope that readers of this book will understand the travails of war, and the fact that unlike any other human endeavor, it is a lesson in sacrifice and resilience. Both Americans and South Koreans understand this moral all too well, and as these pages vividly illustrate, with as good a reason as any.

"One lives in the hope of becoming a memory."

- Antonio Porchia

Memories & Faces

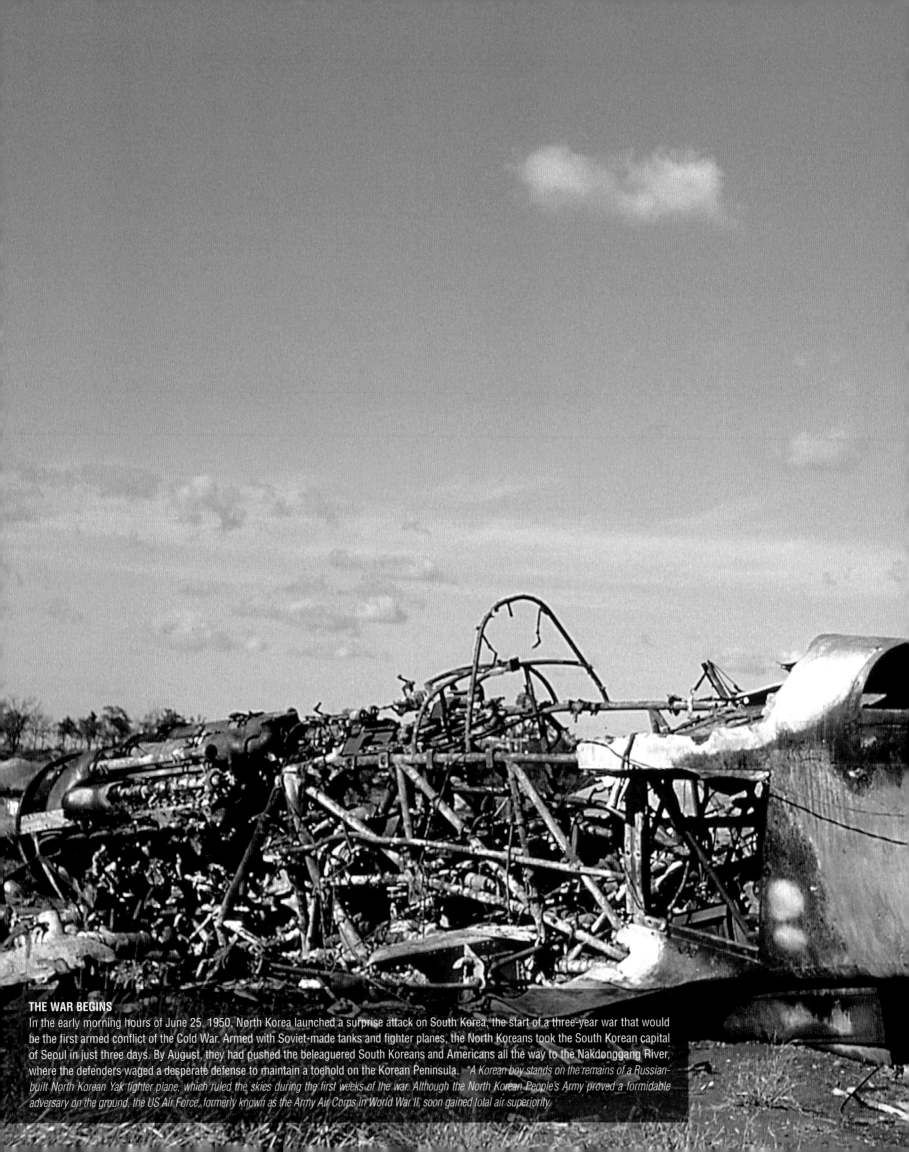

THE WAR BEGINS

In the early morning hours of June 25, 1950, North Korea launched a surprise attack on South Korea, the start of a three-year war that would be the first armed conflict of the Cold War. Armed with Soviet-made tanks and fighter planes, the North Koreans took the South Korean capital of Seoul in just three days. By August, they had pushed the beleaguered South Koreans and Americans all the way to the Nakdonggang River, where the defenders waged a desperate defense to maintain a toehold on the Korean Peninsula. *A Korean boy stands on the remains of a Russian-built North Korean Yak fighter plane, which ruled the skies during the first weeks of the war. Although the North Korean People's Army proved a formidable adversary on the ground, the US Air Force, formerly known as the Army Air Corps in World War II, soon gained total air superiority.

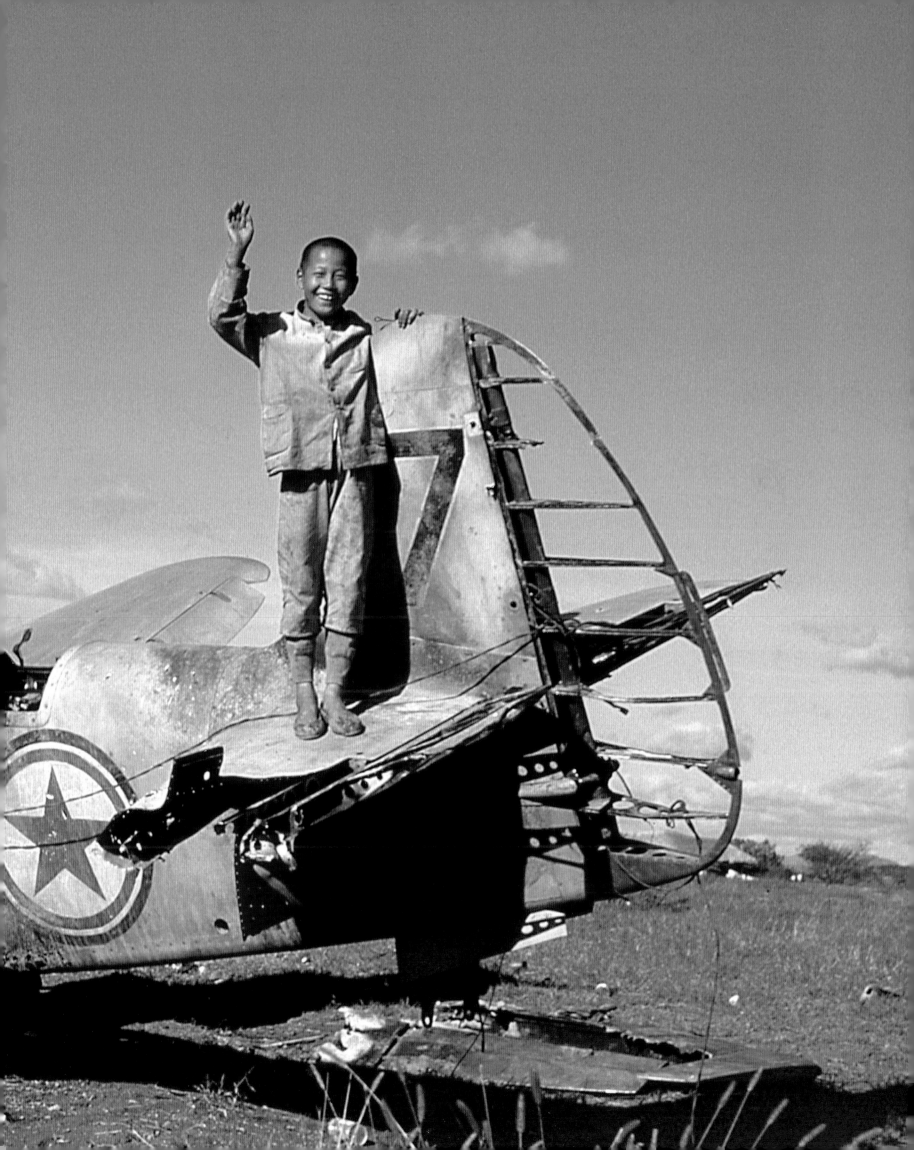

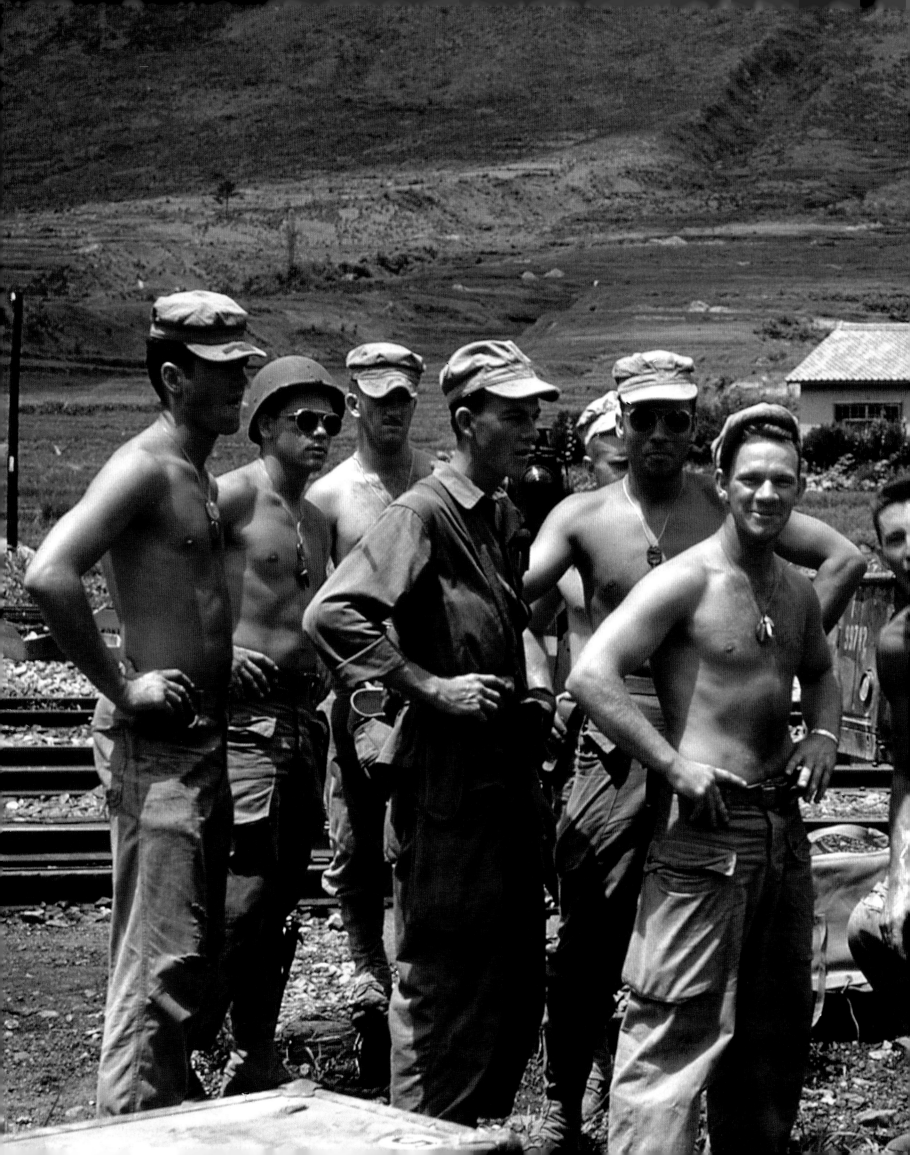

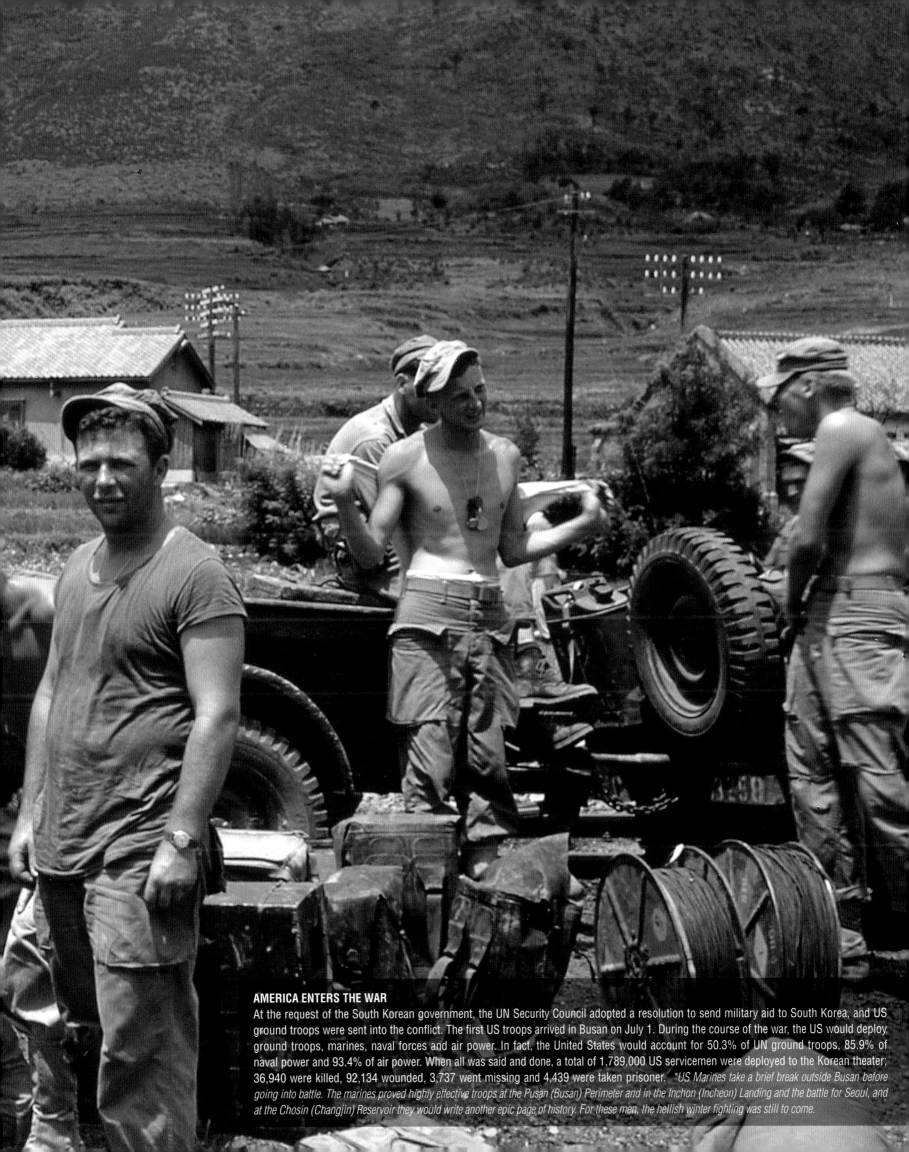

AMERICA ENTERS THE WAR

At the request of the South Korean government, the UN Security Council adopted a resolution to send military aid to South Korea, and US ground troops were sent into the conflict. The first US troops arrived in Busan on July 1. During the course of the war, the US would deploy ground troops, marines, naval forces and air power. In fact, the United States would account for 50.3% of UN ground troops, 85.9% of naval power and 93.4% of air power. When all was said and done, a total of 1,789,000 US servicemen were deployed to the Korean theater; 36,940 were killed, 92,134 wounded, 3,737 went missing and 4,439 were taken prisoner. *US Marines take a brief break outside Busan before going into battle. The marines proved highly effective troops at the Pusan (Busan) Perimeter and in the Inchon (Incheon) Landing and the battle for Seoul, and at the Chosin (Changjin) Reservoir they would write another epic page of history. For these men, the hellish winter fighting was still to come.

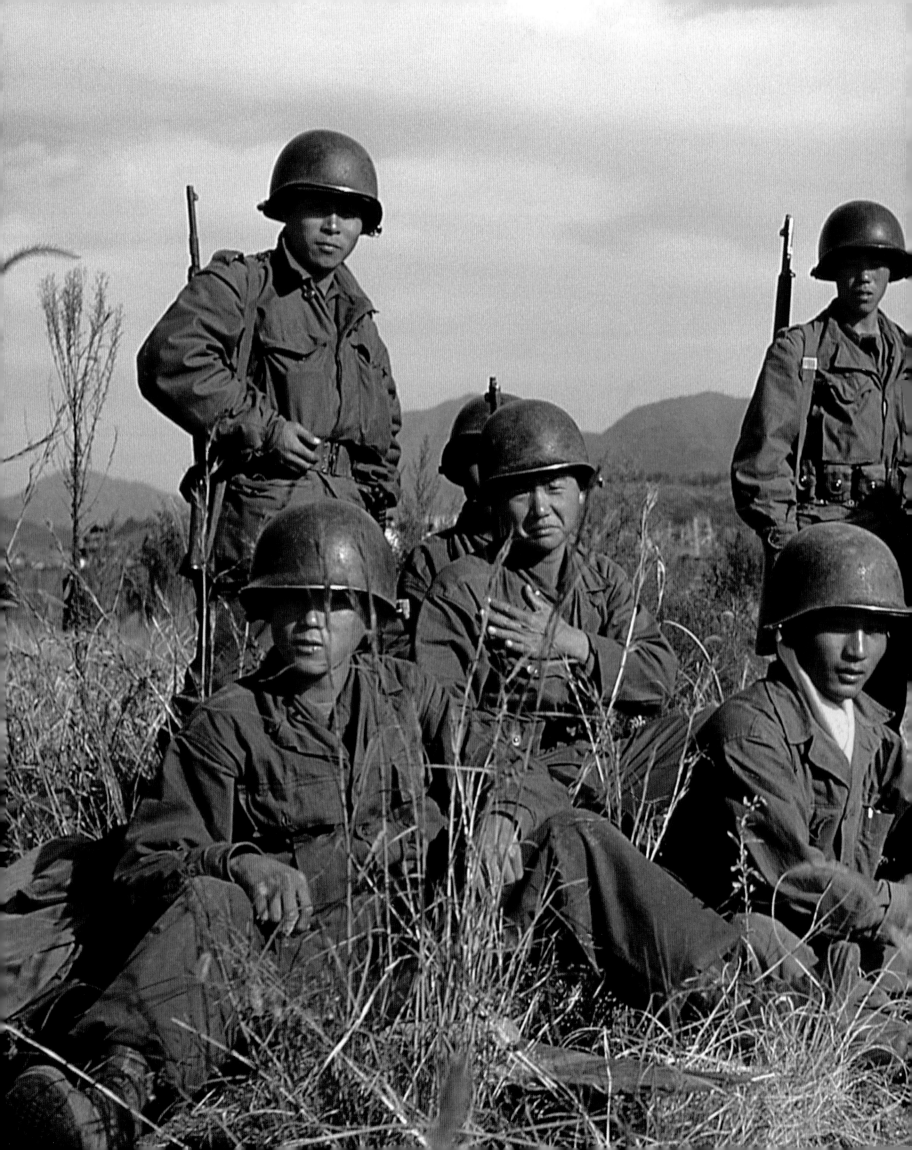

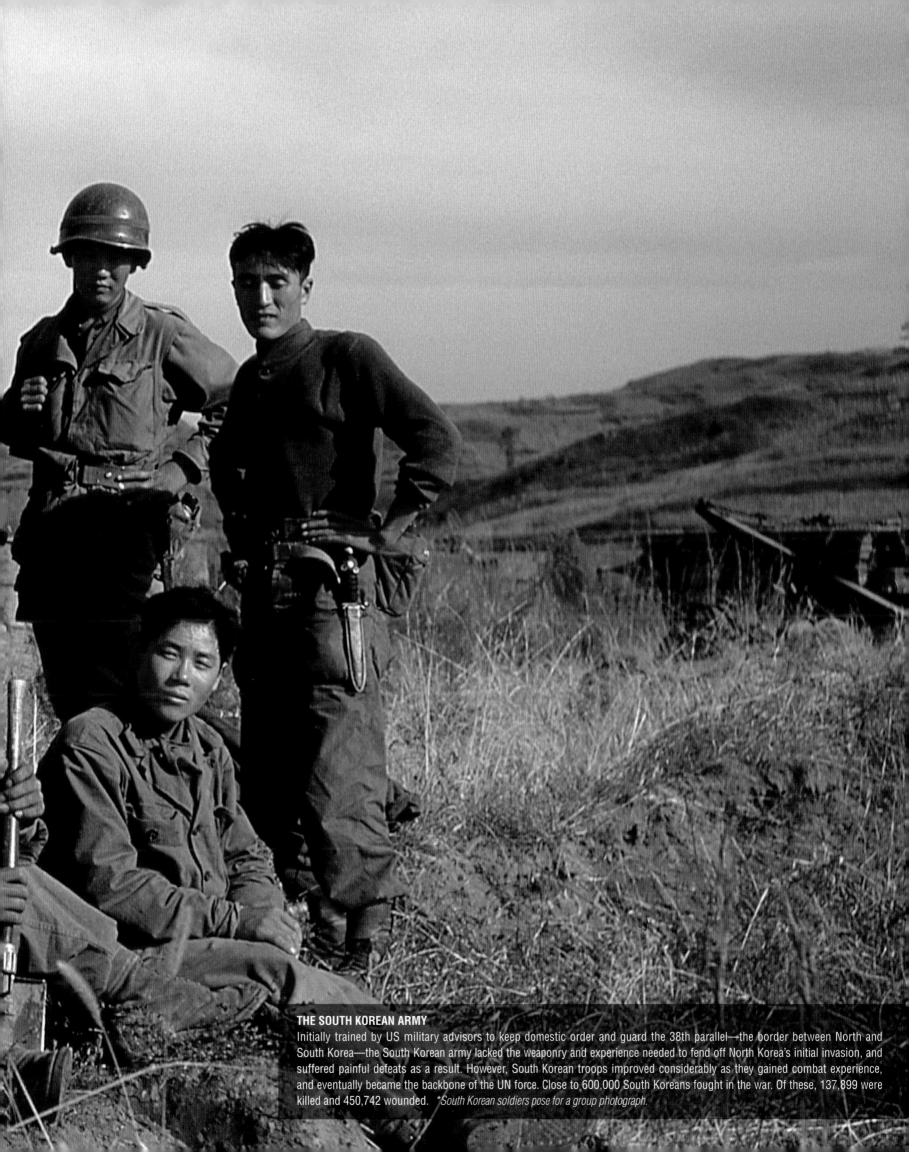

THE SOUTH KOREAN ARMY
Initially trained by US military advisors to keep domestic order and guard the 38th parallel—the border between North and South Korea—the South Korean army lacked the weaponry and experience needed to fend off North Korea's initial invasion, and suffered painful defeats as a result. However, South Korean troops improved considerably as they gained combat experience, and eventually became the backbone of the UN force. Close to 600,000 South Koreans fought in the war. Of these, 137,899 were killed and 450,742 wounded. *South Korean soldiers pose for a group photograph.*

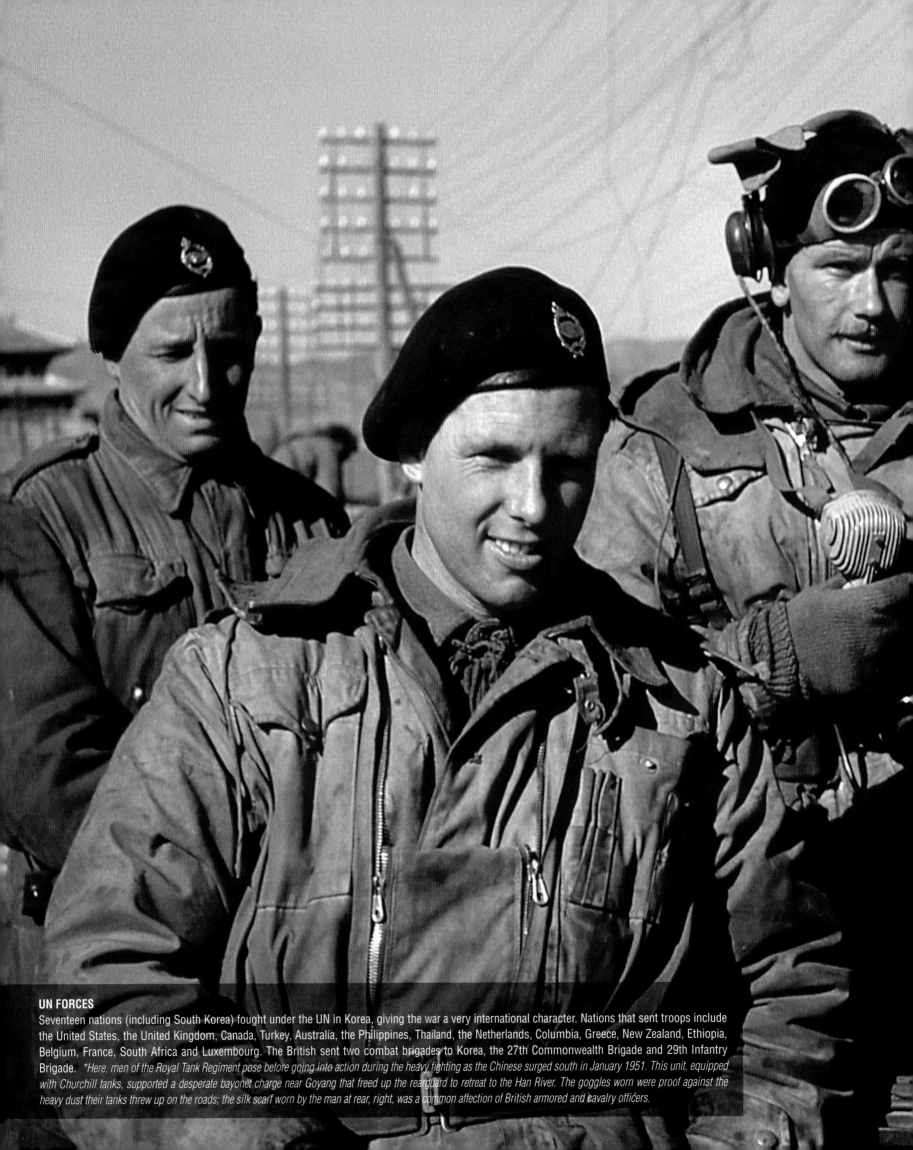

UN FORCES

Seventeen nations (including South Korea) fought under the UN in Korea, giving the war a very international character. Nations that sent troops include the United States, the United Kingdom, Canada, Turkey, Australia, the Philippines, Thailand, the Netherlands, Columbia, Greece, New Zealand, Ethiopia, Belgium, France, South Africa and Luxembourg. The British sent two combat brigades to Korea, the 27th Commonwealth Brigade and 29th Infantry Brigade. *Here, men of the Royal Tank Regiment pose before going into action during the heavy fighting as the Chinese surged south in January 1951. This unit, equipped with Churchill tanks, supported a desperate bayonet charge near Goyang that freed up the rearguard to retreat to the Han River. The goggles worn were proof against the heavy dust their tanks threw up on the roads; the silk scarf worn by the man at rear, right, was a common affection of British armored and cavalry officers.

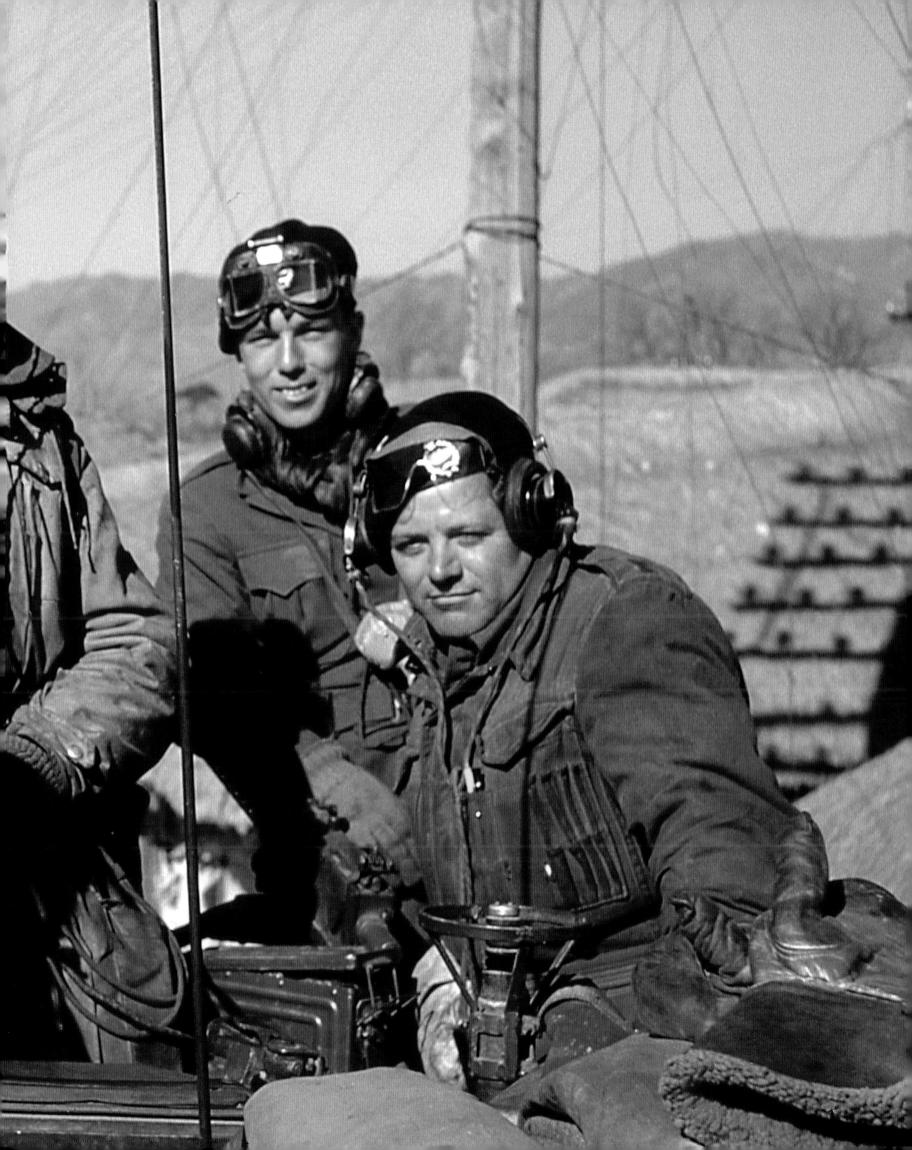

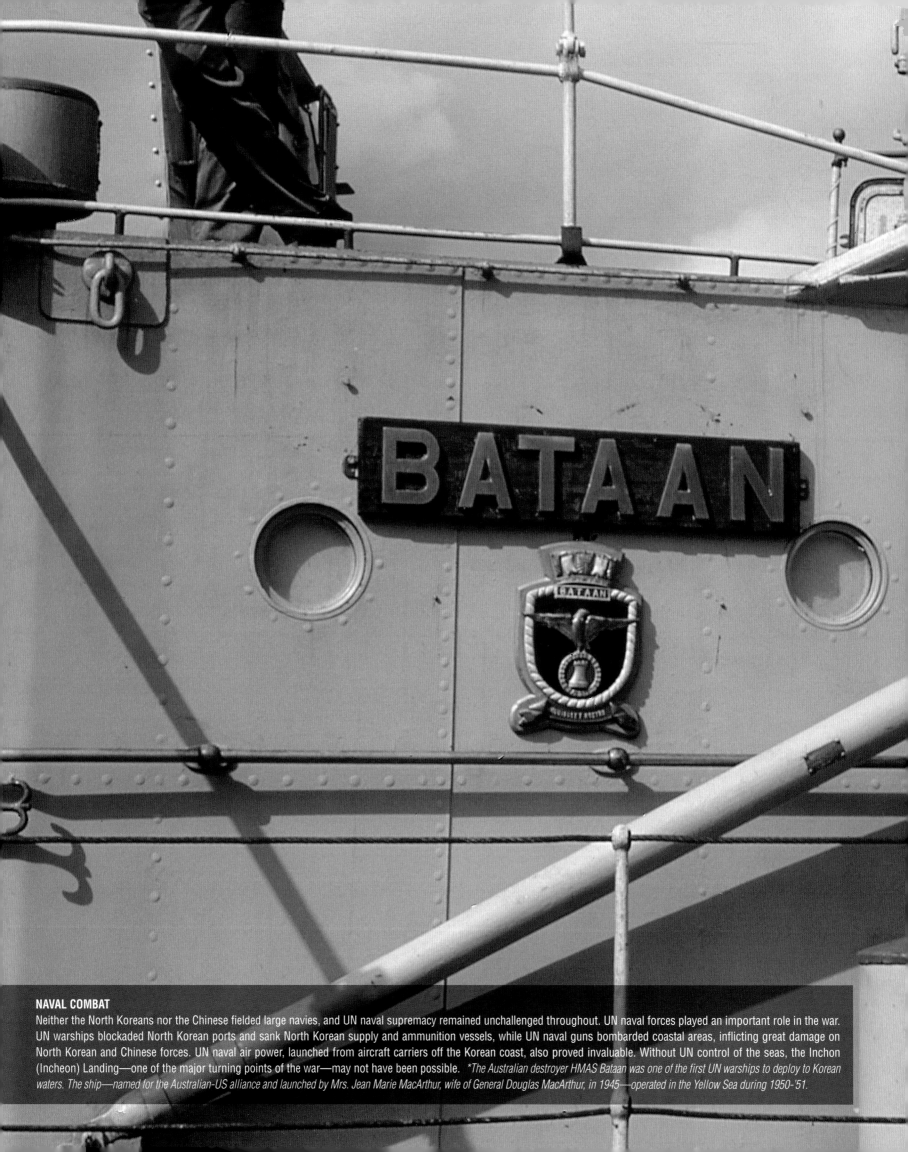

NAVAL COMBAT

Neither the North Koreans nor the Chinese fielded large navies, and UN naval supremacy remained unchallenged throughout. UN naval forces played an important role in the war. UN warships blockaded North Korean ports and sank North Korean supply and ammunition vessels, while UN naval guns bombarded coastal areas, inflicting great damage on North Korean and Chinese forces. UN naval air power, launched from aircraft carriers off the Korean coast, also proved invaluable. Without UN control of the seas, the Inchon (Incheon) Landing—one of the major turning points of the war—may not have been possible. *The Australian destroyer HMAS Bataan was one of the first UN warships to deploy to Korean waters. The ship—named for the Australian-US alliance and launched by Mrs. Jean Marie MacArthur, wife of General Douglas MacArthur, in 1945—operated in the Yellow Sea during 1950-'51.*

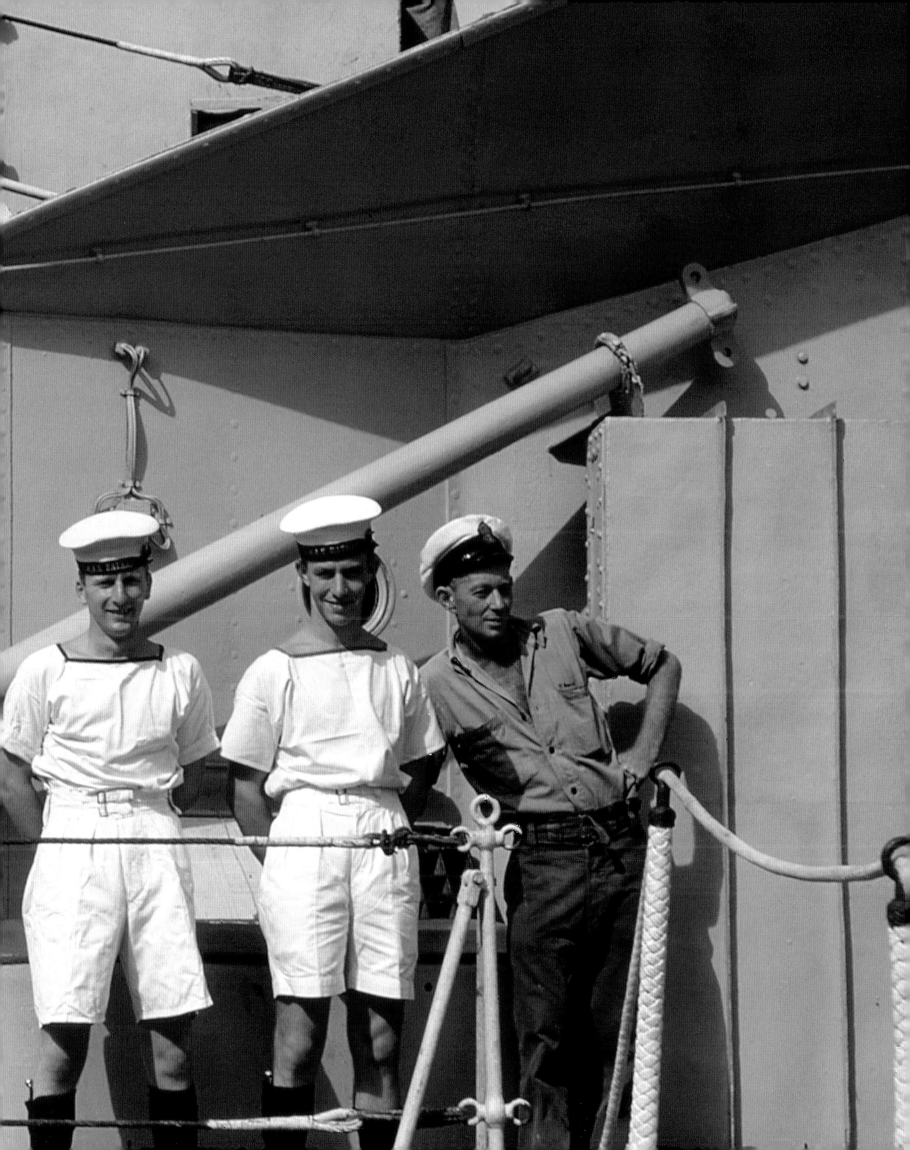

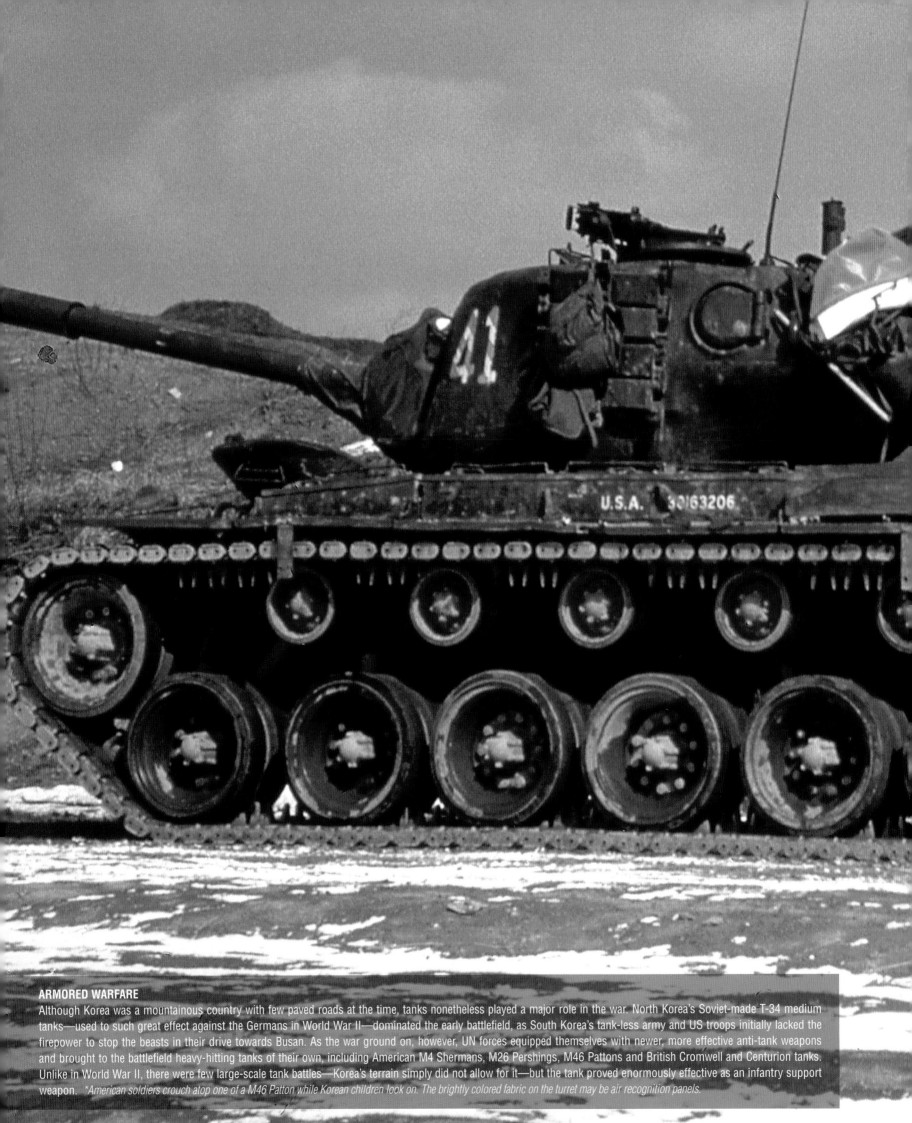

ARMORED WARFARE

Although Korea was a mountainous country with few paved roads at the time, tanks nonetheless played a major role in the war. North Korea's Soviet-made T-34 medium tanks—used to such great effect against the Germans in World War II—dominated the early battlefield, as South Korea's tank-less army and US troops initially lacked the firepower to stop the beasts in their drive towards Busan. As the war ground on, however, UN forces equipped themselves with newer, more effective anti-tank weapons and brought to the battlefield heavy-hitting tanks of their own, including American M4 Shermans, M26 Pershings, M46 Pattons and British Cromwell and Centurion tanks. Unlike in World War II, there were few large-scale tank battles—Korea's terrain simply did not allow for it—but the tank proved enormously effective as an infantry support weapon. *American soldiers crouch atop one of a M46 Patton while Korean children look on. The brightly colored fabric on the turret may be air recognition panels.*

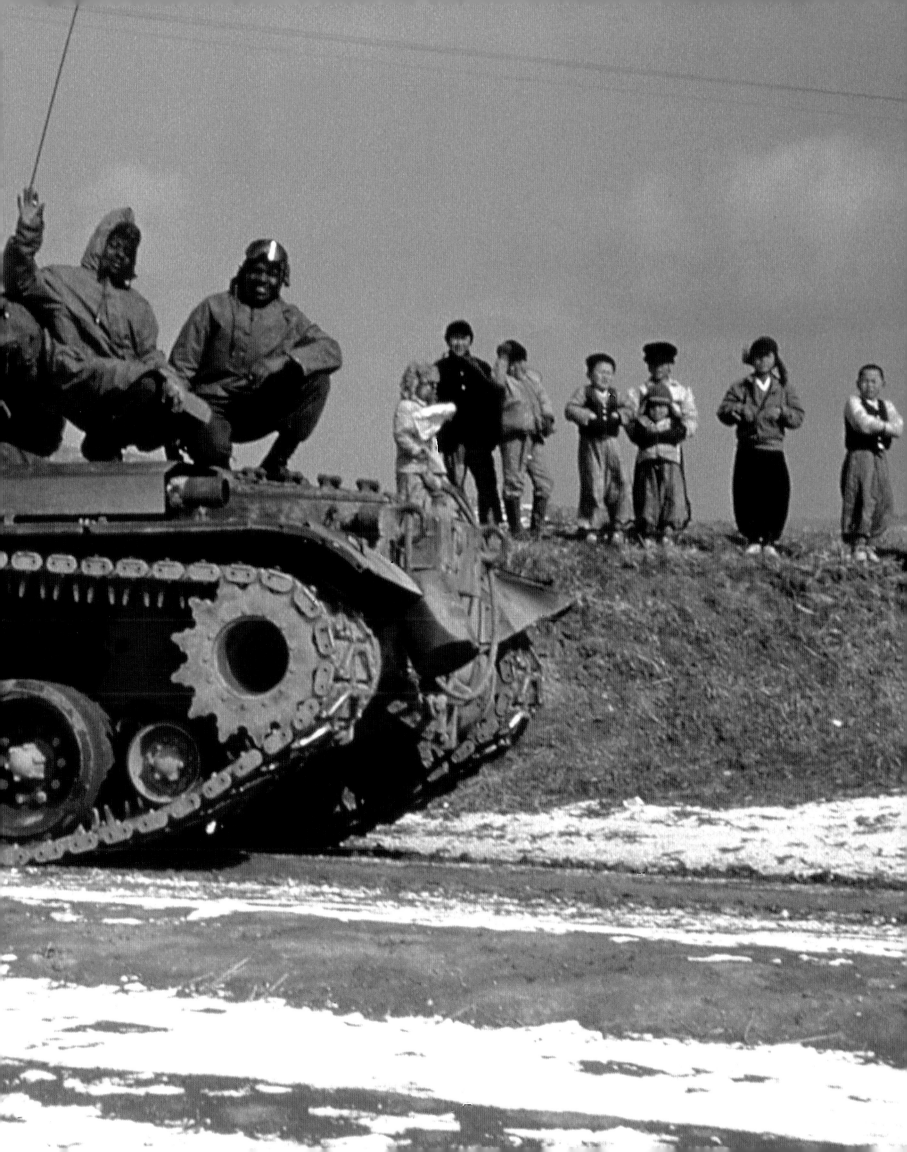

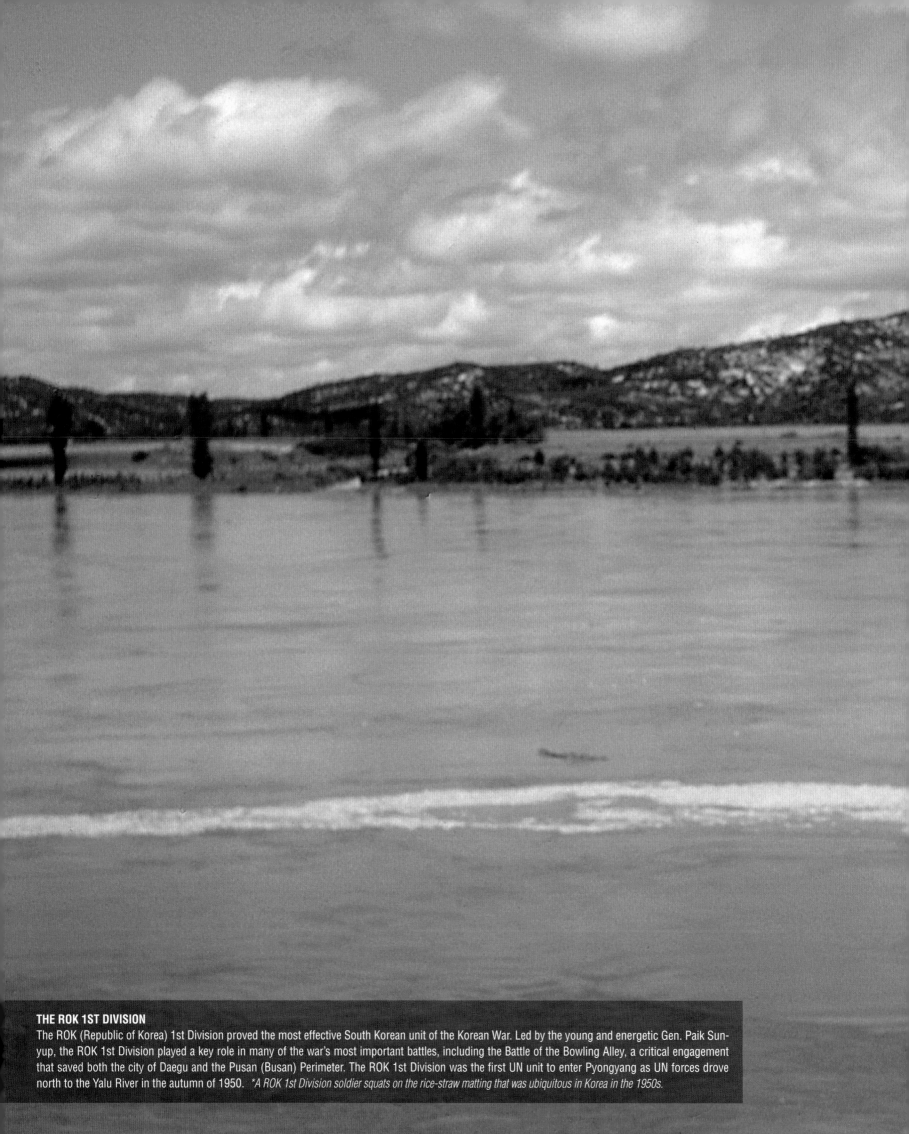

THE ROK 1ST DIVISION
The ROK (Republic of Korea) 1st Division proved the most effective South Korean unit of the Korean War. Led by the young and energetic Gen. Paik Sun-yup, the ROK 1st Division played a key role in many of the war's most important battles, including the Battle of the Bowling Alley, a critical engagement that saved both the city of Daegu and the Pusan (Busan) Perimeter. The ROK 1st Division was the first UN unit to enter Pyongyang as UN forces drove north to the Yalu River in the autumn of 1950. *A ROK 1st Division soldier squats on the rice-straw matting that was ubiquitous in Korea in the 1950s.

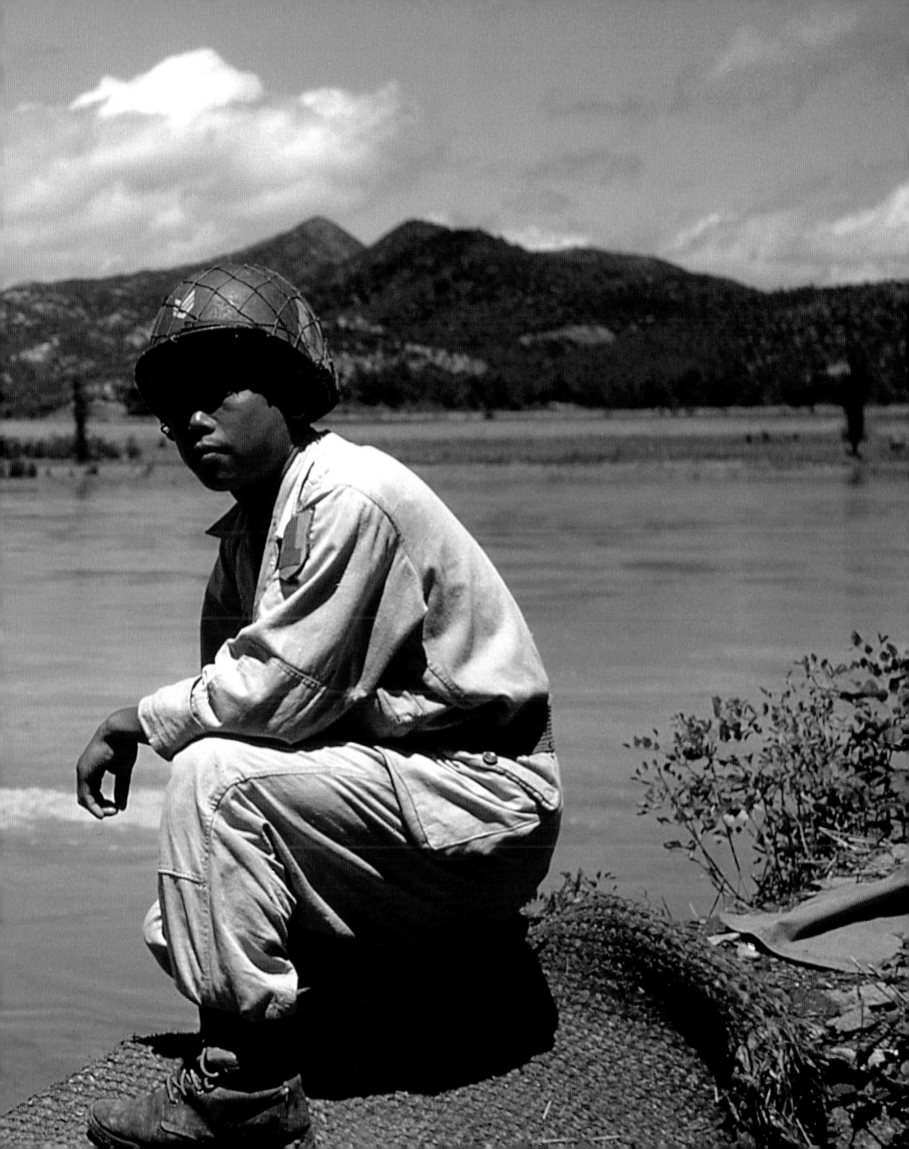

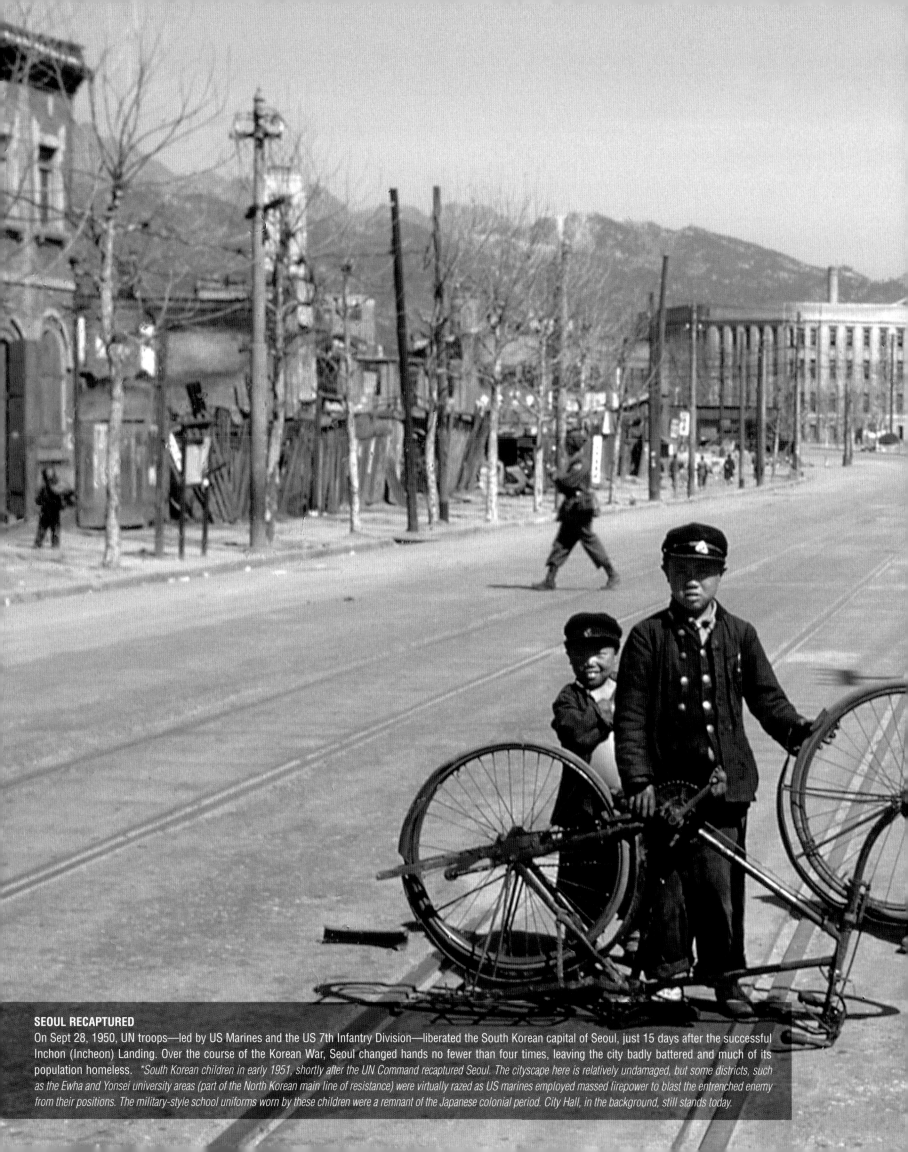

SEOUL RECAPTURED

On Sept 28, 1950, UN troops—led by US Marines and the US 7th Infantry Division—liberated the South Korean capital of Seoul, just 15 days after the successful Inchon (Incheon) Landing. Over the course of the Korean War, Seoul changed hands no fewer than four times, leaving the city badly battered and much of its population homeless. *South Korean children in early 1951, shortly after the UN Command recaptured Seoul. The cityscape here is relatively undamaged, but some districts, such as the Ewha and Yonsei university areas (part of the North Korean main line of resistance) were virtually razed as US marines employed massed firepower to blast the entrenched enemy from their positions. The military-style school uniforms worn by these children were a remnant of the Japanese colonial period. City Hall, in the background, still stands today.

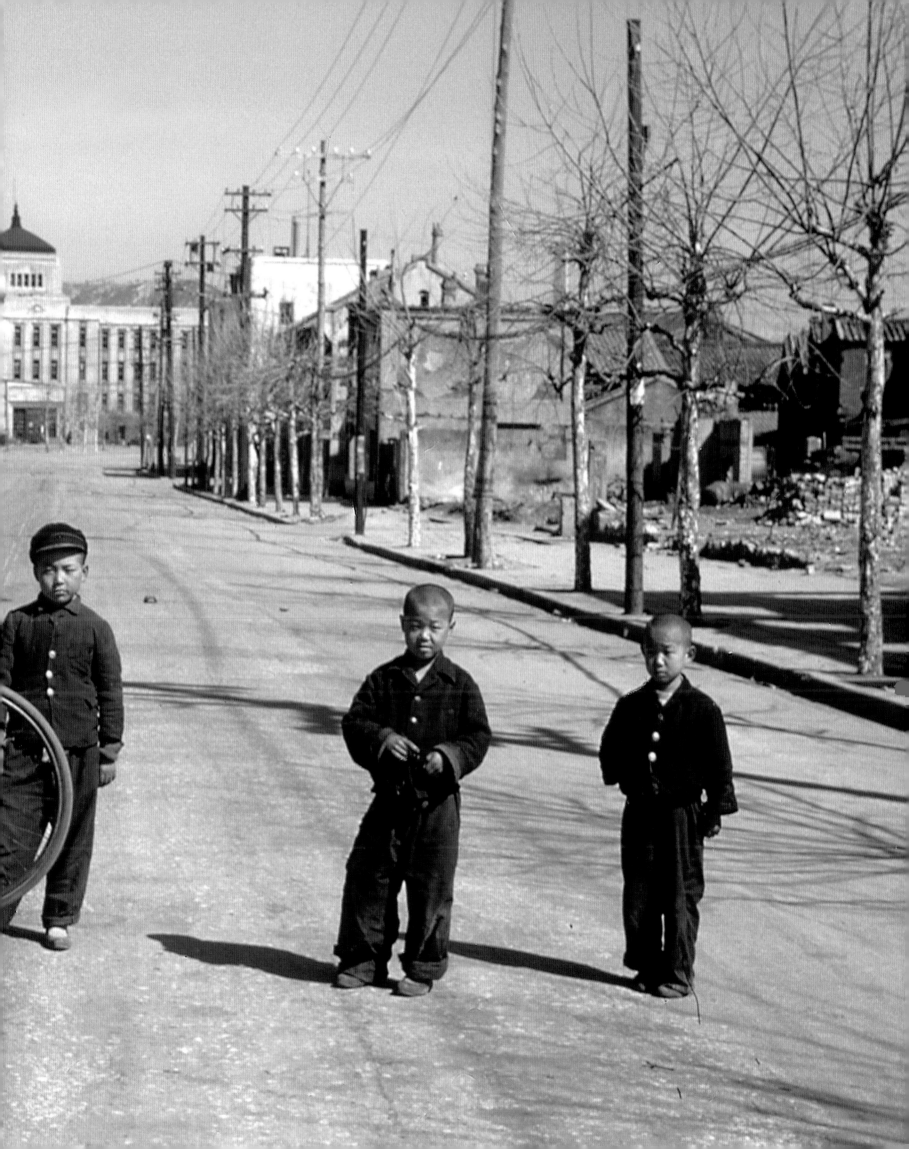

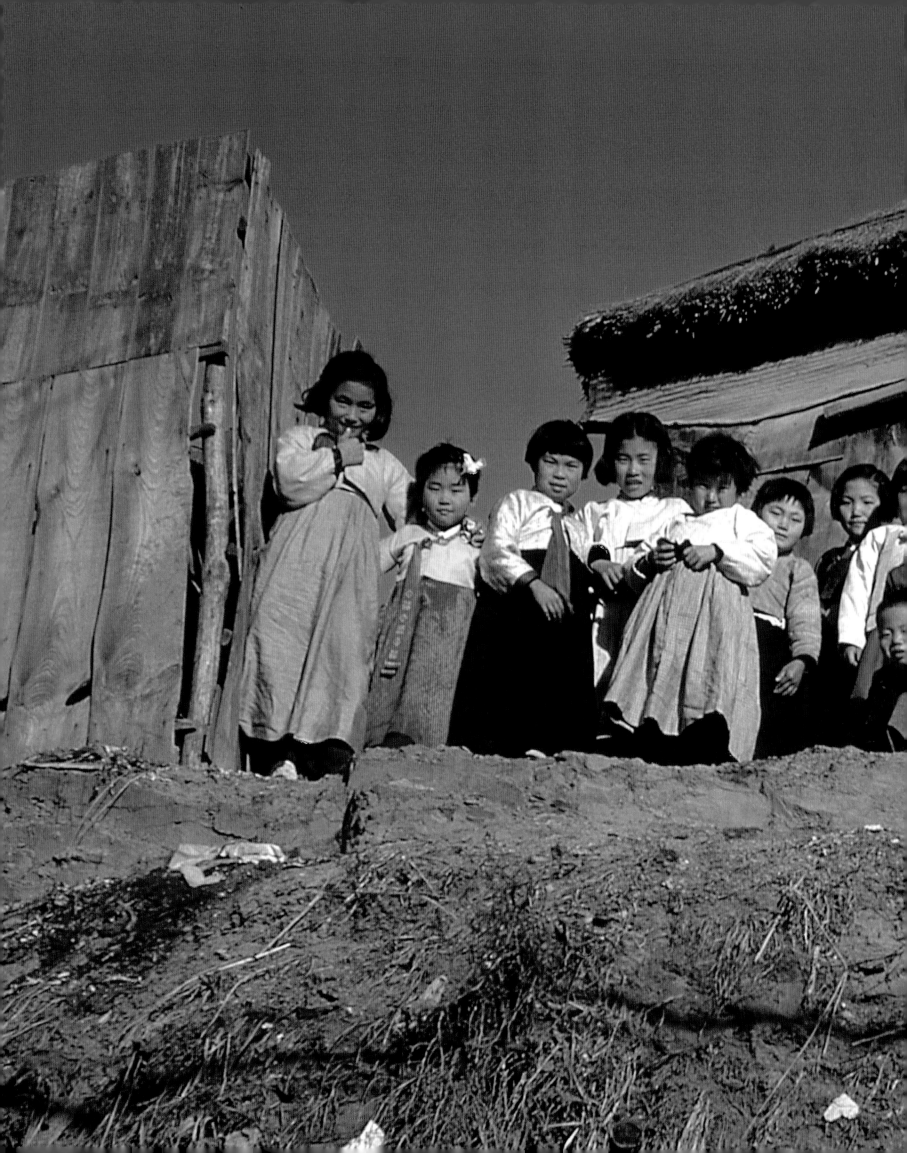

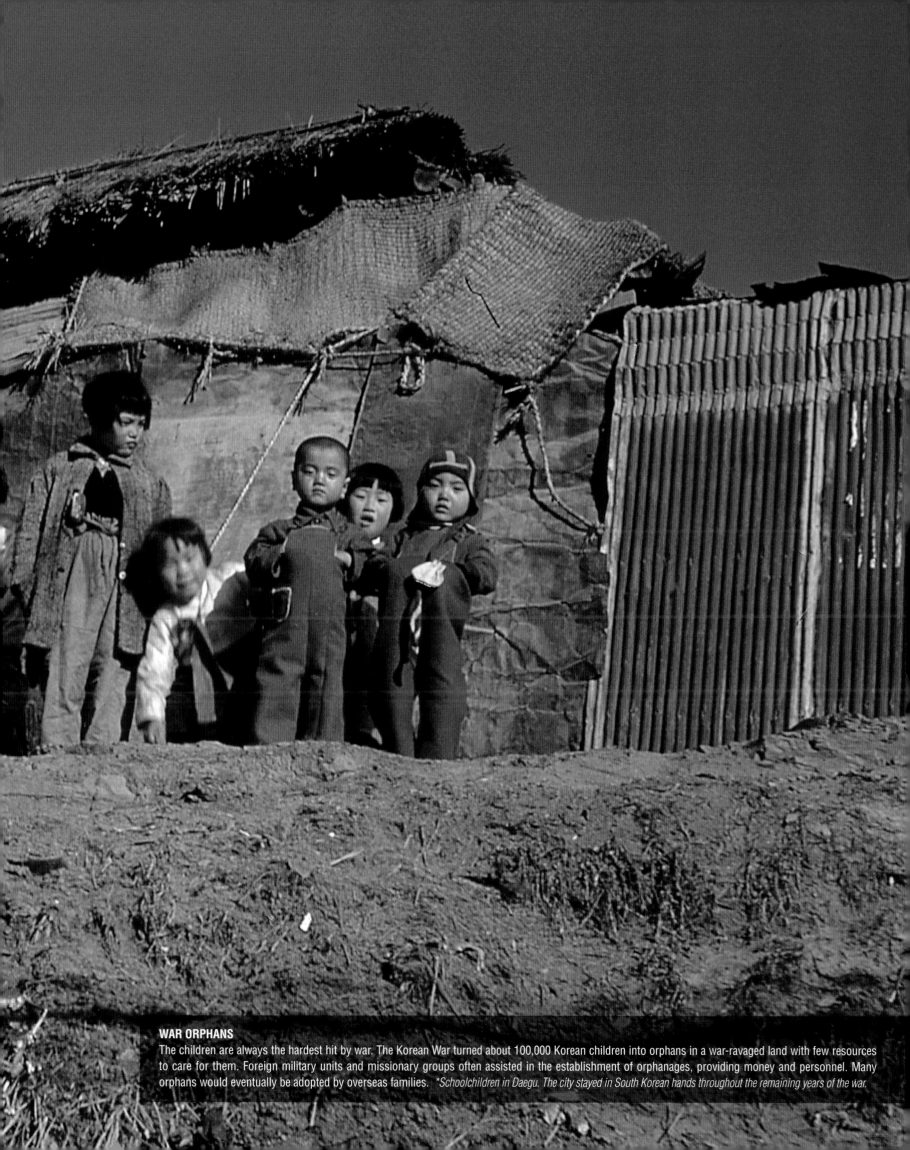

WAR ORPHANS

The children are always the hardest hit by war. The Korean War turned about 100,000 Korean children into orphans in a war-ravaged land with few resources to care for them. Foreign military units and missionary groups often assisted in the establishment of orphanages, providing money and personnel. Many orphans would eventually be adopted by overseas families. *Schoolchildren in Daegu. The city stayed in South Korean hands throughout the remaining years of the war.*

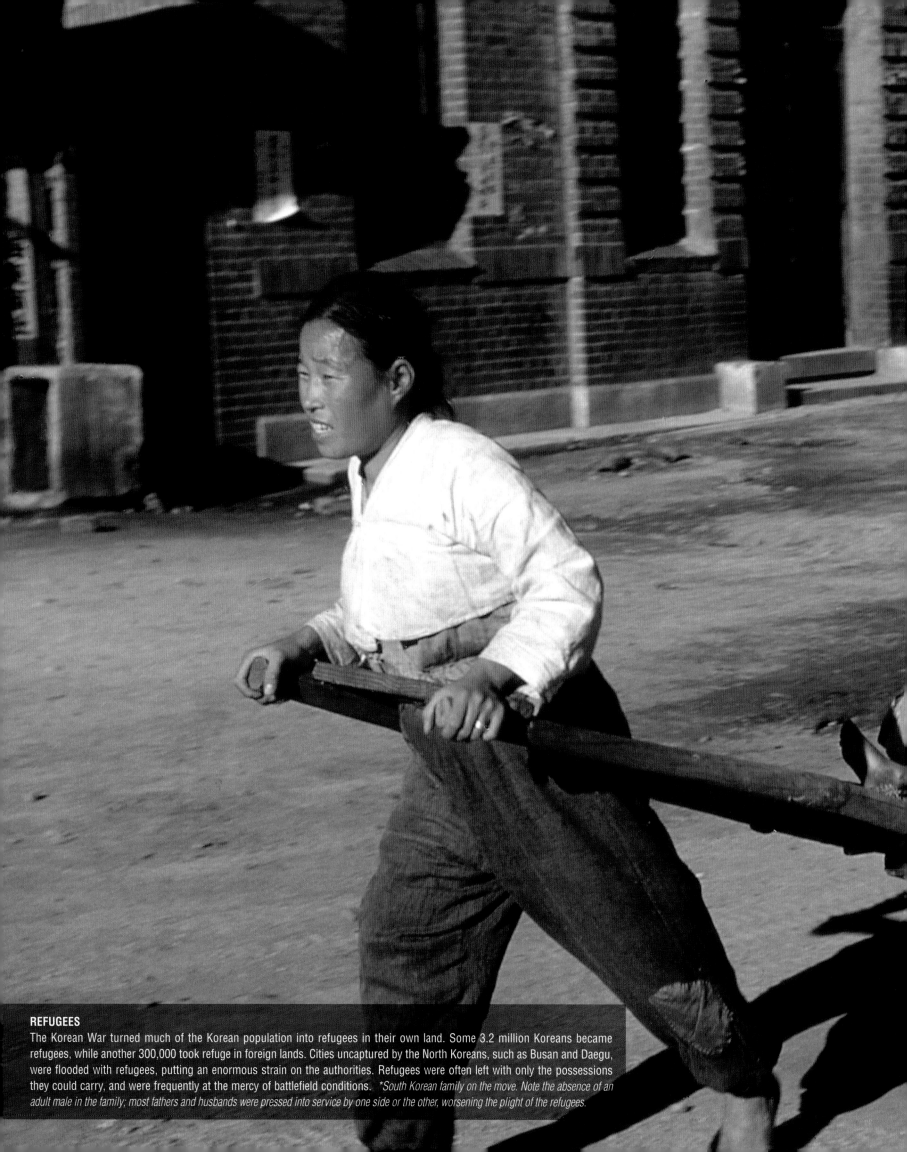

REFUGEES

The Korean War turned much of the Korean population into refugees in their own land. Some 3.2 million Koreans became refugees, while another 300,000 took refuge in foreign lands. Cities uncaptured by the North Koreans, such as Busan and Daegu, were flooded with refugees, putting an enormous strain on the authorities. Refugees were often left with only the possessions they could carry, and were frequently at the mercy of battlefield conditions. *South Korean family on the move. Note the absence of an adult male in the family; most fathers and husbands were pressed into service by one side or the other, worsening the plight of the refugees.*

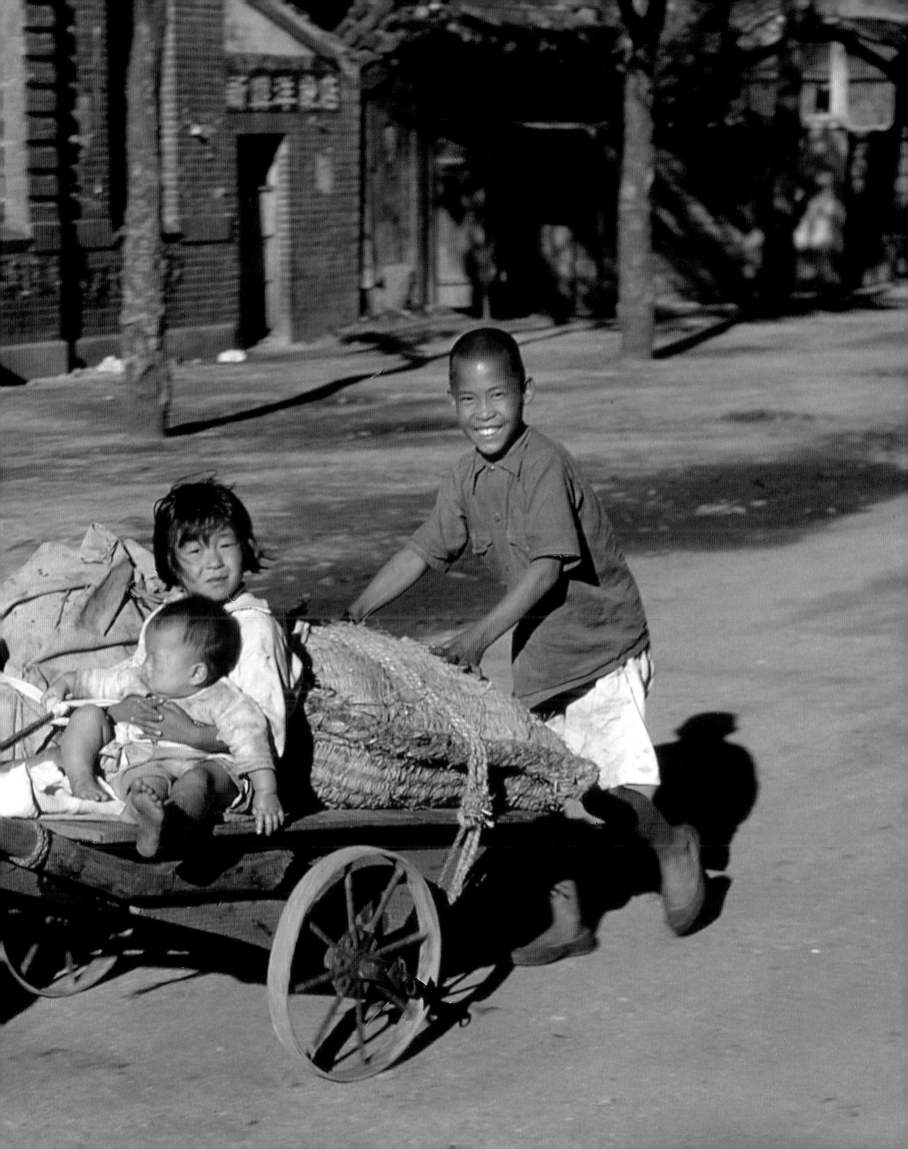

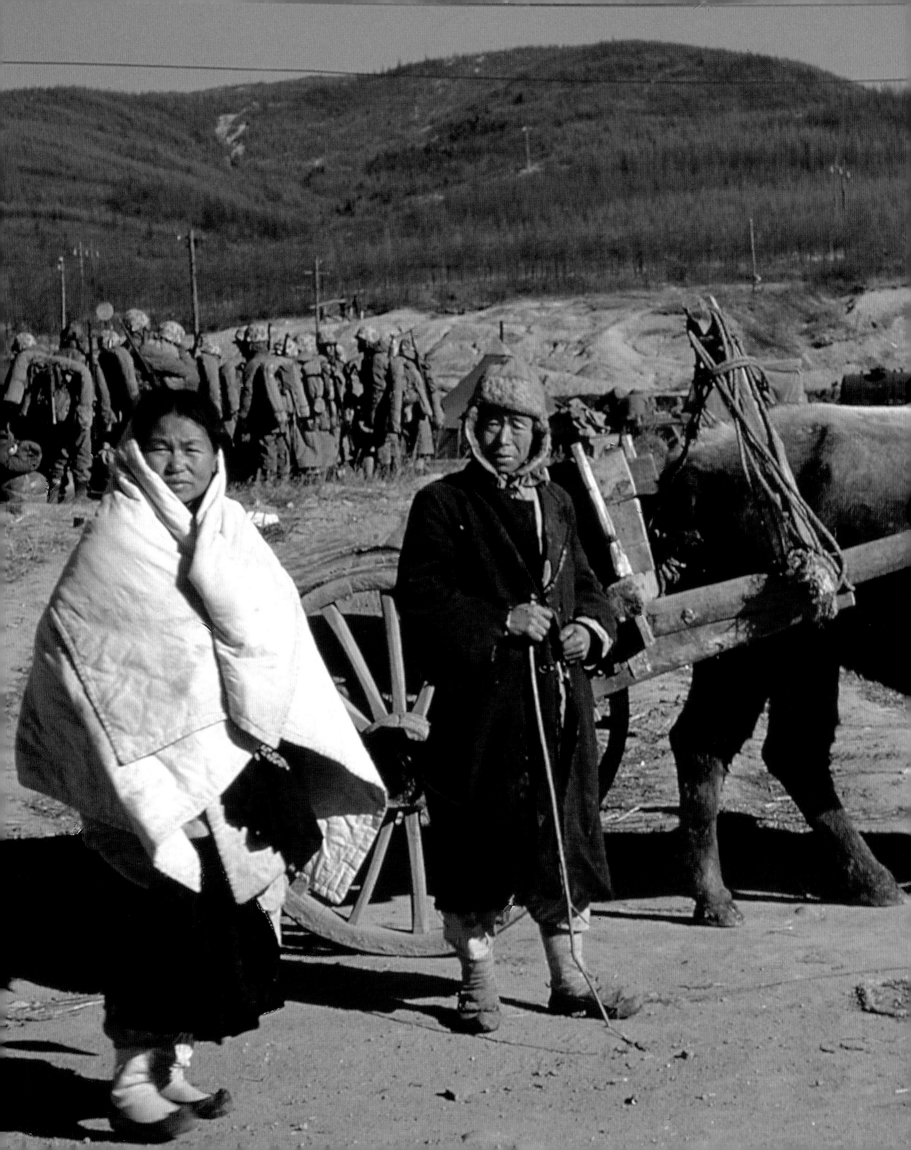

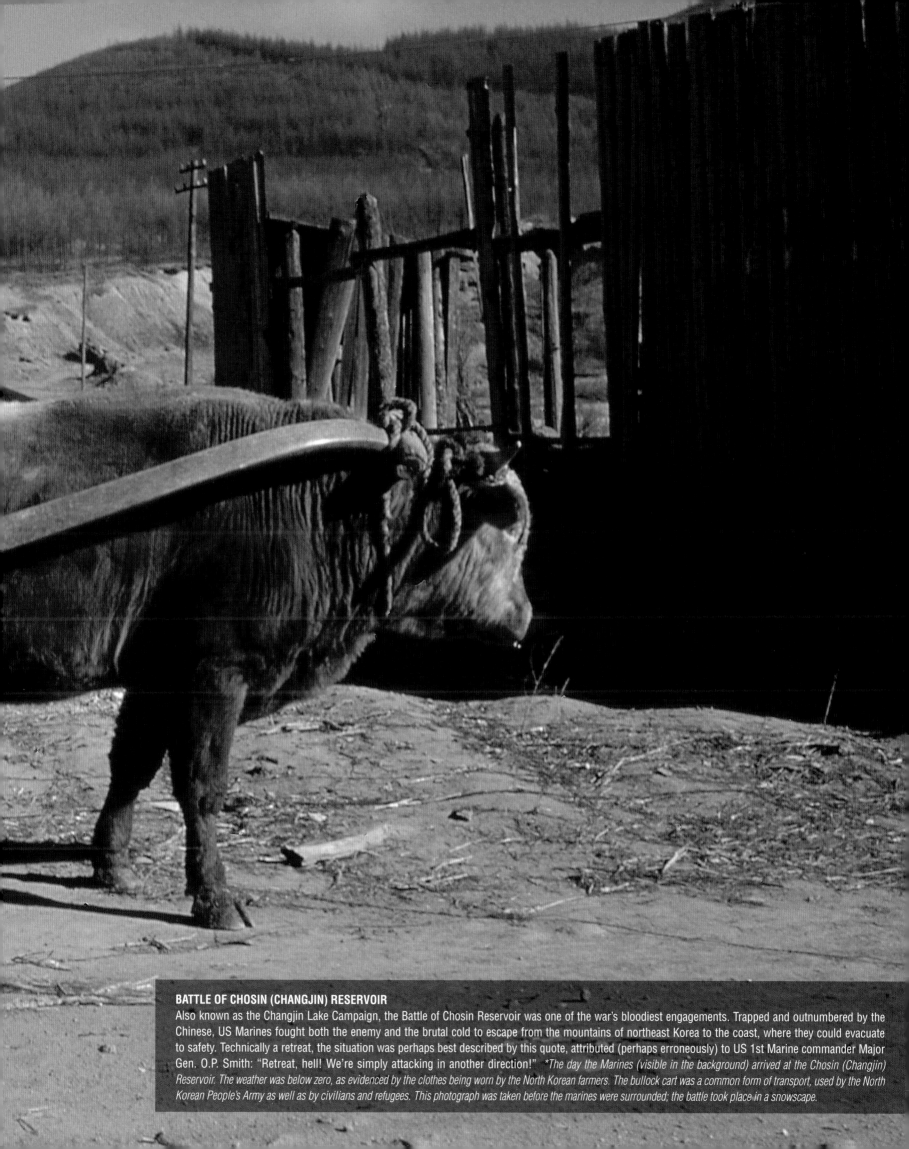

BATTLE OF CHOSIN (CHANGJIN) RESERVOIR
Also known as the Changjin Lake Campaign, the Battle of Chosin Reservoir was one of the war's bloodiest engagements. Trapped and outnumbered by the Chinese, US Marines fought both the enemy and the brutal cold to escape from the mountains of northeast Korea to the coast, where they could evacuate to safety. Technically a retreat, the situation was perhaps best described by this quote, attributed (perhaps erroneously) to US 1st Marine commander Major Gen. O.P. Smith: "Retreat, hell! We're simply attacking in another direction!" *The day the Marines (visible in the background) arrived at the Chosin (Changjin) Reservoir. The weather was below zero, as evidenced by the clothes being worn by the North Korean farmers. The bullock cart was a common form of transport, used by the North Korean People's Army as well as by civilians and refugees. This photograph was taken before the marines were surrounded; the battle took place in a snowscape.*

N.B.C.
WAR CORRESPOND

WAR CORRESPONDENTS

For most Americans, the Korean War was conveyed through the still image. In fact, Korea was the last US war where this was the case, as TV would dramatically change war reporting in Vietnam. Being a war correspondent is a dangerous job, and Korea was no different. A total of 12 American journalists were killed in the war.

Noted American radio commentator Hans von Kaltenborn (1878-1965) poses in front of the NBC jeep. He is wearing a patch on his shoulder that was designed by reporters and used throughout the Korean war.

Cameramen from the Associated Press. Most Korean War photojournalists did their work in black-and-white.

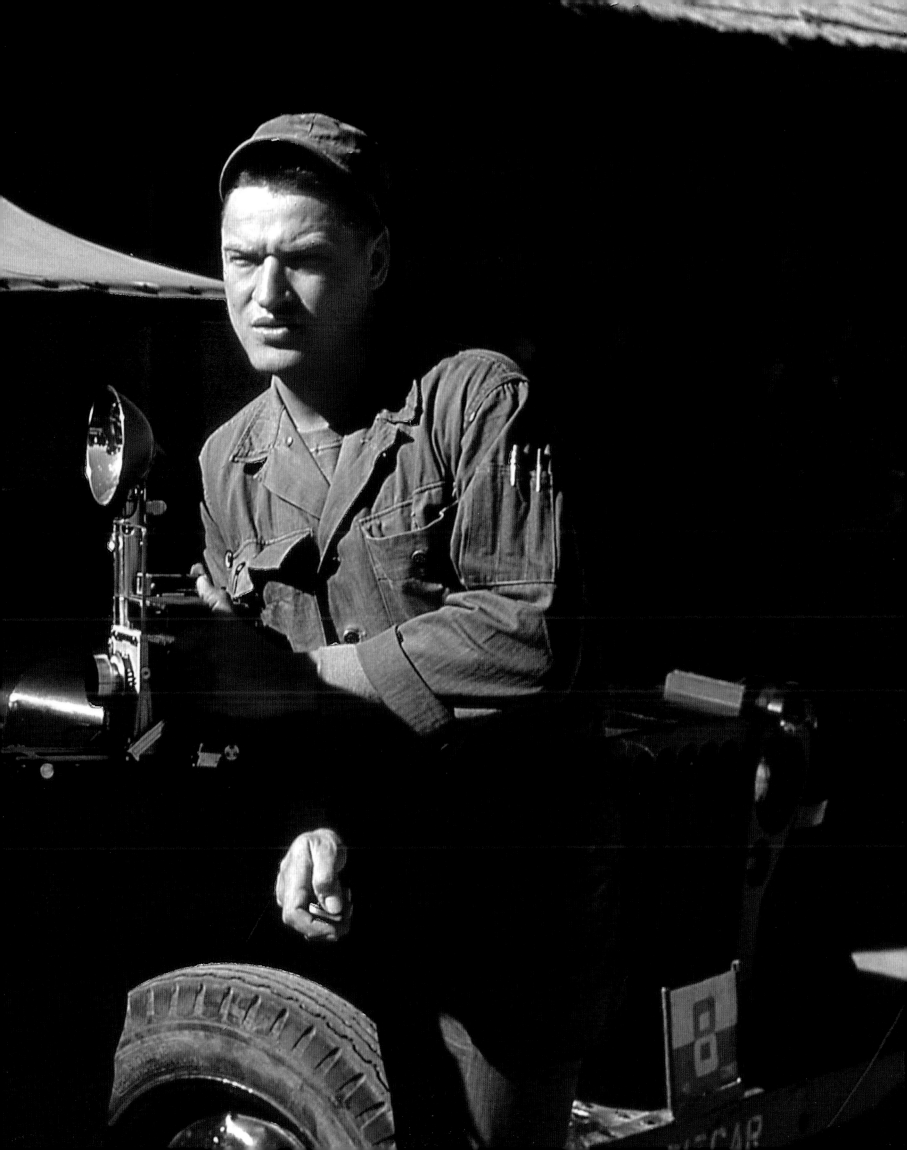

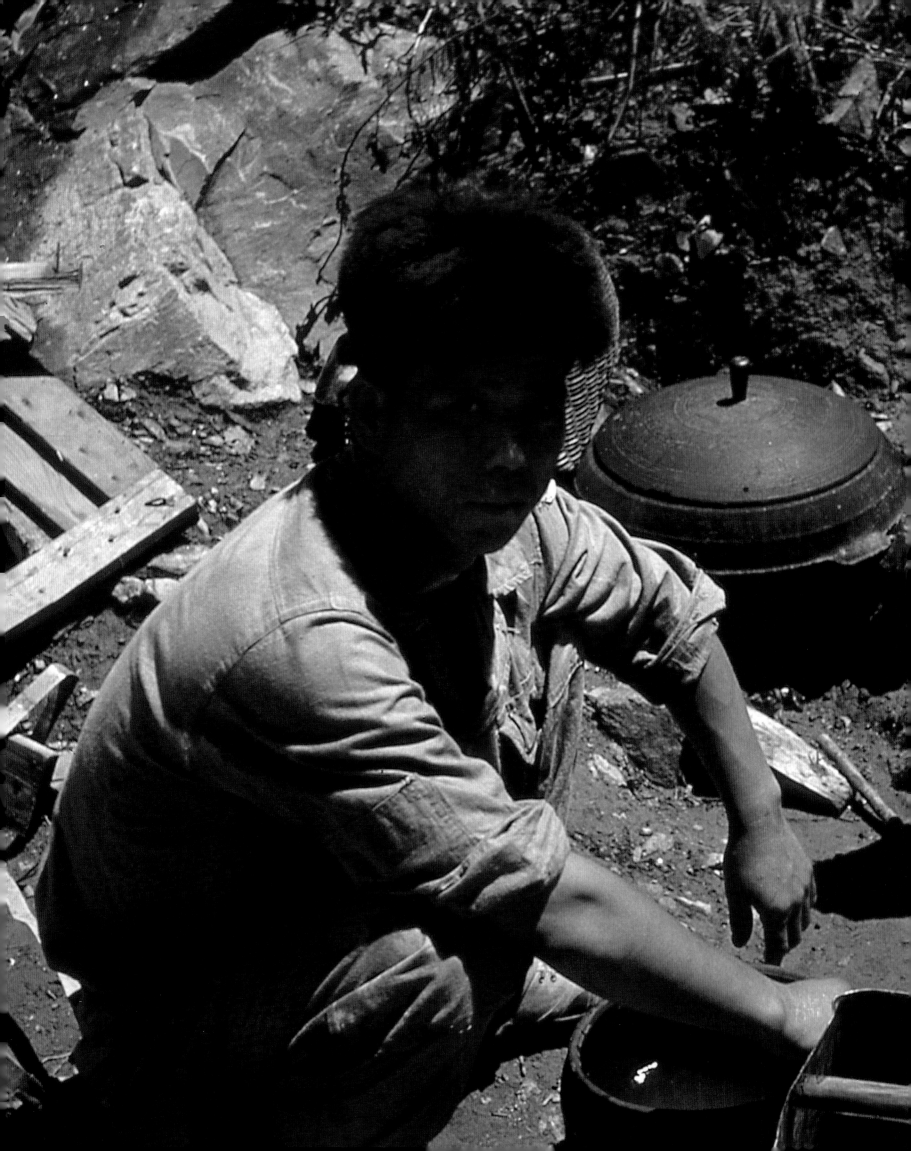

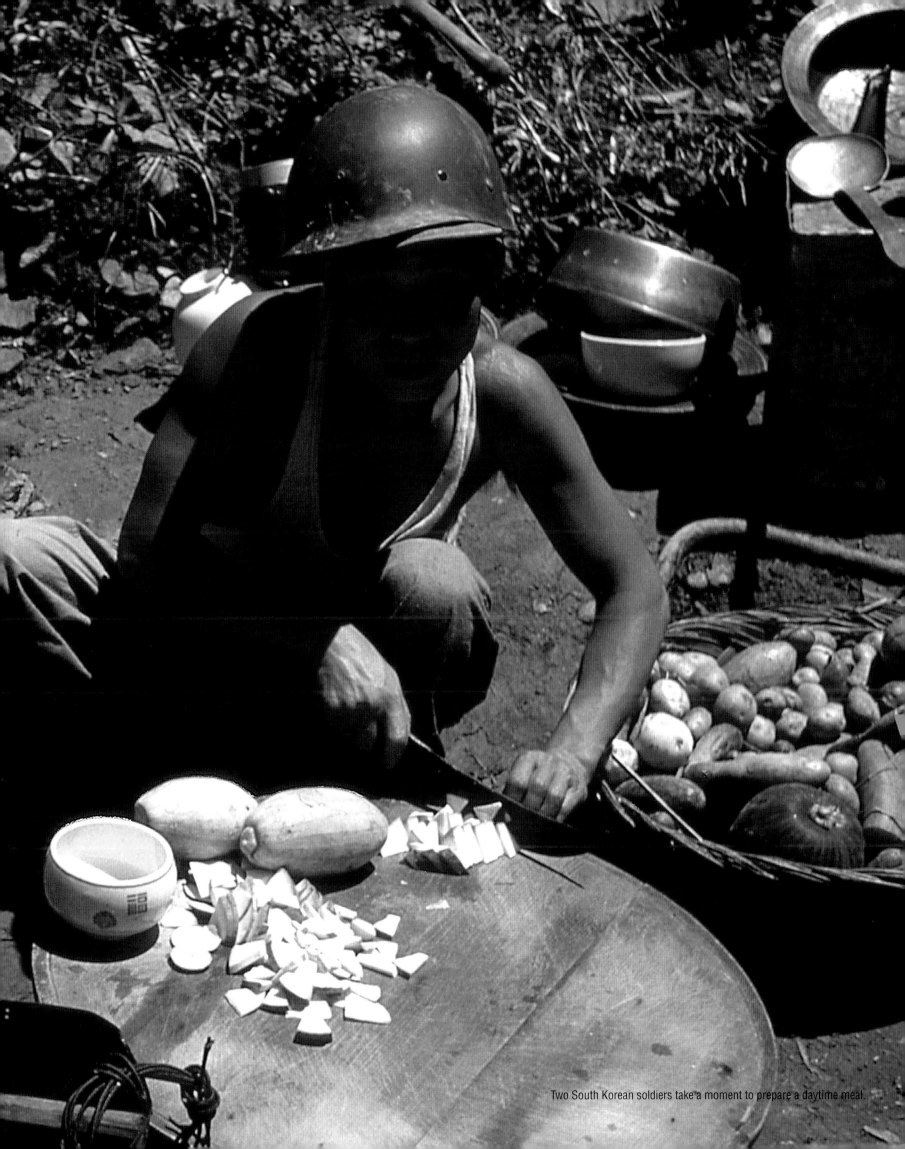

Two South Korean soldiers take a moment to prepare a daytime meal.

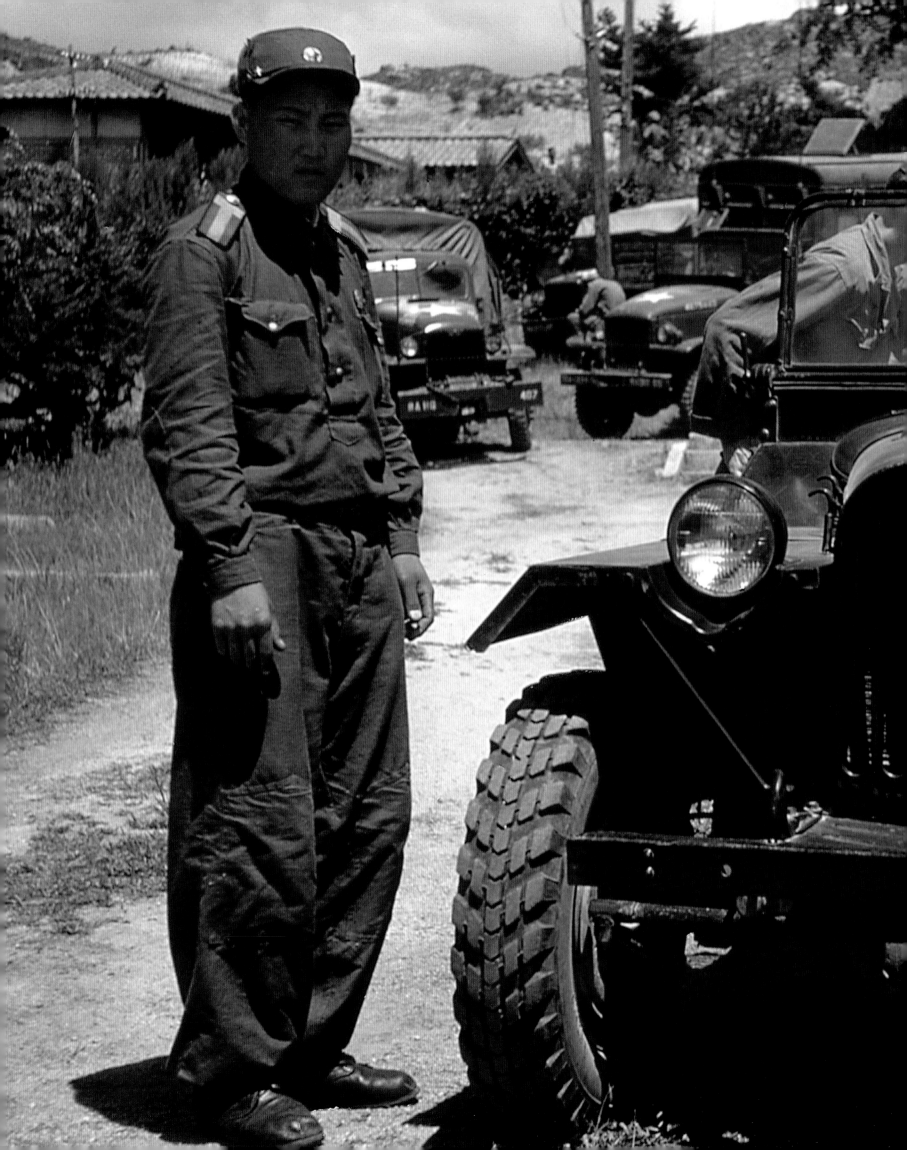

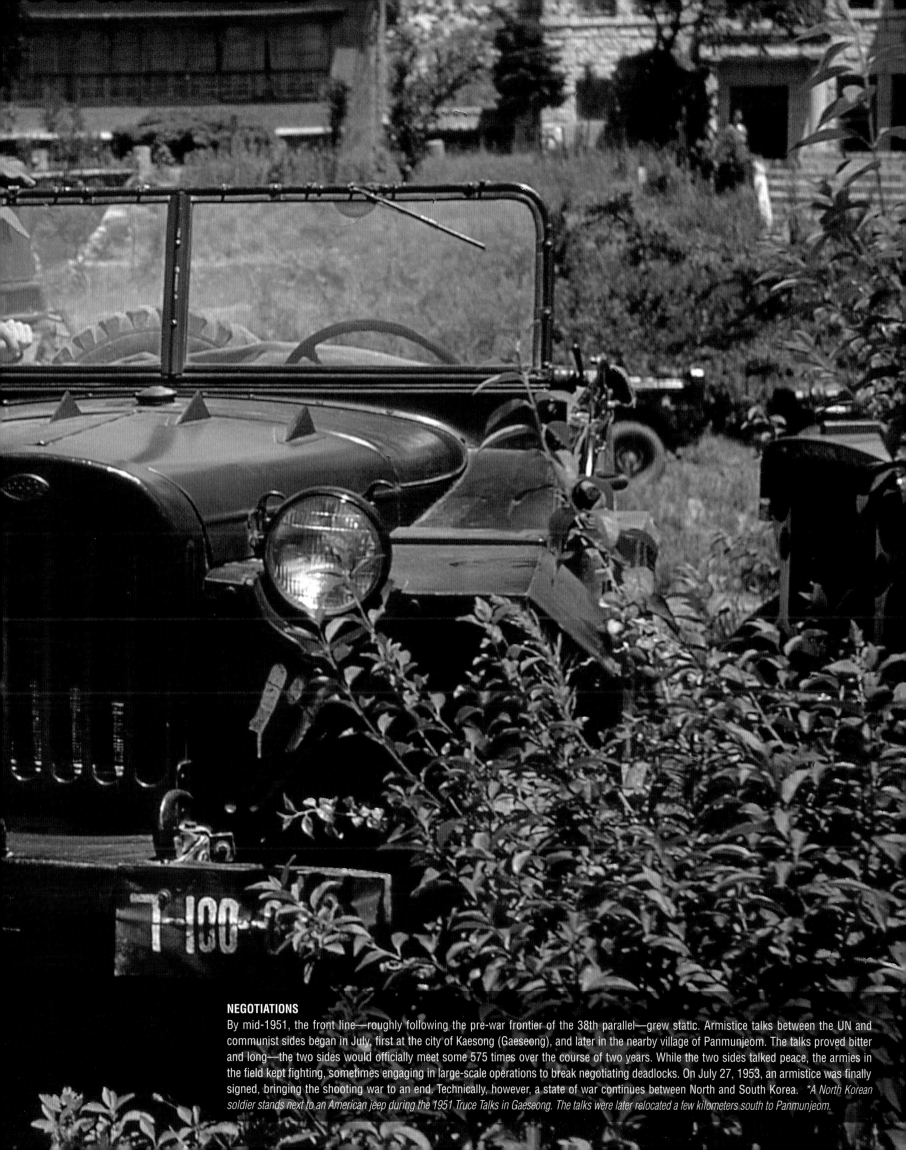

NEGOTIATIONS

By mid-1951, the front line—roughly following the pre-war frontier of the 38th parallel—grew static. Armistice talks between the UN and communist sides began in July, first at the city of Kaesong (Gaeseong), and later in the nearby village of Panmunjeom. The talks proved bitter and long—the two sides would officially meet some 575 times over the course of two years. While the two sides talked peace, the armies in the field kept fighting, sometimes engaging in large-scale operations to break negotiating deadlocks. On July 27, 1953, an armistice was finally signed, bringing the shooting war to an end. Technically, however, a state of war continues between North and South Korea. *A North Korean soldier stands next to an American jeep during the 1951 Truce Talks in Gaeseong. The talks were later relocated a few kilometers south to Panmunjeom.*

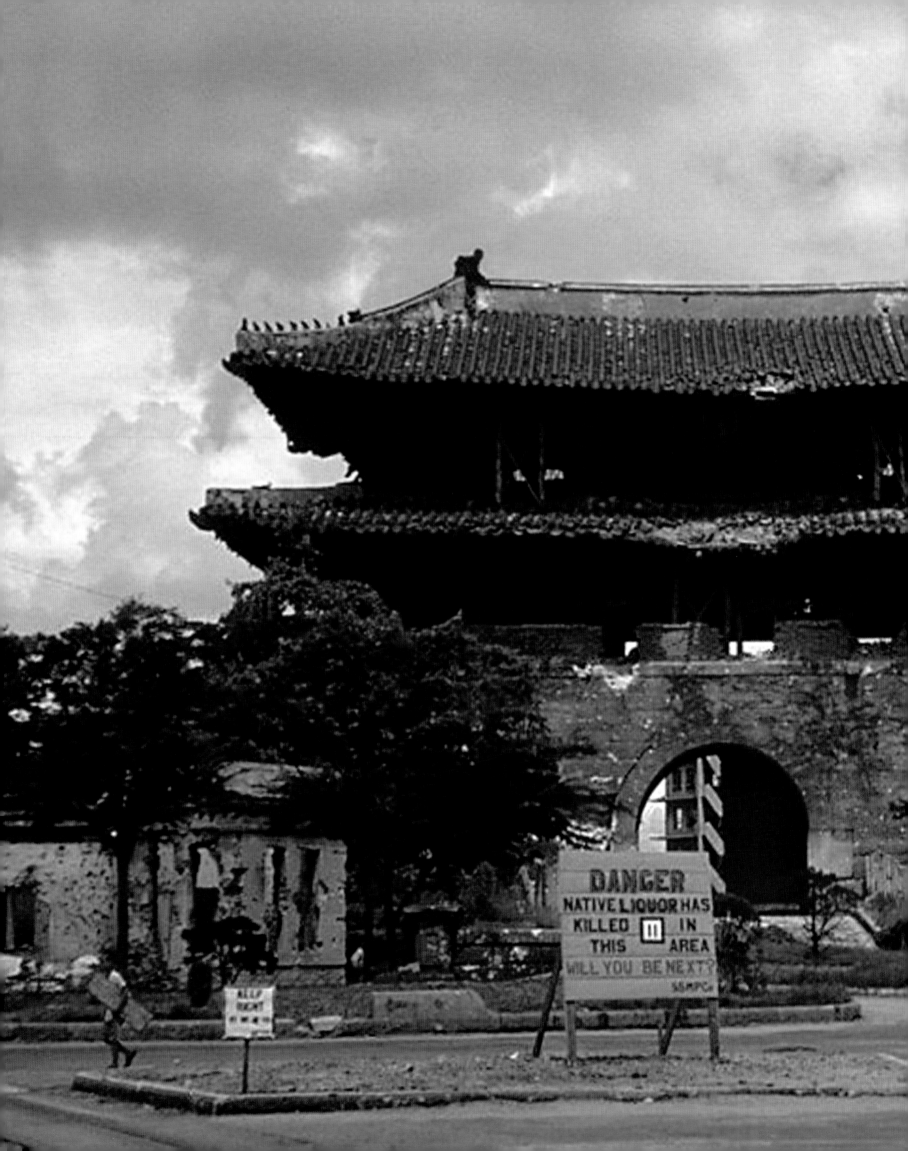

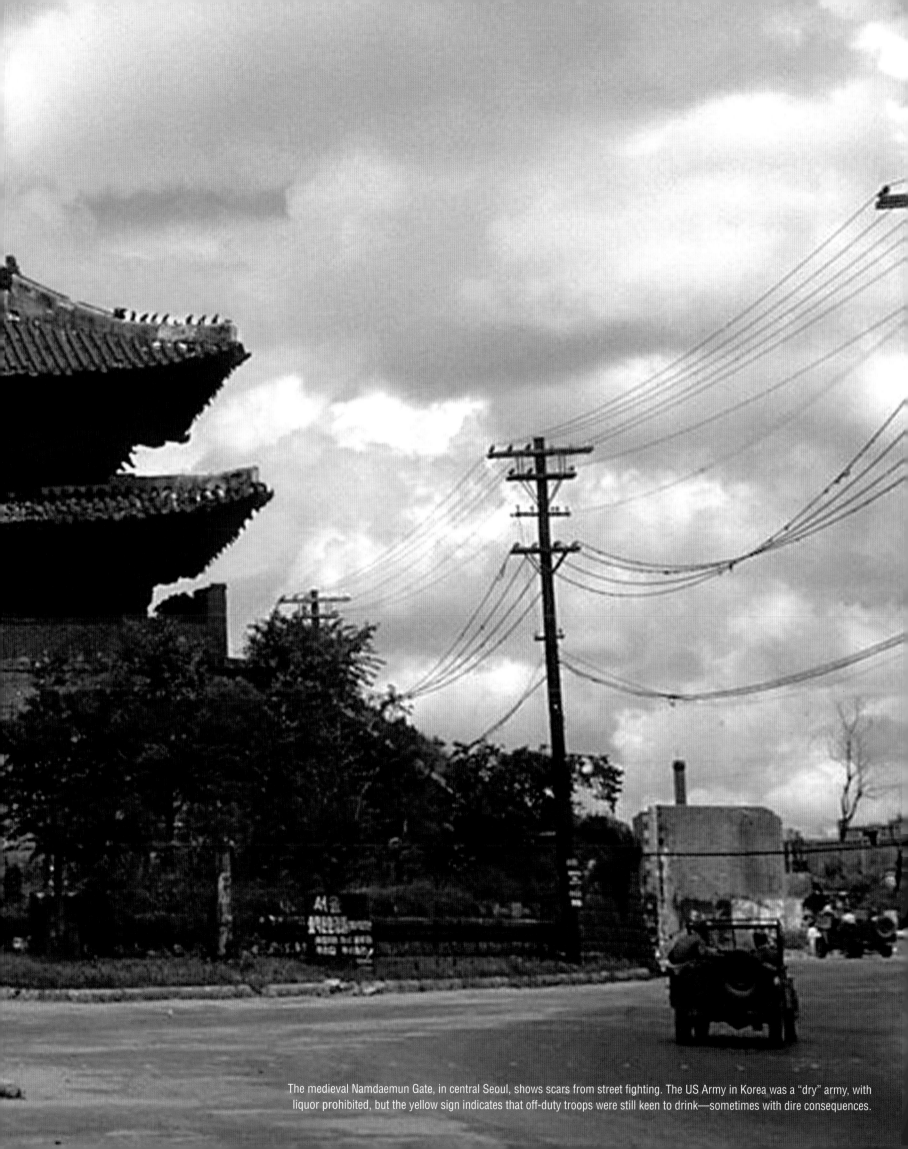

The medieval Namdaemun Gate, in central Seoul, shows scars from street fighting. The US Army in Korea was a "dry" army, with liquor prohibited, but the yellow sign indicates that off-duty troops were still keen to drink—sometimes with dire consequences.

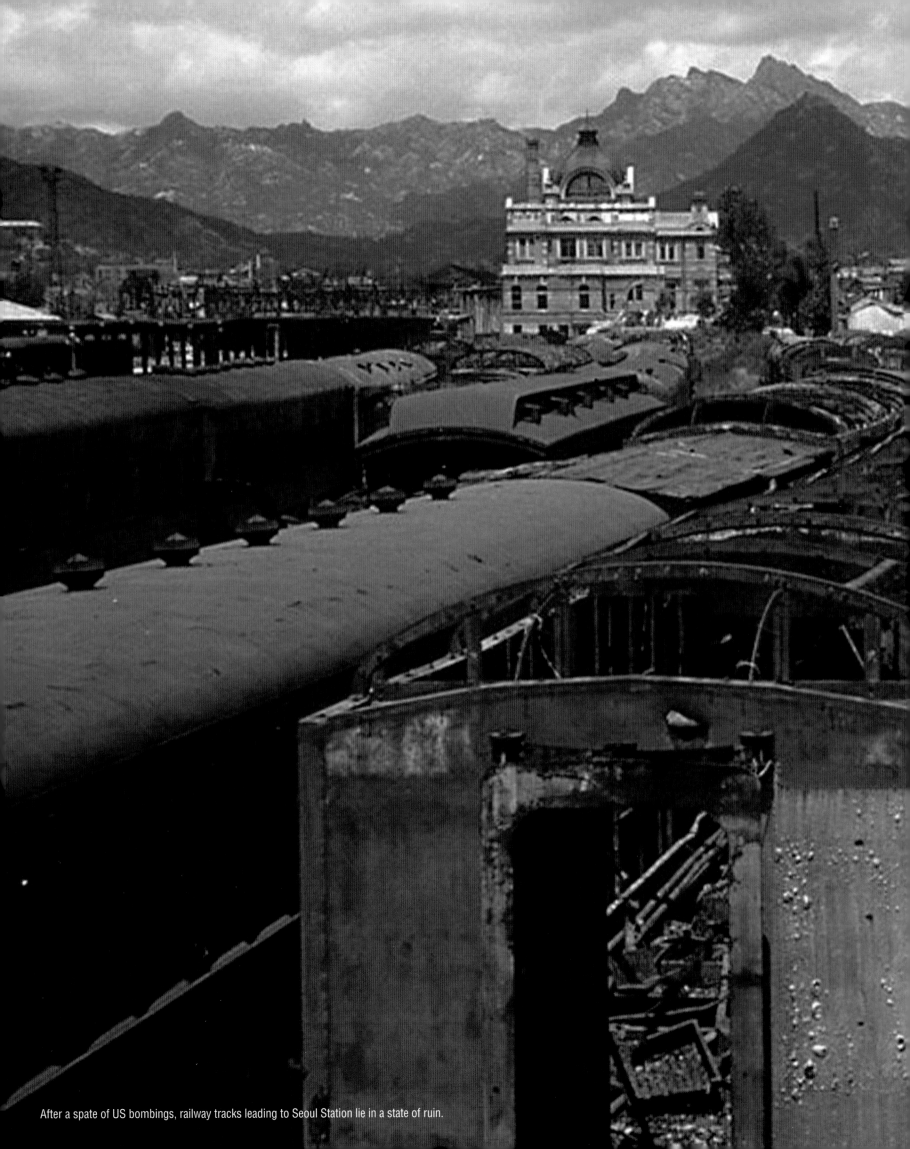

After a spate of US bombings, railway tracks leading to Seoul Station lie in a state of ruin.

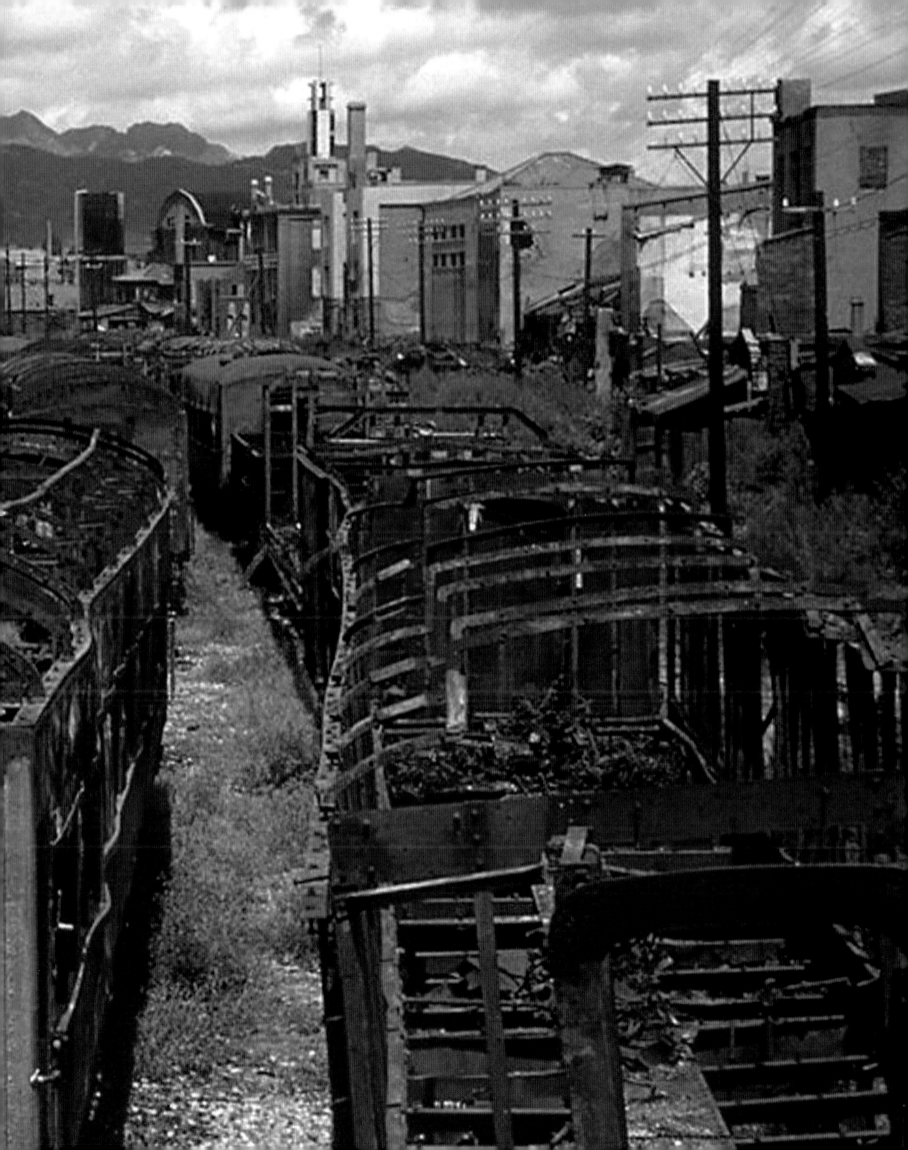

How I First Heard About the War in Korea

"It was a Sunday morning and we had just walked back from a swim on the lovely beach at Kugenuma Kaigan in Japan. During the early years of the occupation in Japan, a group of correspondents shared a house near the beach that had been spared from the fire bomb raids. Keyes Beech of the *Chicago Daily News* and I were the only ones there that day. Keyes beat me to the inviting Japanese wooden hot bath and was in it when our phone rang. The phone was hung on a wall in a closet at standing level, and the mouthpiece was head high. I pulled the receiver off the side of the machine and said 'moshi moshi.' On the phone was my boss in Tokyo, Howard Handelman of the International News Service. He recognized my voice and said, 'Rich, get your fanny back to Tokyo. The North Koreans have just attacked the South!' When I passed the word to Keyes, that ended his hot bath, and I never got mine. We piled into our jeeps and headed for Tokyo.

In Tokyo, the US wire services had been given space by the occupation force in the old Radio Tokyo building, just down the street from the Imperial Hotel. Normally the offices were closed during the night, but on this night, INS moved in a cot, and that cot remained there for the duration of the Korean War. From that Sunday on, all the news offices were manned by reporters around the clock.

From Washington, President Harry Truman ordered General MacArthur into action, and MacArthur flew to Korea to observe the evacuation of American military dependents from Korea either by ship from Incheon Harbor or by plane from Gimpo Airport, closer to Seoul. MacArthur took with him the three heads of the American Wire Services: Russell Brines of the Associated Press, Earnest Hoberecht of the United Press and Howard Handelman of the International News Service. Upon their return, Handelman ordered me to Korea, and I took a train to the southern port of Fukuoka. There, artillery units from the US occupation force were already boarding ships to cross the straits to the southern Korean port of Busan. I talked my way aboard one—an LST (Landing Ship, Tank)—and headed across the straits to Busan in South Korea. It was carrying the first American artillery to reach the country and hold back the Communist forces."

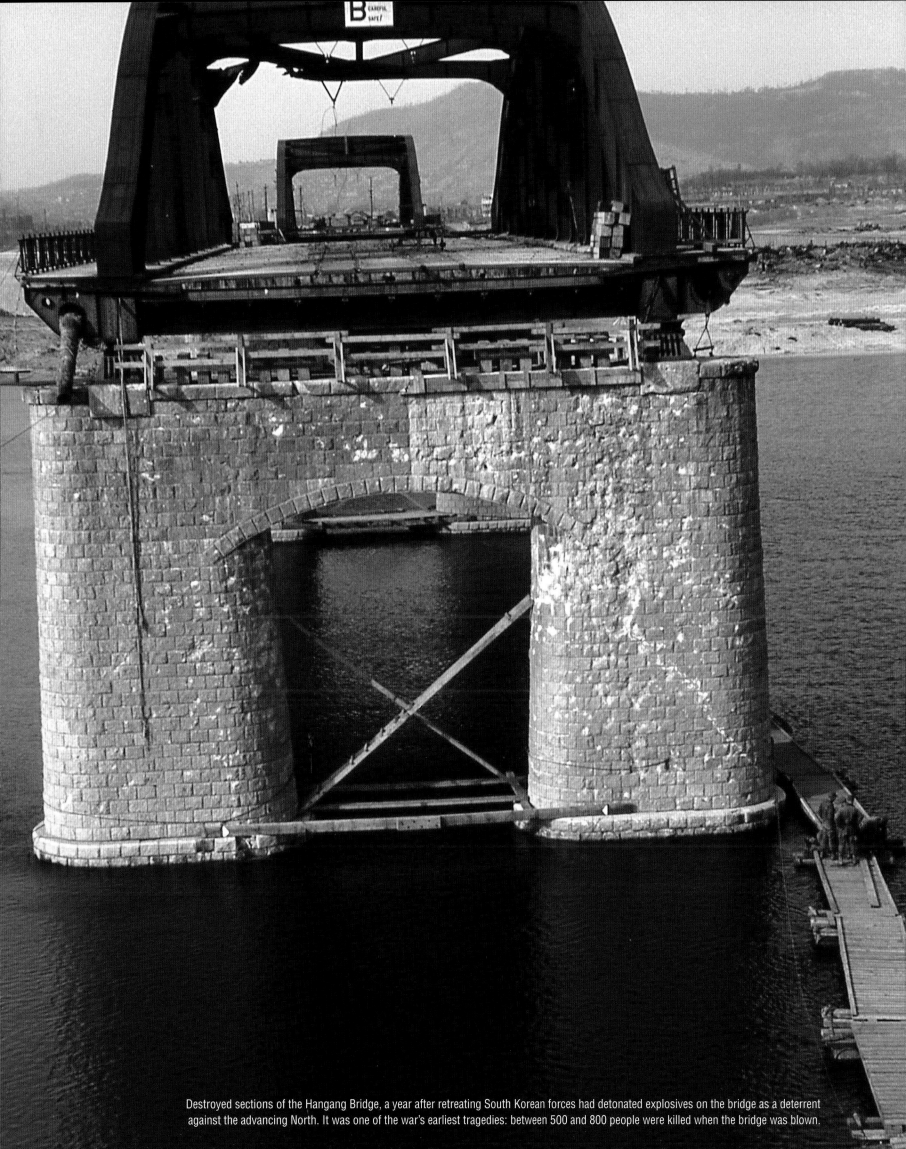

Destroyed sections of the Hangang Bridge, a year after retreating South Korean forces had detonated explosives on the bridge as a deterrent against the advancing North. It was one of the war's earliest tragedies: between 500 and 800 people were killed when the bridge was blown.

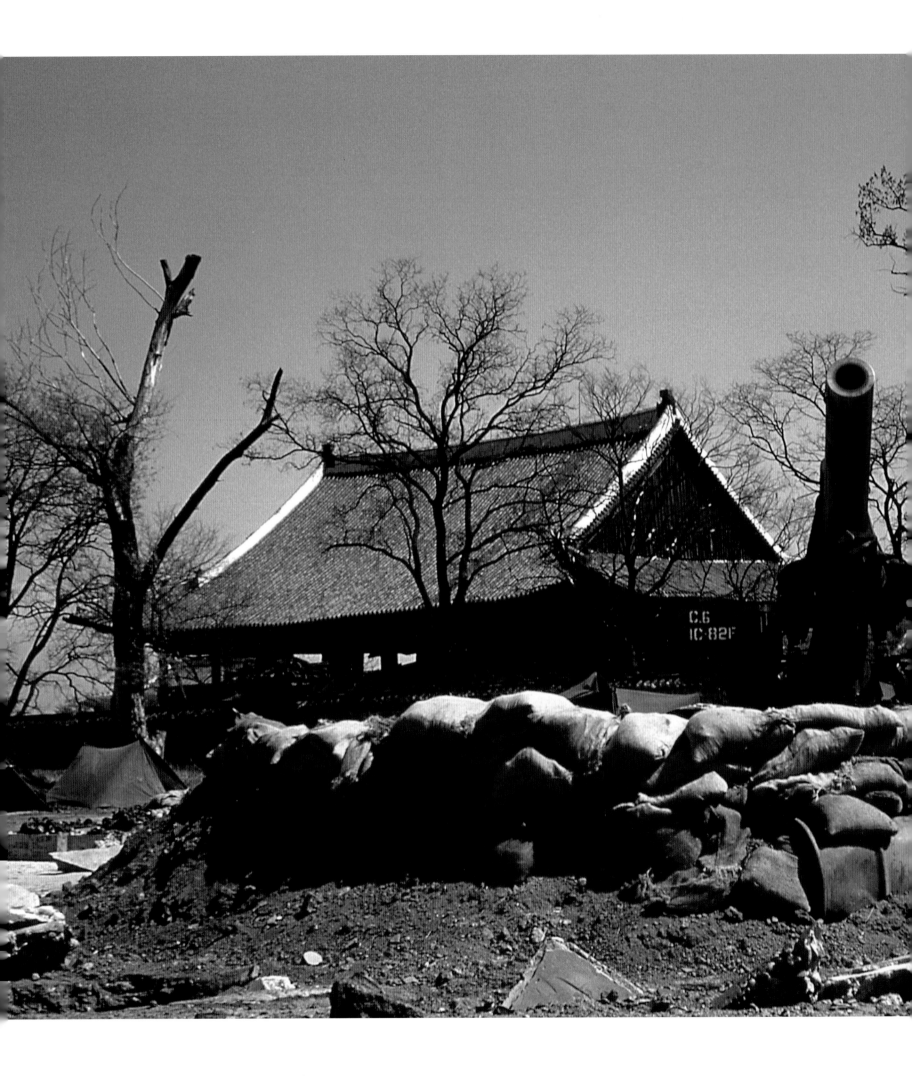

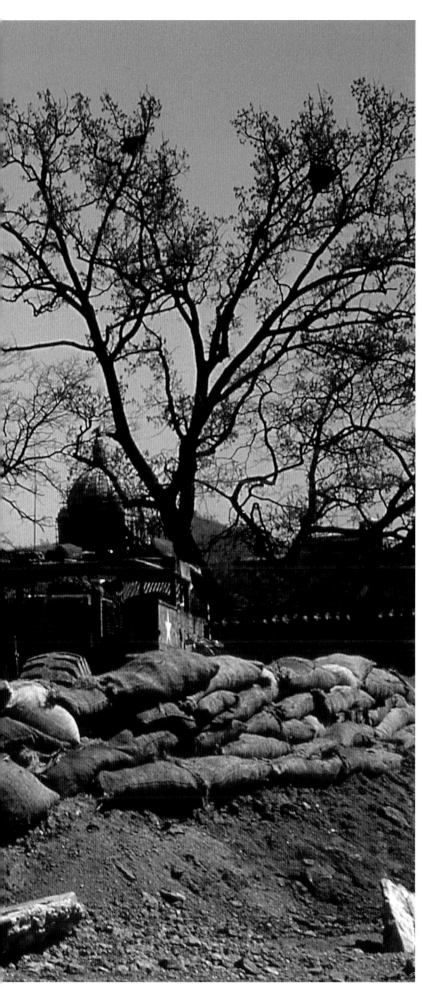

Artillery station by Gyeonghoeru Pavilion in Gyeongbokgung. General James Van Fleet, the US field commander in Korea, relied heavily on artillery to grind up the enemy mass. During the biggest attack of the war, the Chinese Spring Offensive of 1951, he emplaced an artillery park that stretched from the city center to Mapo, five kilometers away.

Encounter with President Rhee

"The city of Seoul had fallen to the North Koreans, and President Syngman Rhee had fled south. Part of his trip was by boat, and he landed at the southernmost tip of Korea at a port called Yeosu. When we heard that Rhee was being brought to Busan, I decided to try and interview him. I had met and interviewed him just a year before, and after filing stories for the International News Service I began to investigate how to get his voice on the air from Busan. I was then the stringer for the American Broadcasting Company, which paid me per broadcast. But getting Rhee's voice out to the world was a challenge. I had no tape recorder, but somebody thought of making a vinyl record of his voice. The only place to do it was the Korean radio station atop a hill above Busan.

Rhee, anxious to get his message out to the world, was most agreeable. We hopped in the limousine that had been provided for him in Busan and headed for the radio station. Television was still far in the future. At the station I interviewed him, and it was recorded on vinyl, run at 78 revolutions per minute (RPM), like the old phonograph records. Now I had Rhee's voice on plastic, but how to get it back to the United States? I finally found an American soldier who had a phonograph and a shortwave radio. He and I played it out into the air for much of the night, requesting that anybody who picked it up should try to get it to the American Broadcasting Company. Since I never heard anything from ABC or anyone else, I had to assume his message never got out, at least the one in his own voice."

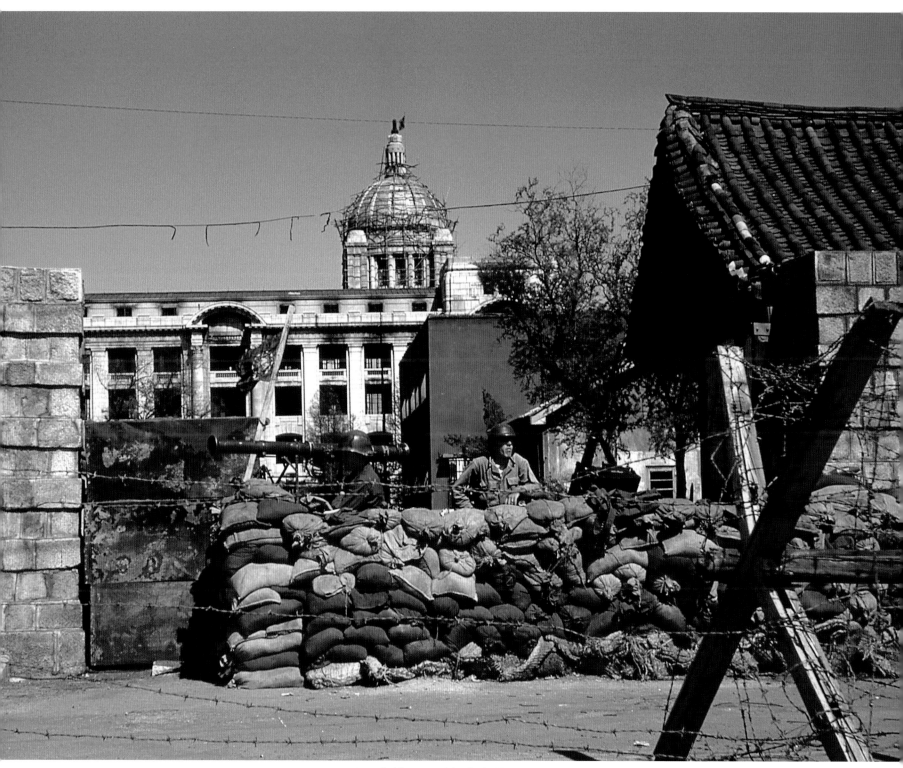

Soldiers guard the Capitol Building, where President Syngman Rhee took the oath of office in 1948.

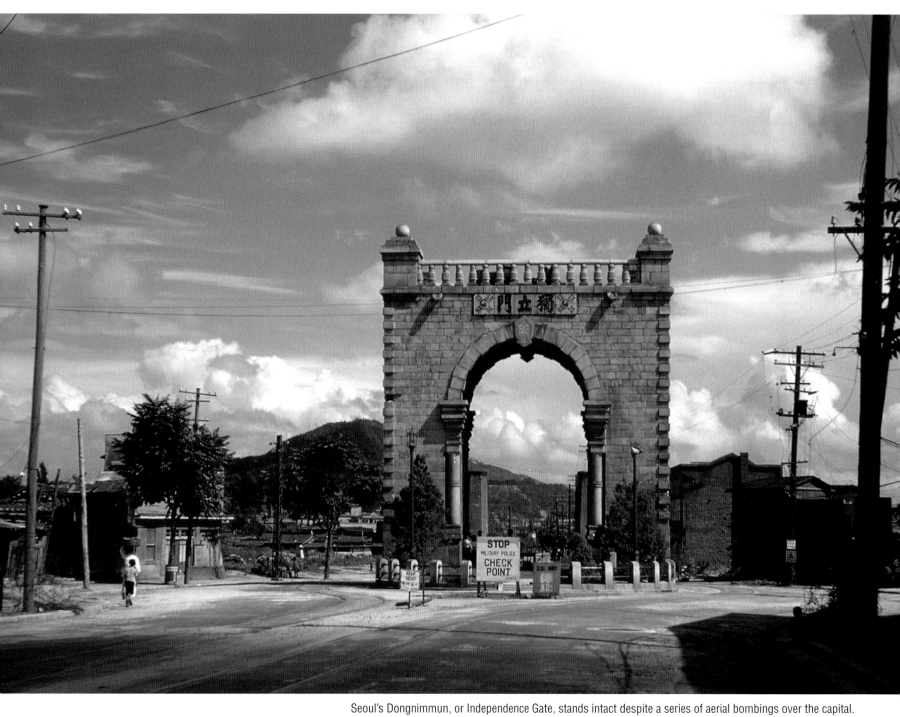

Seoul's Dongnimmun, or Independence Gate, stands intact despite a series of aerial bombings over the capital.

A wintry view from the author's room at the Chosun Hotel from 1950 to '51. Wongudan Altar can be seen in the foreground, with City Hall farther in the distance.

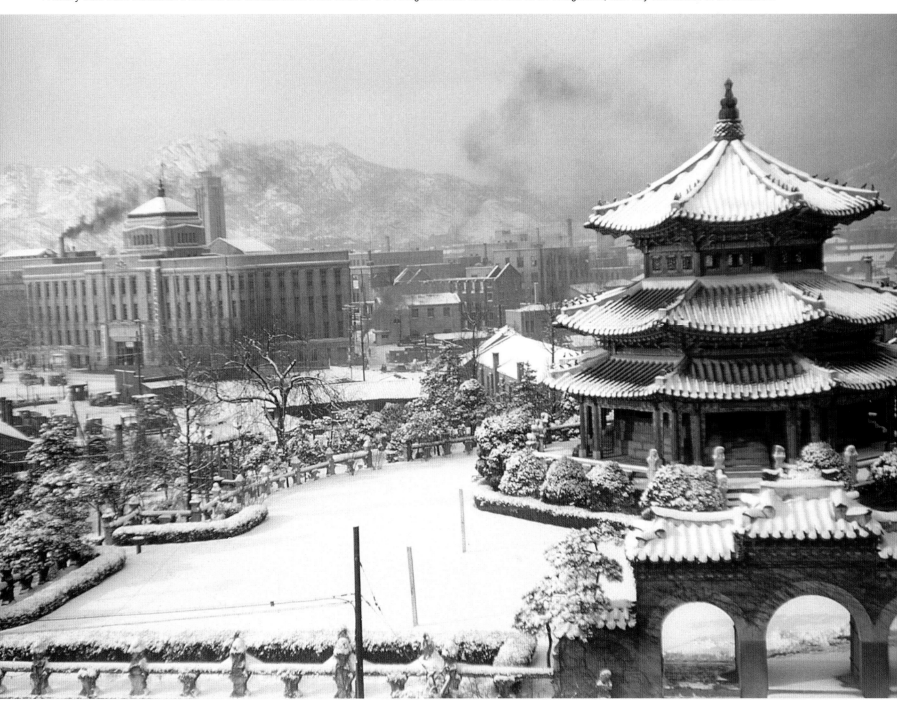

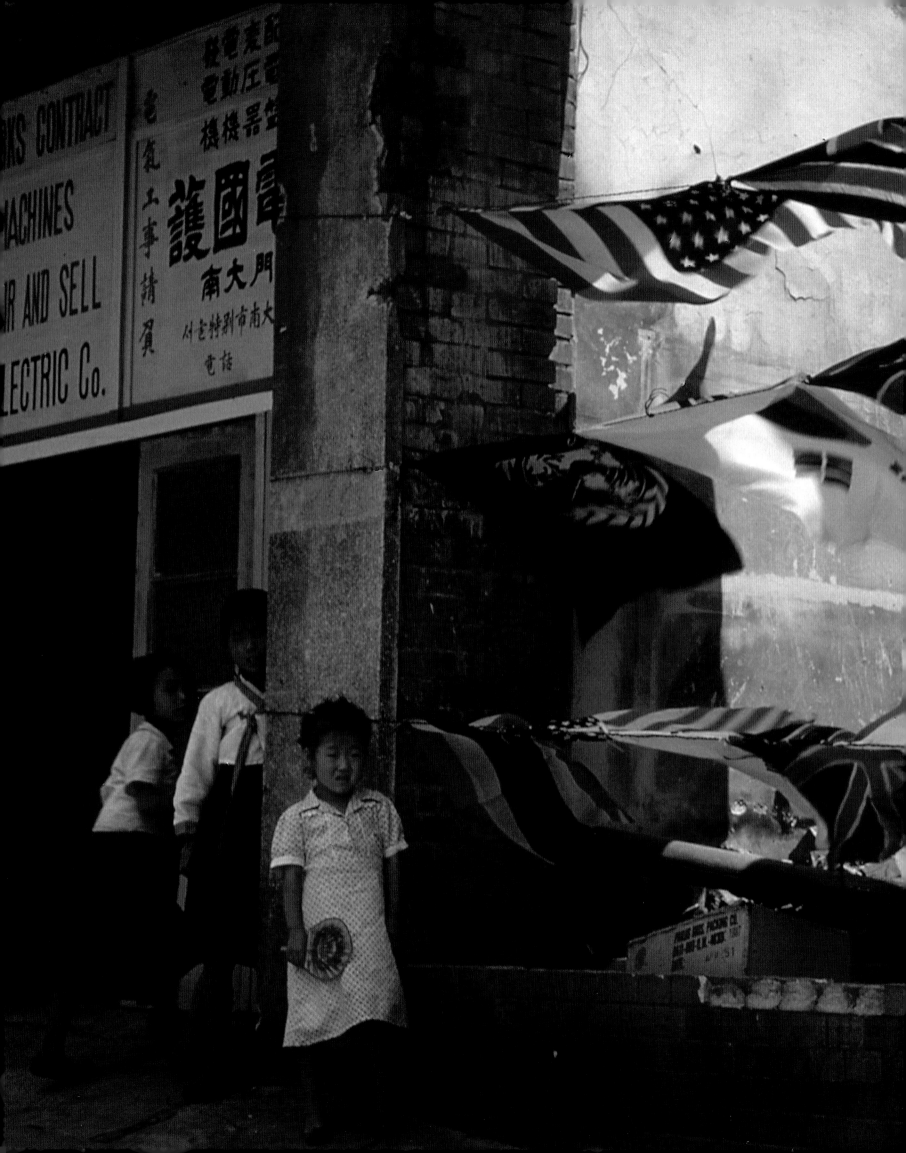

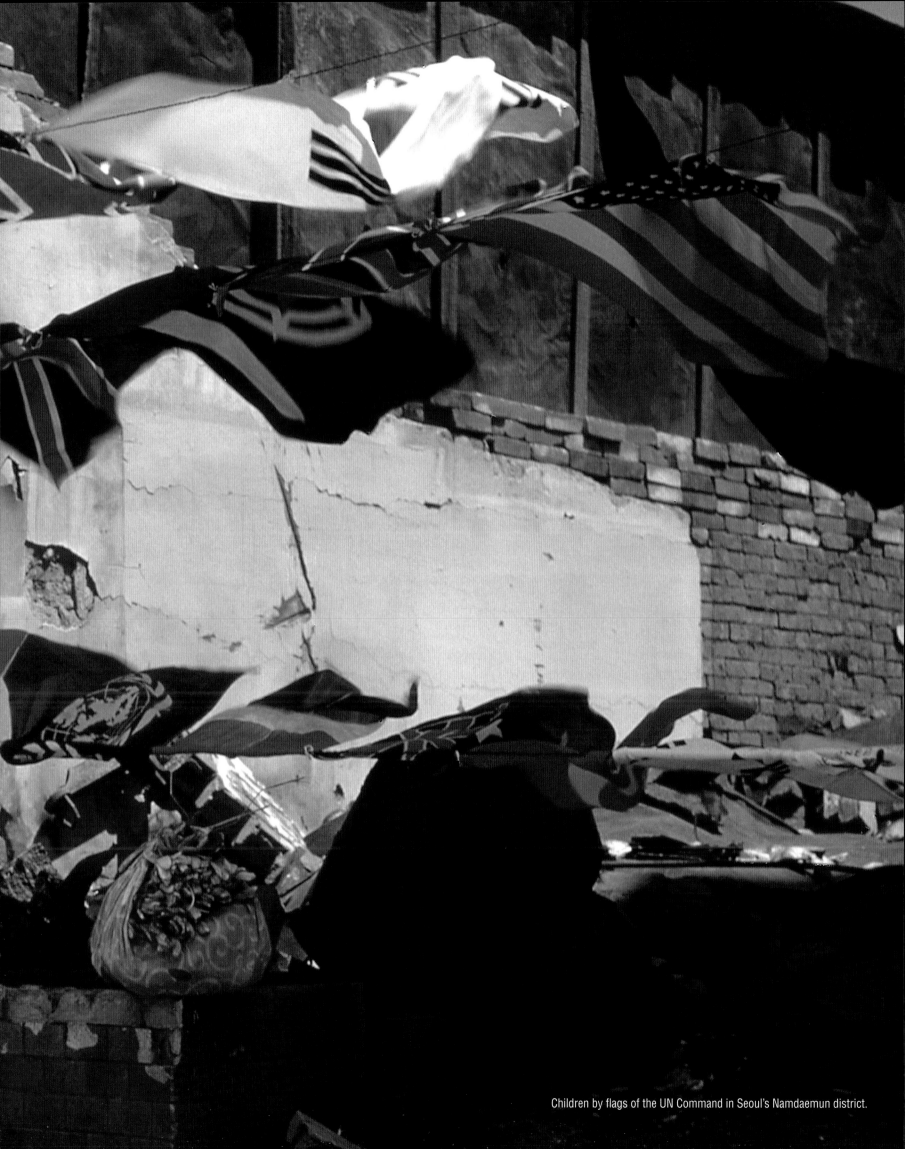

Children by flags of the UN Command in Seoul's Namdaemun district.

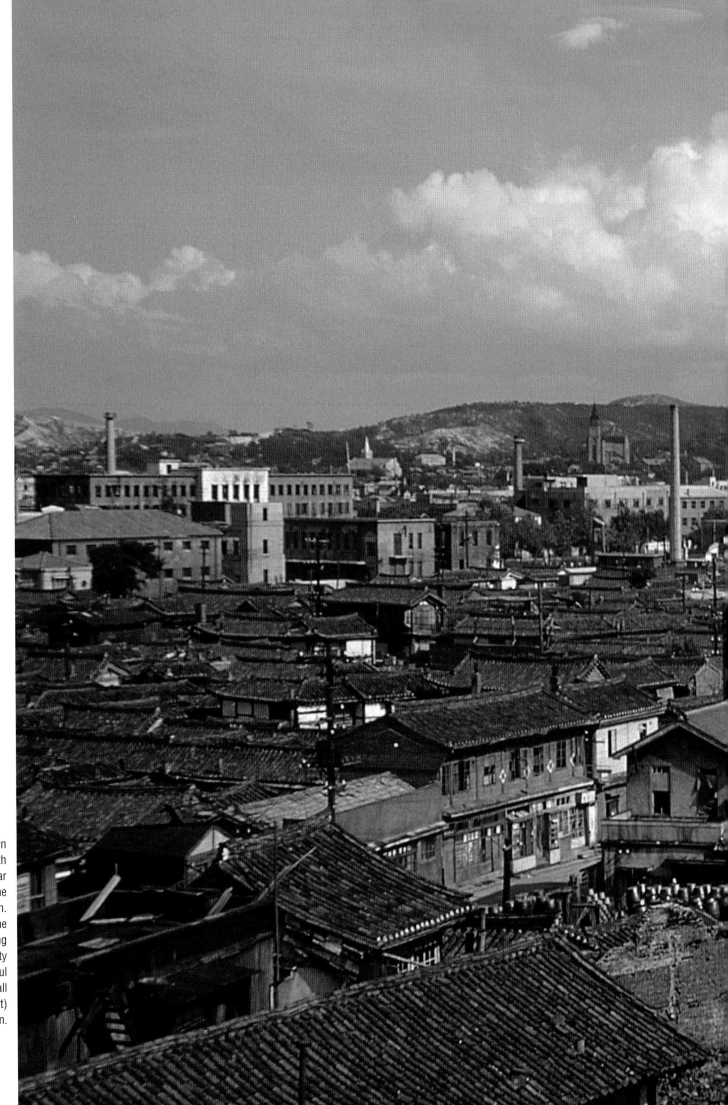

A view of downtown Seoul, looking south from the area near Mt. Inwangsan in the northwest part of town. In the distance, one can see Myeong-dong Cathedral, Seoul City Hall, the tower of Seoul Municipal Council Hall (then the parliament) and Mt. Namsan.

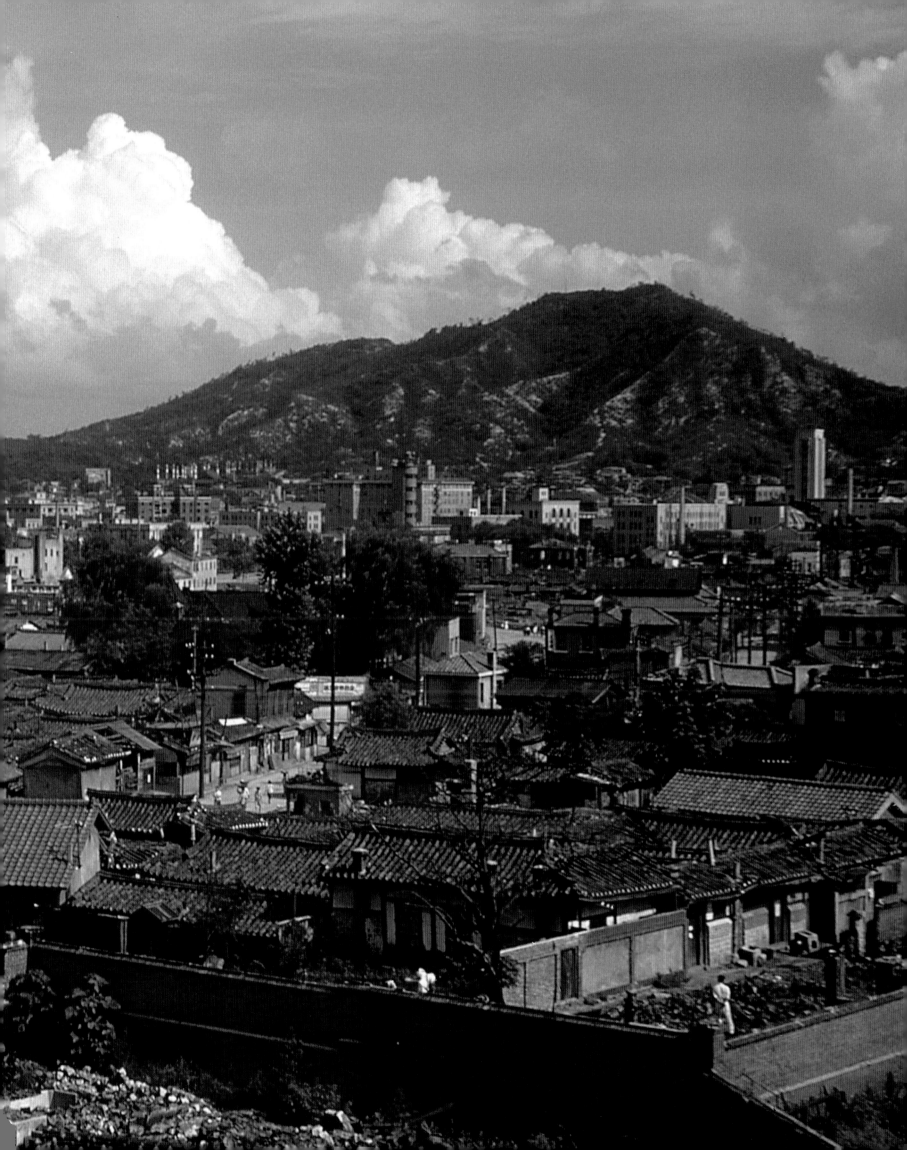

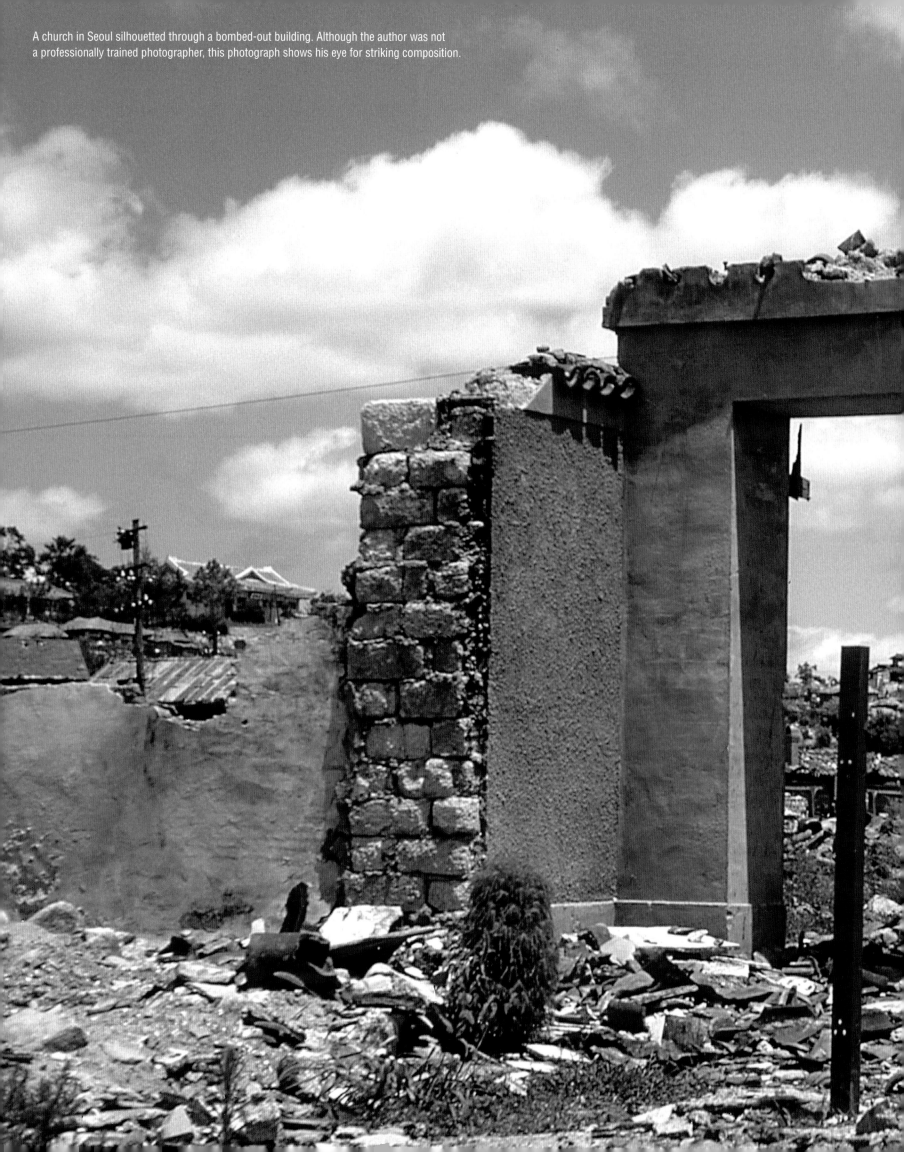
A church in Seoul silhouetted through a bombed-out building. Although the author was not a professionally trained photographer, this photograph shows his eye for striking composition.

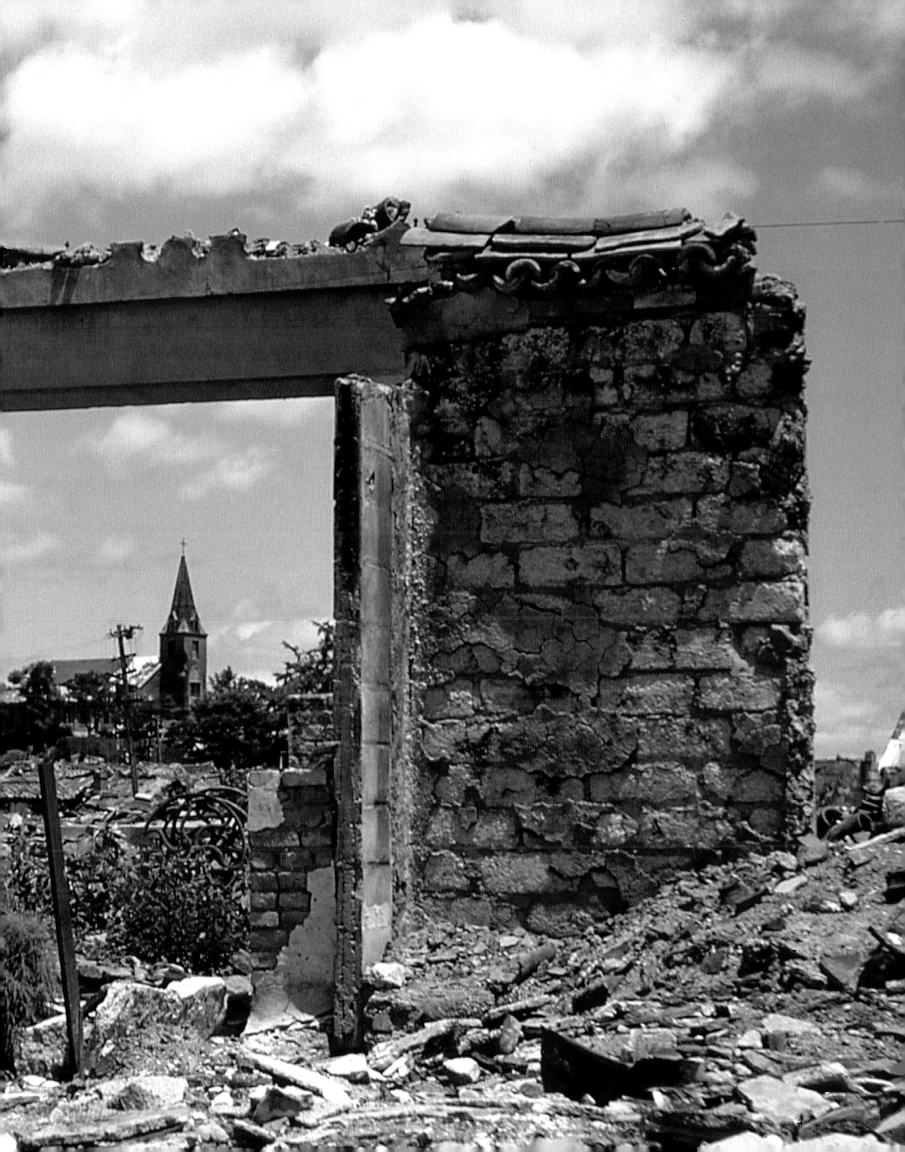

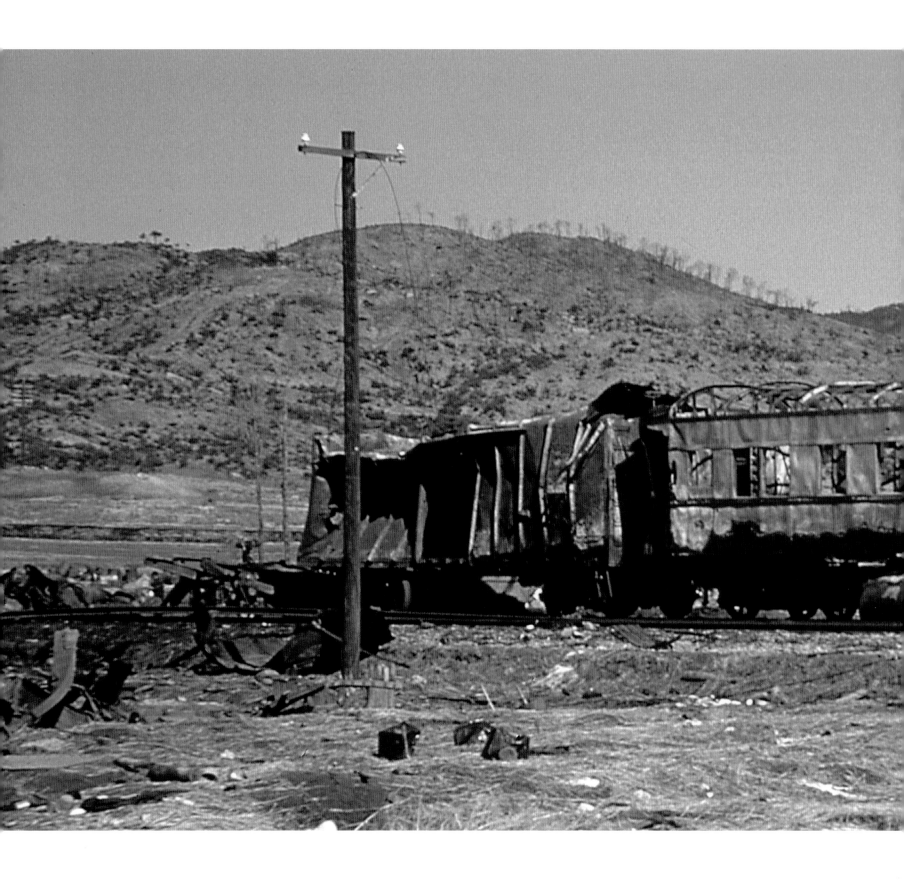

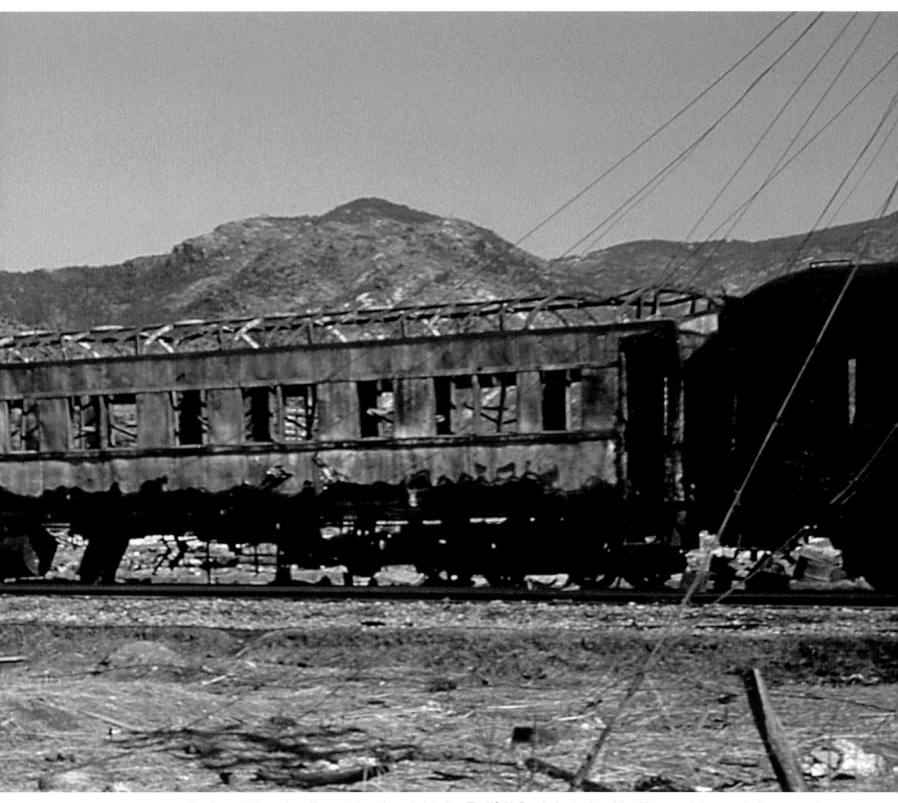

Wreckage of a burned-out Korean train at the end of the line. The US Air Force's domination of the skies severely hampered rail movement by the North Korean People's Army. The blackened wreck indicates that this train may have been caught by napalm—the war's most fearsome munition.

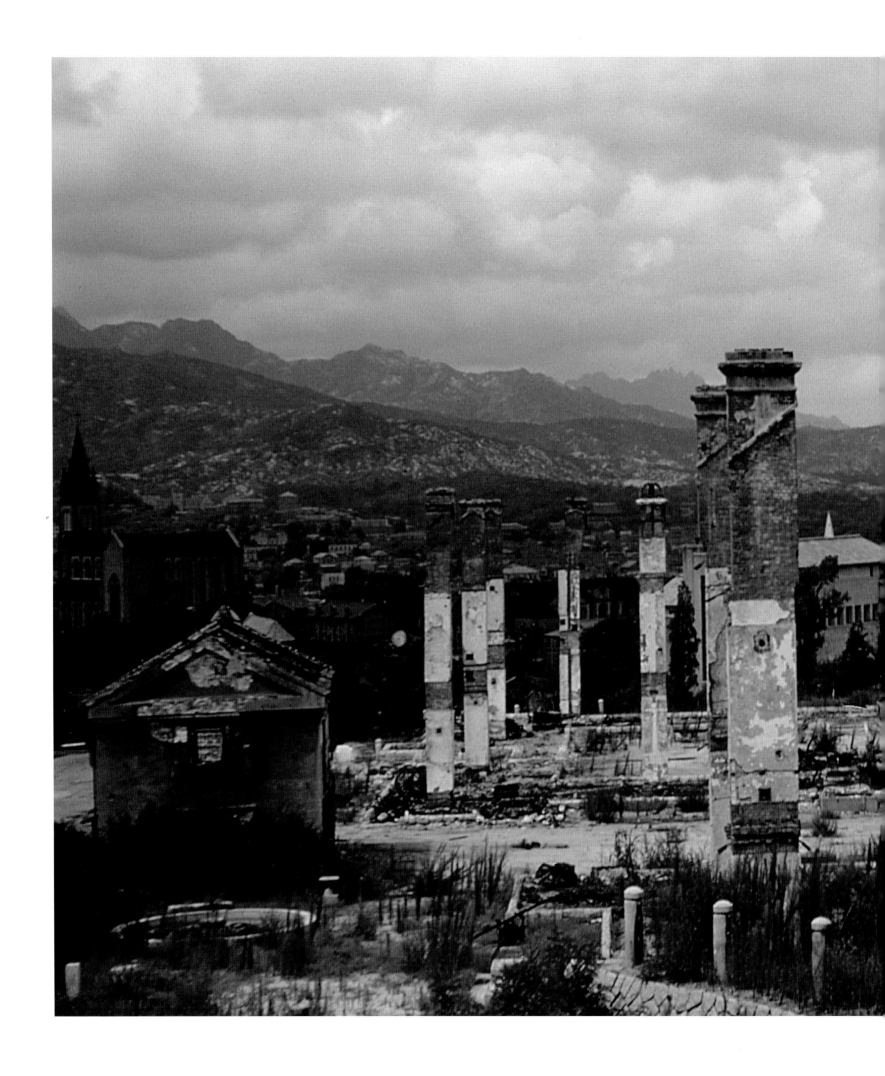

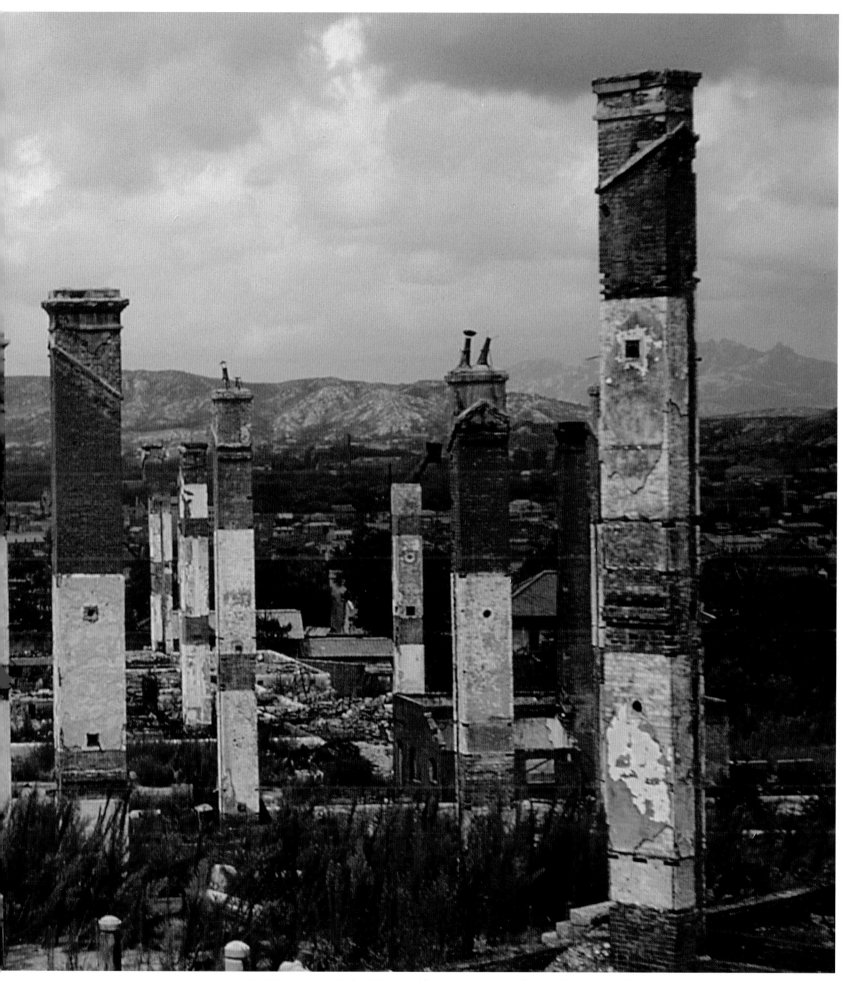

Bombing wreckage in Seoul. In one of the war's more surreal notes, observers would express surprise that it was often chimneys that proved to be the last parts of buildings left standing. Myeong-dong Cathedral, the church at lower left, still stands.

Getting to Daejeon

"The North Koreans were driving rapidly south, and the American GIs sent to help South Koreans were trying to hold a line just north of the city of Daejeon. I went to Busan Airport and found an American pilot who had just flown back from Daejeon in a small plane. He told me to hop in. As we took off and headed north, he asked me to keep a sharp lookout on my side of the plane for Russian Yak fighter planes, which were still active over the area. I complied with his request and scanned the skies nervously until we reached Daejeon. There I found the reporters who had come south from Seoul, set up temporarily in a South Korean government building. In the center of the large room, there was one telephone, controlled by a muscular army sergeant. For days, he controlled the only line out of Korea, carrying news of the war.

Working for a wire service, I had to write my story in short takes because when I stepped over with my copy, the burly sergeant made sure it went to the bottom of the pile. When my copy reached the top, the sergeant would call me over for the laborious process of dictating my story, sentence by sentence, to the home office in Tokyo, where it was relayed to the United States.

As more correspondents poured in, waiting for the phone line became so frustrating that some of them would fly back to southern Japan each afternoon, file their stories from there and return to the war the next day.

The night I got to Daejeon I found a desk for my typewriter. At another desk pulled up against mine was that of Ian Morrison of London's *The Times*, typing out his story. After he filed his story to *The Times*, he began to relax. Across the desk I noticed him pulling out a Sherlock Holmes pipe and a batch of letters and beginning to answer them. It was only later that I realized that Morrison was probably writing to Belgian-Chinese novelist Han Suyin, whose love affair with Morrison later became the book *A Many-Splendoured Thing* and the song and film *Love Is A Many-Splendored Thing*. That night we both slept atop our desks on an army blanket. In the morning we went our separate ways, and I never saw Morrison again. A few weeks later, the jeep in which he was riding with two other men struck a mine and all were killed on August 12, 1950."

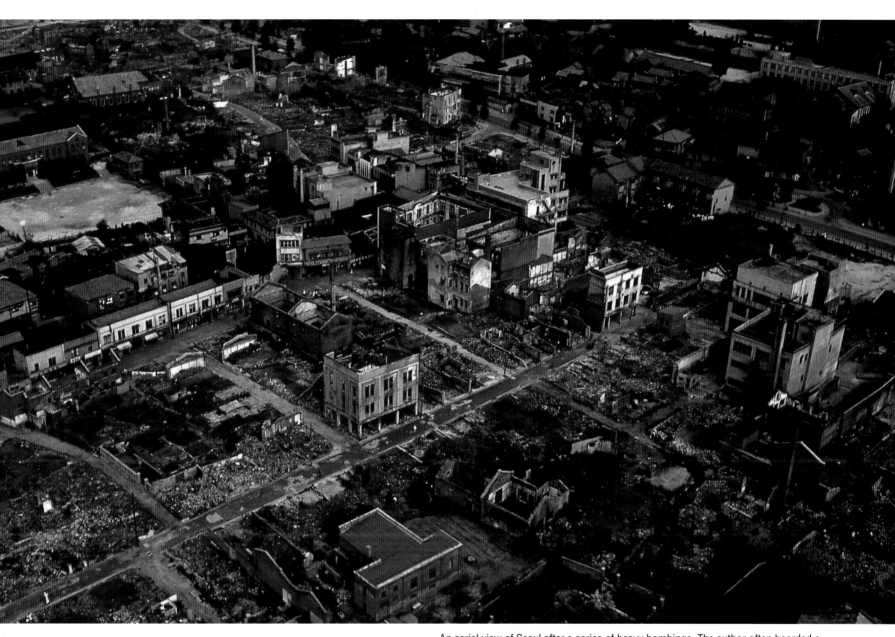

An aerial view of Seoul after a series of heavy bombings. The author often boarded a forward observer plane, used by the military to track enemy progress.

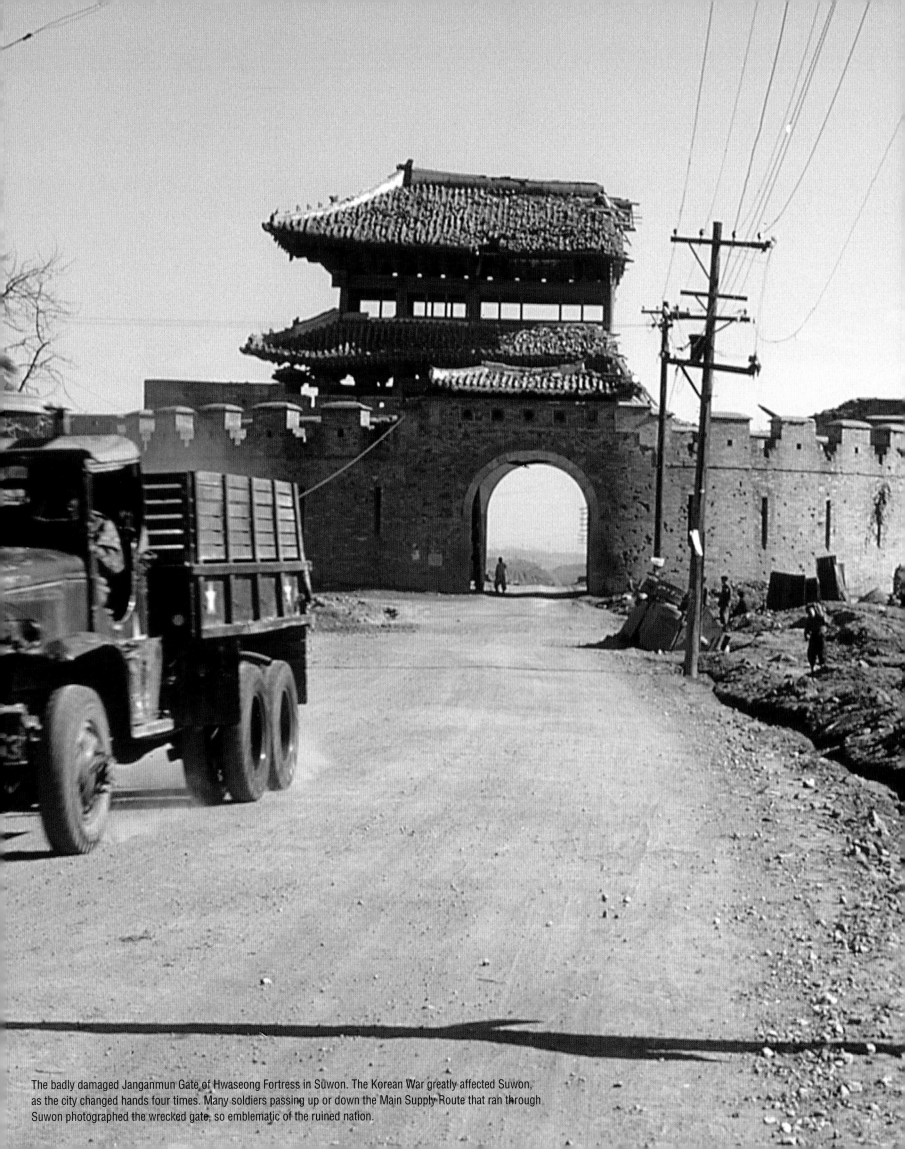

The badly damaged Janganmun Gate of Hwaseong Fortress in Suwon. The Korean War greatly affected Suwon, as the city changed hands four times. Many soldiers passing up or down the Main Supply Route that ran through Suwon photographed the wrecked gate, so emblematic of the ruined nation.

In the Line of Fire

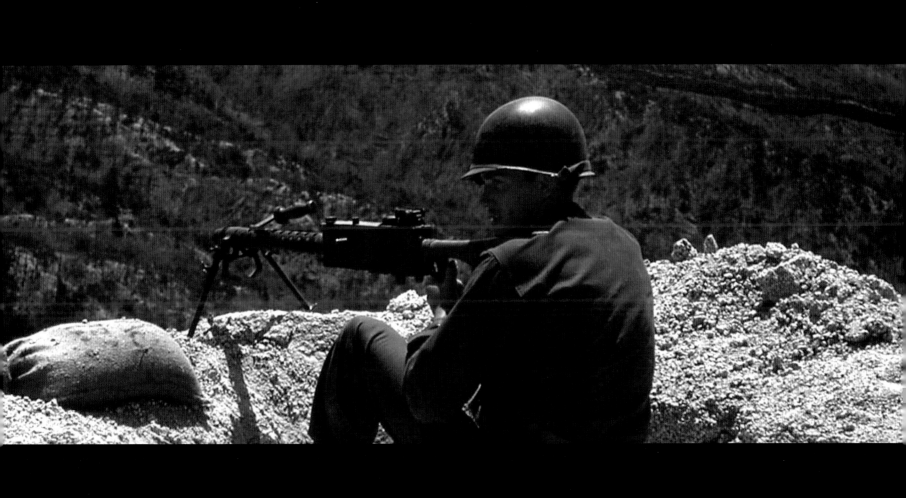

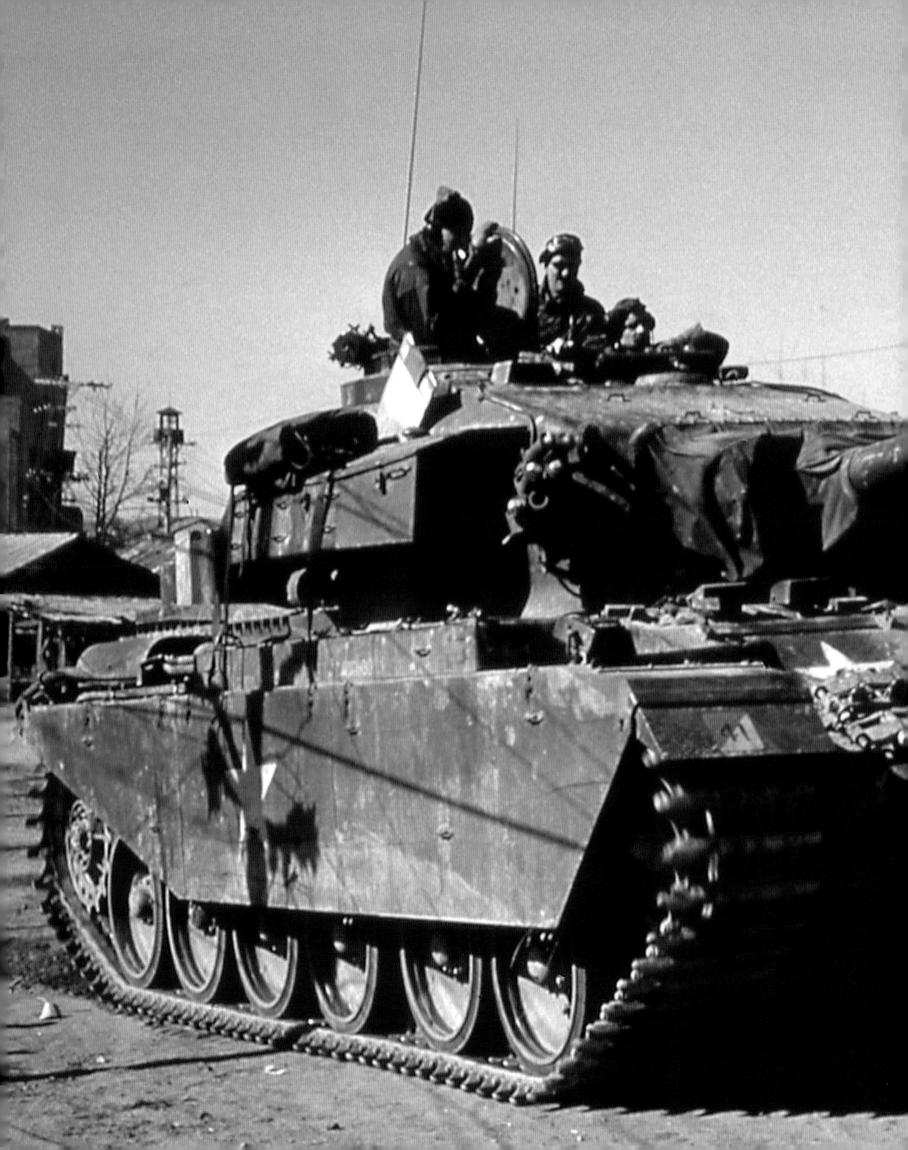

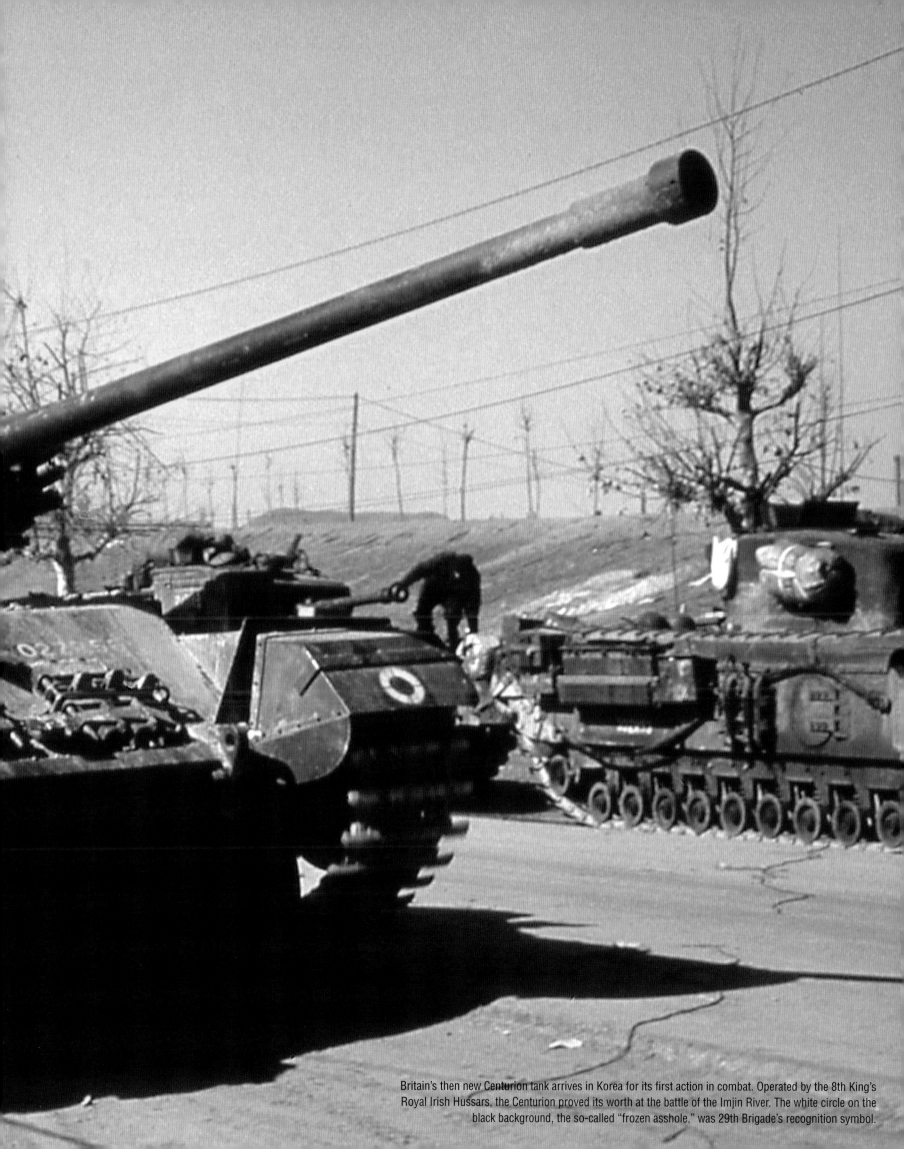

Britain's then new Centurion tank arrives in Korea for its first action in combat. Operated by the 8th King's Royal Irish Hussars, the Centurion proved its worth at the battle of the Imjin River. The white circle on the black background, the so-called "frozen asshole," was 29th Brigade's recognition symbol.

British troops with Churchill tanks take up positions.

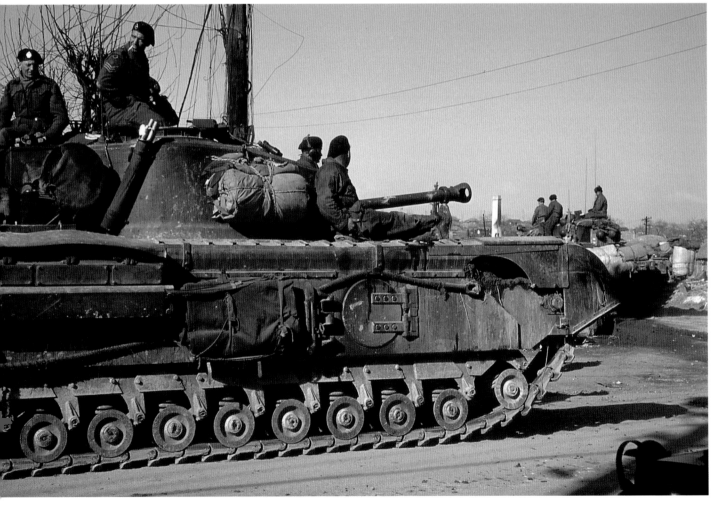

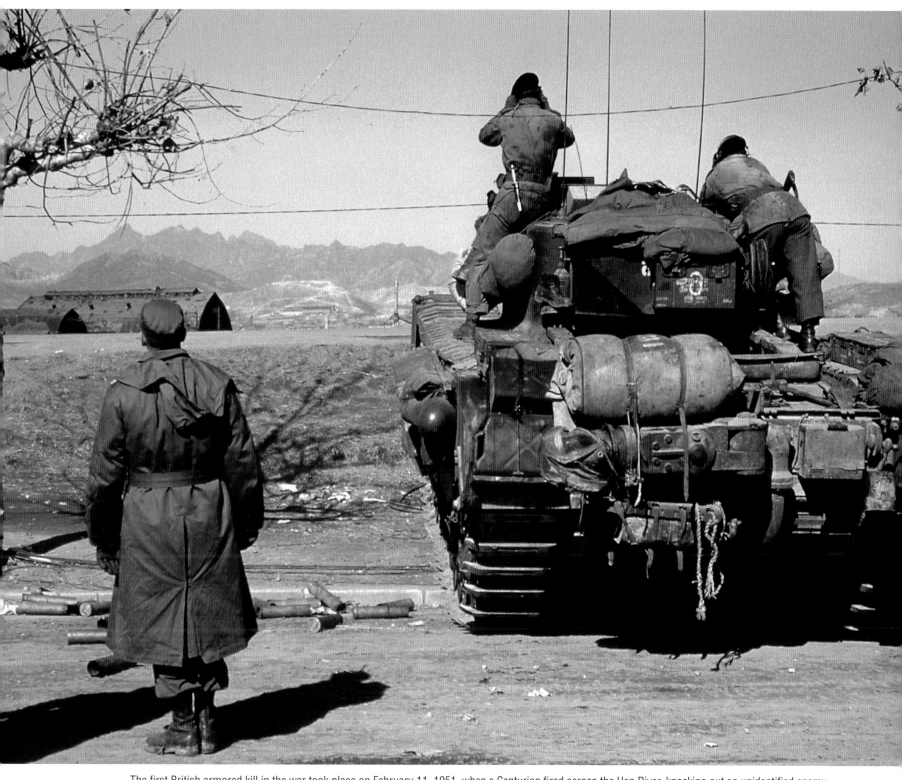

The first British armored kill in the war took place on February 11, 1951, when a Centurion fired across the Han River, knocking out an unidentified enemy tank from 3,000 yards. It was later found to be a British Cromwell—captured by the Chinese during the desperate fighting near Goyang in January.

Pusan (Busan) Perimeter

"As the North Koreans continued to push south in the summer of 1950, American reinforcements poured in. However, during the end of July and the rest of August, UN forces continued to fall back until they were confined to a corner of the country around the city of Busan. Busan was a vital port for bringing in supplies and had to be held. Had the North Koreans managed to take Busan, they might have driven American forces entirely off the Korean Peninsula, and the history of Asia would have been very different. But UN forces held. They formed a line around Busan that became known as the Pusan (Busan) Perimeter. Now the only major cities held by UN forces were the port of Busan and the city of Daegu, which had become the northernmost airstrip in Korea and the center of activity.

At Daegu Airstrip, I collected many stories by interviewing the American flyers on their return. They would fly up over the fast-moving lines of the North Koreans heading southward. One pilot told me he had just flown over a certain city and seen North Korean tanks lined up in the city square, indicating that the city had fallen to the North Koreans. On the pilots' return I was able to interview them while the military debriefer waited patiently. The men doing the fighting wanted their relatives back in the United States to know where they were and what they were doing."

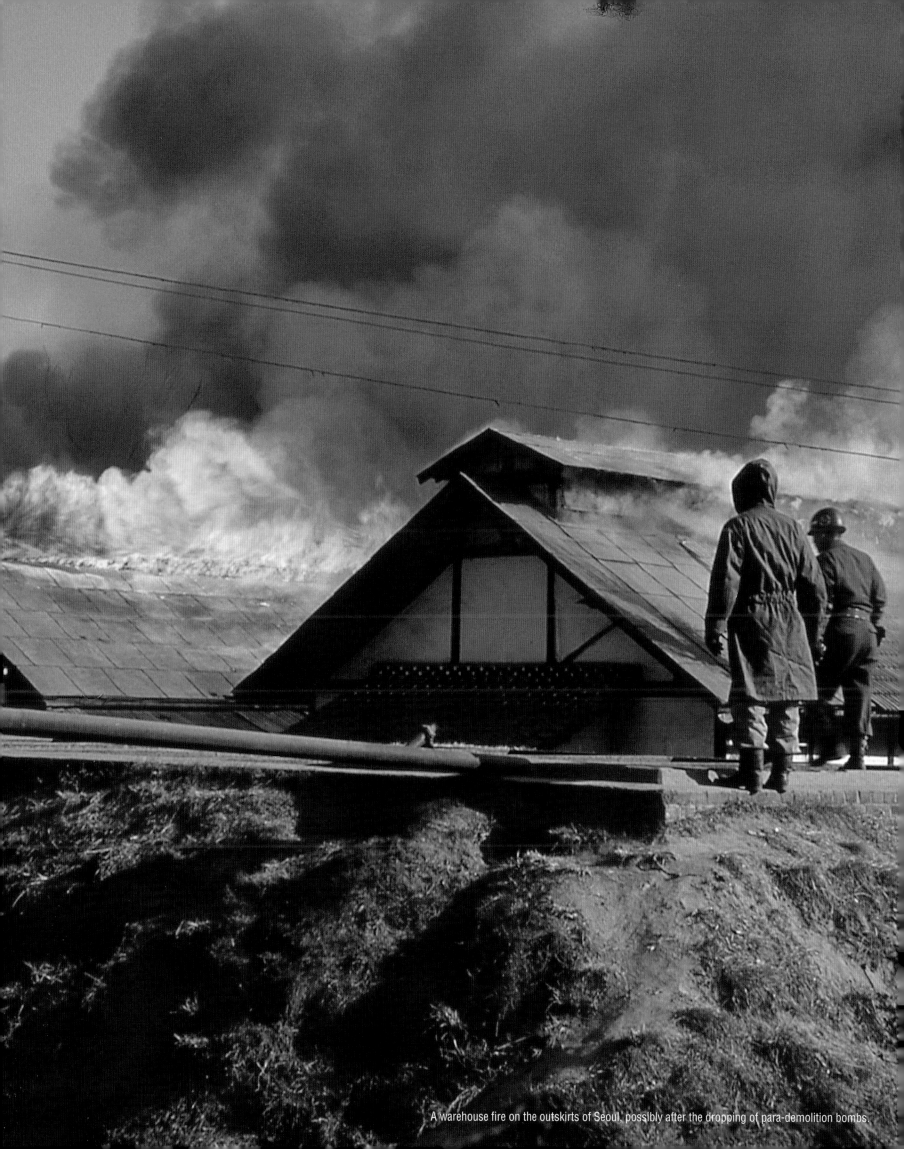

A warehouse fire on the outskirts of Seoul, possibly after the dropping of para-demolition bombs.

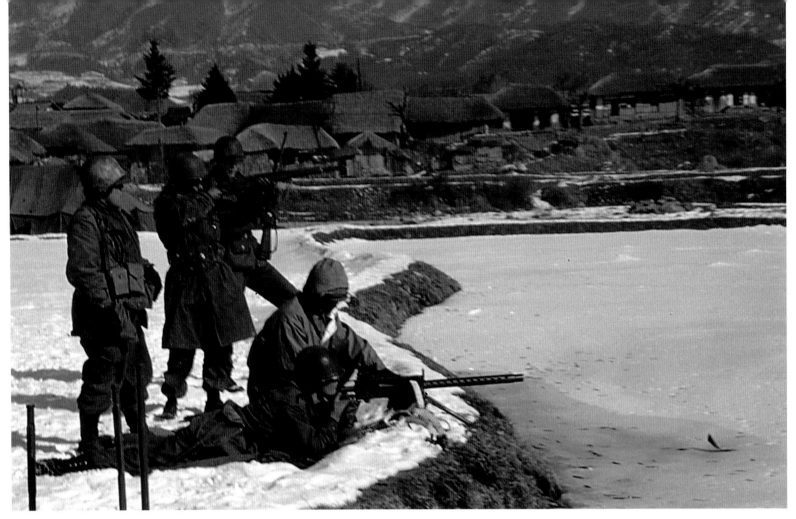

US soldiers confront a skirmish across
a frozen lake. Thatched roof houses
are huddled in the background; these
thatched roofs were highly vulnerable
to tracer ammunition and napalm.
The high profile of the troops here
suggests that there is no incoming fire.

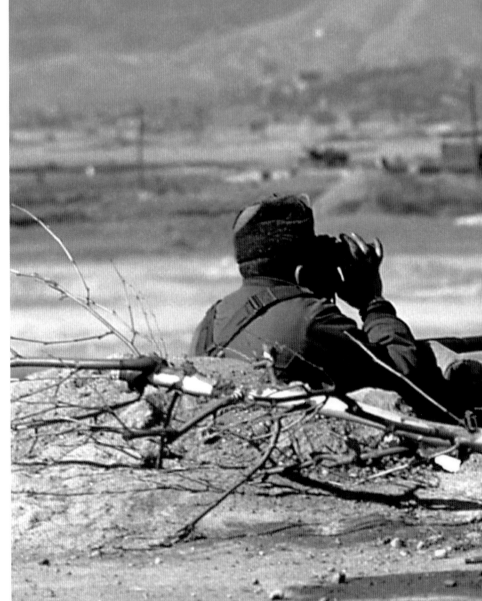

US troops man a Browning machine gun near
Gimpo Airfield outside Seoul in late winter
1950. UN fortunes were at their lowest ebb;
the Chinese would soon be in the capital.

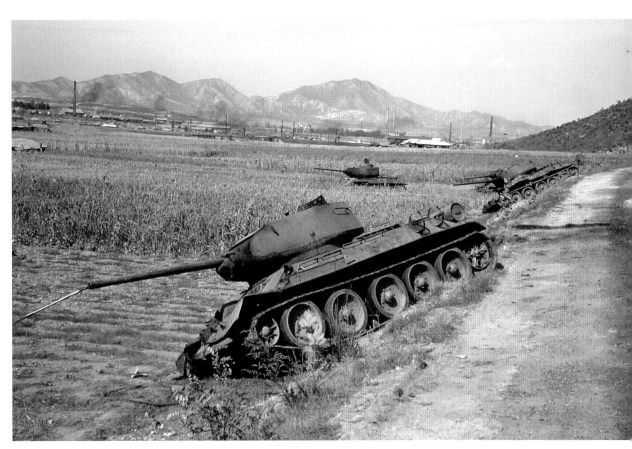

Soviet-built North Korean T-34 tanks knocked out during the Inchon (Incheon) Landing. The T-34 was the outstanding tank of World War II, but in Korea, with no effective air cover, it was easy prey for the US Air Force. Many North Korean armored vehicles were abandoned by their crews for lack of fuel—proof of the efficacy of aerial interdiction of the North Korean supply lines.

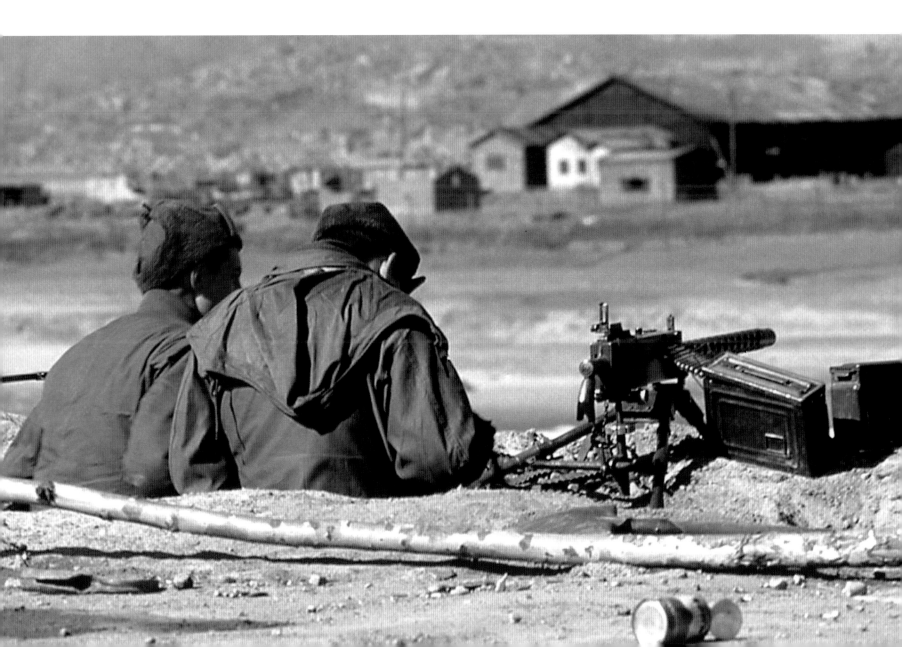

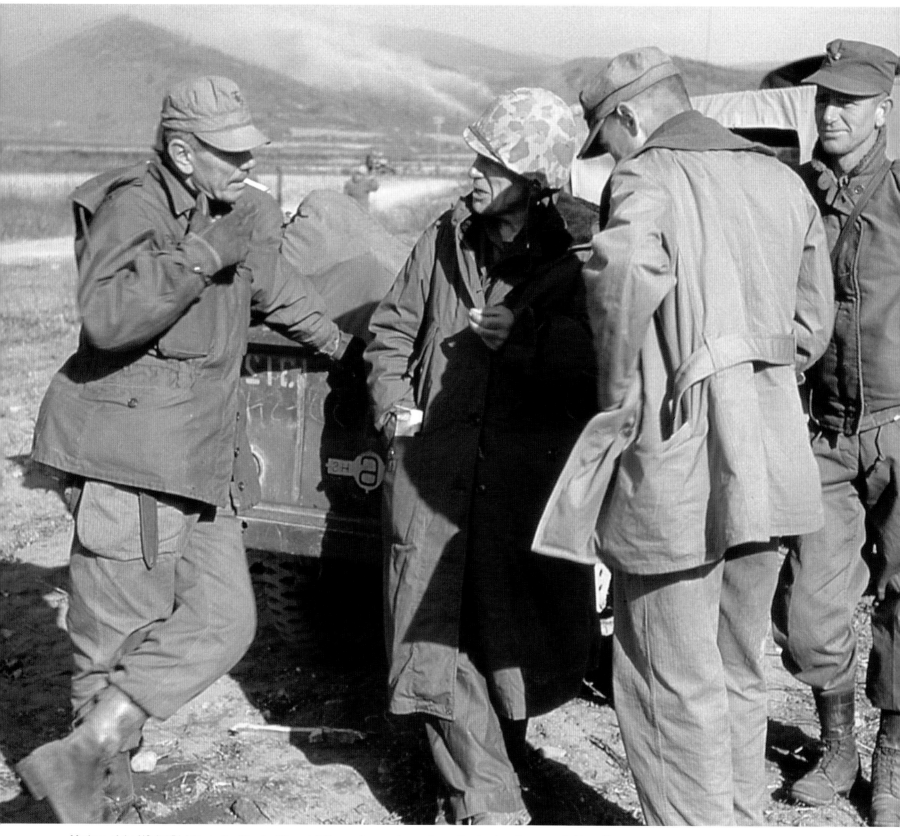

Marines of the US 1st Division in the Chosin (Changjin) Reservoir area of operations. Smoke rises from a probable artillery strike in the background. Soon after this photo was taken, these elite troops would be fighting for their lives.

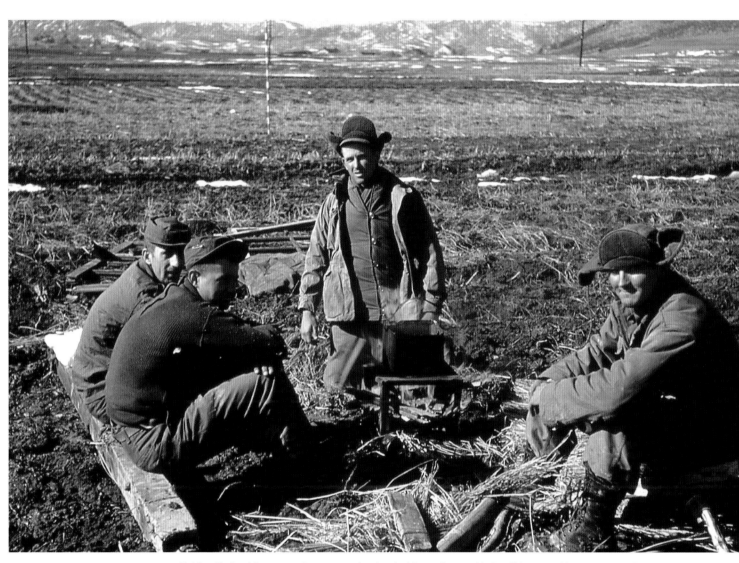

Unidentified soldiers try to keep warm despite the bitter winter cold. Conditions would soon get much worse: the Chosin (Changjin) Reservoir is the coldest part of Korea, and winter was about to descend in all its bitterness.

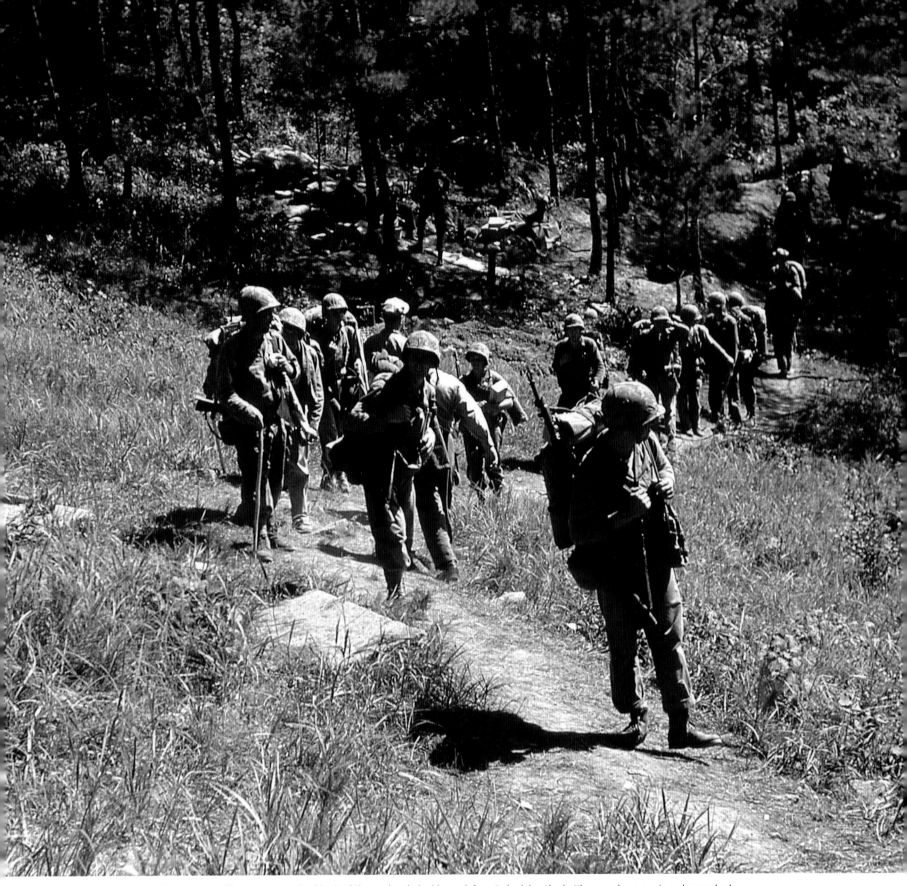

A platoon emerges from a forest. Trees were a rarity. Much of the peninsula had been deforested, giving the battlegrounds an austere, barren look.

Dead Chinese Men

"After the communists retook Seoul in January 1951, the retreating UN forces made a stand south of the Han River. One frigid night I joined the US 25th Division somewhere south of Suwon, 25 miles below the Han River. Some action was obviously expected, because when we prepared to bed down in an empty house close to division headquarters, we were told to sleep with our boots on (as if any sleep was possible). All night, there was gunfire nearby, and American tanks rolled up and down the road outside the building where we stayed. It was a sleepless night with shots crackling all around us.

In the morning, at a schoolhouse only a few buildings away, we found dead Chinese soldiers lying inside and on the ground outside. It had been a wild battle, the Chinese had obviously lost, and that incident, I think, was their most southerly penetration in Korea."

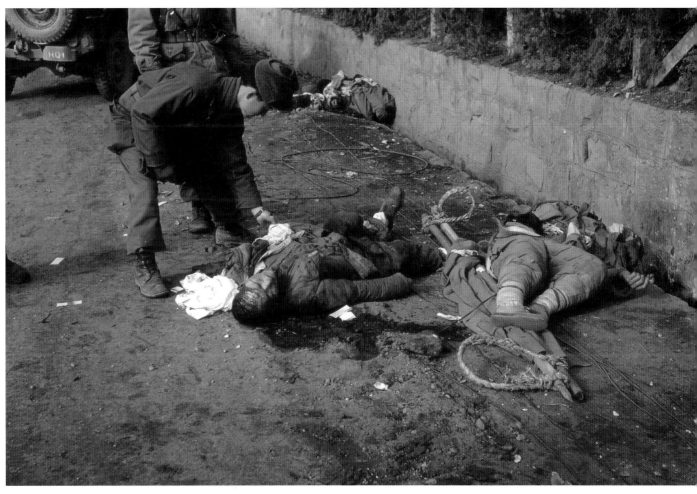

Two dead Chinese "volunteers" after a skirmish in a schoolhouse south of the city of Suwon. This was in 25th American Division territory and probably the farthest point of Chinese advancement after entering the Korean War and driving back the UN forces.

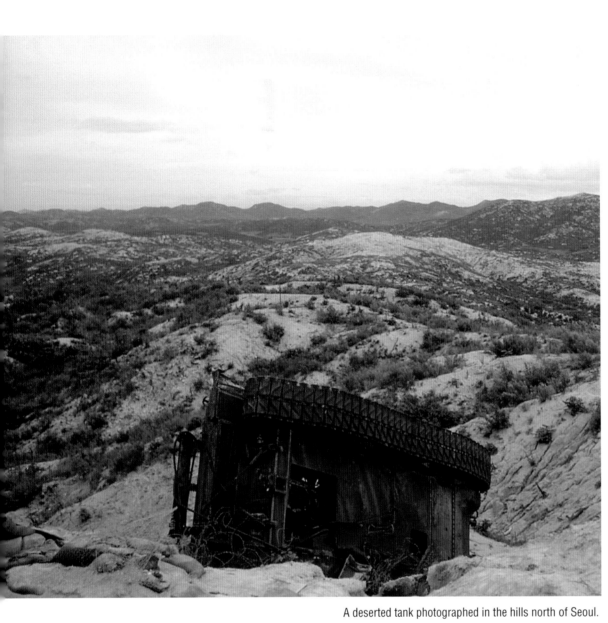

A deserted tank photographed in the hills north of Seoul.

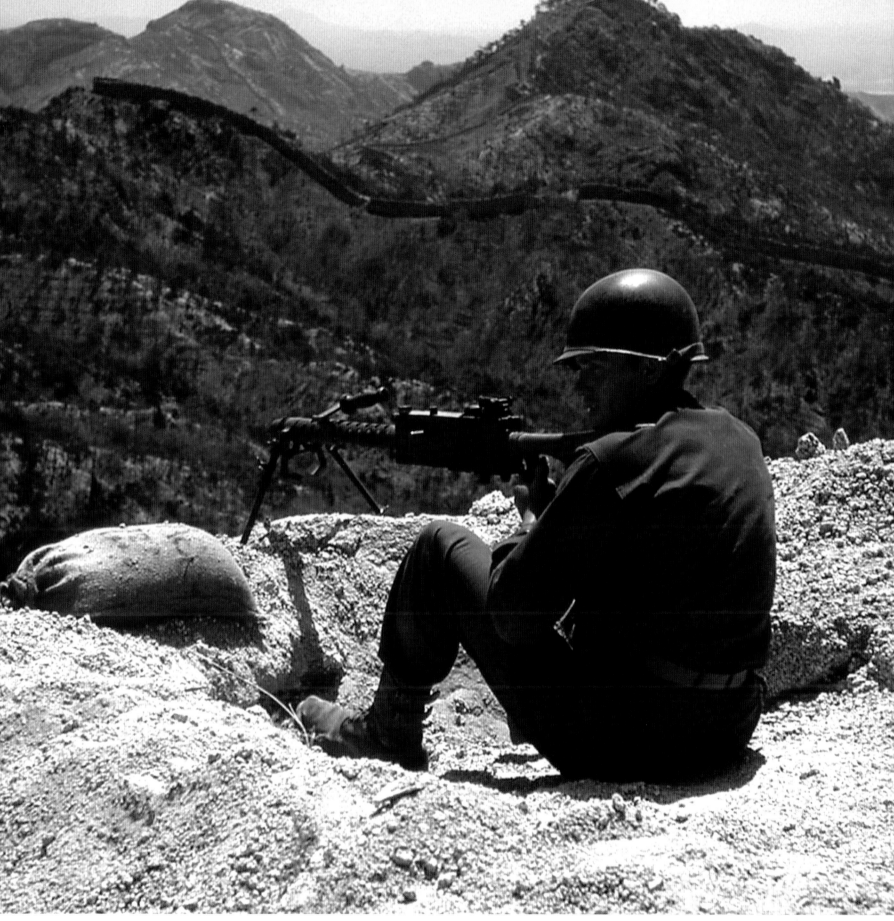

A soldier stands guard in the hills north of Seoul, despite the commencement of peace talks in July 1951.
This is probably a posed photograph: the defensive position is shallow, and the man's machine gun has no ammunition belt.

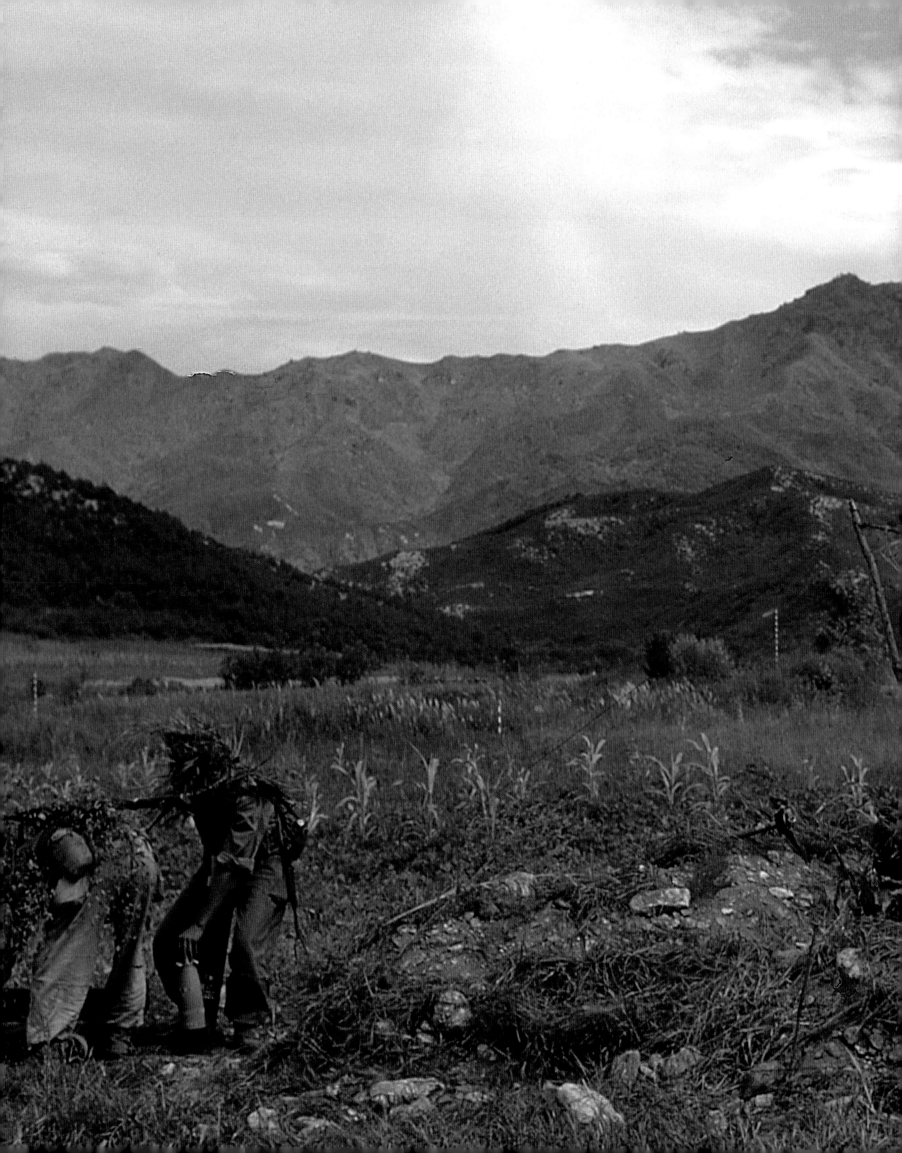

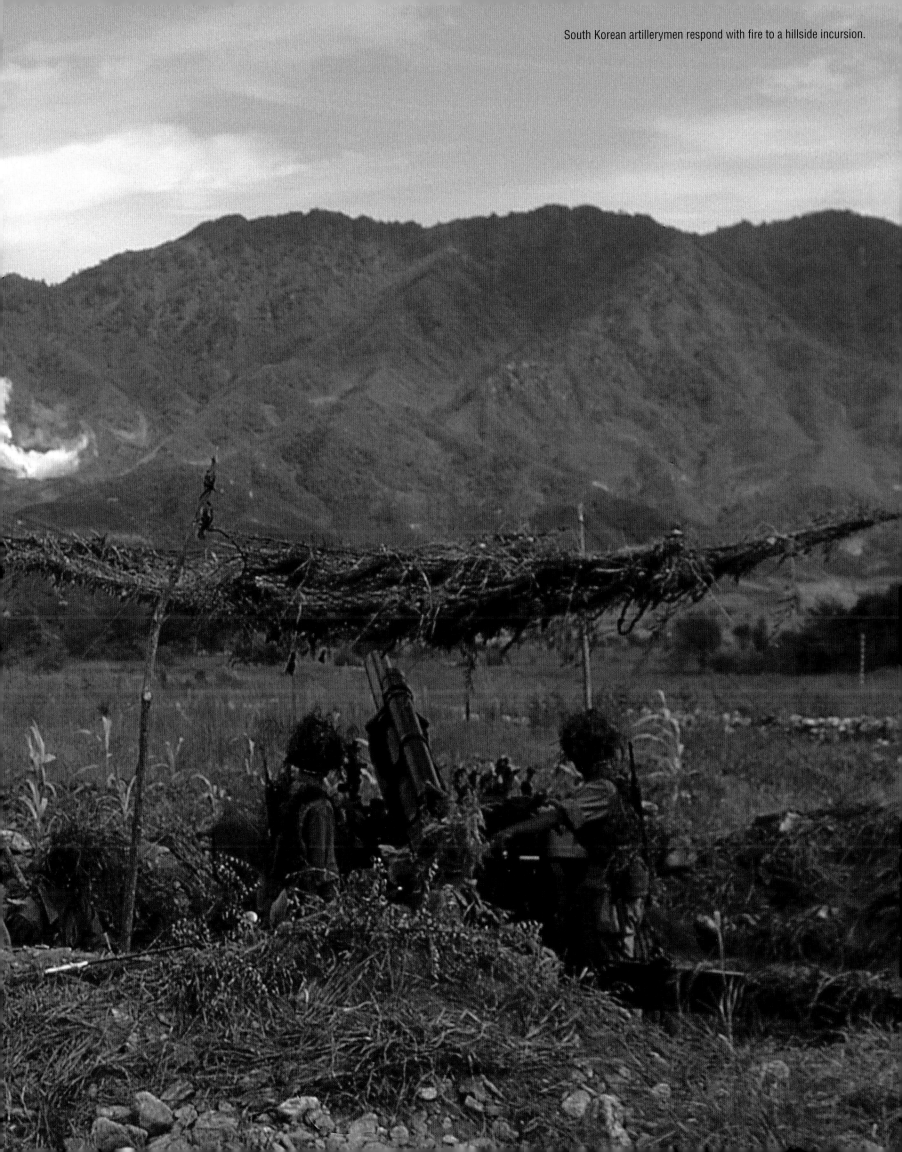

South Korean artillerymen respond with fire to a hillside incursion.

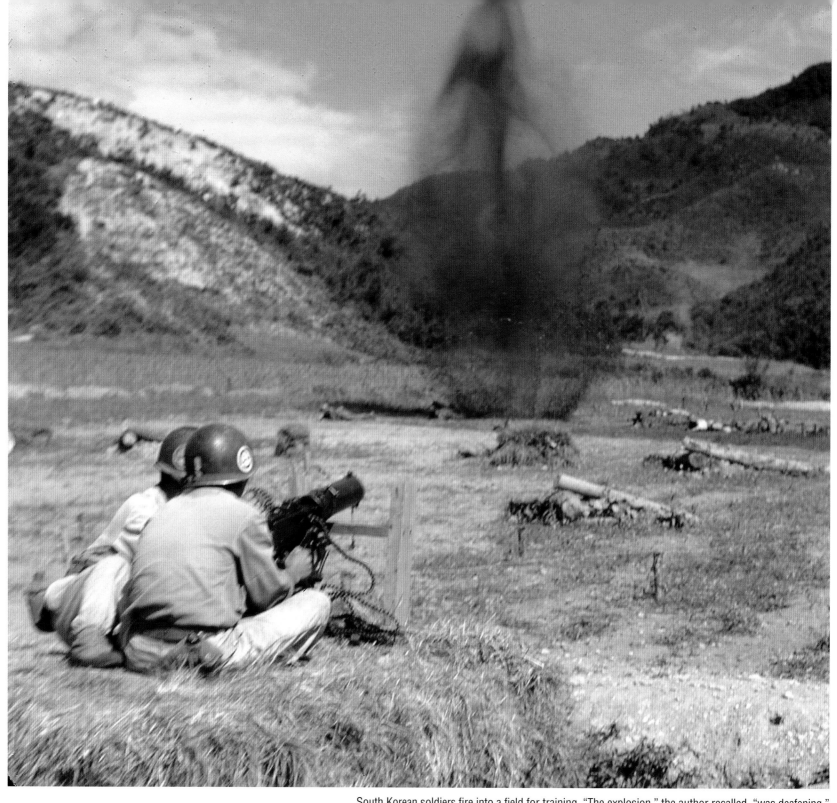

South Korean soldiers fire into a field for training. "The explosion," the author recalled, "was deafening."

An American military advisory group trains young South Korean recruits in the use of a heavy M-1 rifle. "They would take eight or nine shots at a target," the author explained, "and that was the training."

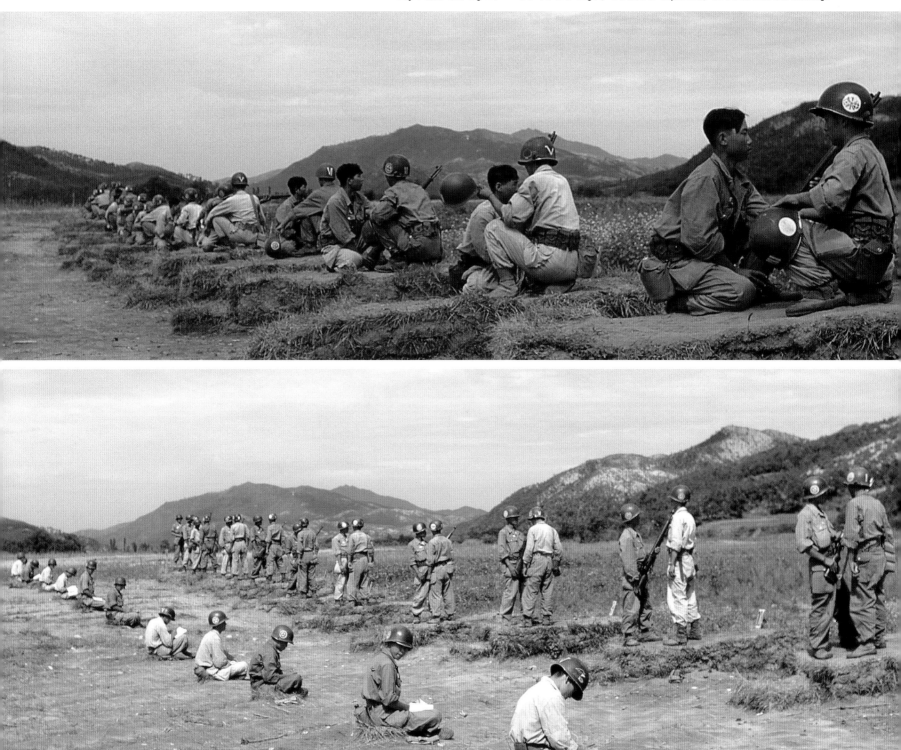

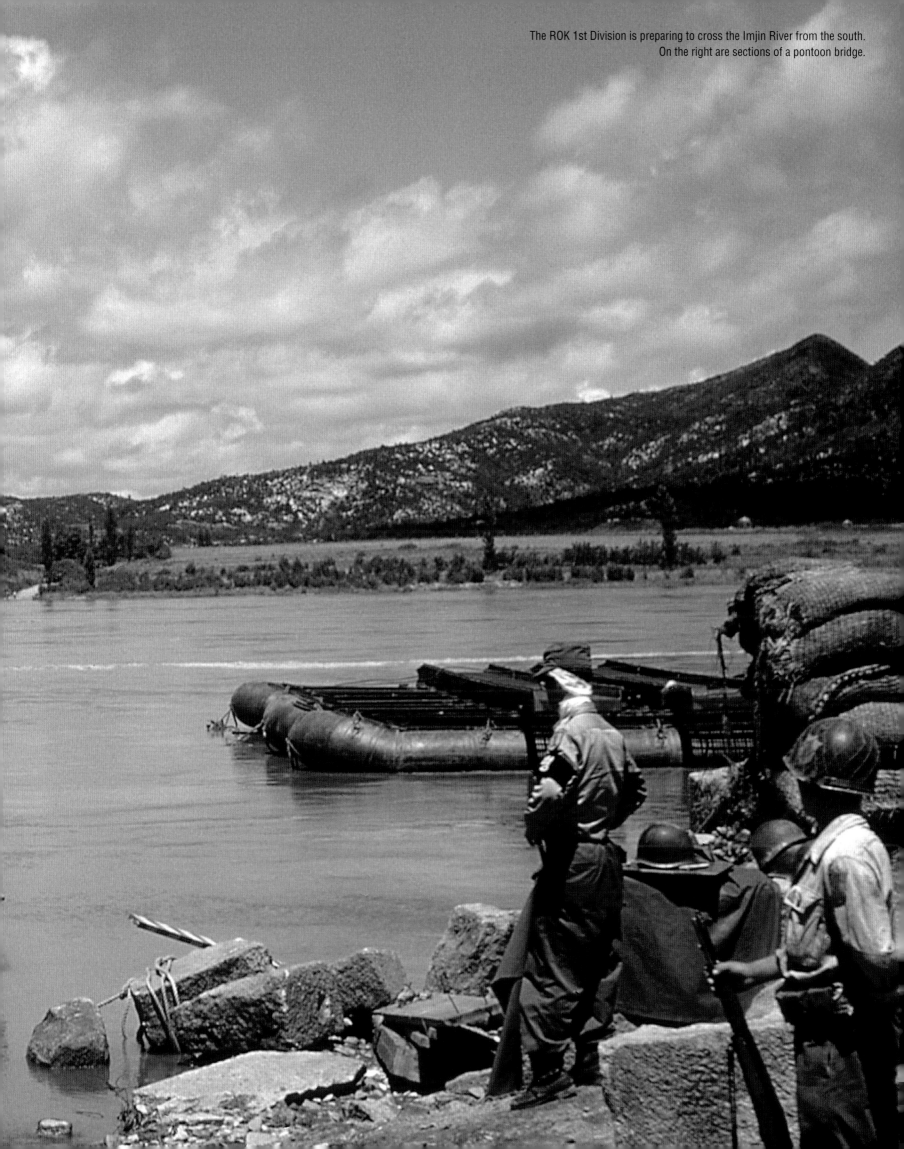

The ROK 1st Division is preparing to cross the Imjin River from the south. On the right are sections of a pontoon bridge.

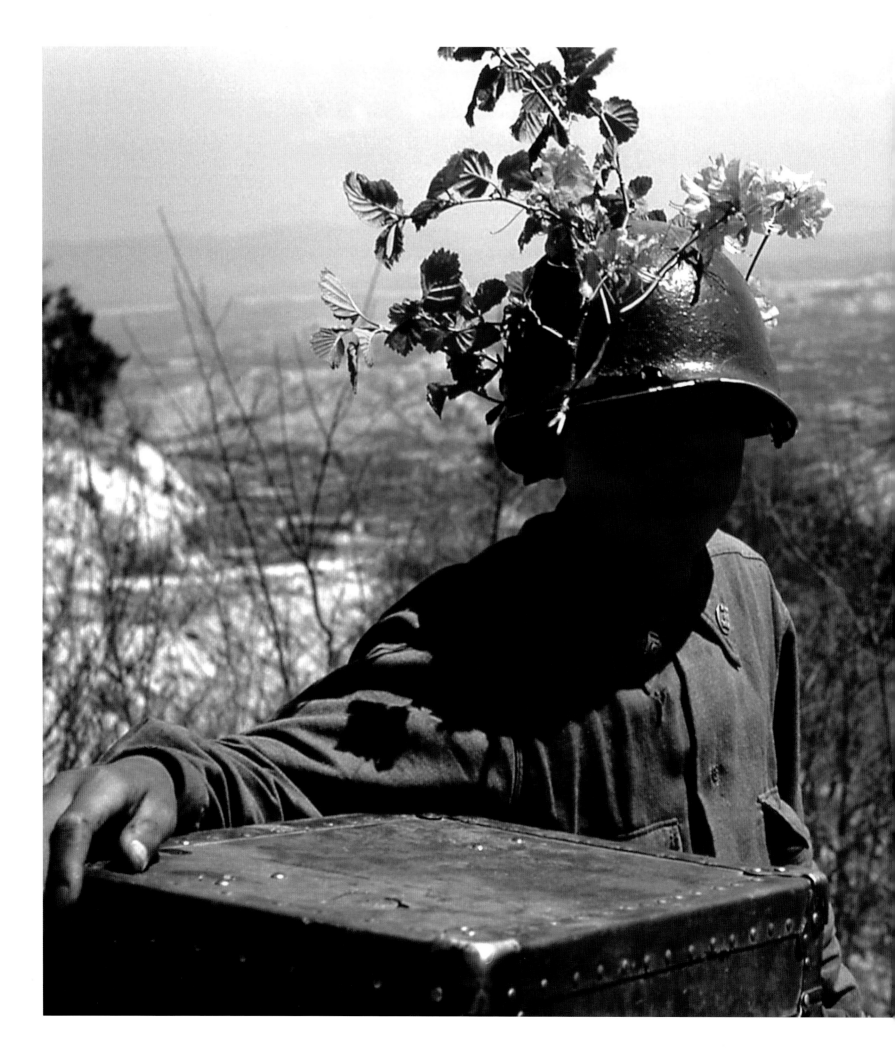

A young member of South Korea's fighting force
heralds spring while donning battlefield camouflage.
Many soldiers were pleased to see the hillside azaleas
blooming, proof that the bitter winter was finally over.

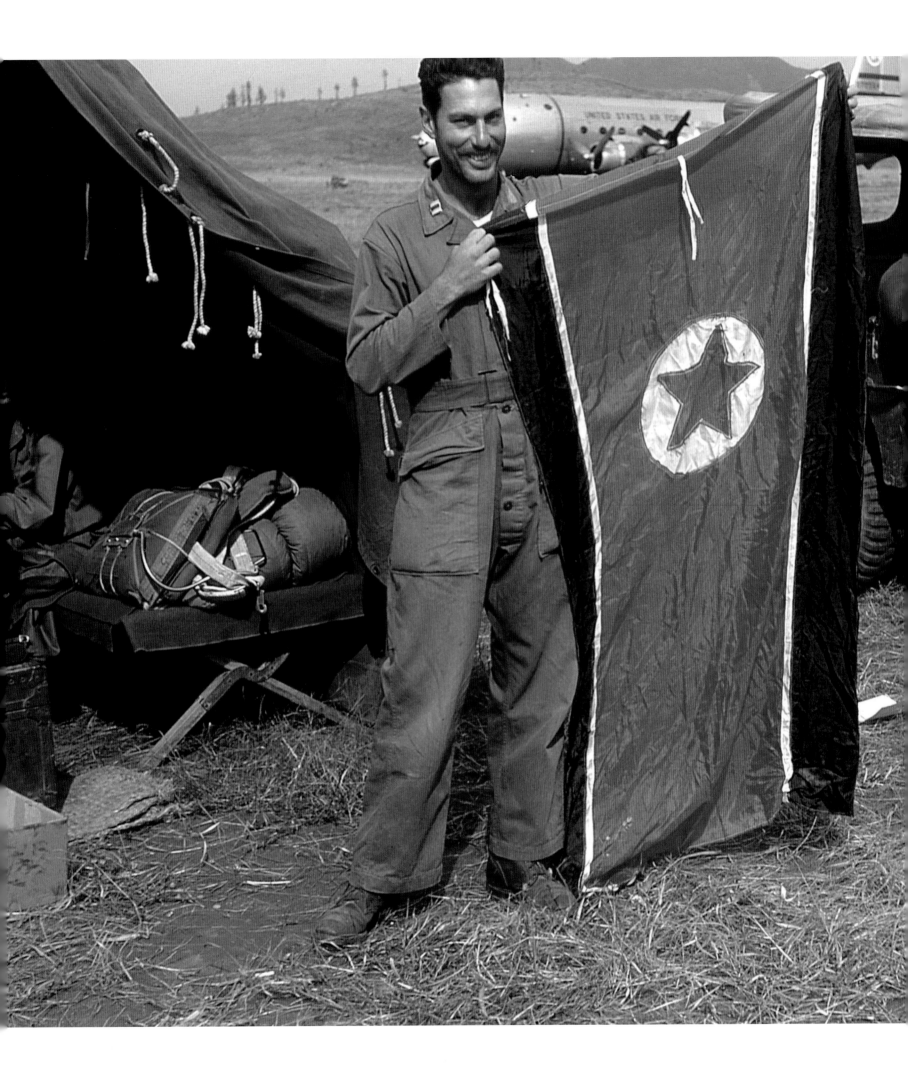

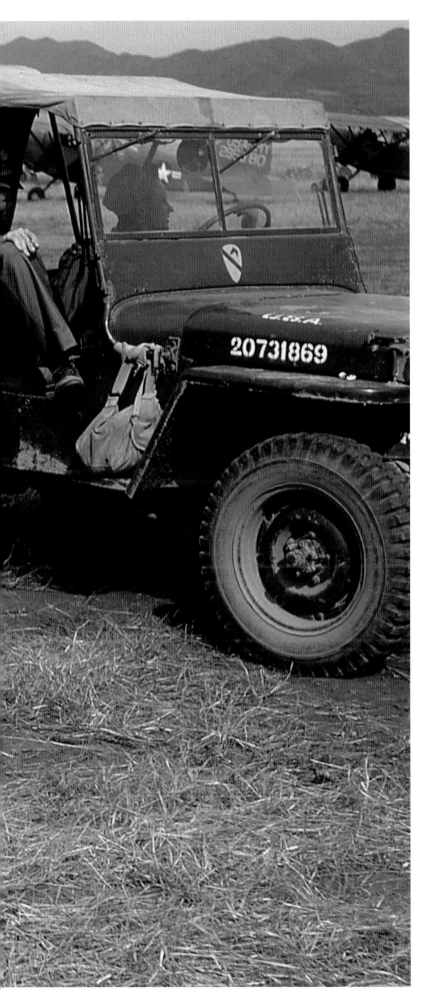

An officer of the 1st Cavalry Div. holds a captured North Korean flag in October 1950 as American troops move north from Seoul. They would eventually capture the North Korean capital of Pyongyang on the 19th of that same month.

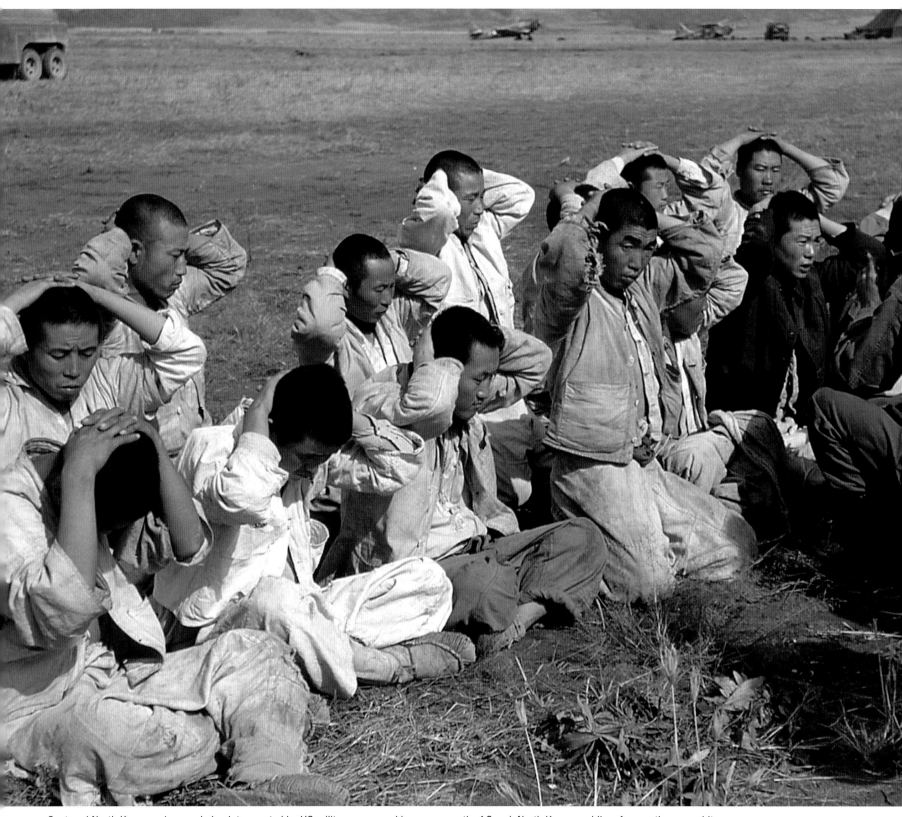

Captured North Korean prisoners being interrogated by US military personnel in an area north of Seoul. North Korean soldiers frequently wore white civilian clothing, which would have dire repercussions when UN troops fired into crowds of refugees infiltrated by the enemy.

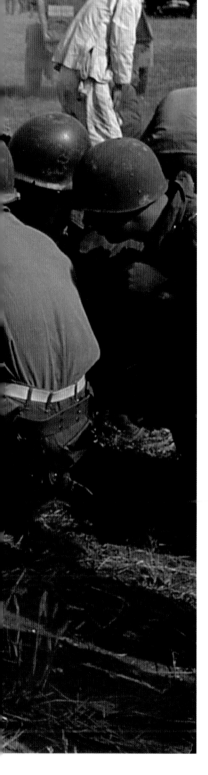

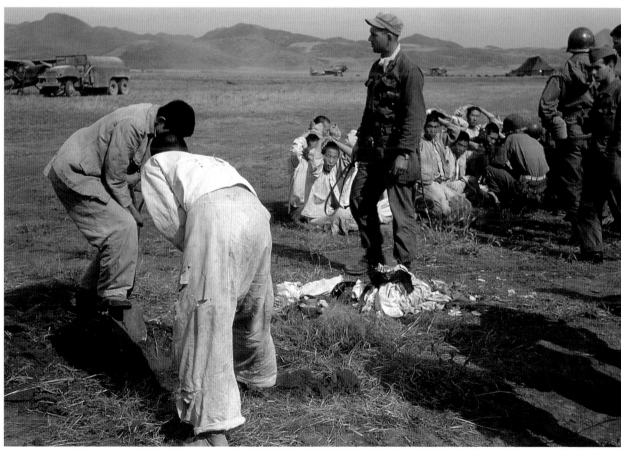

The yellow scarf worn by the soldier to the right indicates that he is a member of the 7th Cavalry Regiment, the famous unit that was wiped out under Colonel George Custer at Little Big Horn.

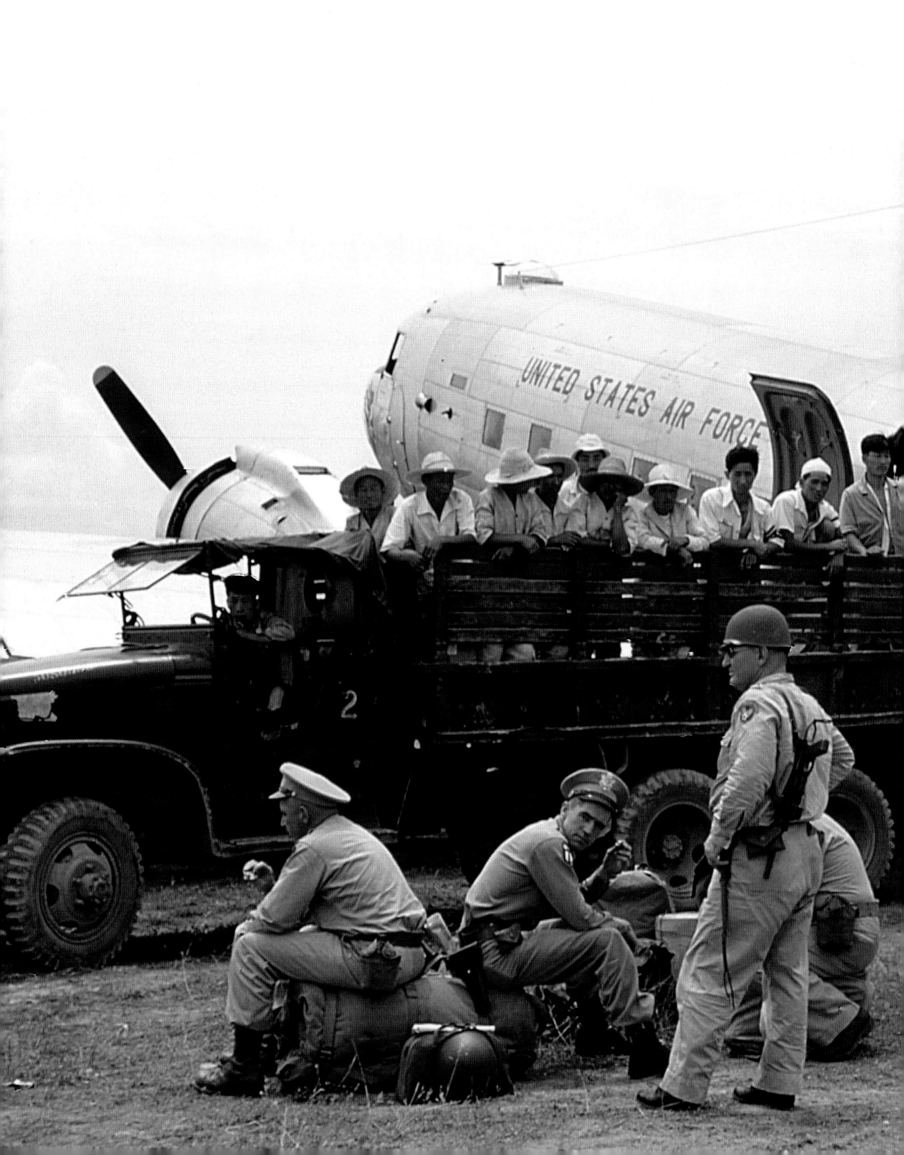

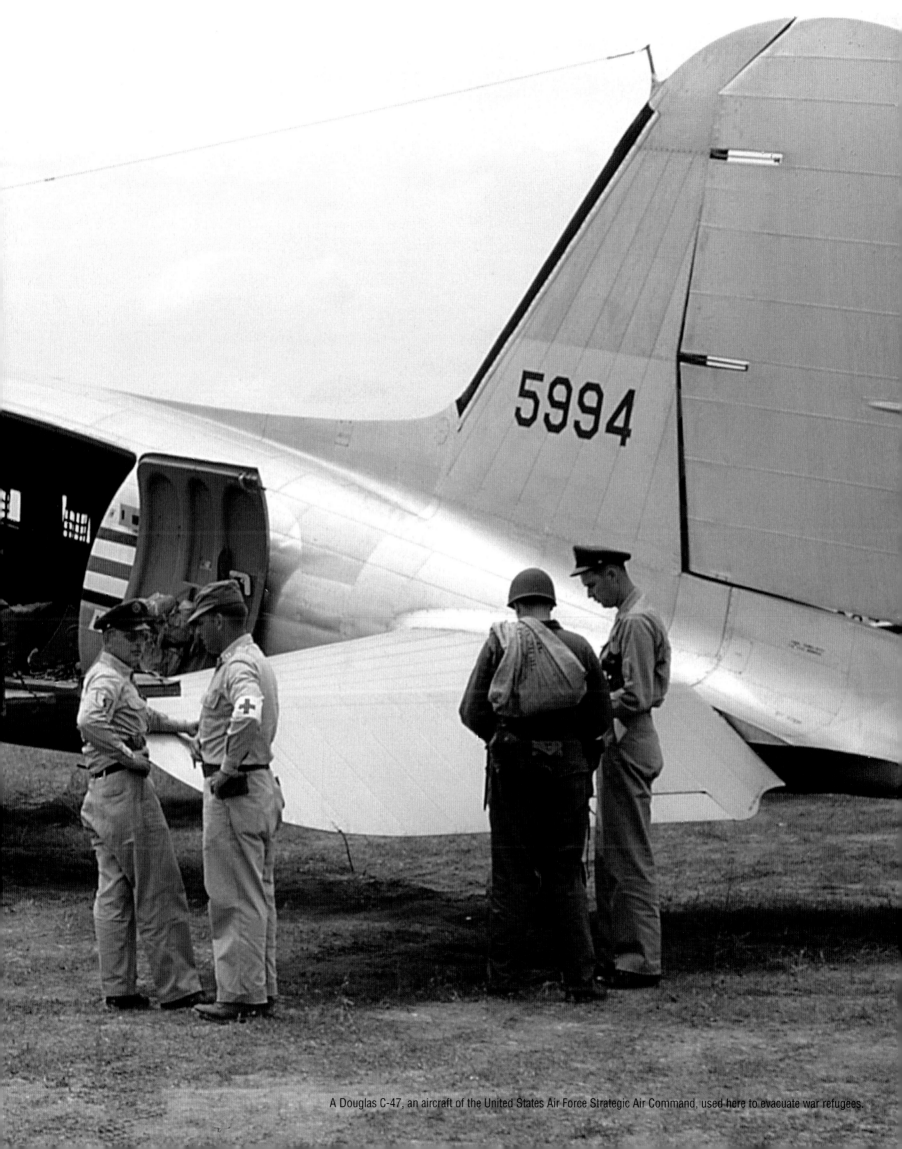

5994

A Douglas C-47, an aircraft of the United States Air Force Strategic Air Command, used here to evacuate war refugees.

UN Press Badge

"On one of the first days of January 1951, I headed back to Korea from Japan, with a group of other UN newsmen. We hadn't been sure how to identify ourselves on our clothing, but somebody at the press club in Tokyo came up with the idea of a new insignia. Since it was now a United Nations war, he designed a square shoulder patch in blue and white, which said simply 'UN War Correspondent.' As far as I am aware, nobody, neither the UN nor the Far East Command, formally approved it, but we all wore it and had no trouble being identified. I still have one on an old khaki shirt."

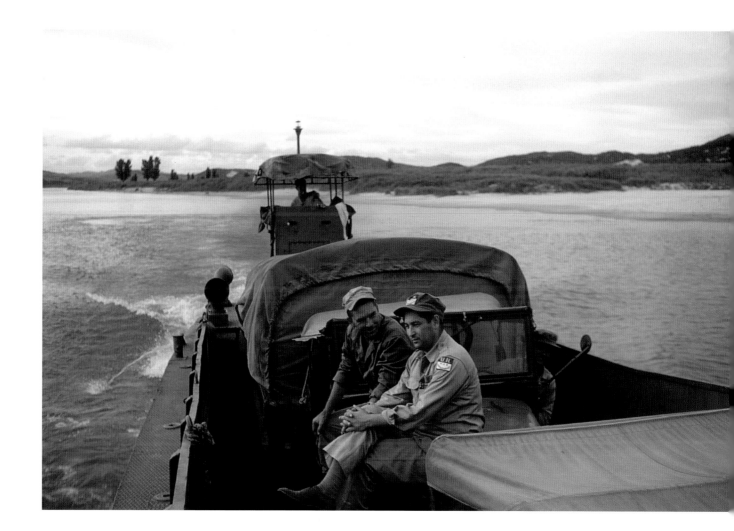

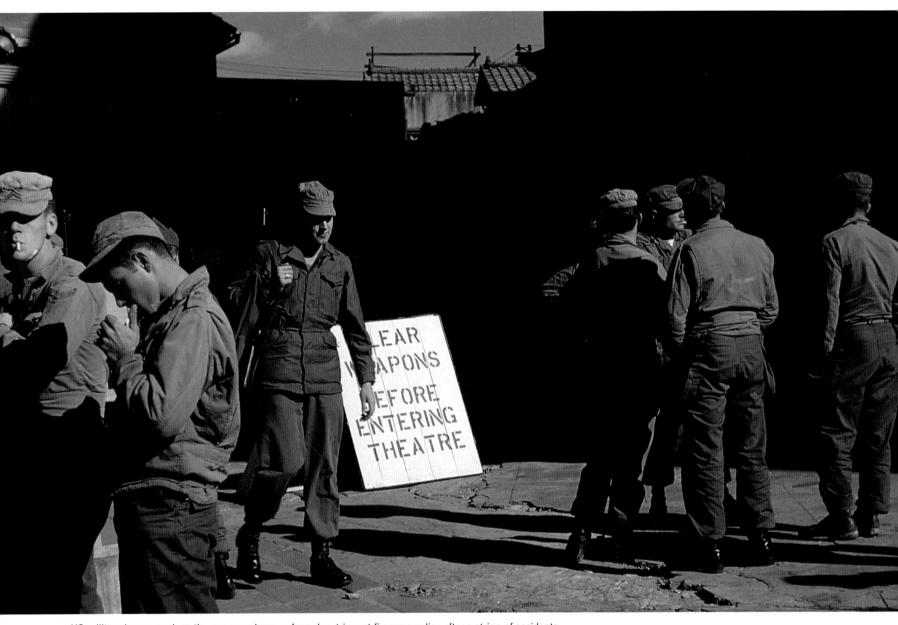

US military bases, such as the one seen here, enforced a stringent firearms policy after a string of accidents.

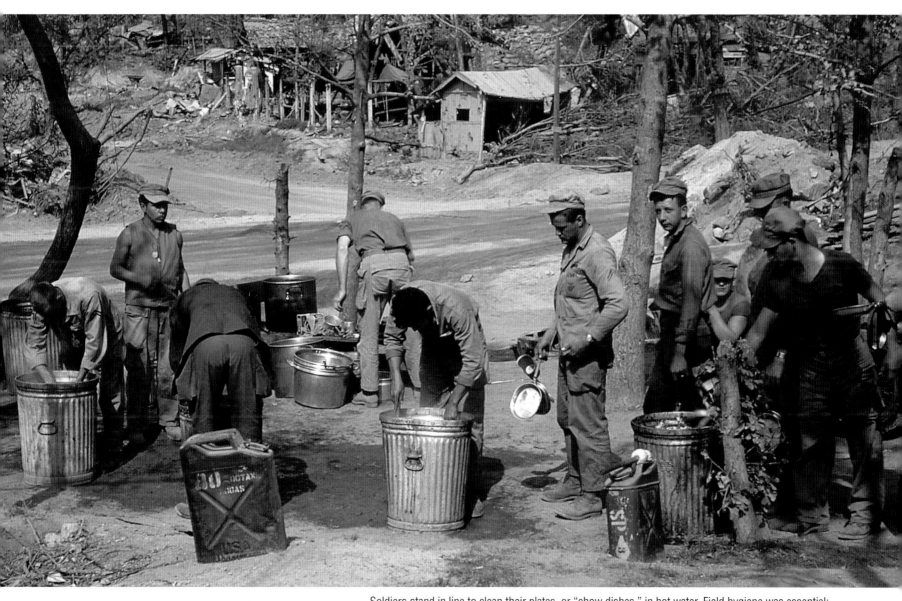

Soldiers stand in line to clean their plates, or "chow dishes," in hot water. Field hygiene was essential;
if one man came down with a bug, it would soon be passed along to the rest of his unit.

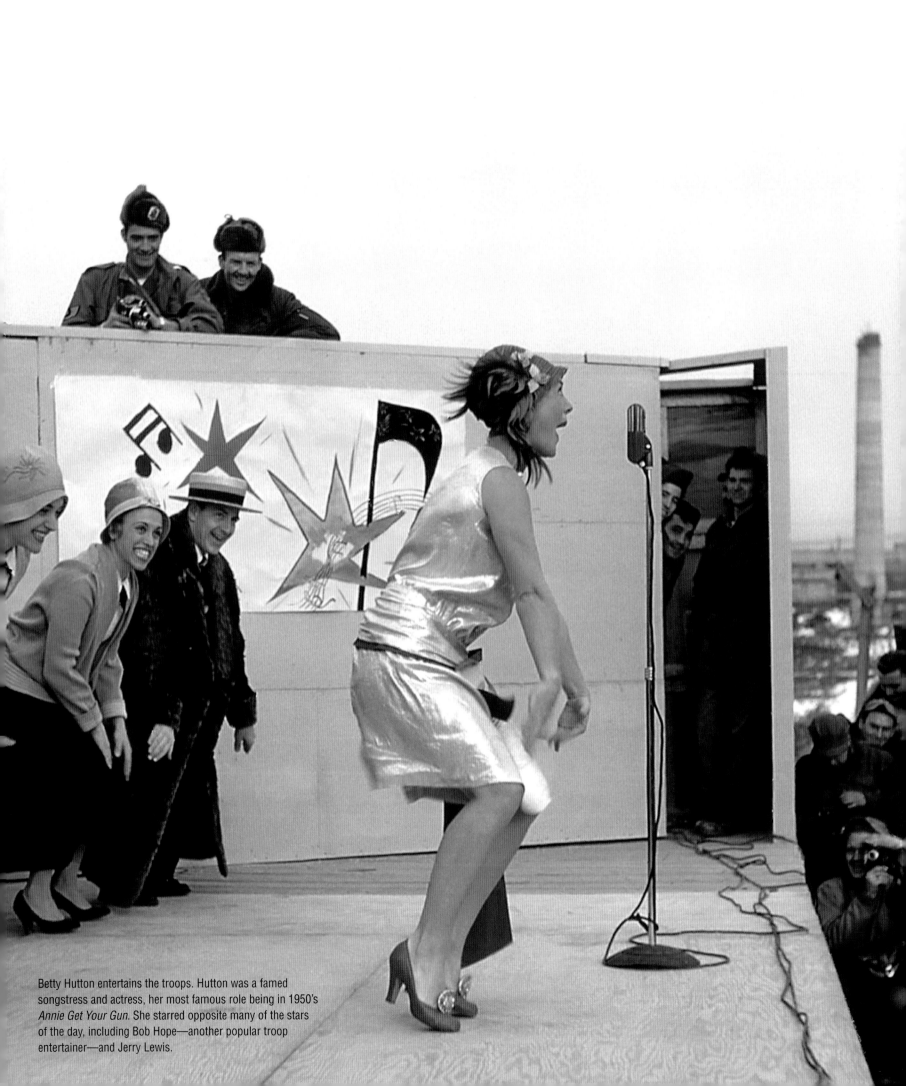

Betty Hutton entertains the troops. Hutton was a famed songstress and actress, her most famous role being in 1950's *Annie Get Your Gun*. She starred opposite many of the stars of the day, including Bob Hope—another popular troop entertainer—and Jerry Lewis.

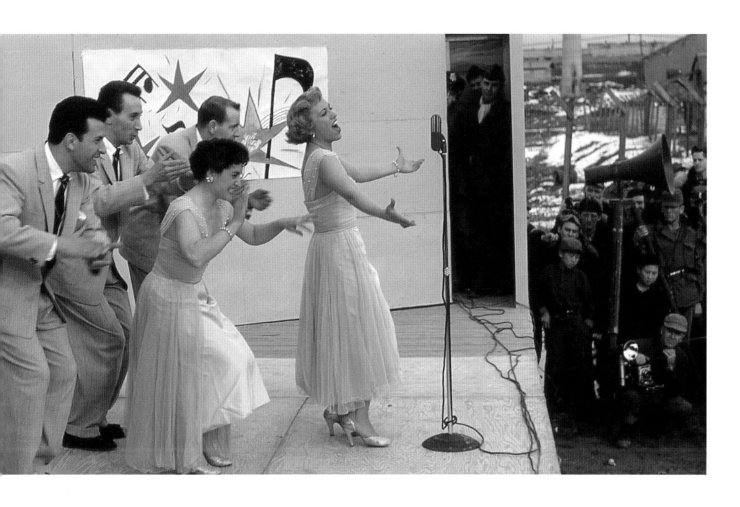

Betty Hutton gets an airplane ride after her performance.

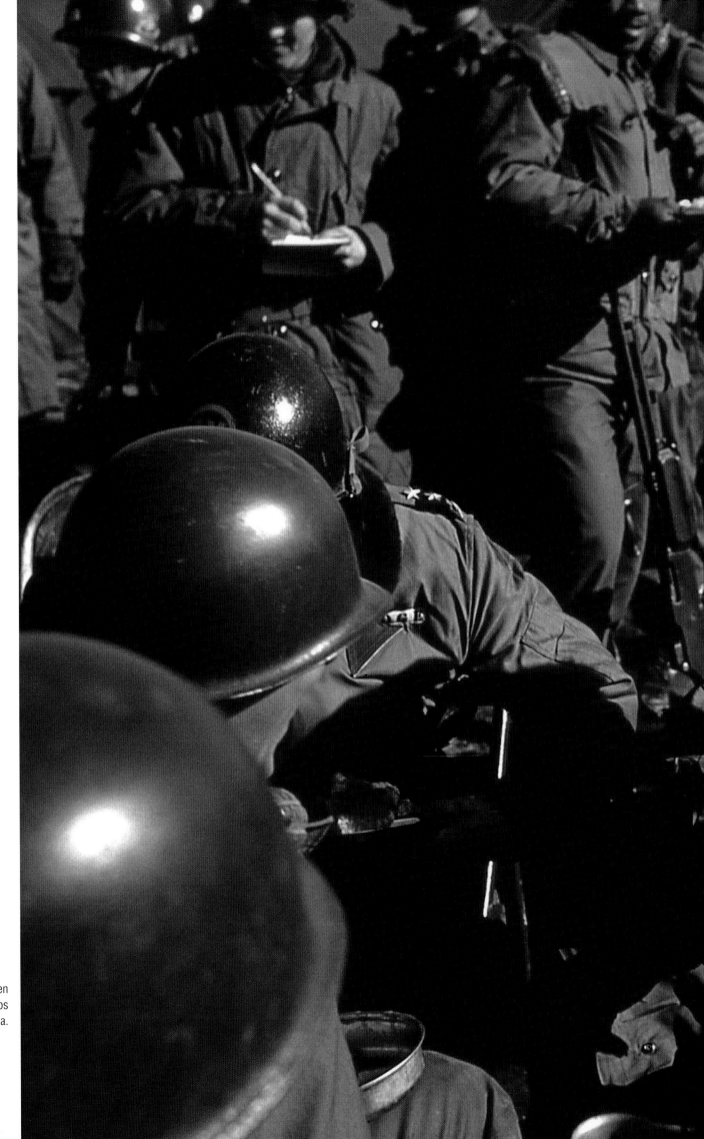

US Vice President Alben Barkley dines with troops on a visit to Korea.

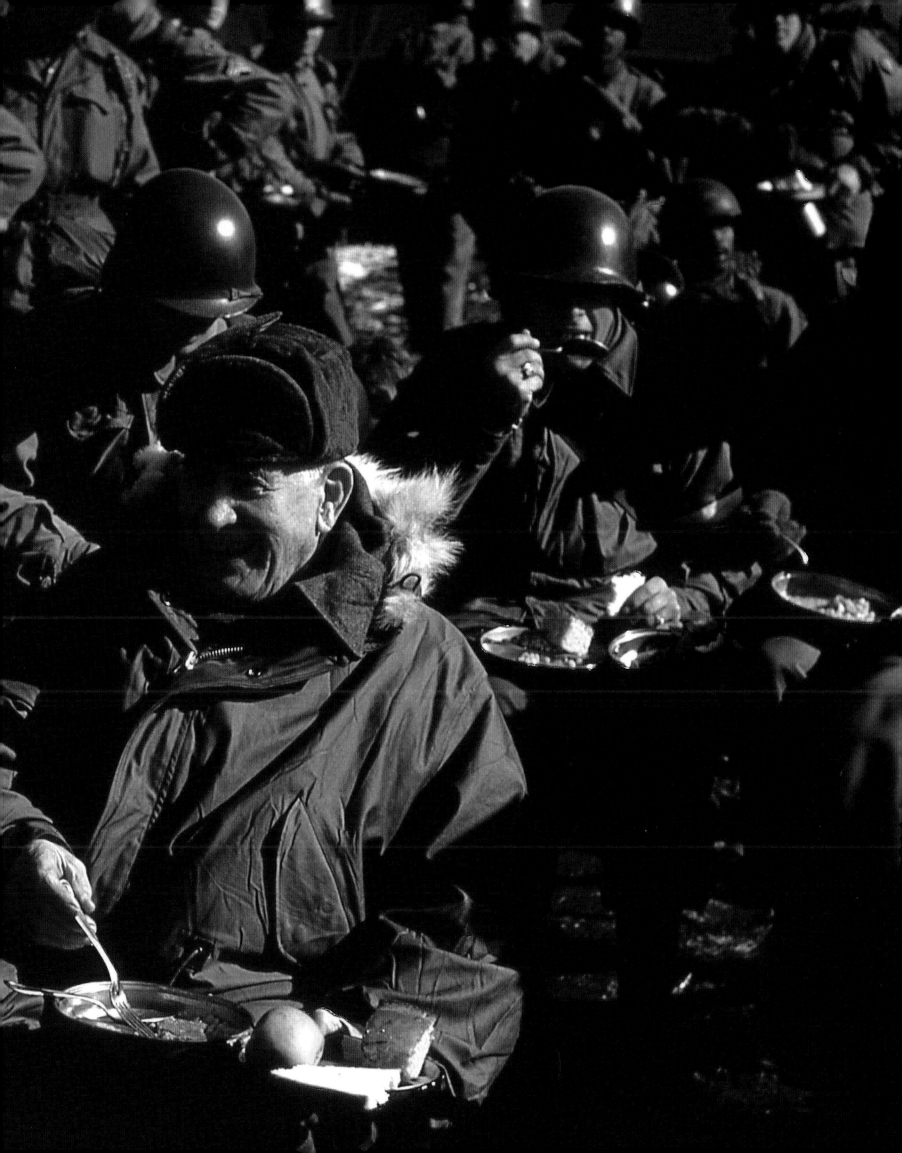

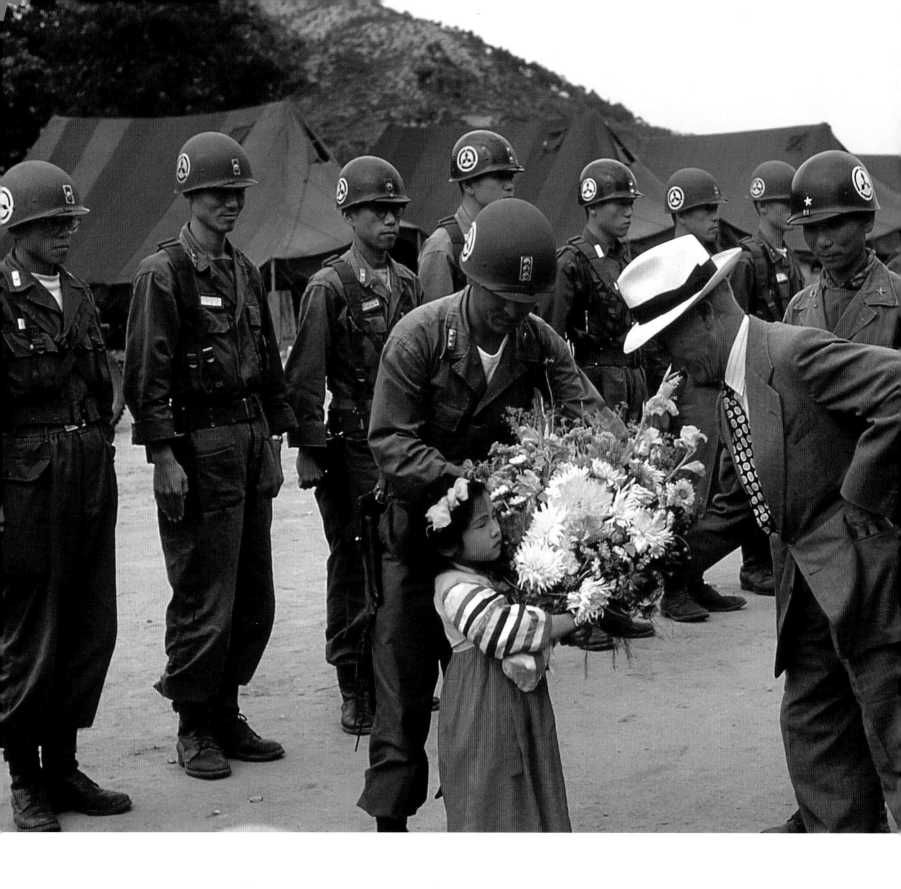

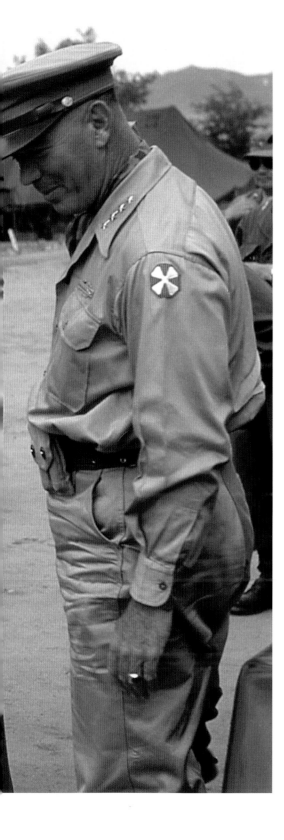

President Syngman Rhee accepting a bouquet of flowers from a young South Korean child after a military debriefing in 1951. General James Alward Van Fleet stands to the right.

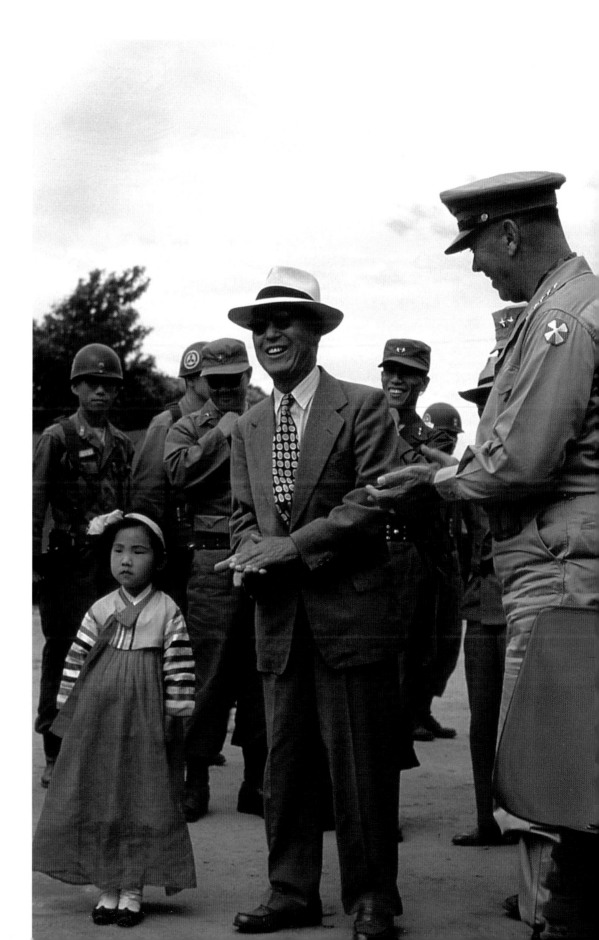

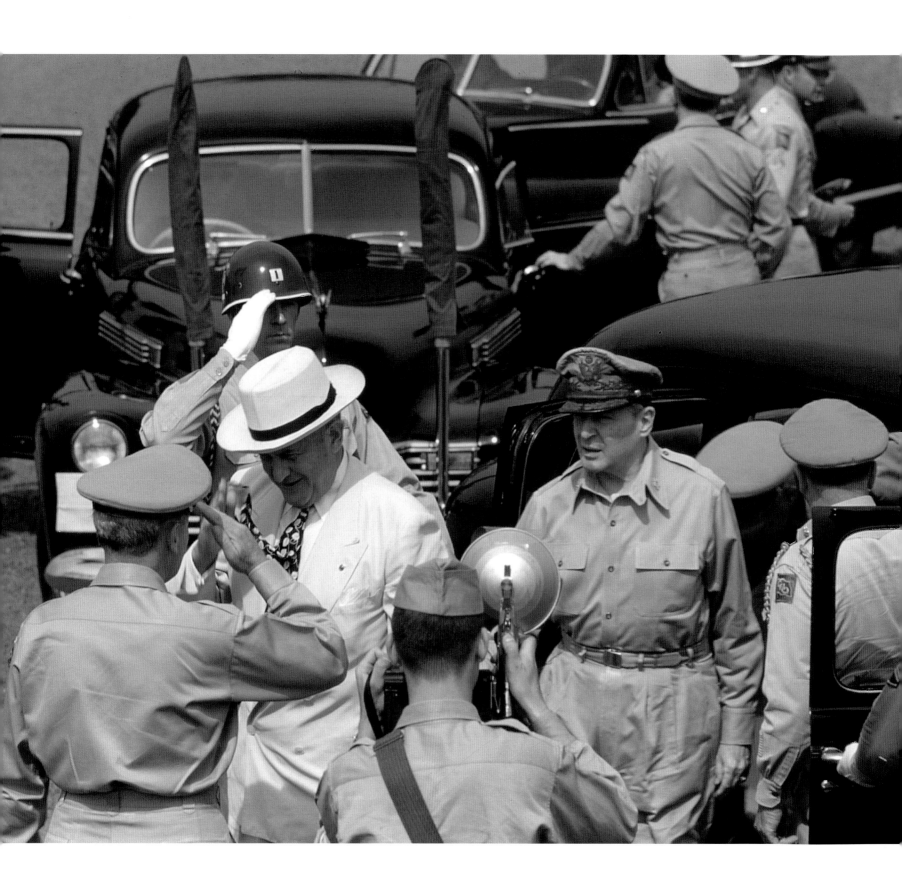

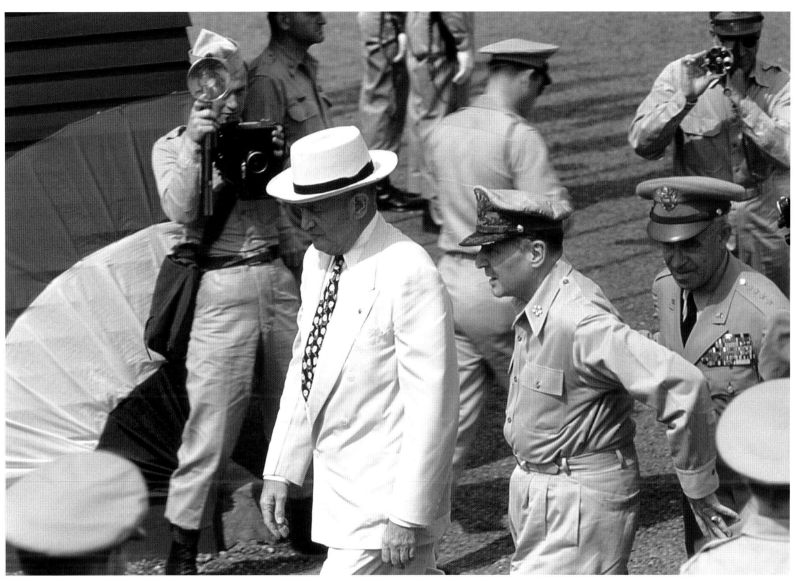

General Douglas MacArthur (center) escorts then Secretary of Defense Louis Johnson (left) and Chief of Staff General Omar Bradley (right) to the viewing stand for a welcoming ceremony in Tokyo on June 19, 1950, days before North Korea invaded South Korea and started the war.

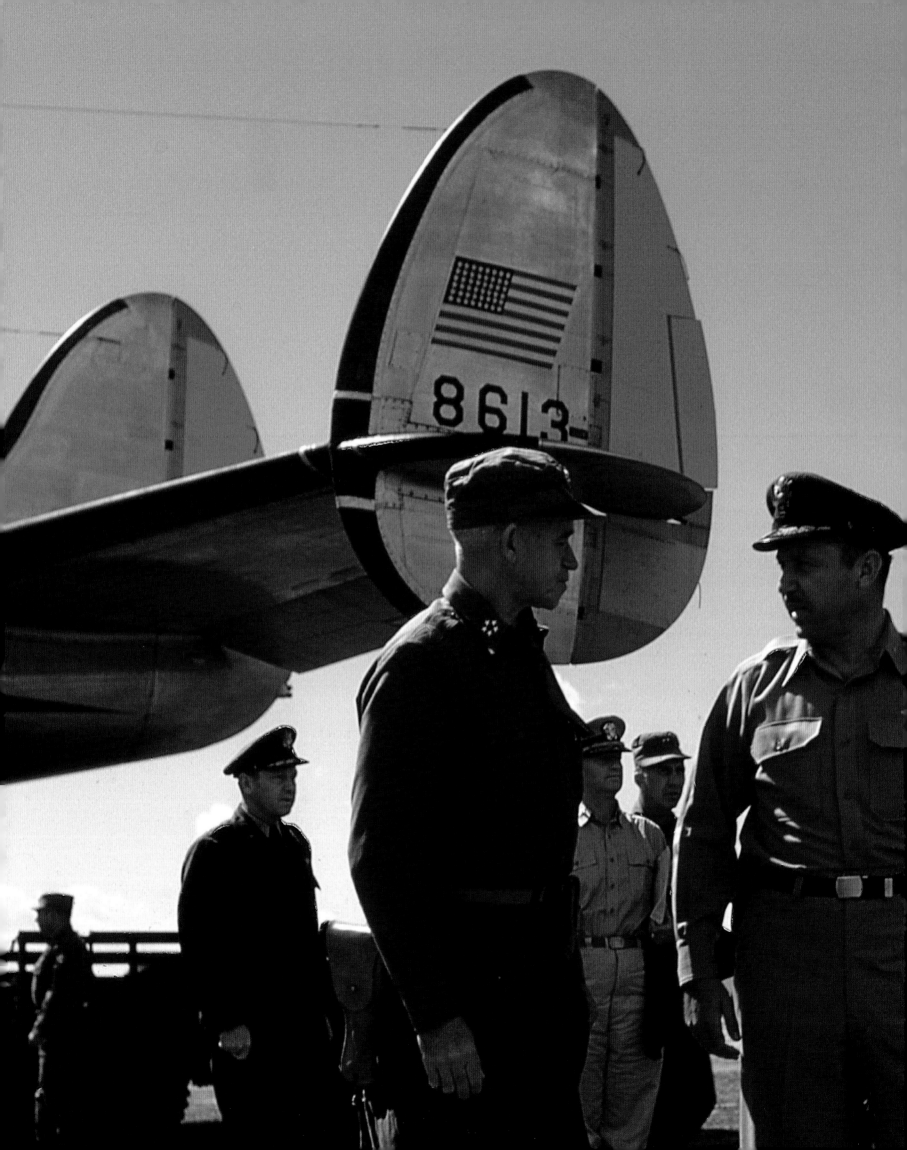

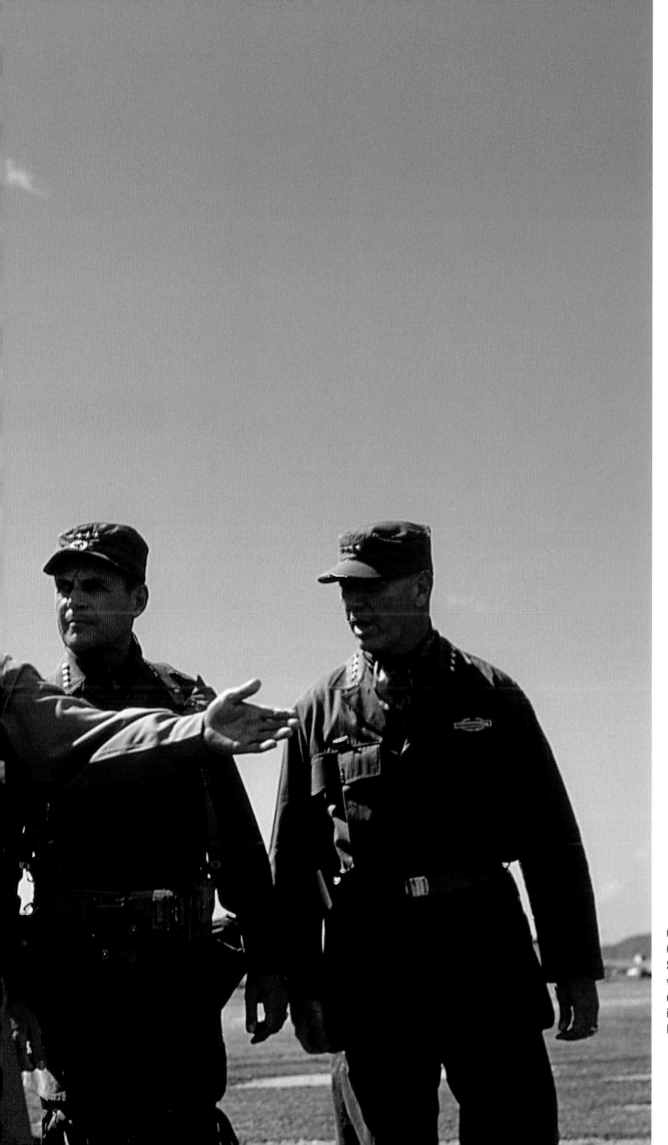

General Omar Bradley (left), Chairman of the Joint Chiefs of Staff, arrives in Korea. Bradley was a strong critic of MacArthur's desire to expand the Korean War into China. General Matthew Ridgway is standing middle right.

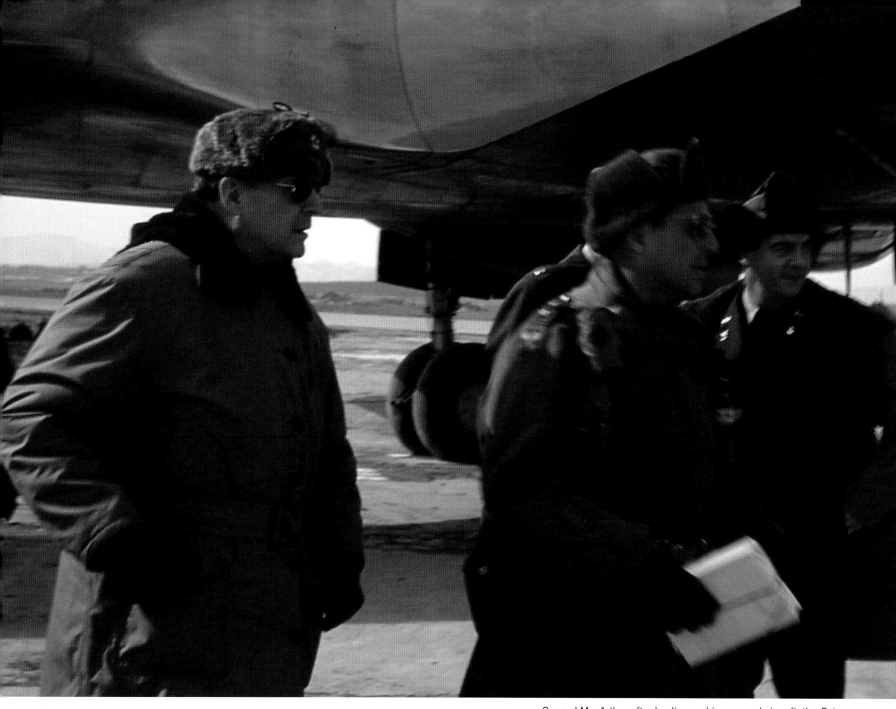

General MacArthur after landing on his personal aircraft, the *Bataan*.

General Mark Clark (center), who succeeded General Matthew Ridgway as commander of the United Nations forces in 1952. Clark signed the cease-fire agreement with North Korea in 1953.

U.S. ARMY
O1385

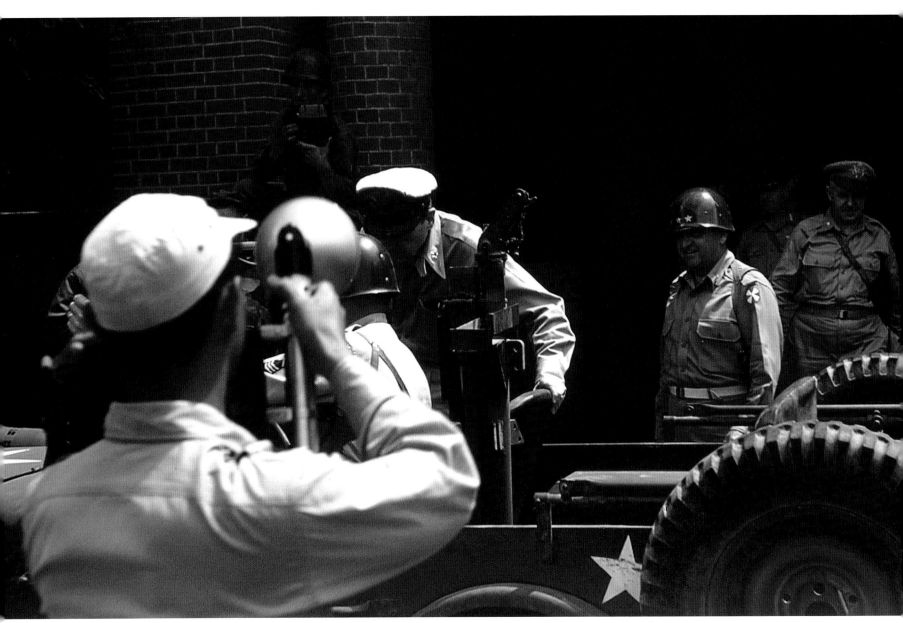

General MacArthur, Supreme Commander of the Allied Powers, climbs aboard a jeep. Behind him is General Walton Walker, who was killed a short while later in his own jeep when it was hit by a cargo truck. Walker, the first US ground commander to defend South Korea, is commemorated in modern Seoul in an unusual manner for a general. The US Army Rest and Recreation Center was named after him in the 1960s, and the center was later handed over to South Korea and transformed into a hotel, today's Sheraton Walker Hill Hotel and Casino.

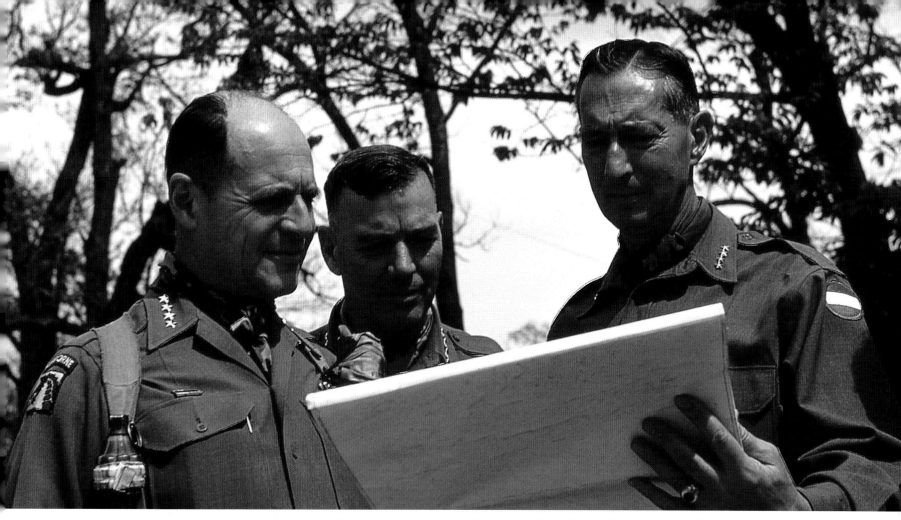

Three key leaders in the Korean War—from left to right, General Matthew Ridgway, General James Van Fleet and General Mark Clark. Note the hand grenade attached to Ridgway's equipment—his trademark, and a highly unusual accoutrement for a general.

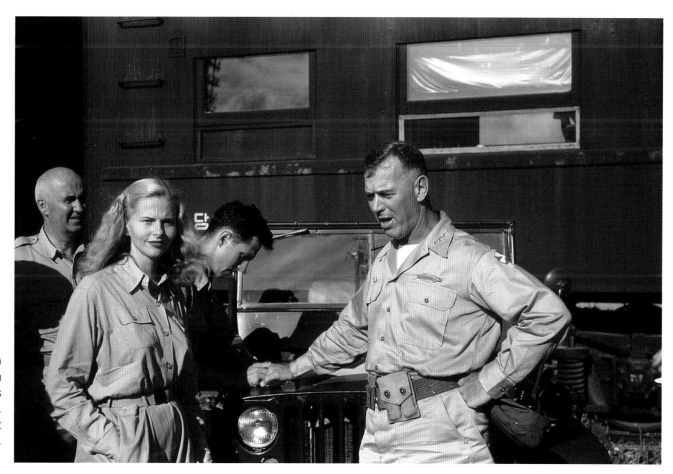

General Van Fleet (right) stands beside a press train where correspondents lived during peace talks. On the left is correspondent Linda Mangelsdorf Beech.

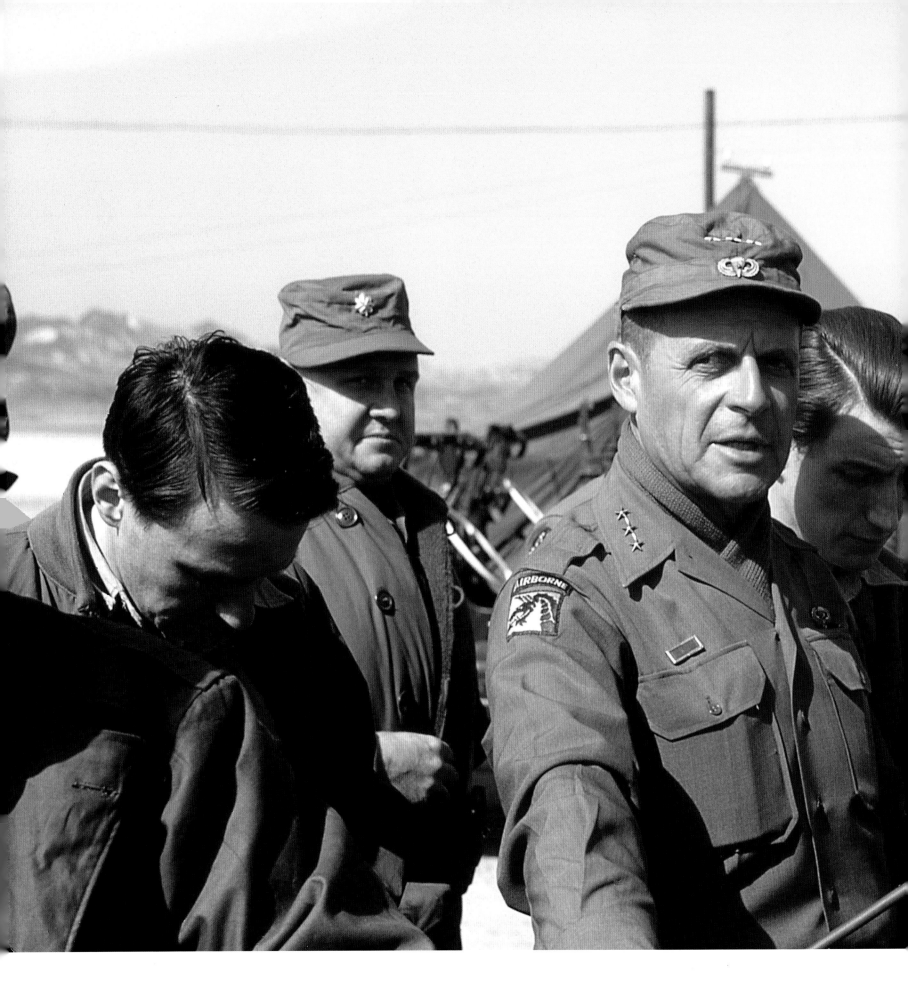

A Decisive Turning Point

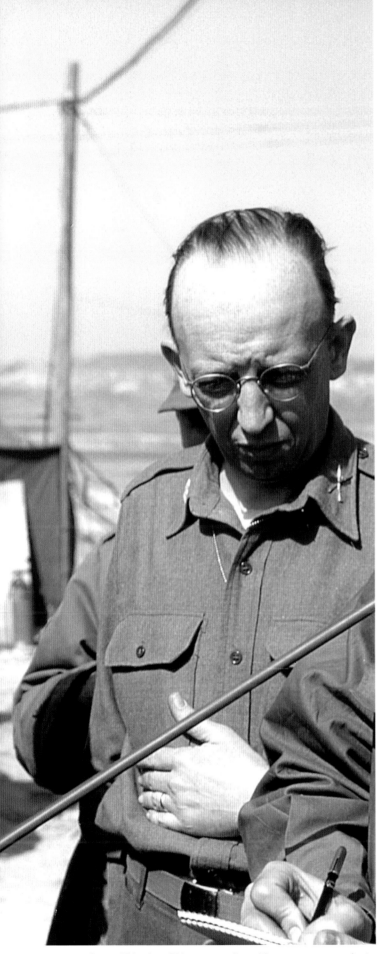

General Matthew Ridgway meeting with press correspondents.

"General Ridgway pulled together the beleaguered UN forces after the massive Chinese intervention had driven him south. He decided to retake the city of Seoul and begin driving the communists back northward. He called reporters into his headquarters, not only Americans but other UN reporters like the British, the French, the Greeks and others, and laid out his complete plan of attack, which would kick off a few days later. As a former US intelligence officer in the Marine Corps, I couldn't believe that he was revealing top secret tactical information to a group of reporters. But he won our hearts when he said, 'I'm telling you this so you go and join whichever outfit you want to be with when the drive begins.' Amazingly enough, the newsmen, all of them from various UN countries, kept the secret. As far as I know, there were no breaches of his trust. Seoul was retaken, and under General Van Fleet the Chinese and North Koreans were driven back northward in fighting that went on from mid-winter until summer.

In late March and early April of 1951, the Chinese, with hundred of thousands of men at their disposal, launched a massive attack southward. The battle raged across the entire width of the Korean Peninsula, and Chinese soldiers died by the tens of thousands, from heavy artillery fire, close air support in front of the UN front lines, and the use of napalm. Because their long supply line was hammered by the Americans day and night, they seemed unable to sustain a major attack for more than five days. Then they had to halt and wait to be replenished with food and ammunition. This went on throughout most of April 1951. It began again in May with the same effect, but Seoul remained in the hands of the UN Command."

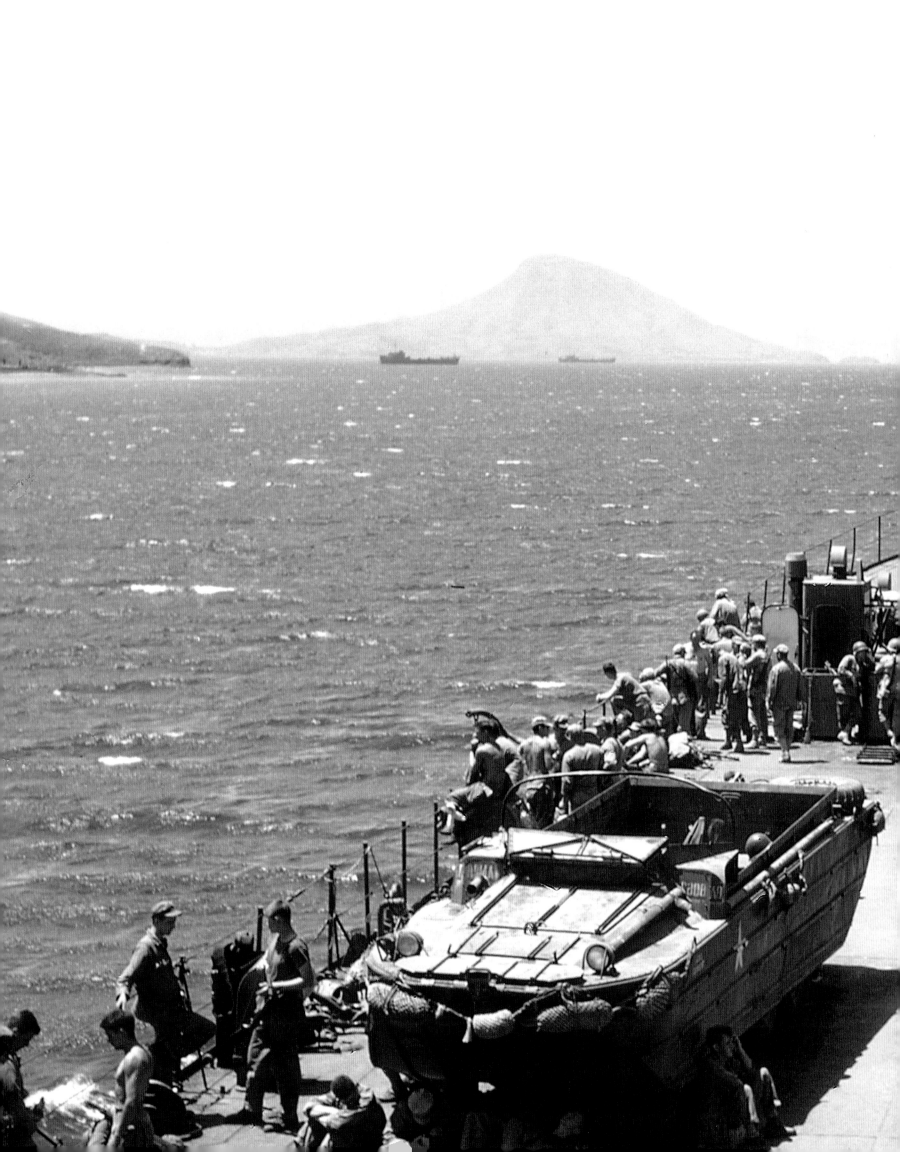

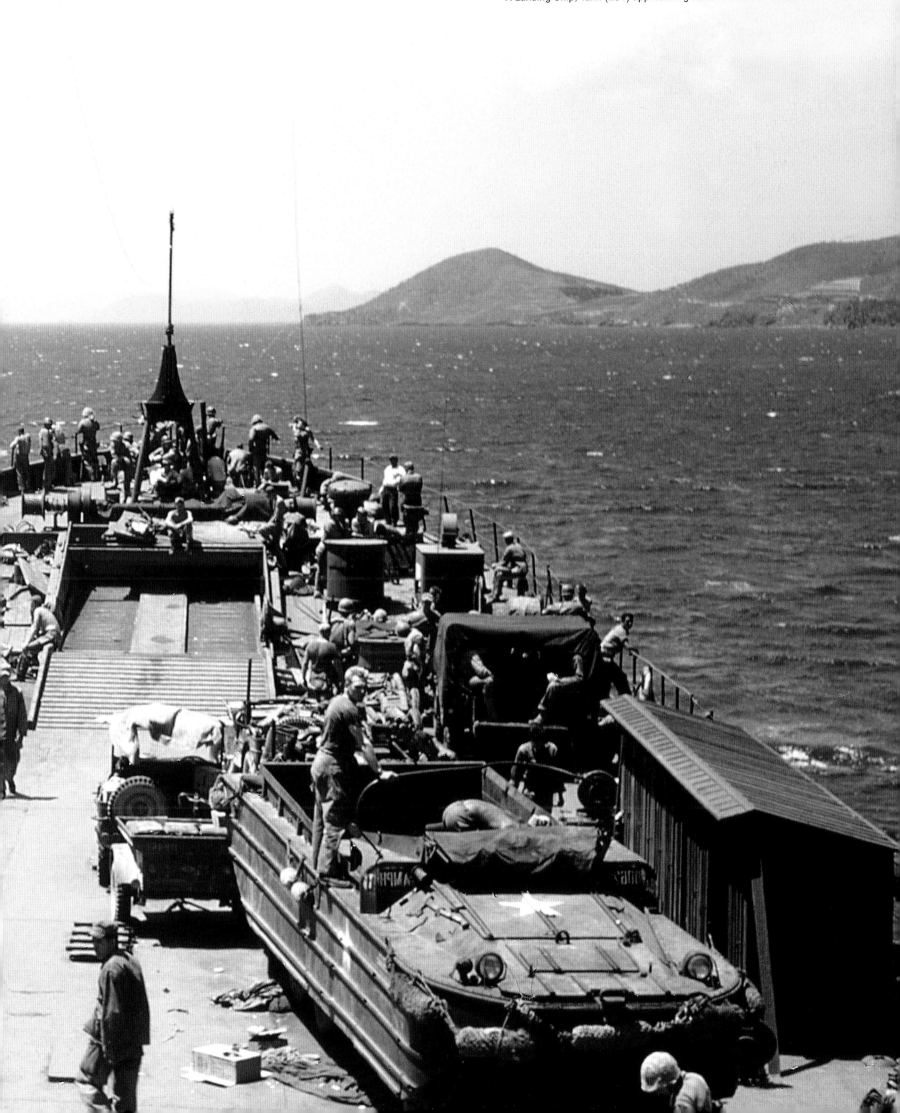
A Landing Ship, Tank (LST) approaching Busan Harbor in the summer of 1950.

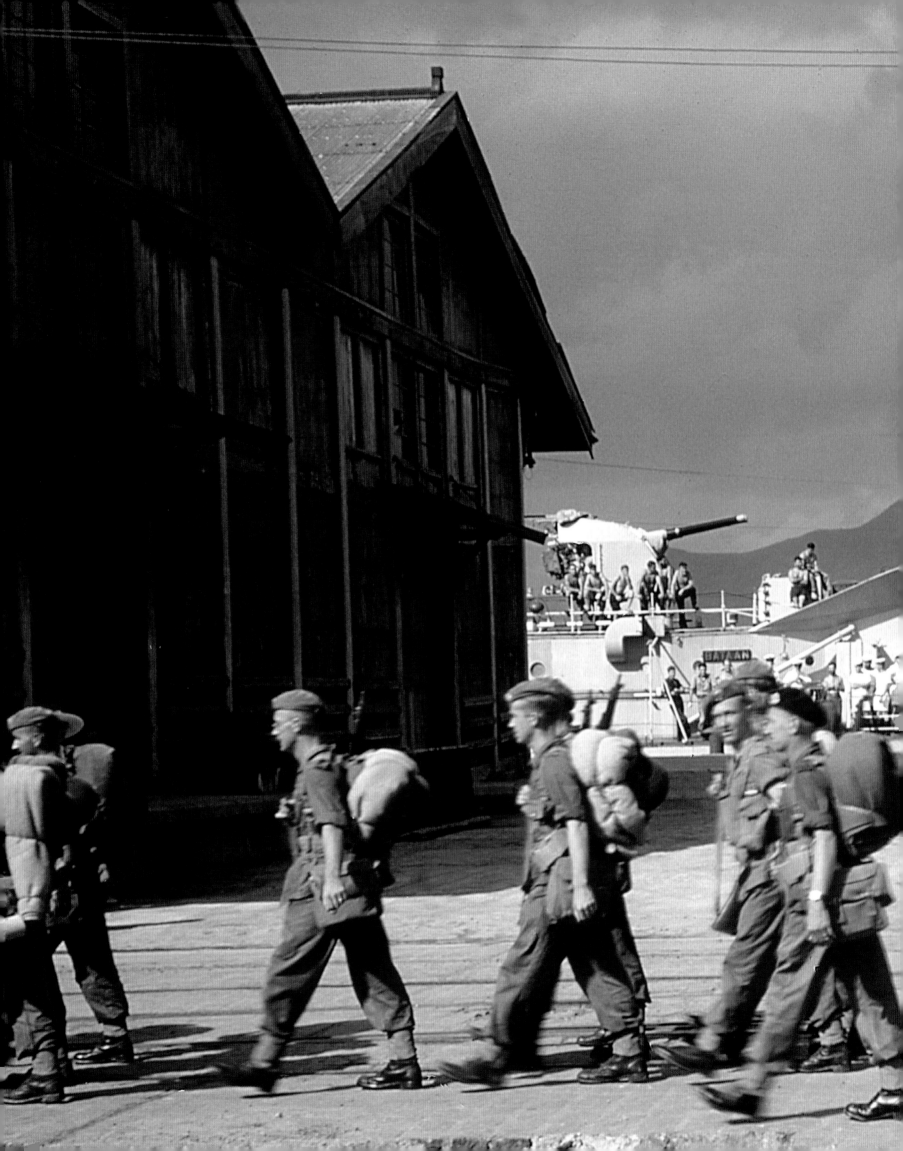

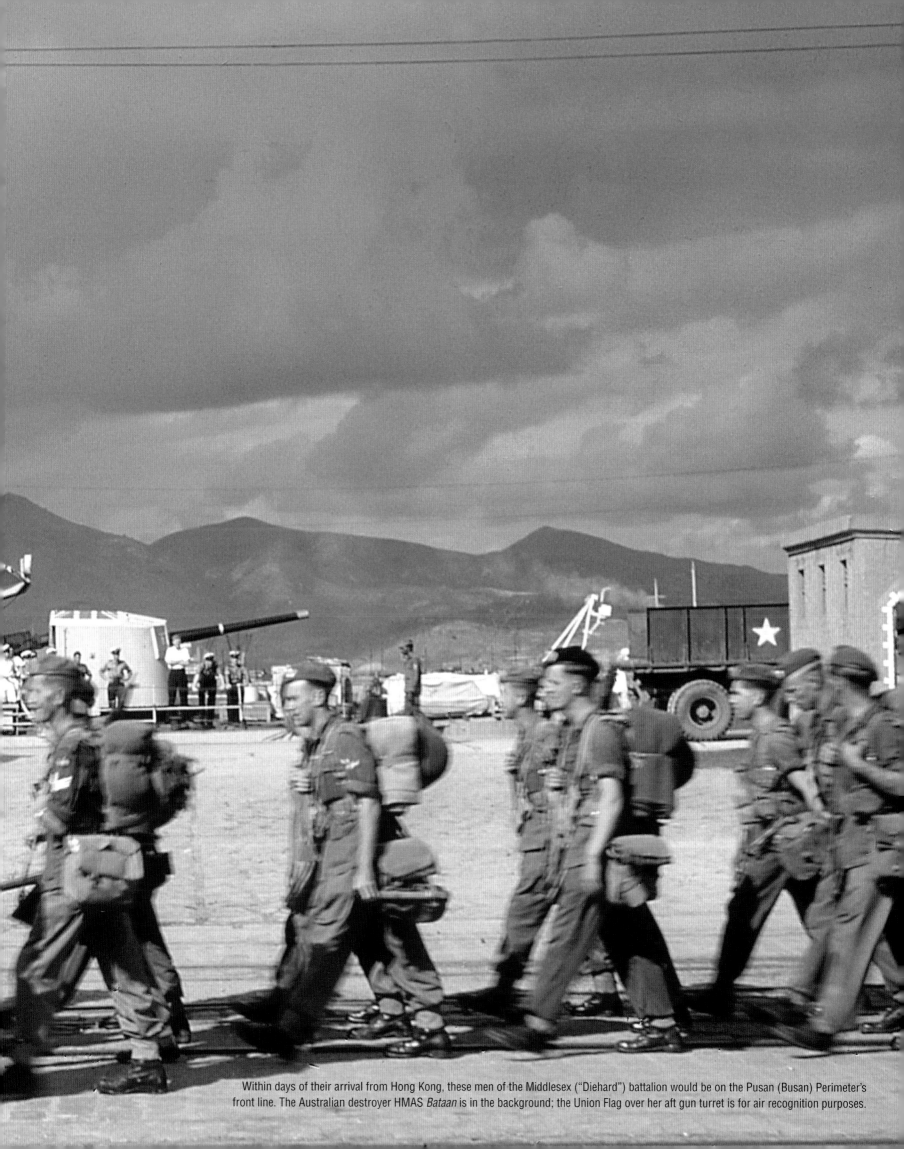

Within days of their arrival from Hong Kong, these men of the Middlesex ("Diehard") battalion would be on the Pusan (Busan) Perimeter's front line. The Australian destroyer HMAS *Bataan* is in the background; the Union Flag over her aft gun turret is for air recognition purposes.

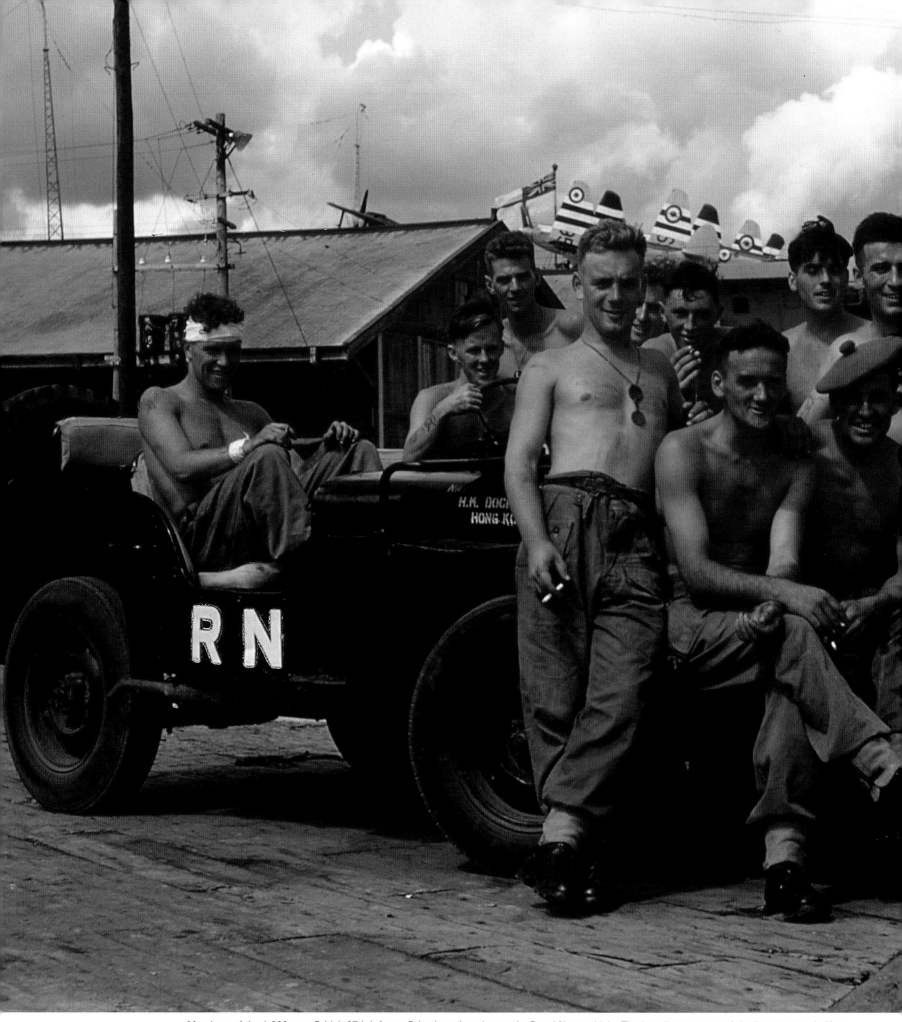

Members of the 1,600-man British 27th Infantry Brigade gathered around a Royal Navy vehicle. The battalion was one of the first to serve in Korea. These men are from the famous Argyll and Sutherland Highlanders; the man second from right is wearing the traditional tam o'shanter battledress bonnet. In their first major battle on the Nakdonggang River, the Argylls suffered heavy casualties in a friendly fire incident when bombed by US aircraft.

The British Arrive

"British troops were sent from Hong Kong and landed in Busan. They included contingents of Scotsmen complete with their kilts. The night they landed I had just finished a meal aboard the Australian destroyer *Bataan*. As we went on deck I heard the skirl of bagpipes. So did everyone else, it seemed. American truck drivers stopped their vehicles and climbed on the hoods to watch the Scotsmen march by, their hobnail boots crunching on the cobblestone. I grabbed my tape recorder and ran down the gangway as the piping approached. I fell in step with the sergeant major leading the march and asked him, 'What song are you playing?' Without missing a beat and still waving his baton, he replied, ''ighland Laddie, our rrr-regimental march!' The newly arrived Brits boarded a train, and I rode with them to their base near the front lines, from where they prepared to enter combat in the next couple of days."

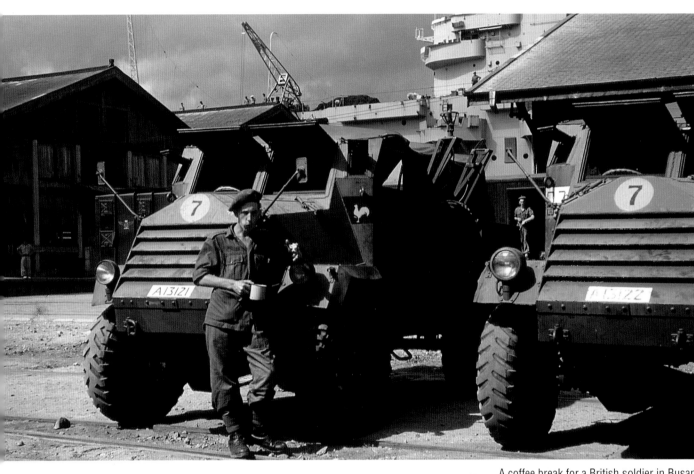

A coffee break for a British soldier in Busan.

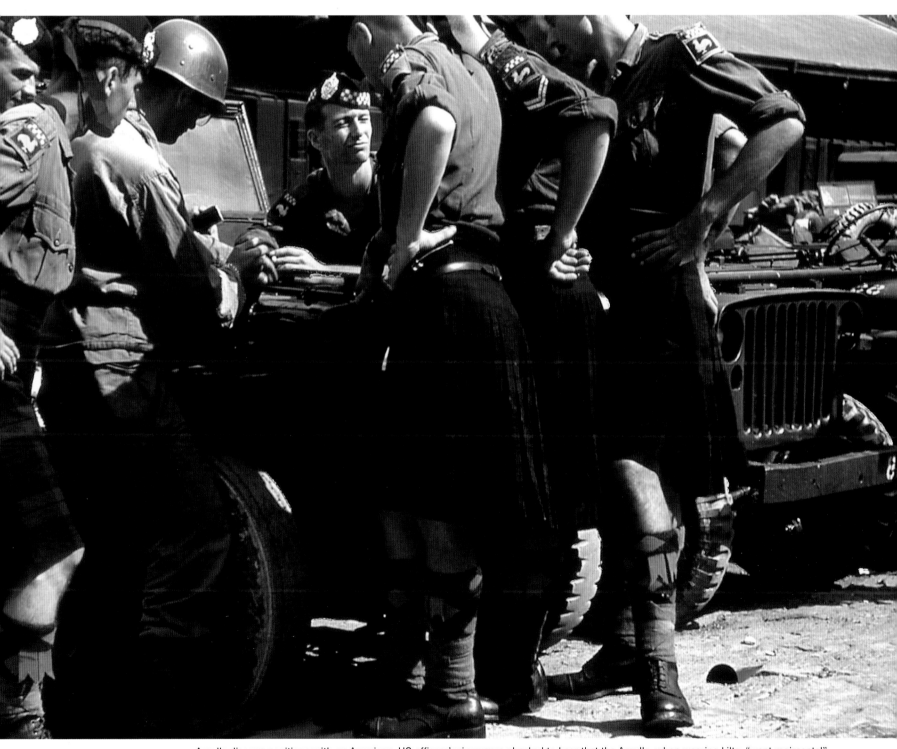

Argylls discuss positions with an American. US officers' wives were shocked to hear that the Argylls, when wearing kilts, "went regimental" (without underpants). In the field, of course, combat uniforms were worn.

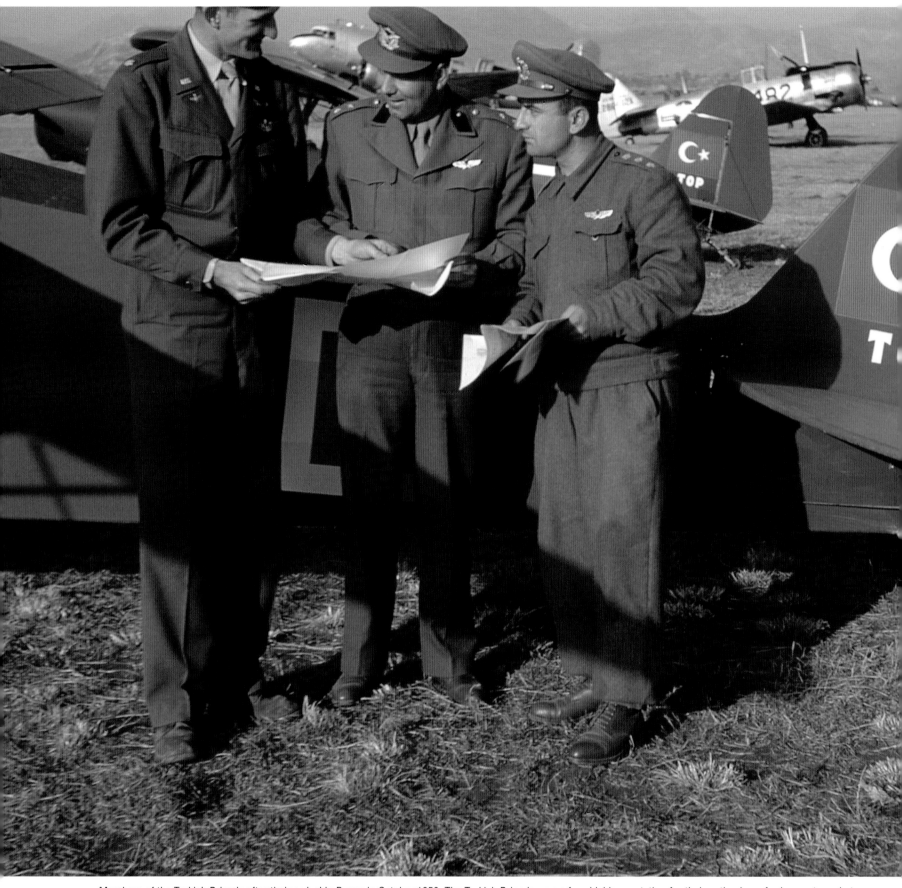

Members of the Turkish Brigade after their arrival in Busan in October 1950. The Turkish Brigade won a formidable reputation for their enthusiasm for bayonet combat. Their example led General MacArthur to declare, "The Turks are the hero of heroes. There is no impossibility for the Turkish Brigade."

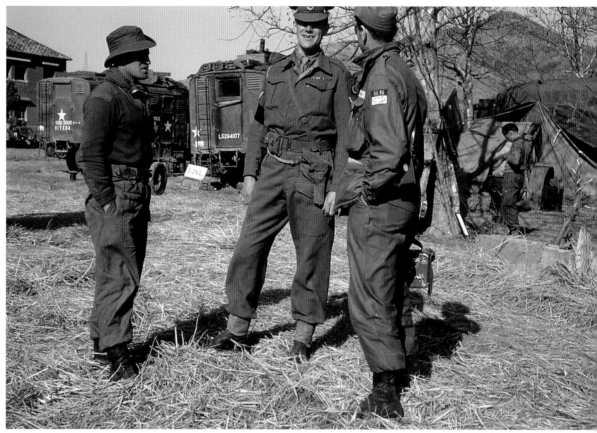

Two British soldiers talking to a UN correspondent.

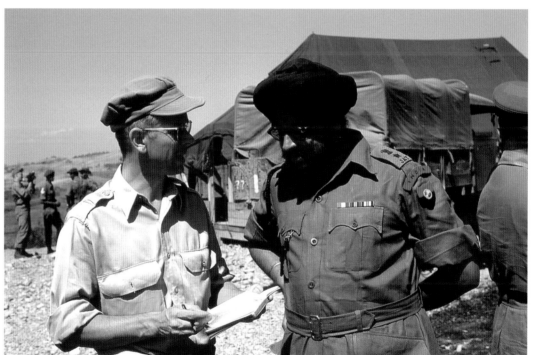

The author (left) interviewing a soldier of the Indian Army Medical Corps.

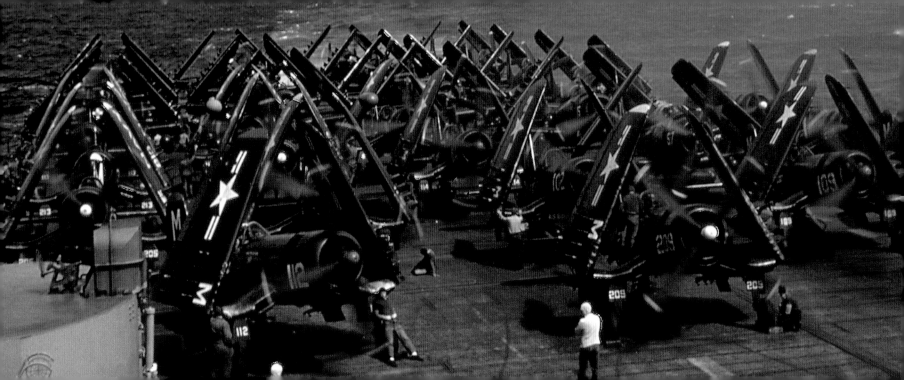

Weapons of War

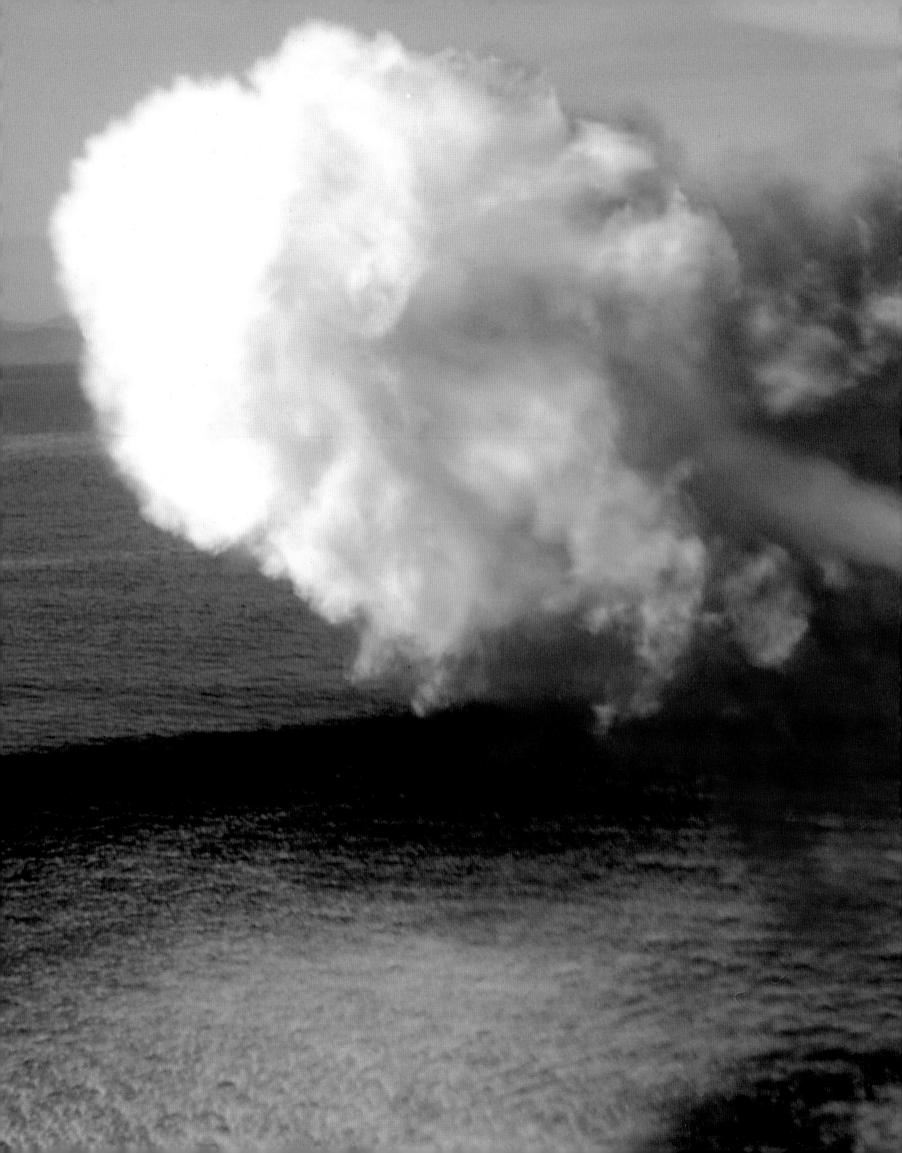

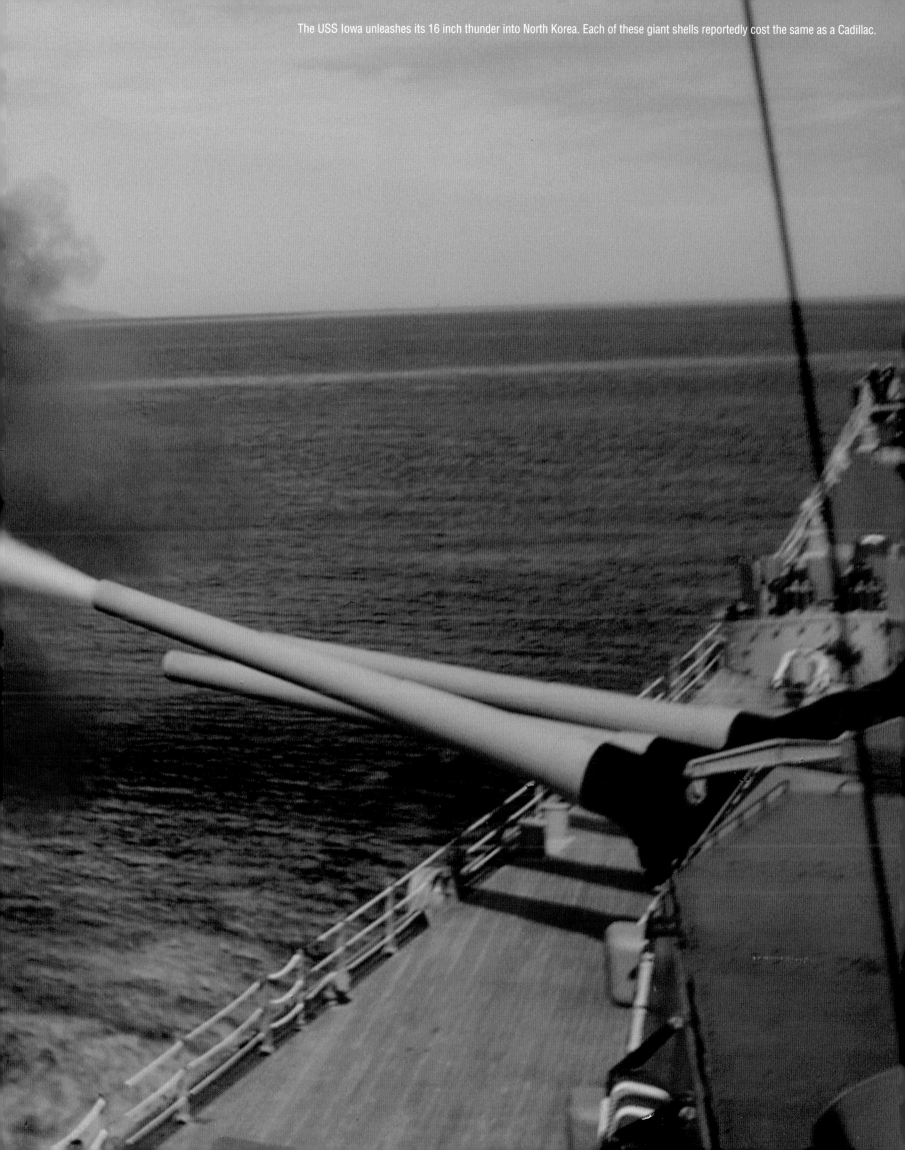

The USS Iowa unleashes its 16 inch thunder into North Korea. Each of these giant shells reportedly cost the same as a Cadillac.

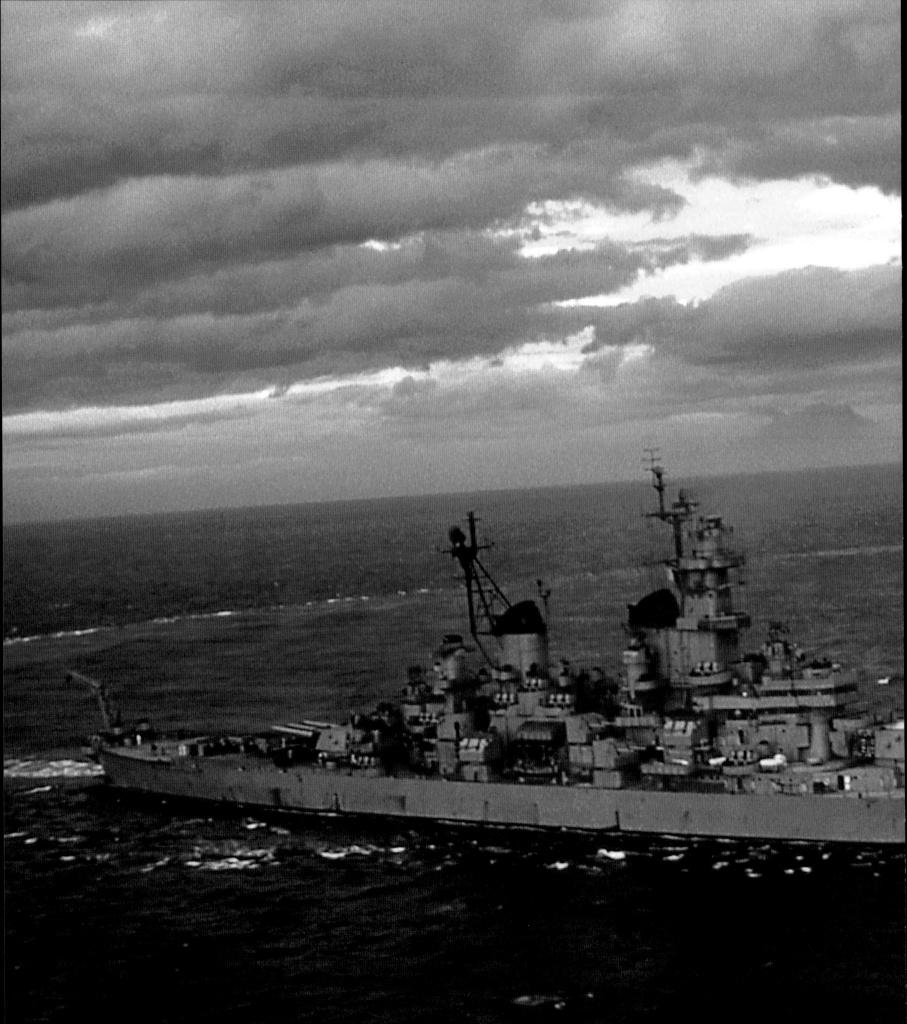

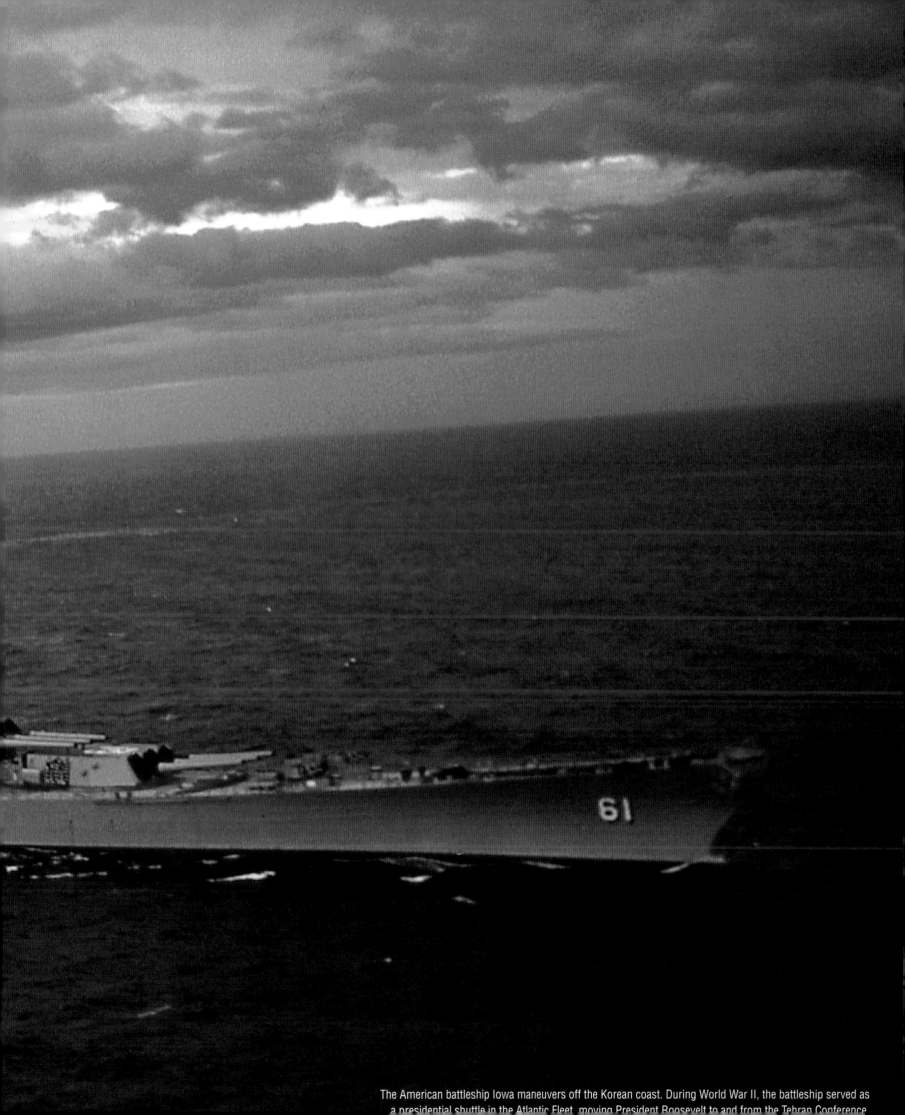

The American battleship Iowa maneuvers off the Korean coast. During World War II, the battleship served as a presidential shuttle in the Atlantic Fleet, moving President Roosevelt to and from the Tehran Conference

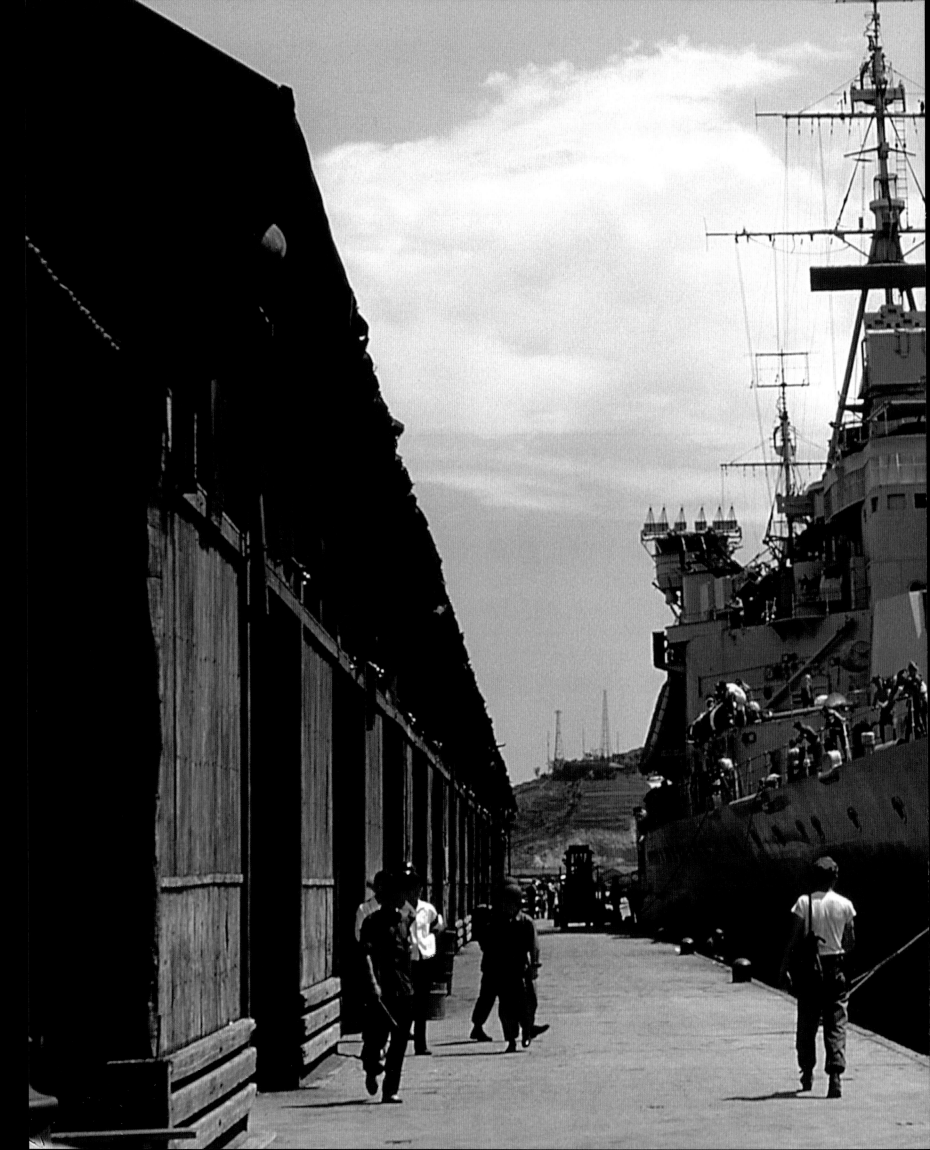

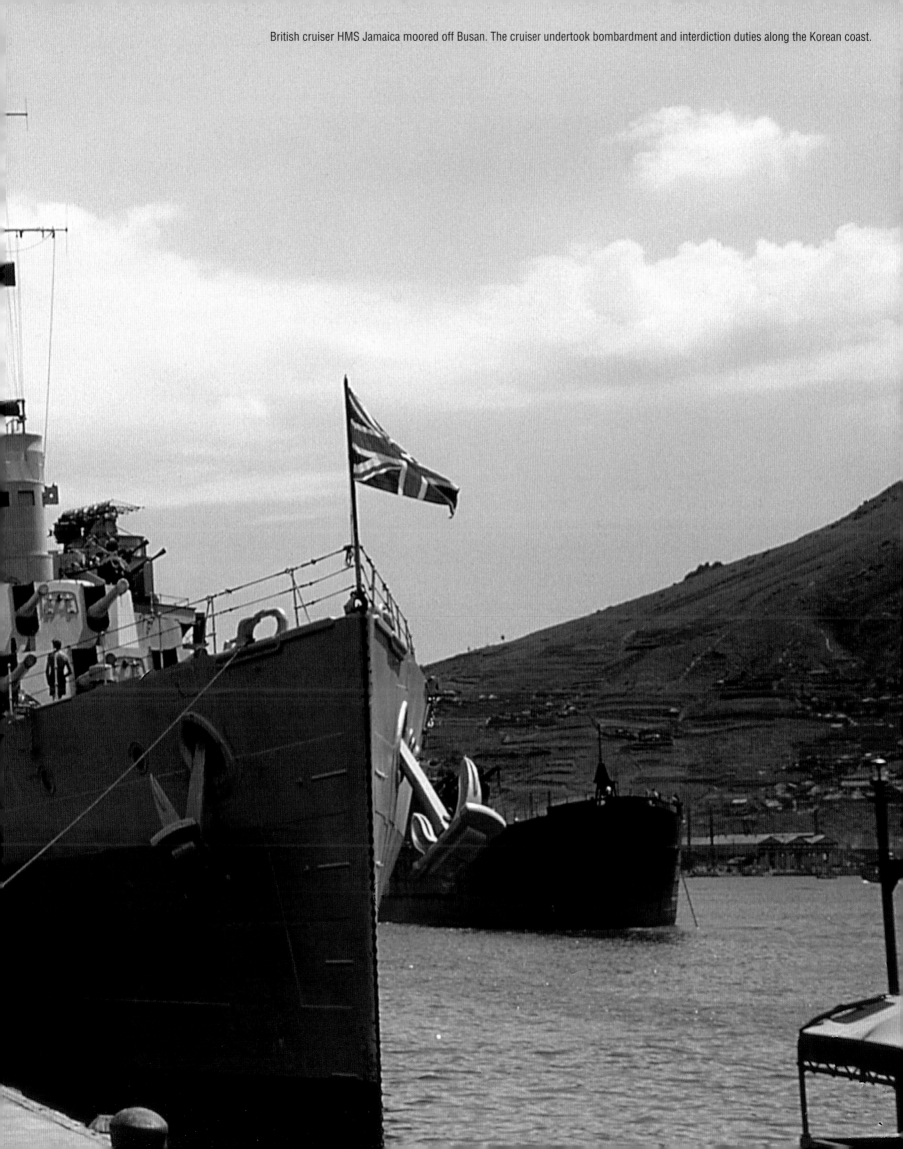

British cruiser HMS Jamaica moored off Busan. The cruiser undertook bombardment and interdiction duties along the Korean coast.

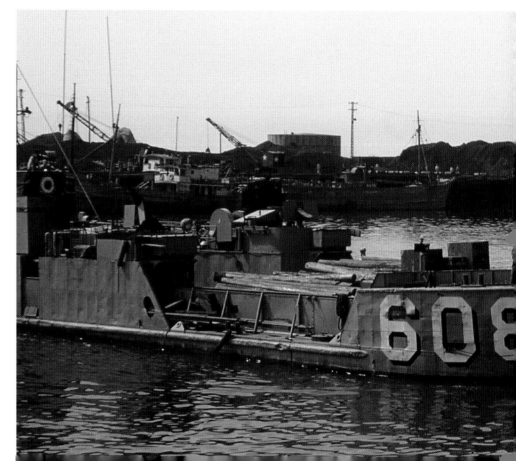

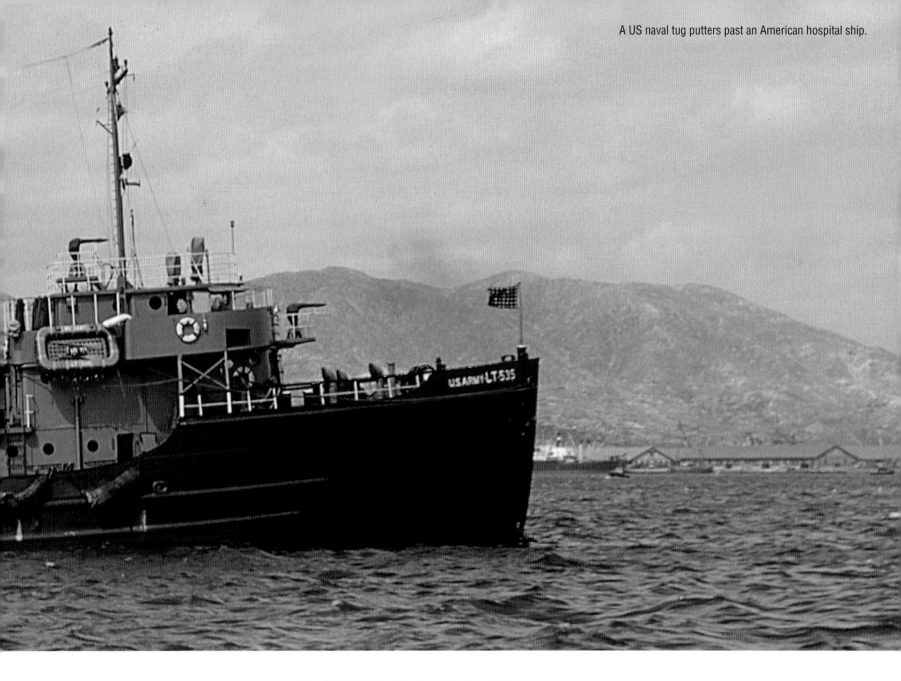

A US naval tug putters past an American hospital ship.

The USS LST-608, a Landing Ship, Tank (LST).

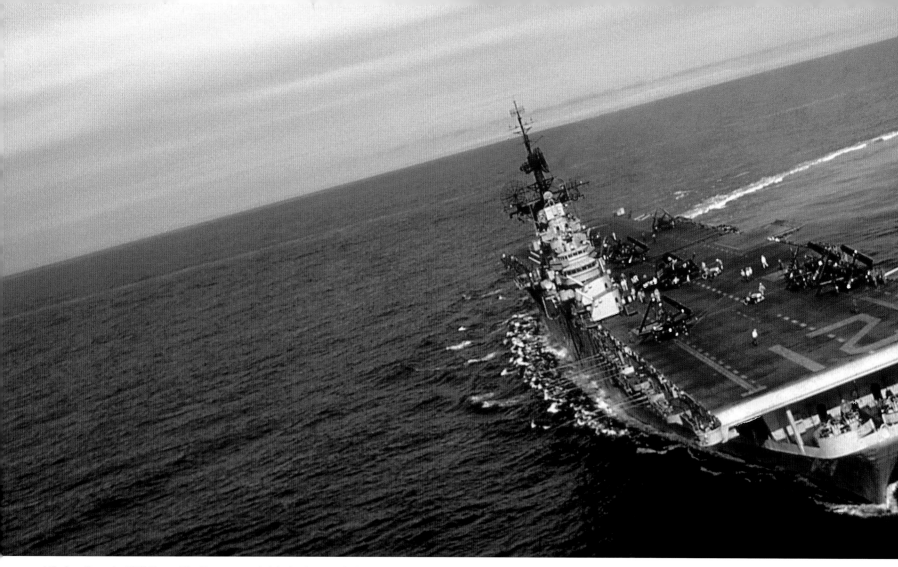

US aircraft carrier USS Boxer. The Boxer earned eight battle stars for her service in Korea.

The Boxer, with US Air Force and Navy planes flying overhead.

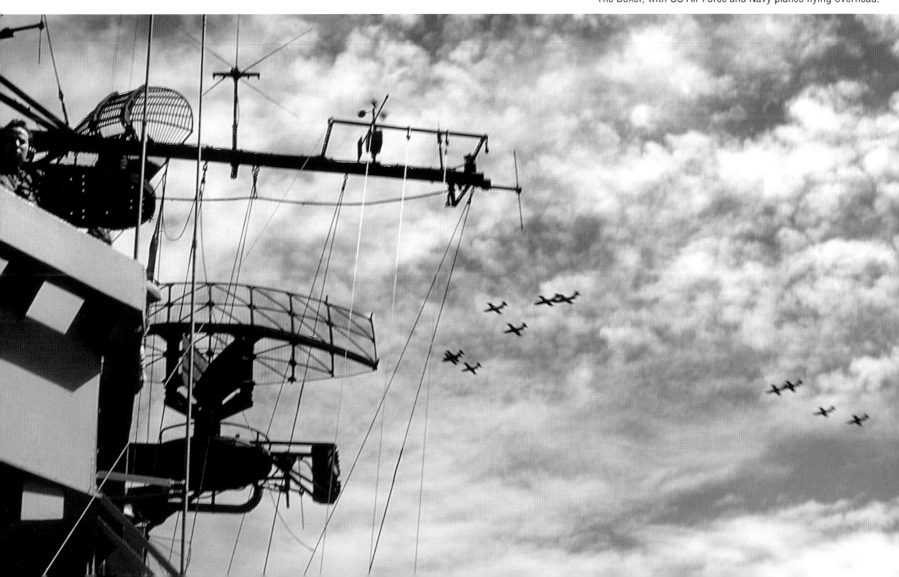

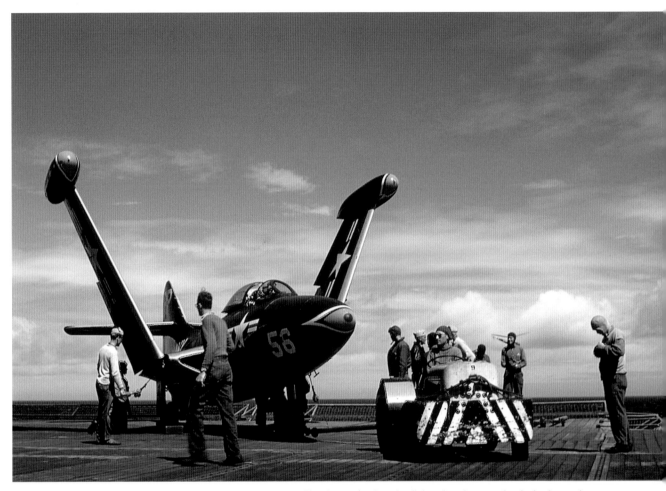

Naval crew work on jet fighter bombers on the deck of a carrier.

A crew member on the flight
deck prior to launch, admist a
typical scene on an American
aircraft carrier.

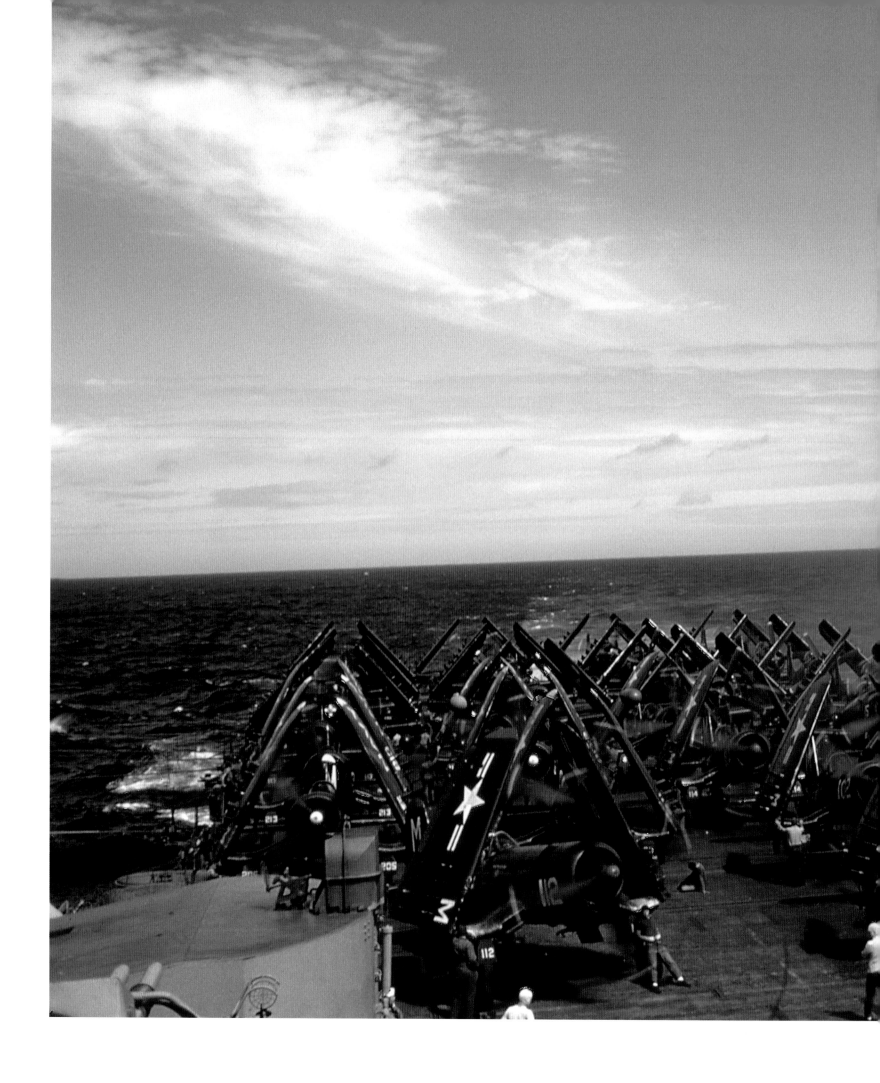

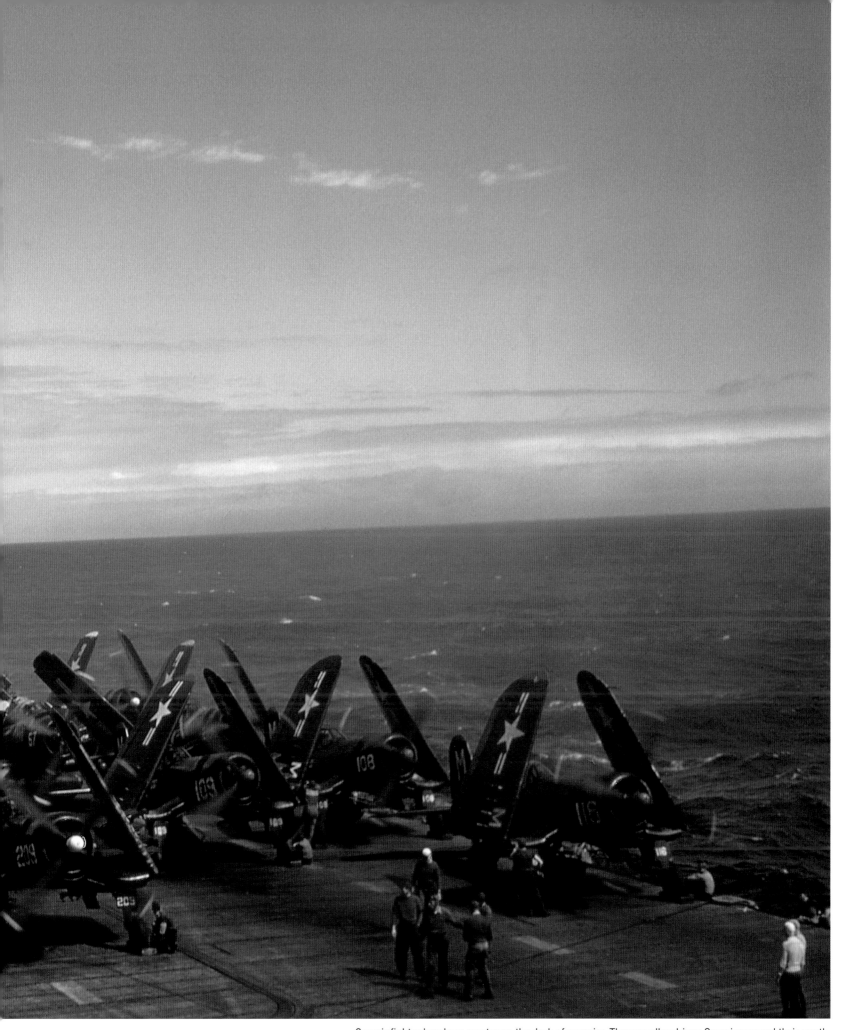

Corsair fighter bombers muster on the deck of a carrier. The propeller-driven Corsairs proved their worth as ground support aircraft, notably during the breakout from Chosin (Changjin) Reservoir.

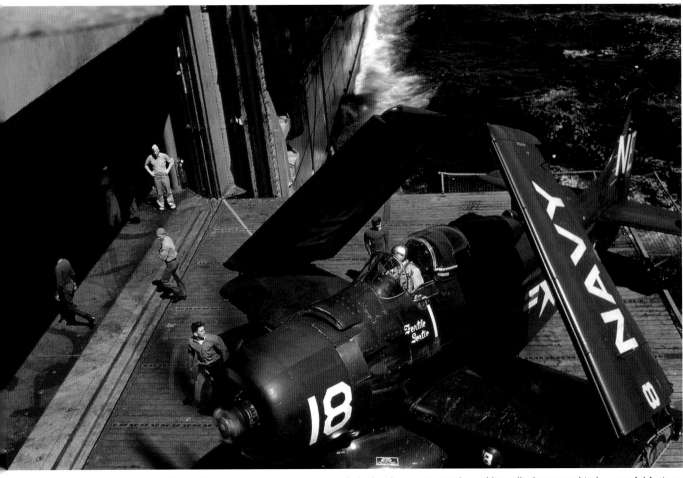

During the Korean War, the Corsair was used mostly in the close support role, and its gull wing proved to be a useful feature.

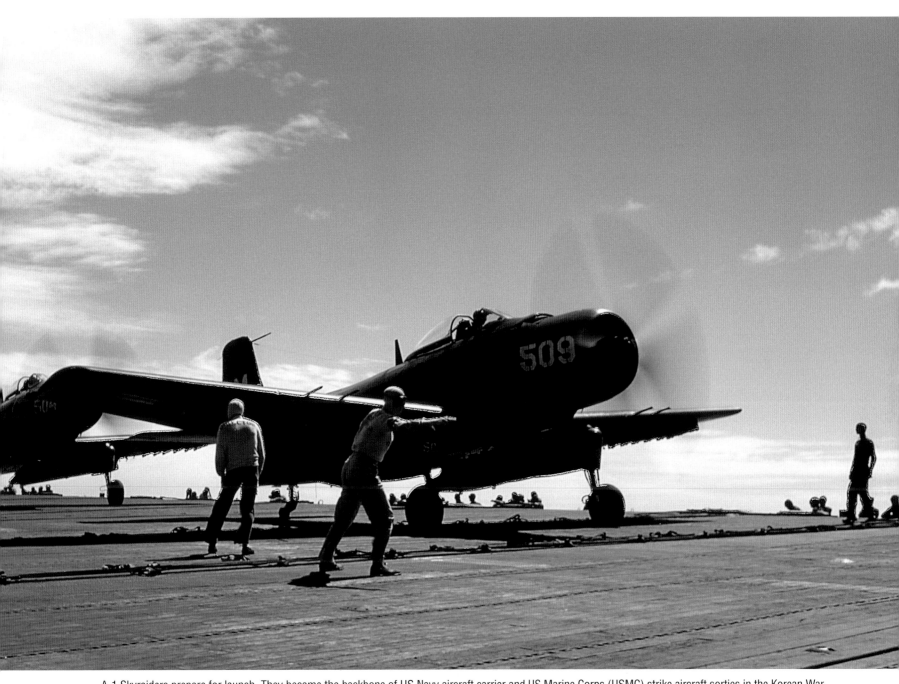

A-1 Skyraiders prepare for launch. They became the backbone of US Navy aircraft carrier and US Marine Corps (USMC) strike aircraft sorties in the Korean War.

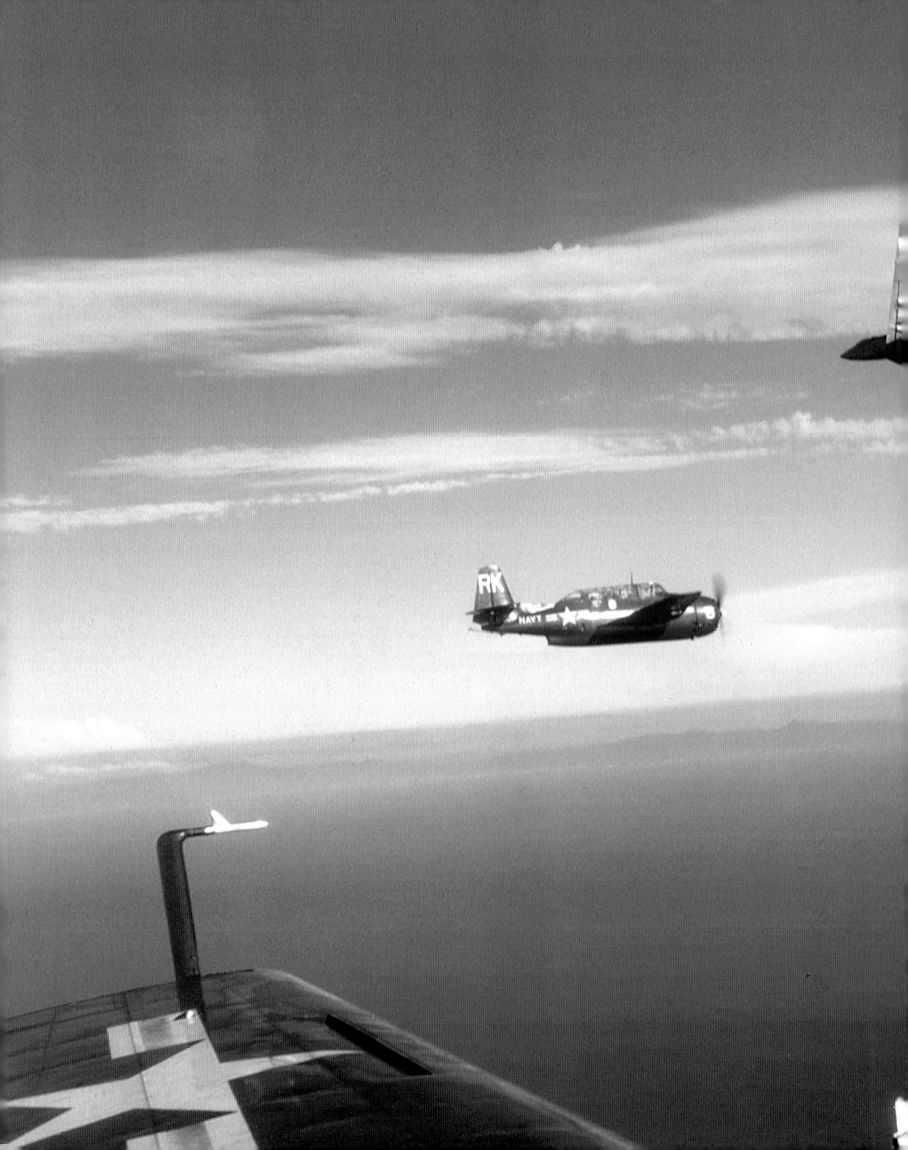

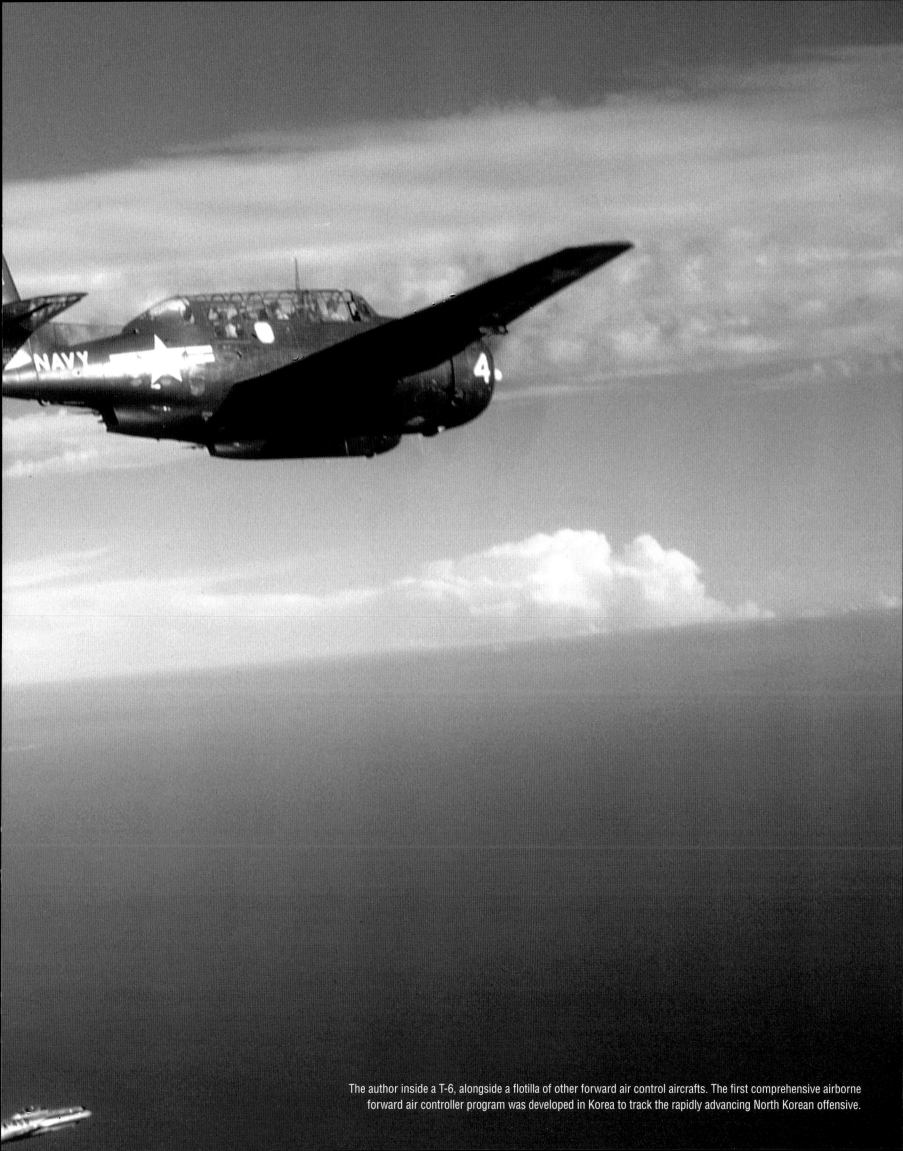

The author inside a T-6, alongside a flotilla of other forward air control aircrafts. The first comprehensive airborne forward air controller program was developed in Korea to track the rapidly advancing North Korean offensive.

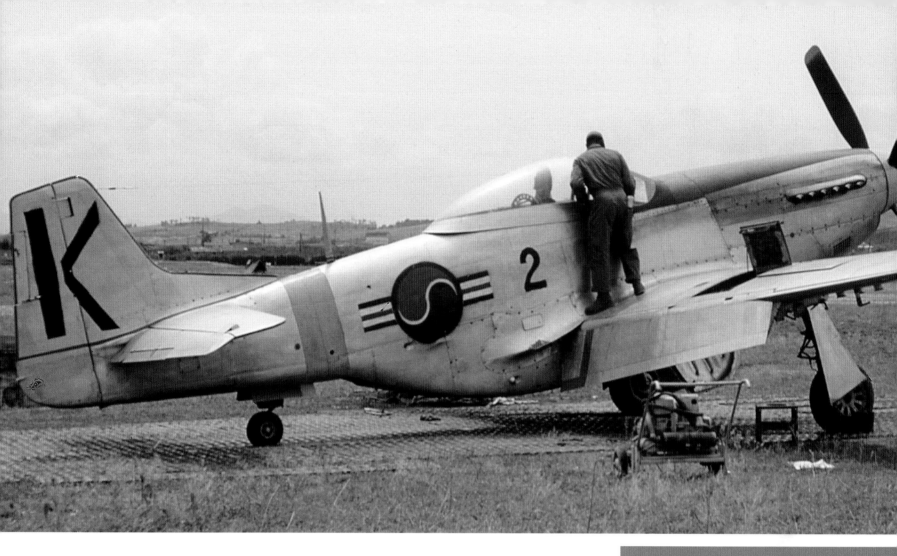

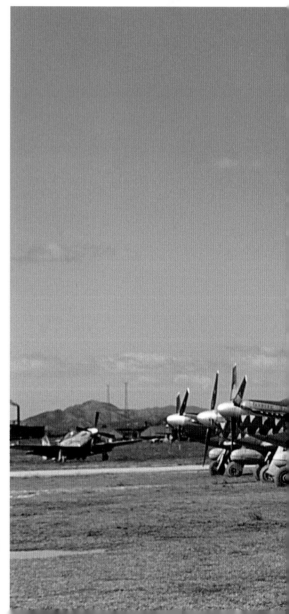

A team of F-51 Mustangs. These aircraft were recommissioned to meet the need
for long-range fighter-bombers that could operate from Korean airfields.

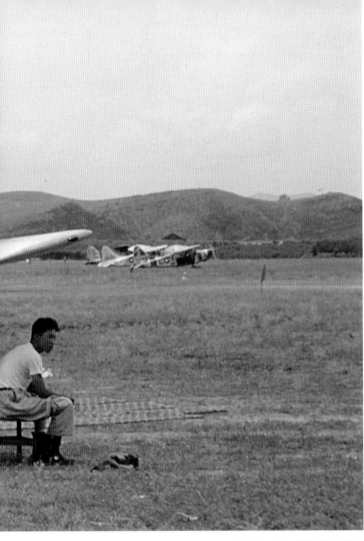

Members of the ROK Air Force prepare a fighter aircraft, the North American F-51D, for flight. F-51D fighters were among the first to be deployed by the ROKAF.

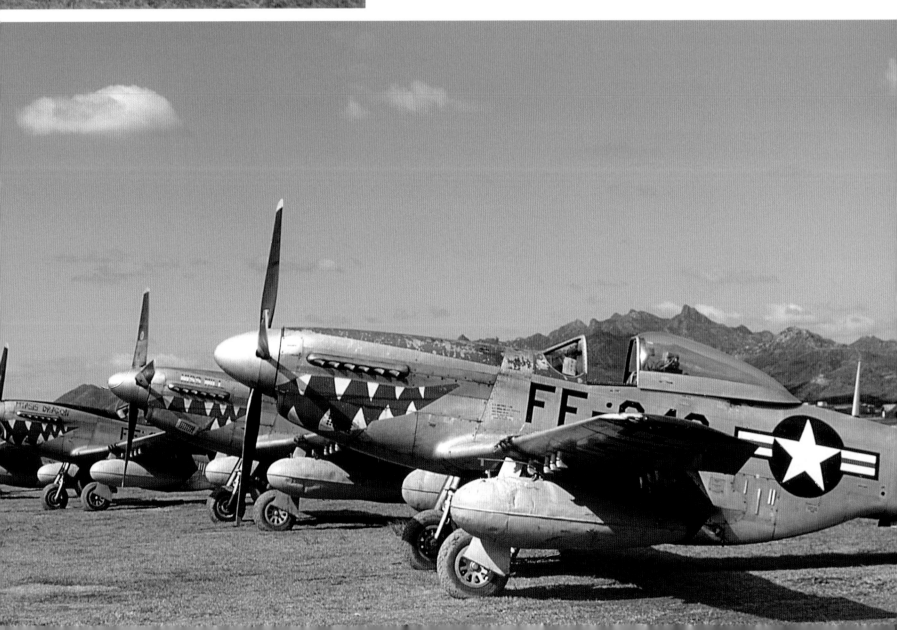

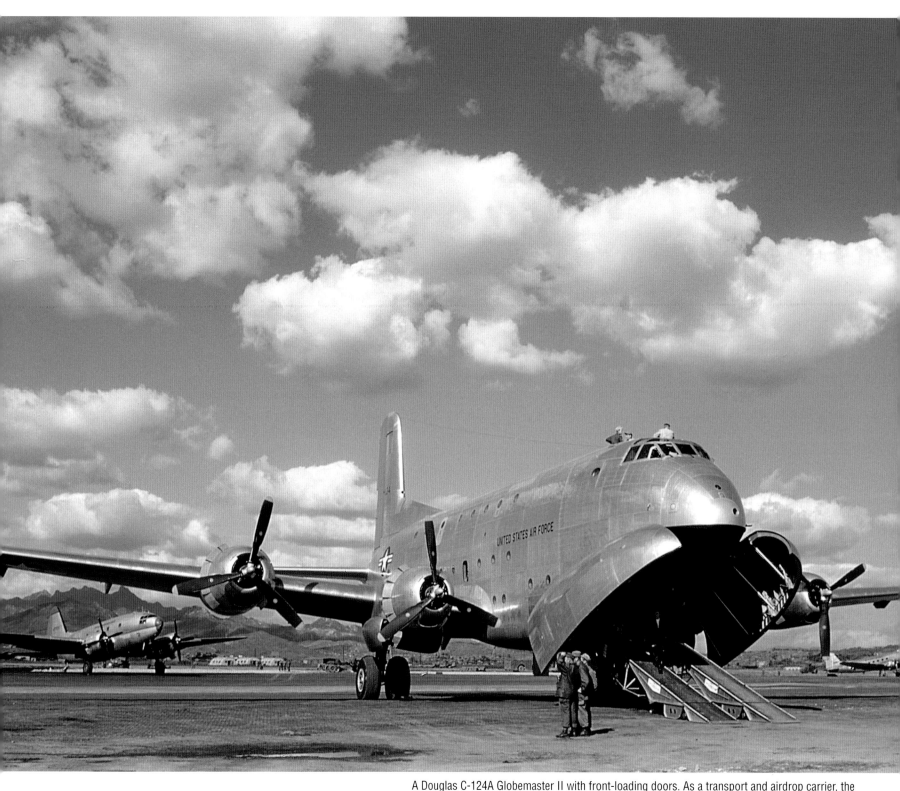

A Douglas C-124A Globemaster II with front-loading doors. As a transport and airdrop carrier, the system began actively serving the United States Air Force as early as May 1950.

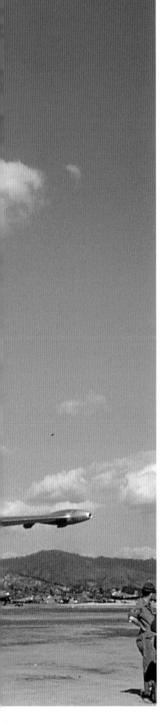

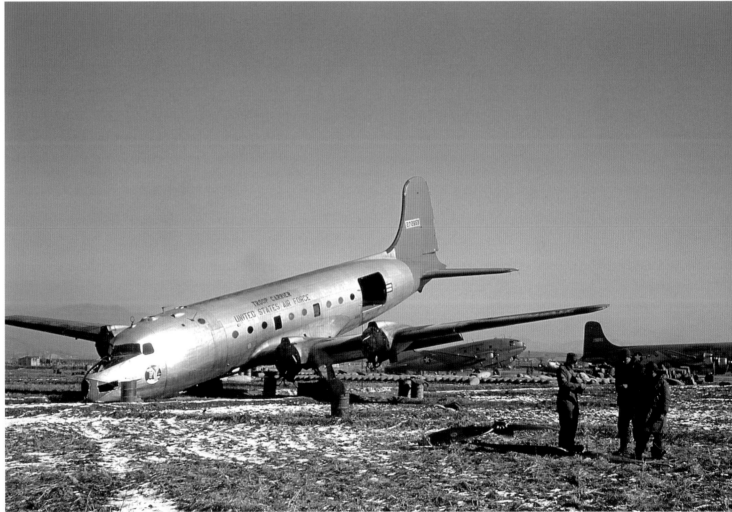

A crashed Douglas C-47. These aircraft were frequently used for medical evacuations.

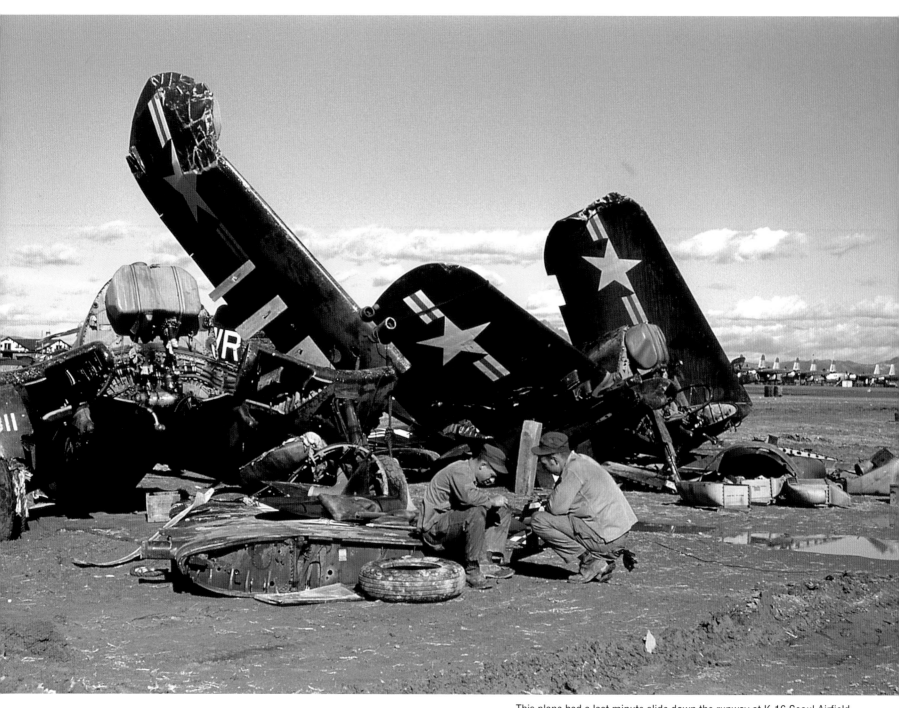

This plane had a last minute slide down the runway at K-16 Seoul Airfield.
The author thinks this may have been the crash landing of legendary baseball player and fighter pilot Ted Williams.

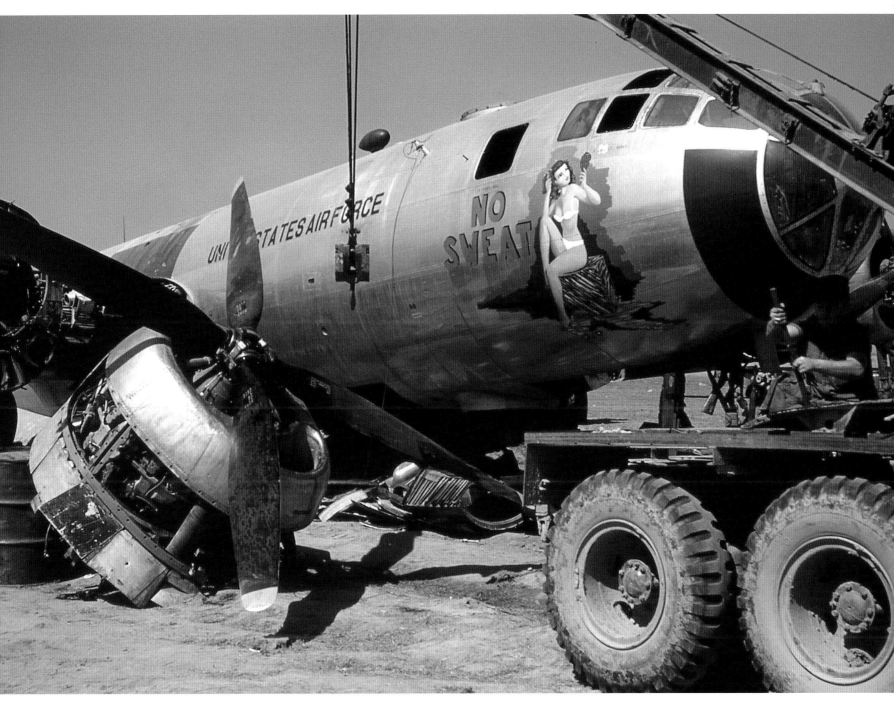

'No Sweat': Nose art on the fuselage of a US military aircraft. In addition to the shark face motif, sensual pin-up women were a popular choice on planes.

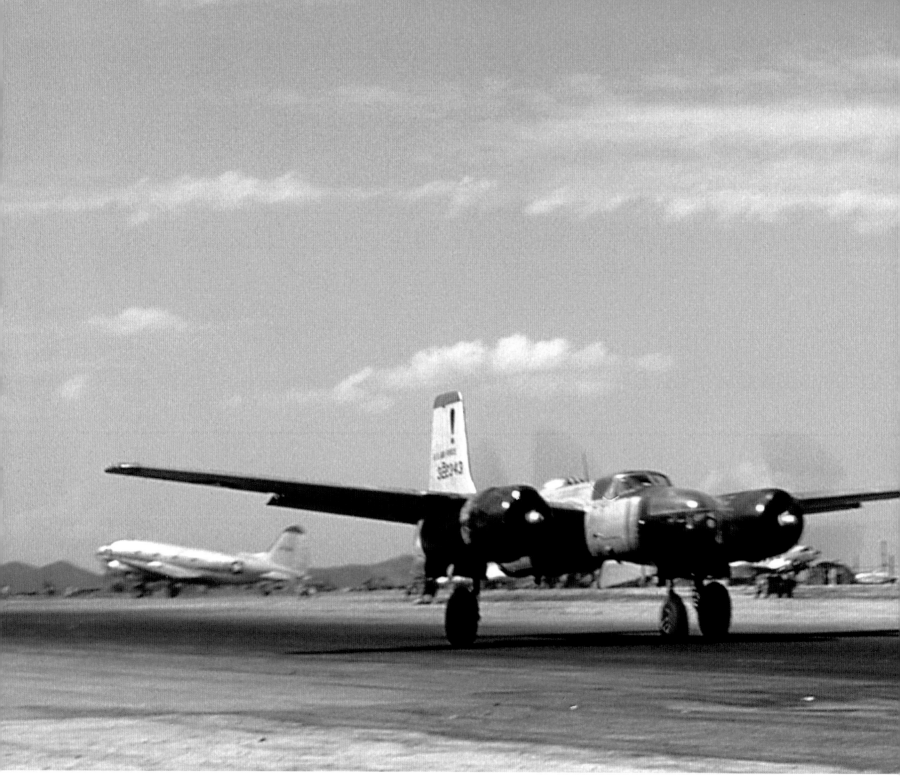

A B-26 Invader prepares for flight at K-9, East Busan Air Base.

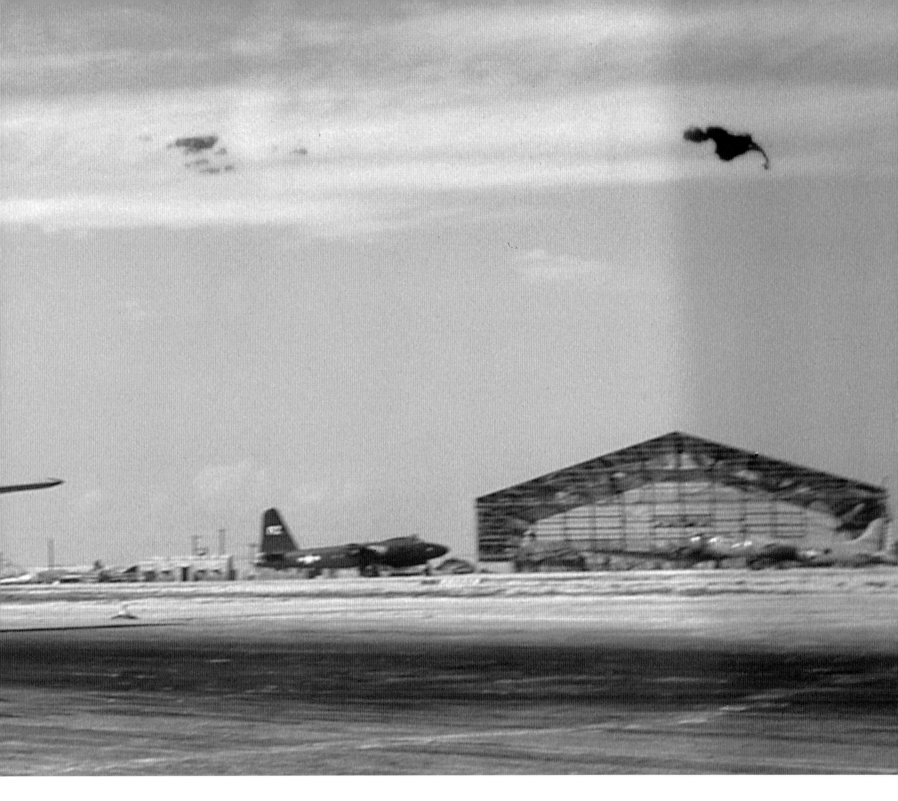

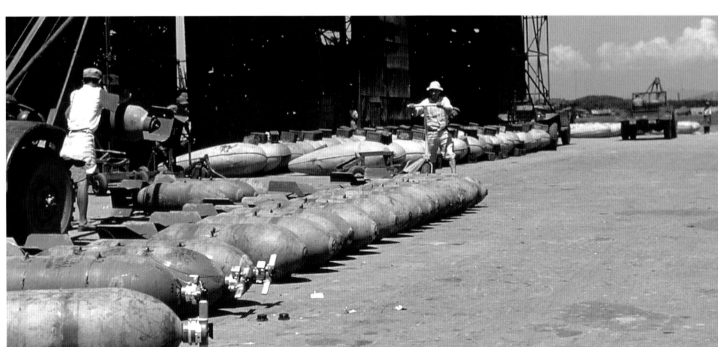

US napalm bombs ready to be loaded onto planes. During the Korean War, US forces dropped a quarter of a million pounds (113,398 kilograms) of napalm bombs every day. Napalm, or jellied petroleum, flowed like liquid fire and was effective against entrenched enemy troops. Even some UN soldiers considered the "hell bombs" diabolical weapons.

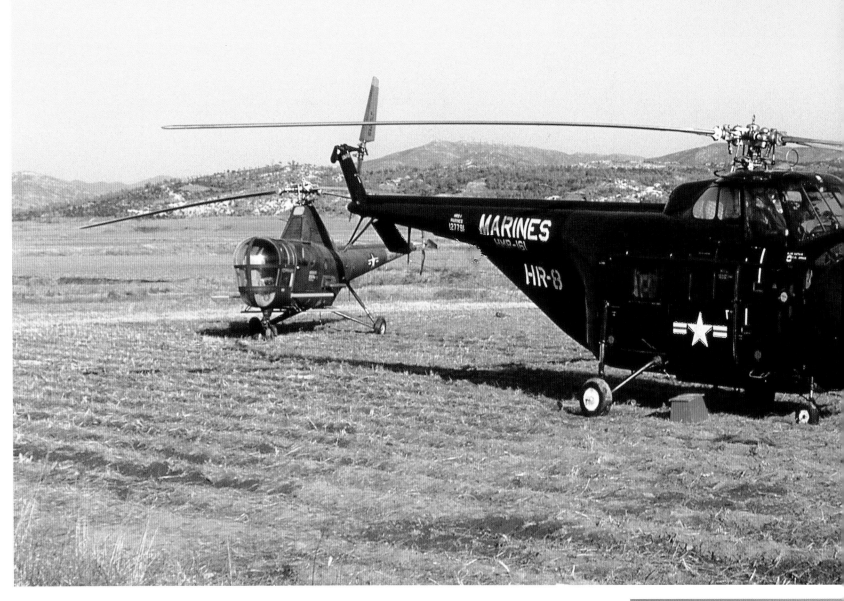

Helicopters

"Helicopters came into use late in World War II. I recall the first one we saw overhead in Hawaii. To our amazement, it was just sitting there in the air. But the Marines brought them to the battlefront in Korea. The first day the Marines went into action west of Busan, it was hot and muggy. Two Marines on a high ridge line collapsed from heat exhaustion. There were two helicopters on the ground, and one man was put in each helicopter with medics. Bob Miller of the United Press and I with the International News Service received permission to fly back with them to a medical unit in Busan. It was our first helicopter ride, and we both wrote stories on the first use of helicopters in a combat zone. It wasn't long before helicopters could be found all over Korea, and by the Vietnam War they filled the skies."

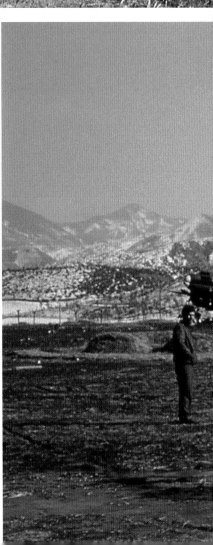

Helicopters were first introduced in the closing stages of World War II, where they were used for medical evacuation. In Korea, they were much more widely used, for observation, supply and casualty evacuation. In the jagged terrain, their vertical take-off and landing abilities proved invaluable assets. The Sikorsky H-5/SO3S-1 (left) gained a reputation for rescuing pilots shot down behind enemy lines and evacuating wounded personnel from frontline areas, before the H-19 Chickasaw (right) replaced it in most roles.

The Bell H-13 was used during the Korean War for all tasks; wire laying, liaison, reconnaissance, training and medical evacuation.

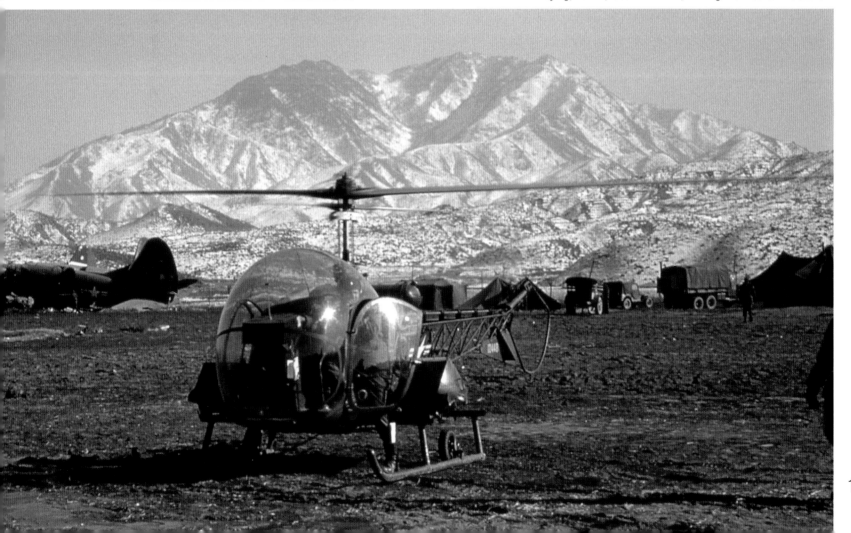

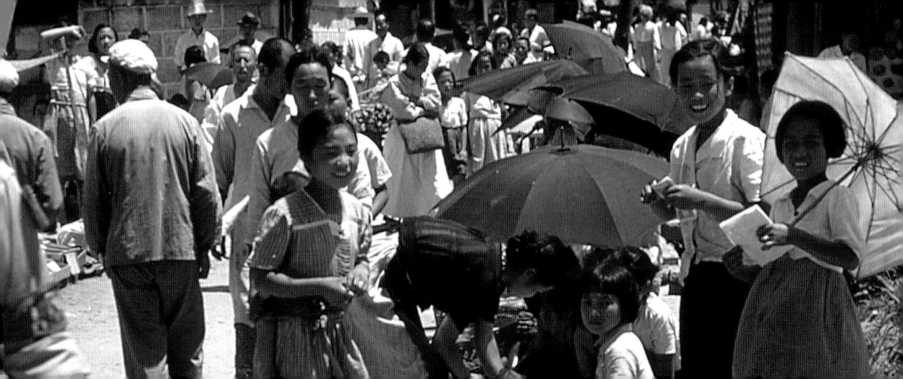

A Resilient People

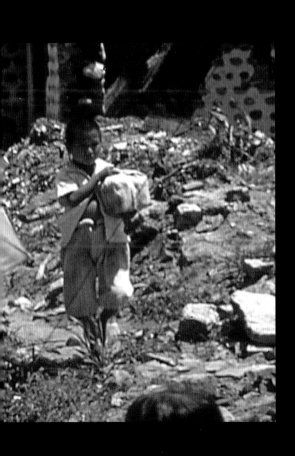

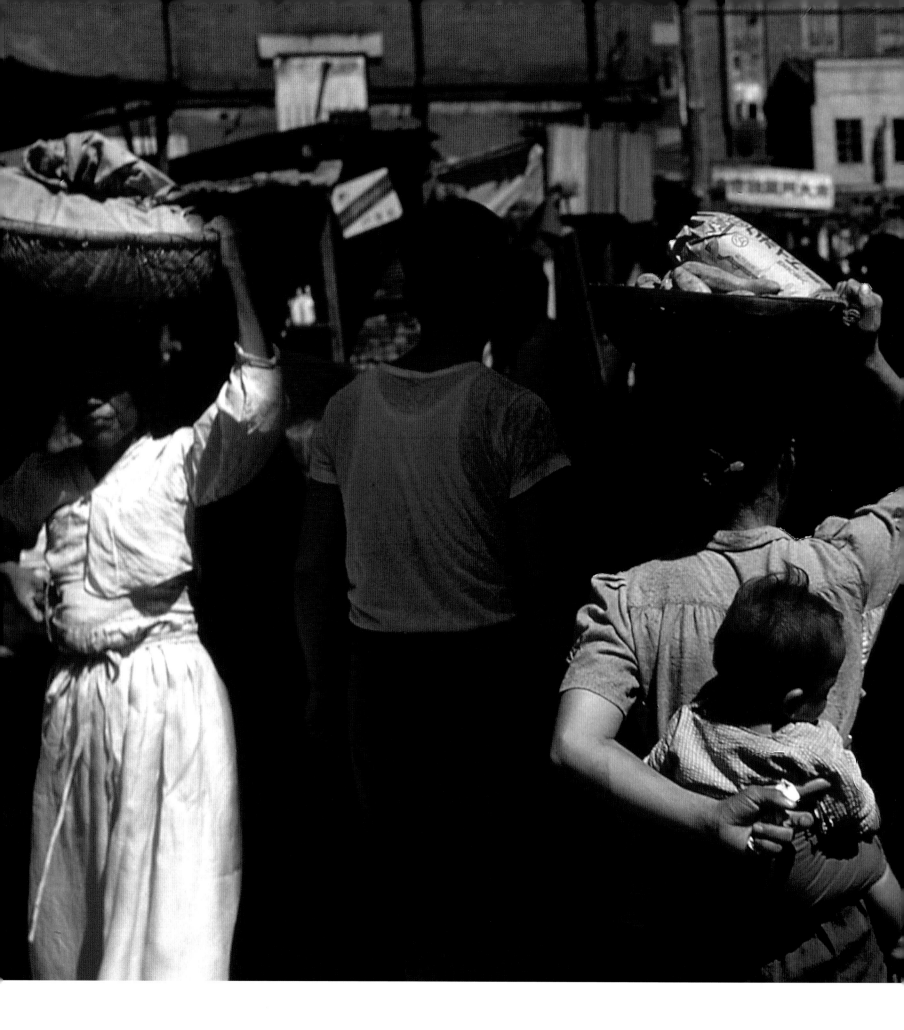

"A load on the head and a baby on the back" is how the author summarized this picture of a wartime marketplace in Seoul.

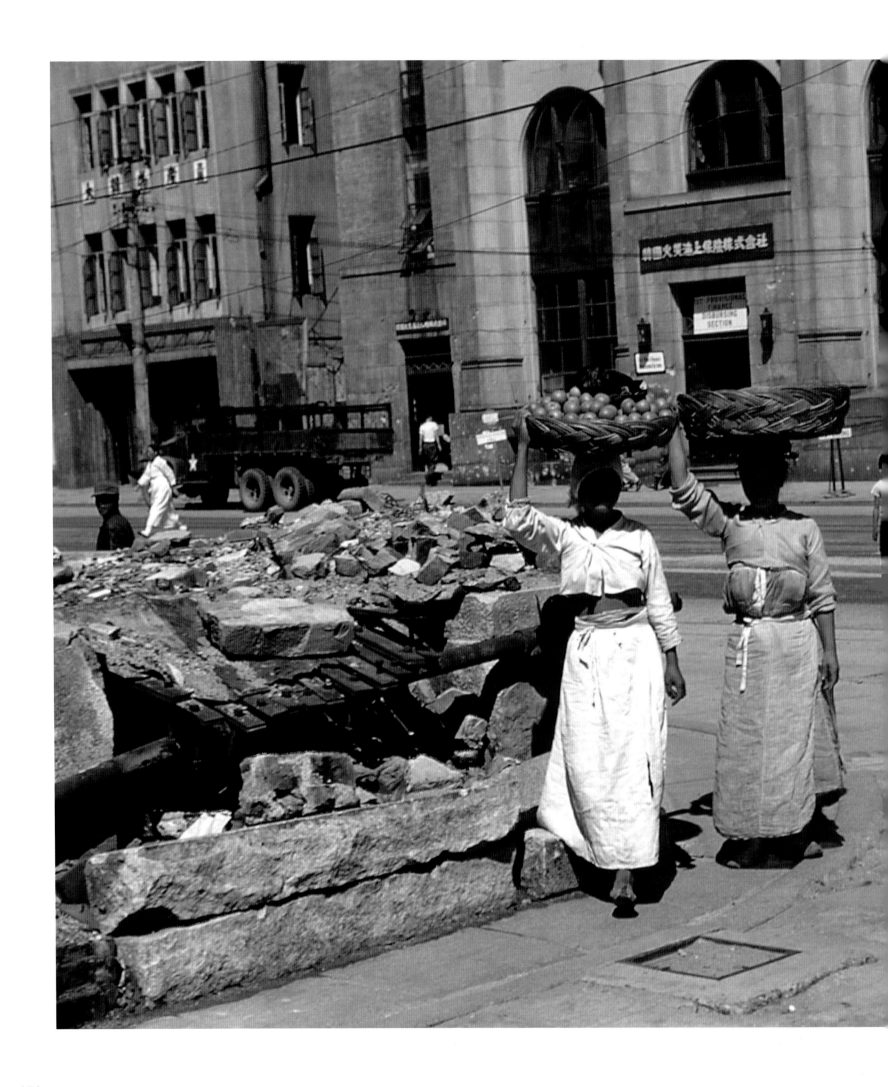

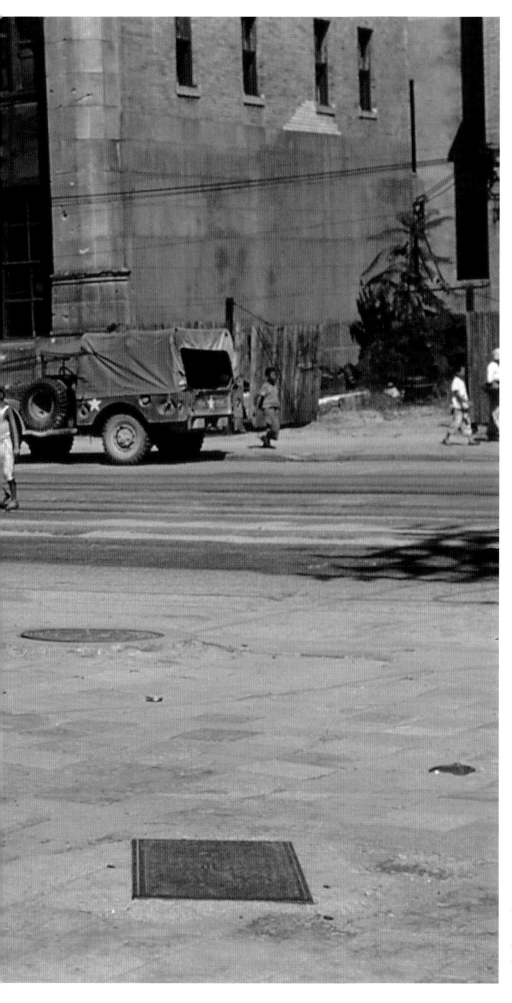

Women in Namdaemun Market carrying basket-loads of produce. These two women are wearing the traditional white clothes Koreans had worn for centuries; Koreans used to call themselves the *Baegui Minjok*, the "white-clad people."

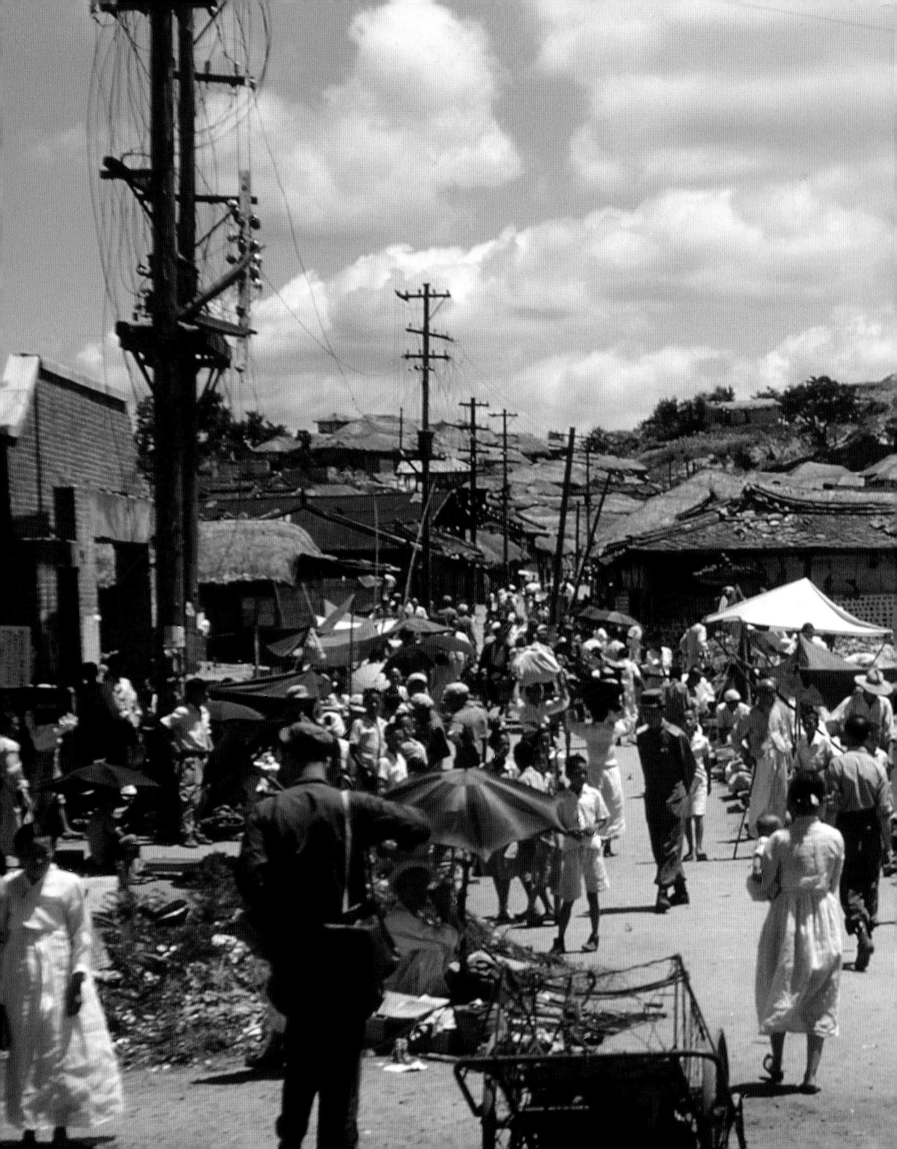

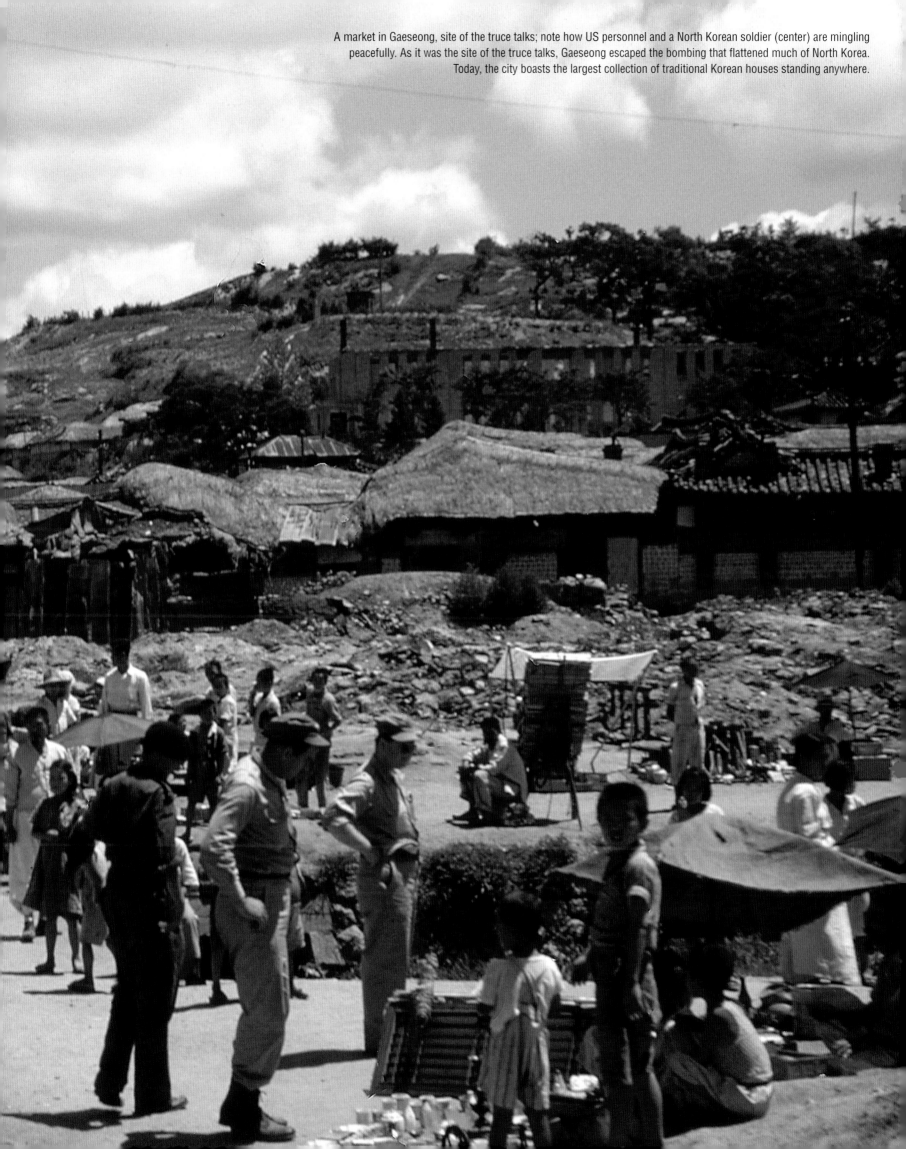

A market in Gaeseong, site of the truce talks; note how US personnel and a North Korean soldier (center) are mingling peacefully. As it was the site of the truce talks, Gaeseong escaped the bombing that flattened much of North Korea. Today, the city boasts the largest collection of traditional Korean houses standing anywhere.

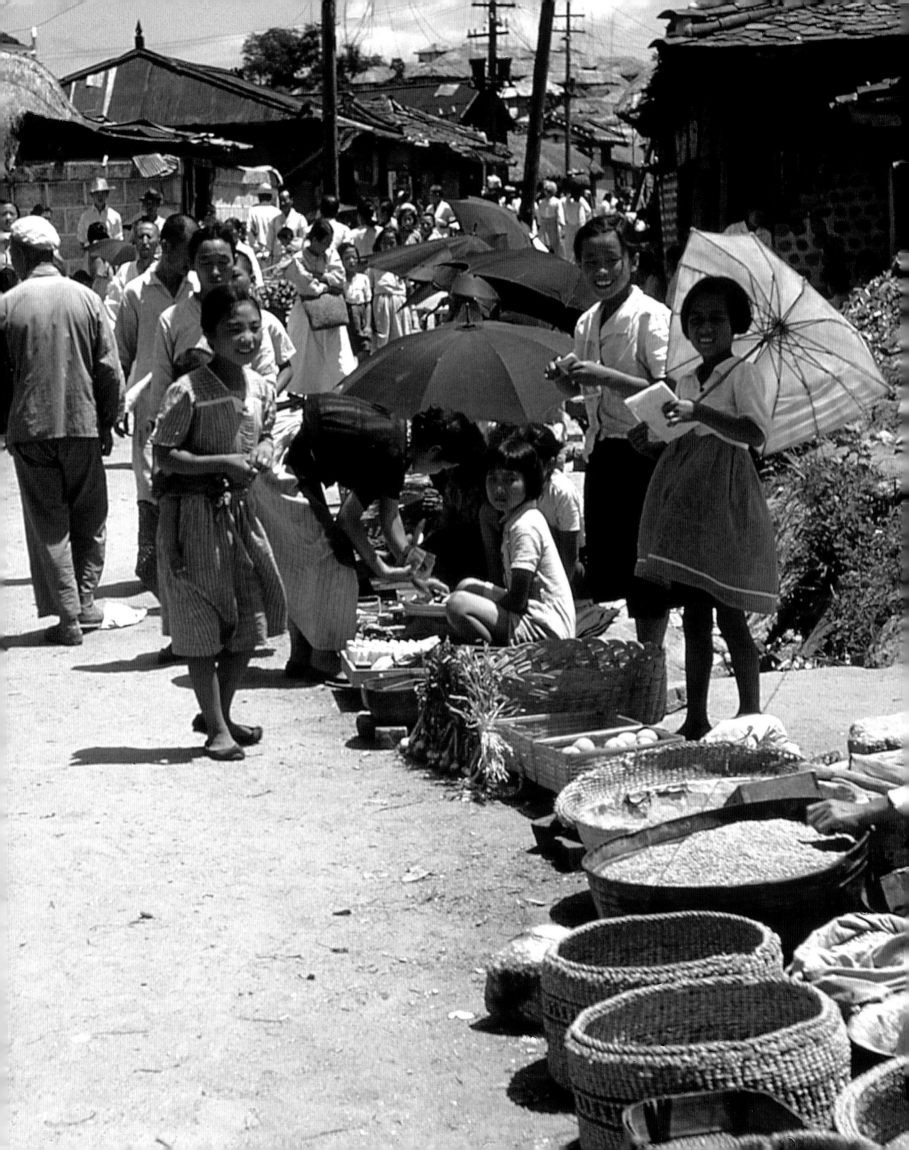

Market scenes in Gaeseong.

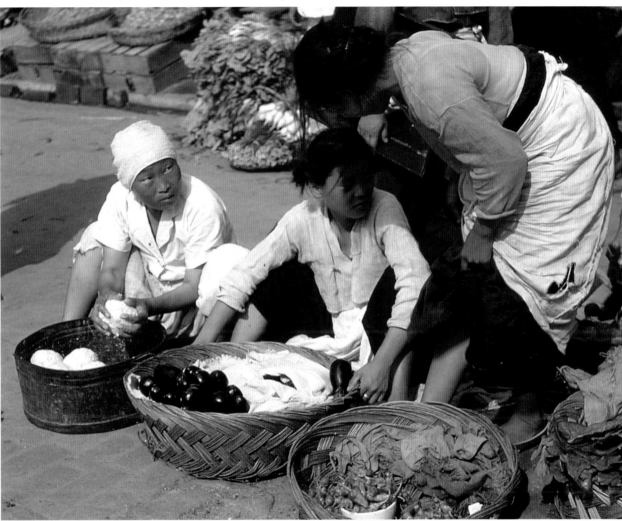

Market scenes in South Korea.

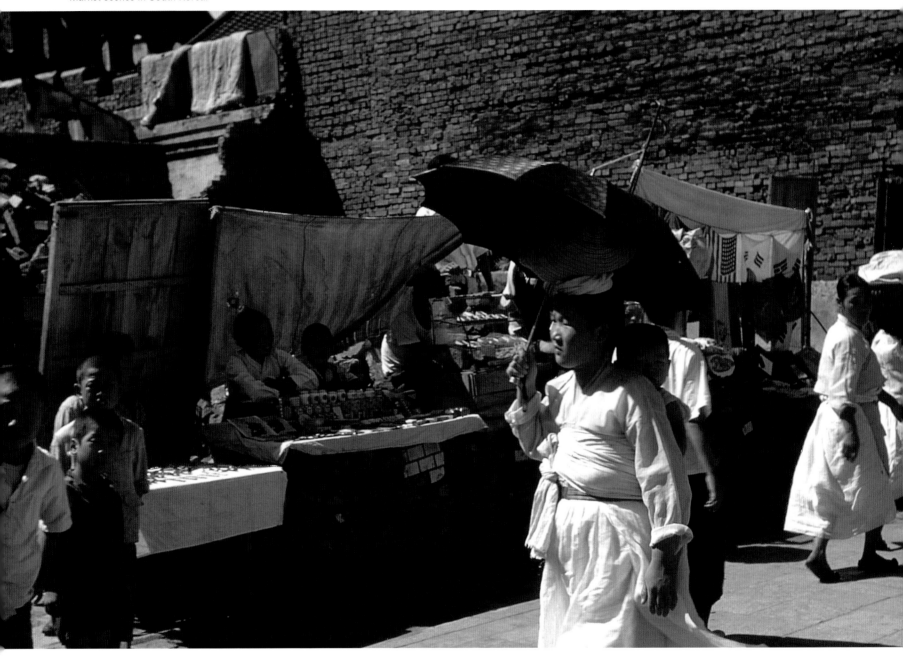

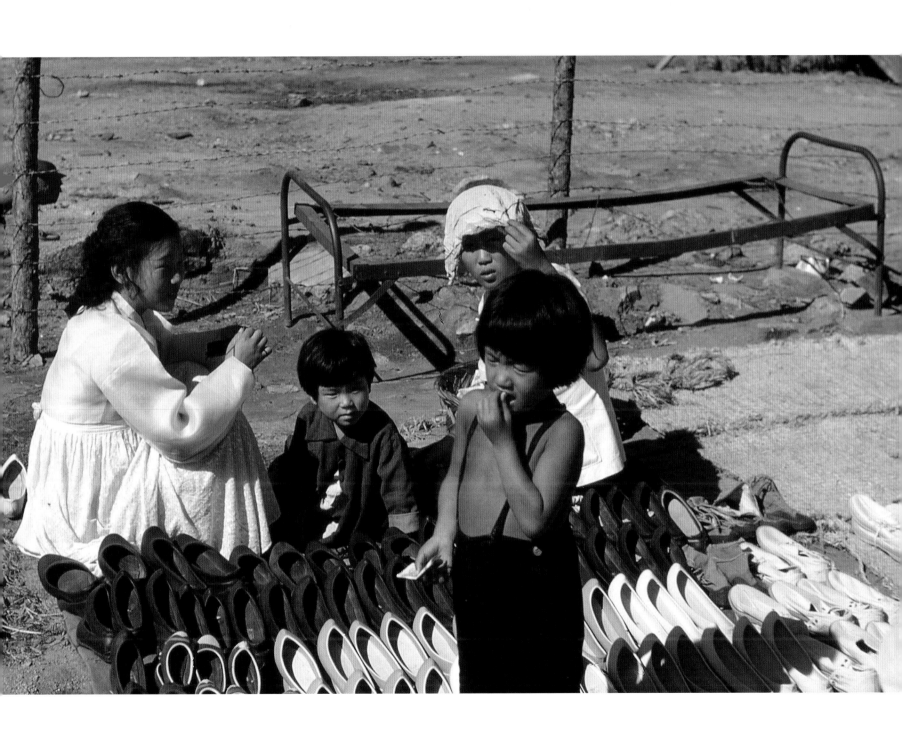

A young South Korean boy presides over a hodgepodge of used goods, ranging from kitchenware to aged photographs of popular pre-war starlets.

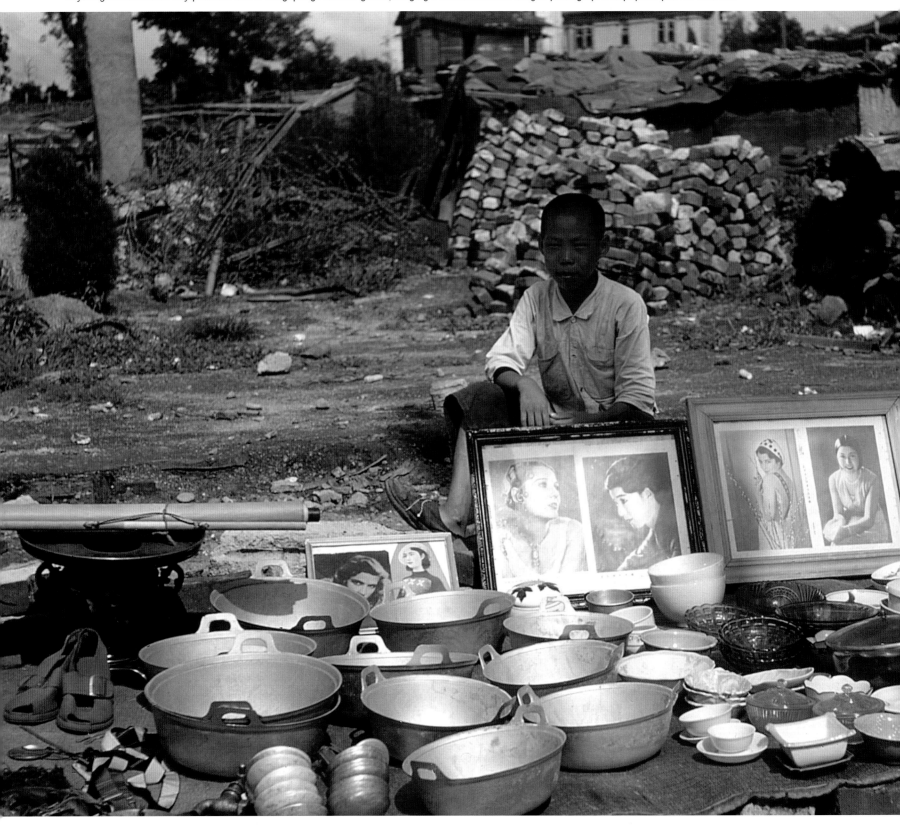

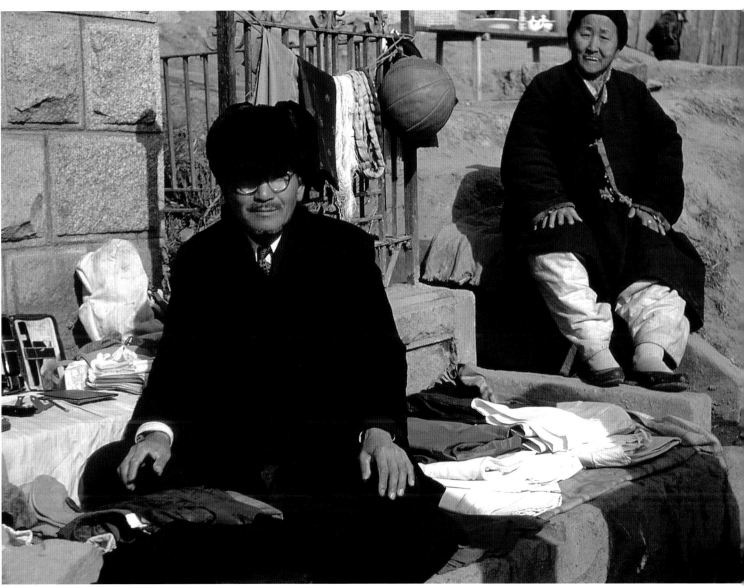

Civilians at a flea market selling clothing.

Women gathered together to do the laundry. Wooden paddles were often used to beat clothes clean.

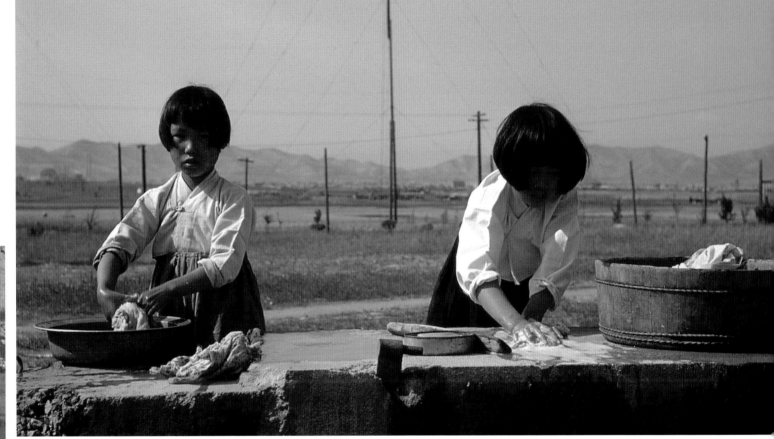

Students of Changduk Girls' High School and others celebrate President Syngman Rhee's second-term inauguration on August 15, 1952.

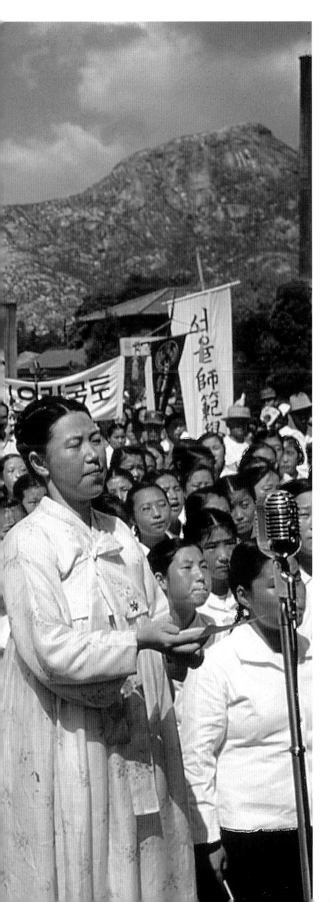

Despite the war, commemoration of Korea's Independence Day, a date that coincided with President Rhee's 1952 inauguration, takes place in the area surrounding the Capitol Building, or *Jungang-cheong*.

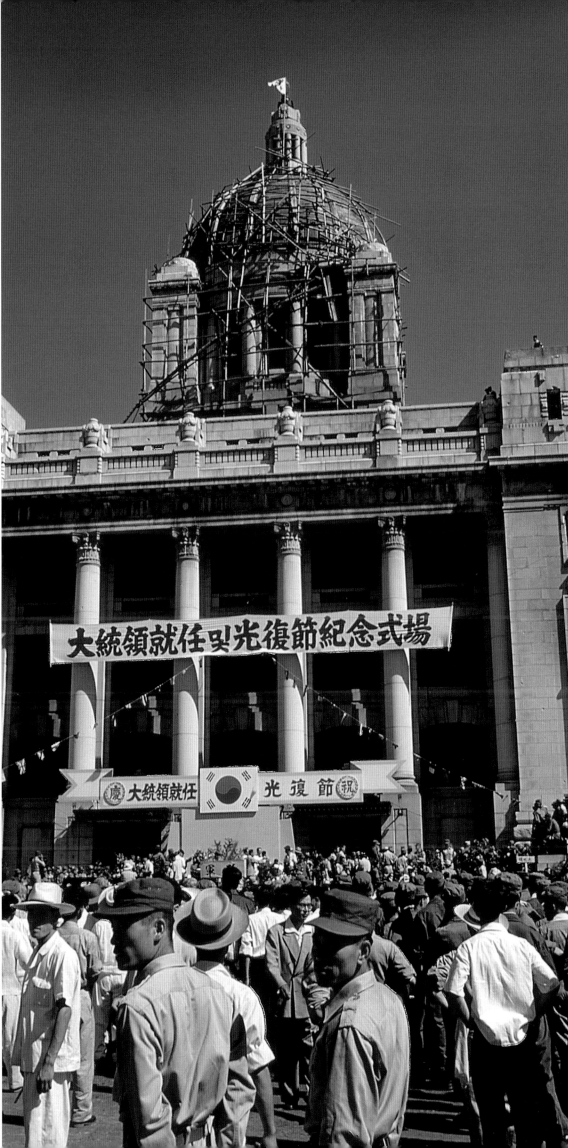

大統領就任및光復節紀念式場

慶 大統領就任 光復節 祝

Recruits to the ROK Army under marching orders in Seoul. The process of South Korea's modernization accompanied the war, but in the beginning, most South Korean soldiers went into battle almost completely untrained.

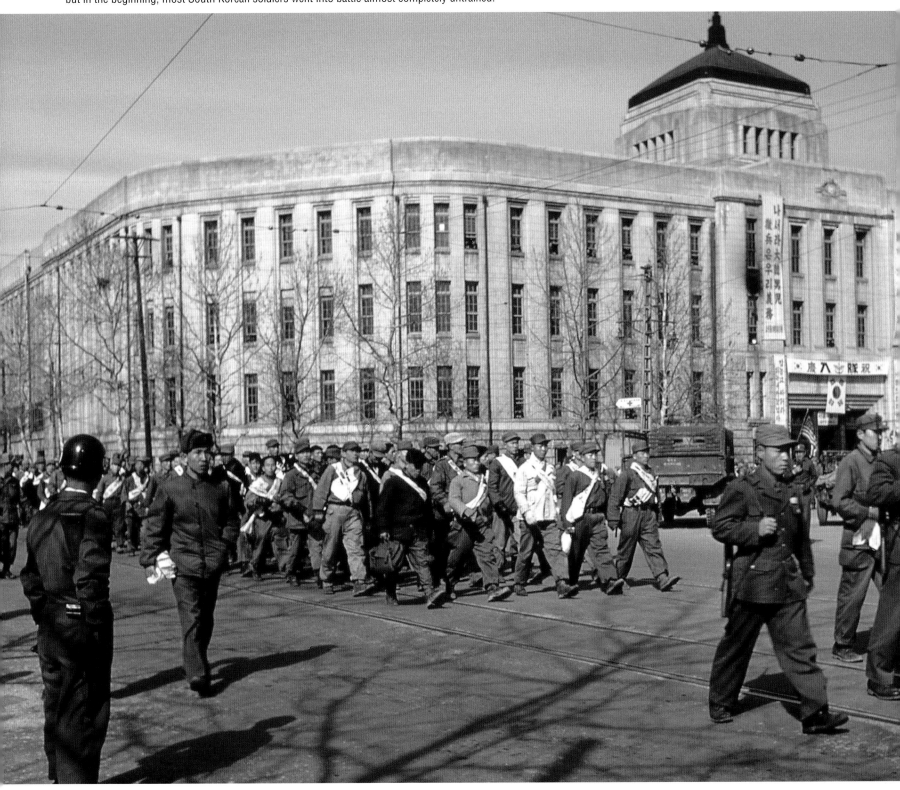

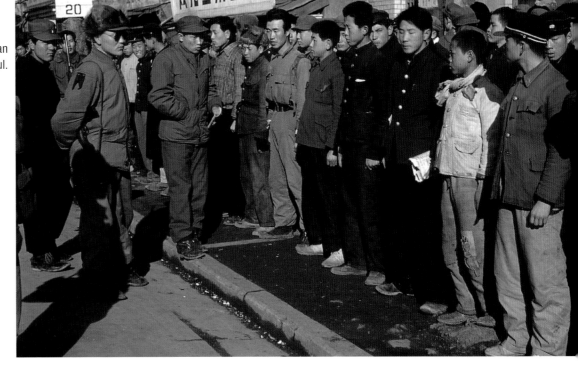

A crowd of young South Korean military recruits in Seoul.

South Korean recruits outside City Hall just after the first recapture of Seoul in early winter 1950.

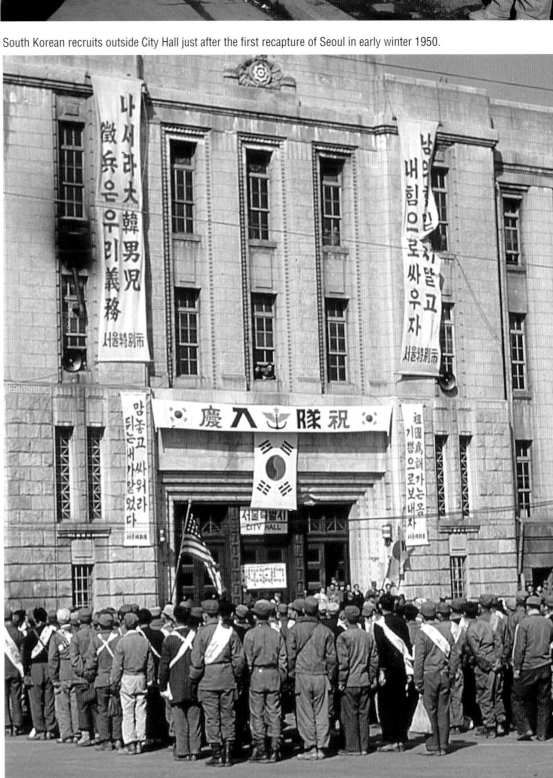

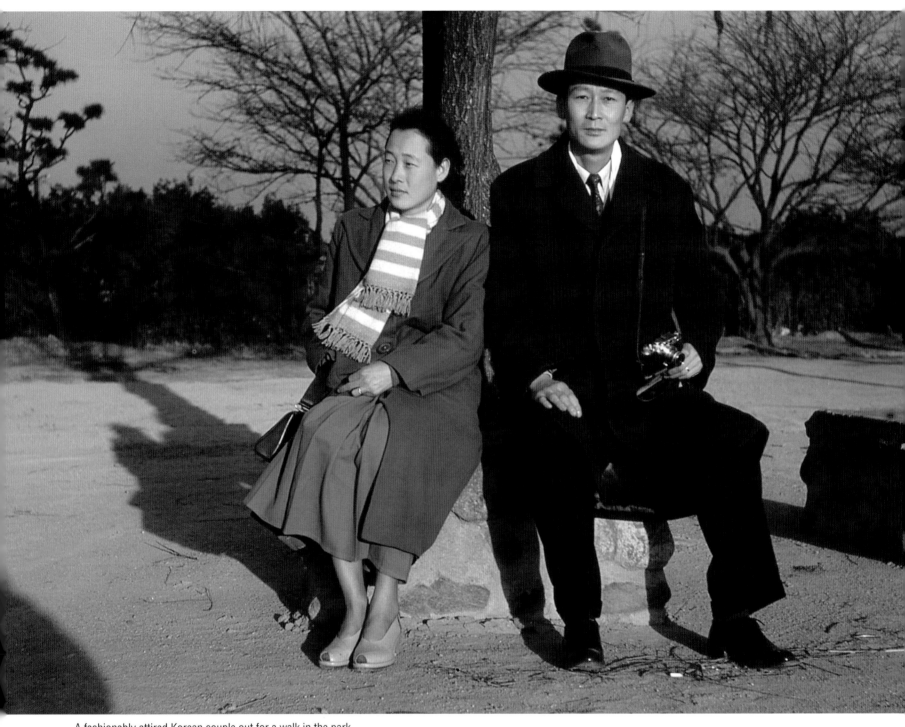

A fashionably attired Korean couple out for a walk in the park.

Children standing in front of a photo studio. They are dressed in traditional festively colored clothing; perhaps they have come to take a commemorative photograph.

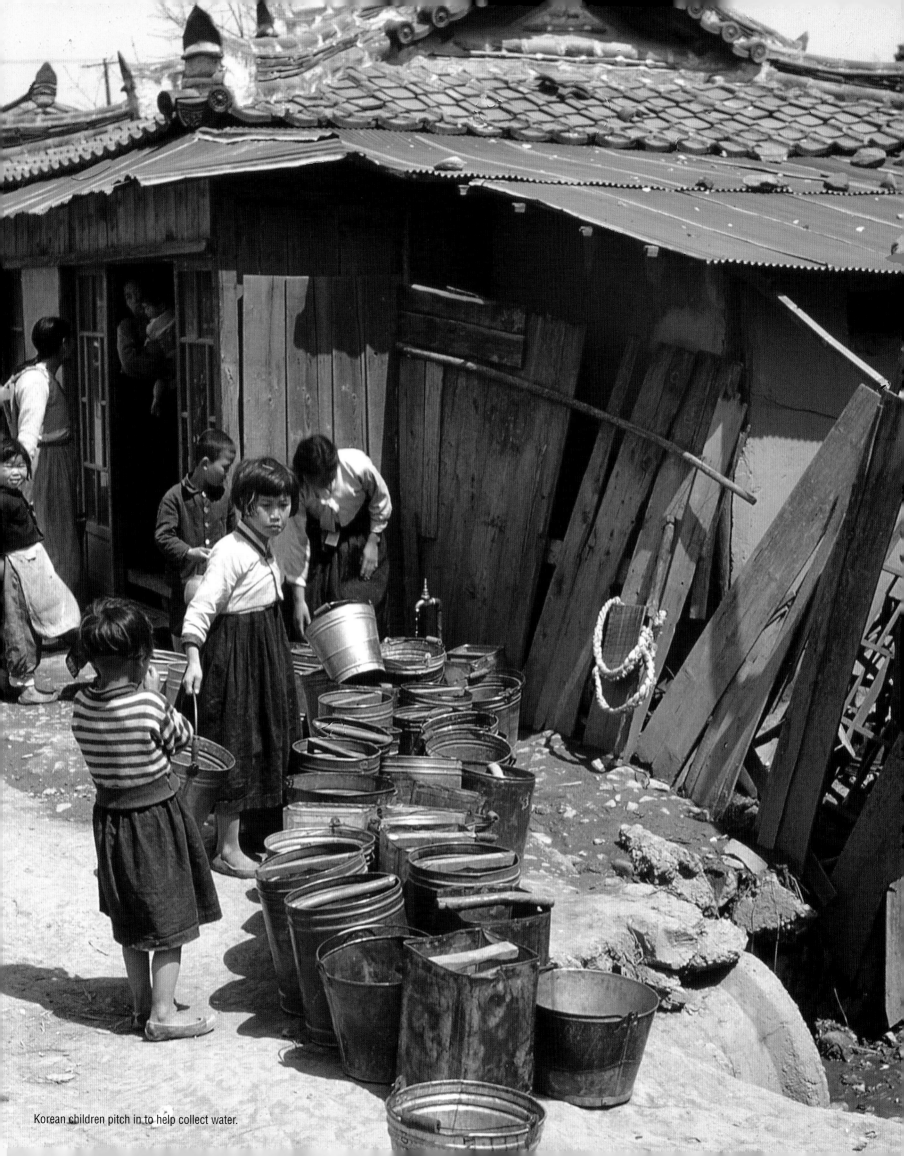

Korean children pitch in to help collect water.

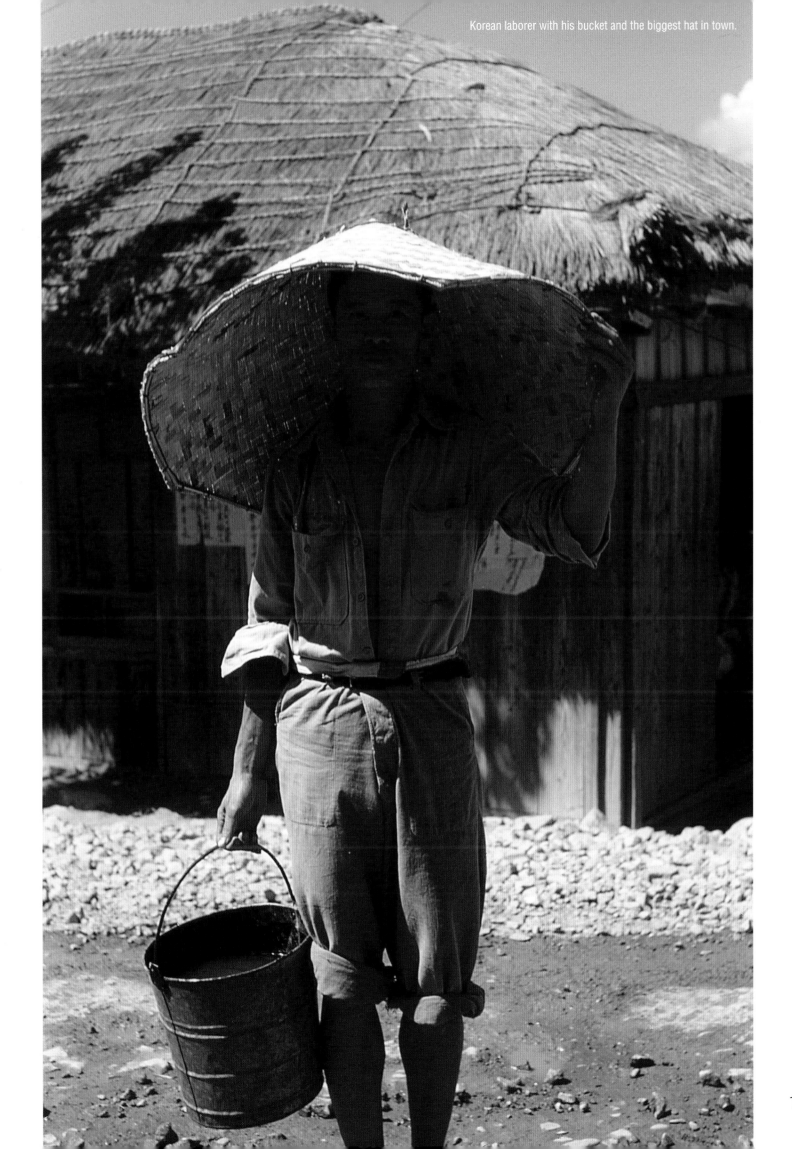

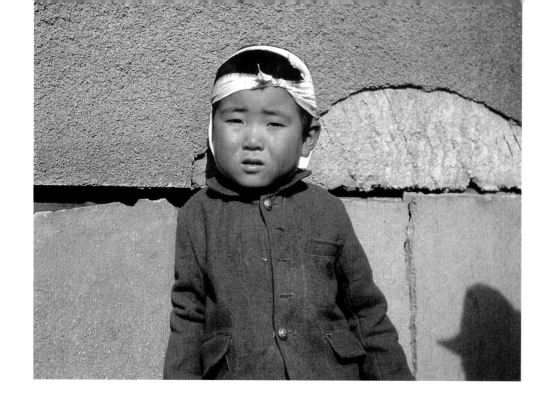

A South Korean child outside Gimpo Airfield. This child is clad in military castoffs—typical attire for the time. In the background is a mounted anti-aircraft gun. While UN forces did not have much to fear from enemy aircraft, these weapons, with their devastating firepower, proved effective against mass infantry attack.

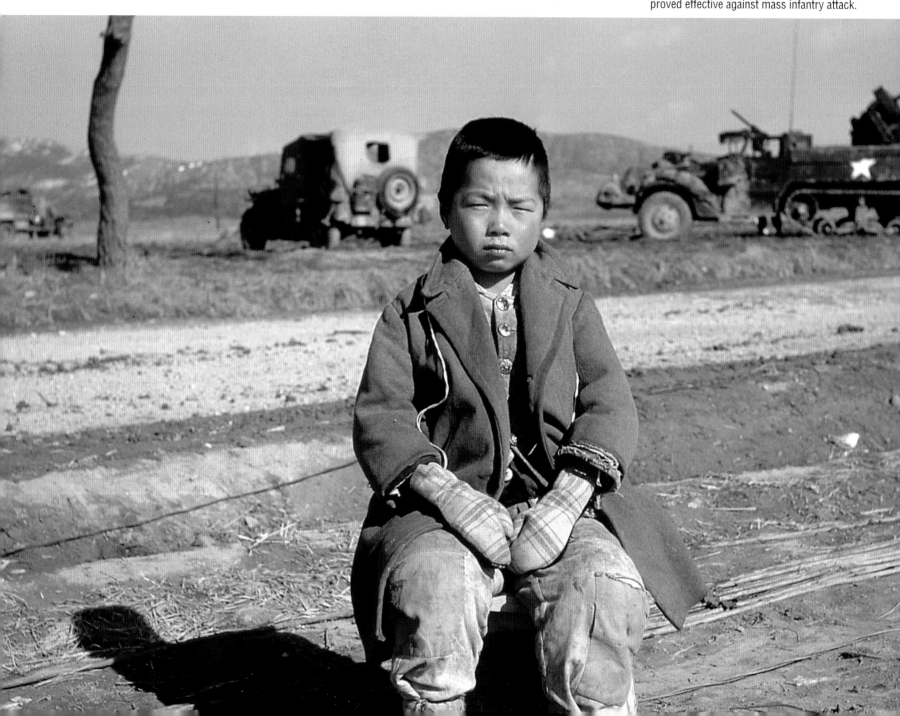

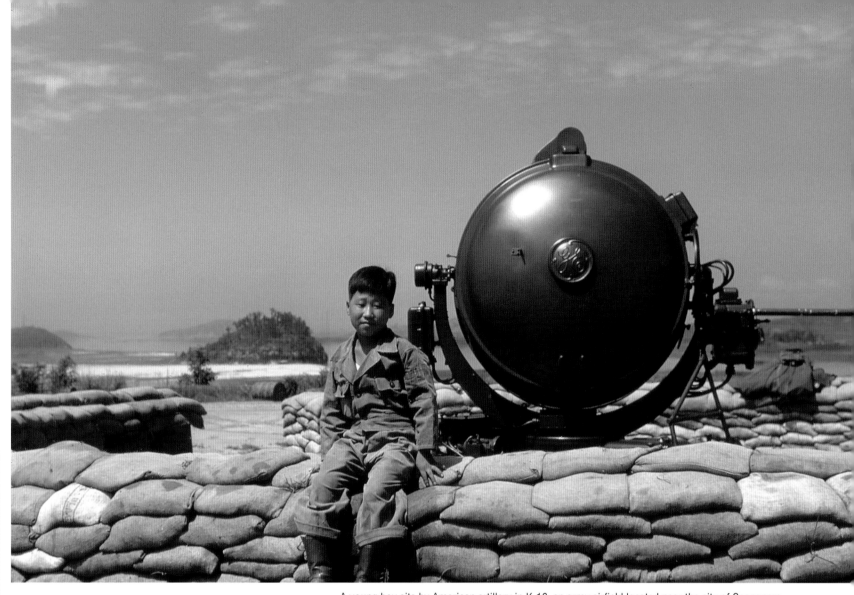

A young boy sits by American artillery in K-16, an army airfield located near the city of Seongnam.

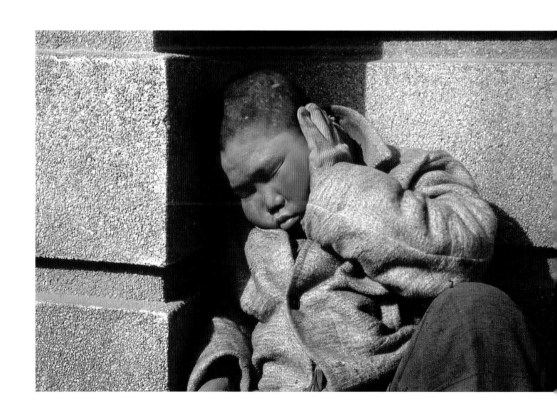

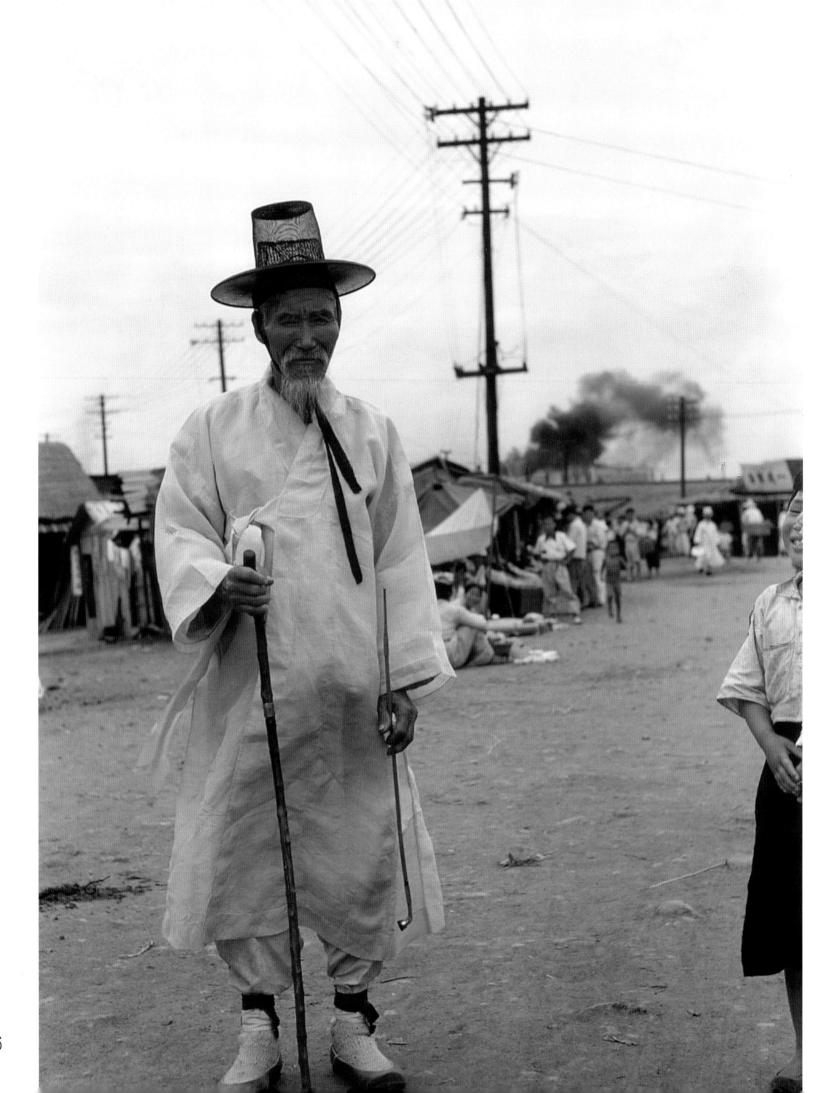

An elderly Korean gentleman poses with his cane, top hat and elongated pipe.

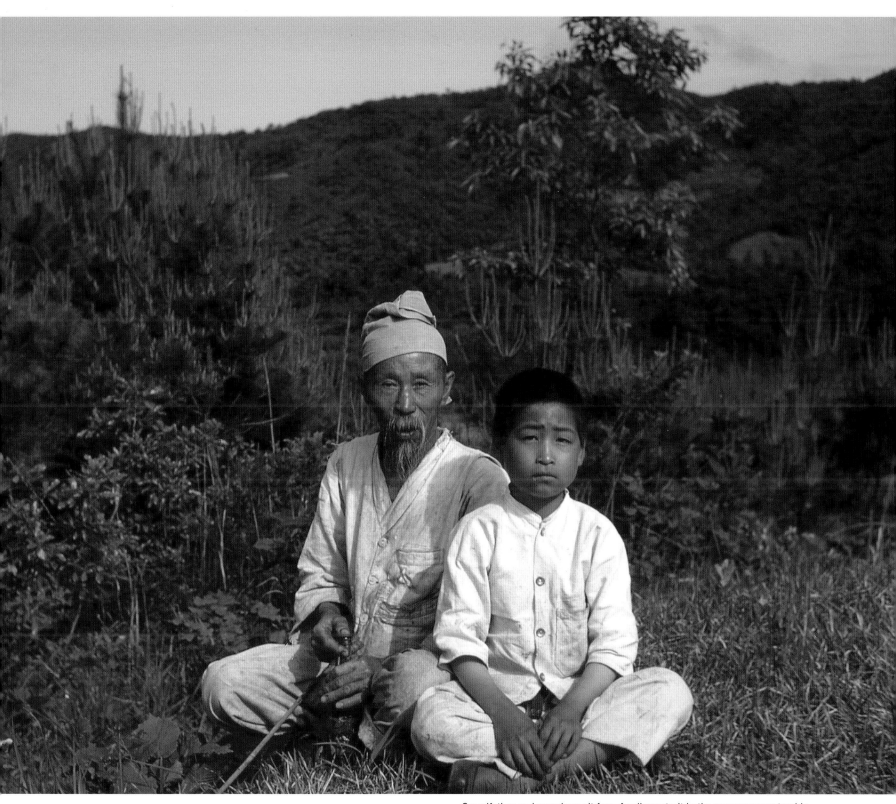

Grandfather and grandson sit for a family portrait in the summer countryside.

Early summer in the South Korean countryside. Farmers plant rice.
Despite the war, the seasons changed as they always had, and the fields had to be tended.

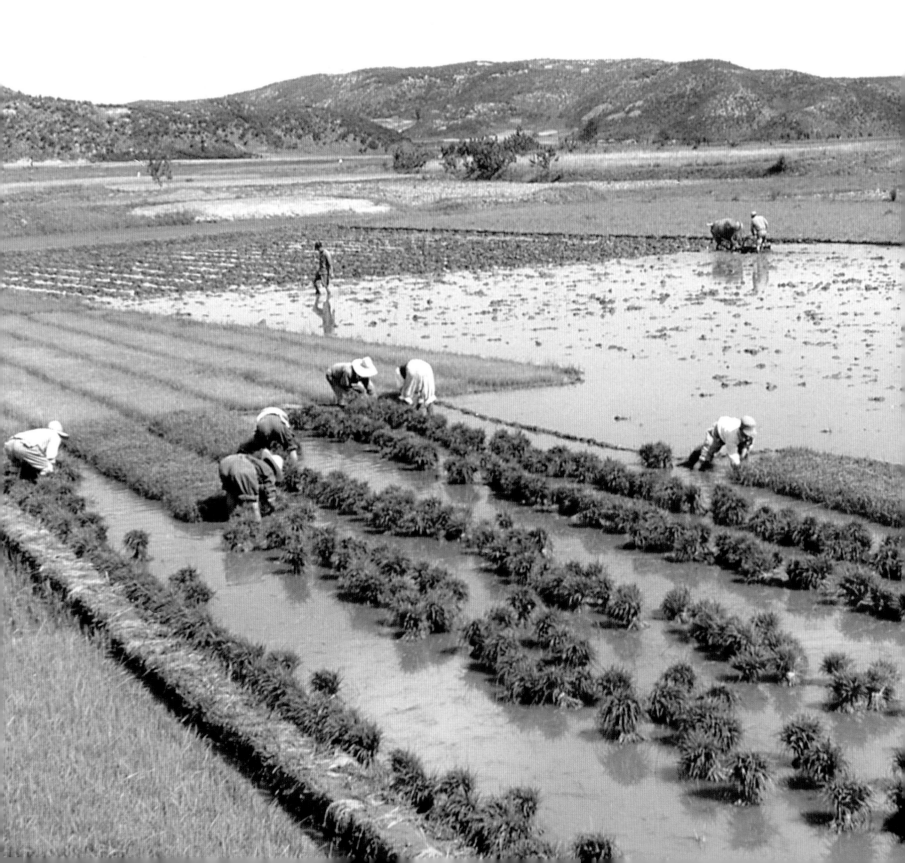

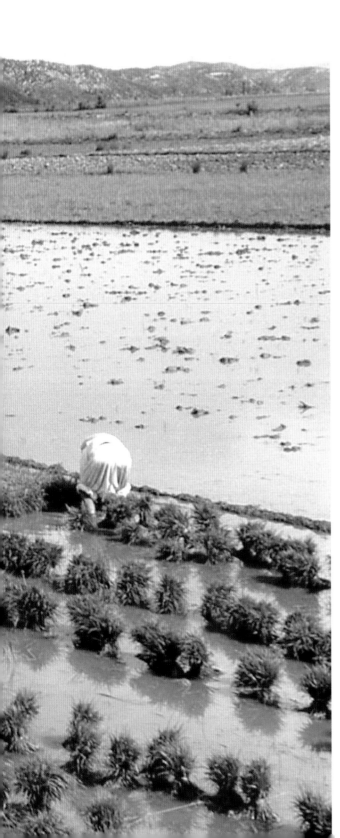

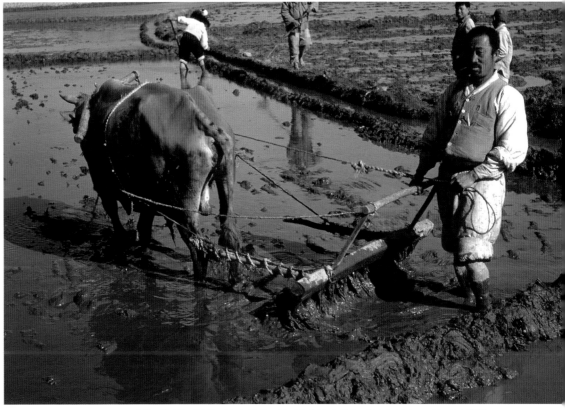

A South Korean farmer toils beside his beast of burden on a summer rice field.

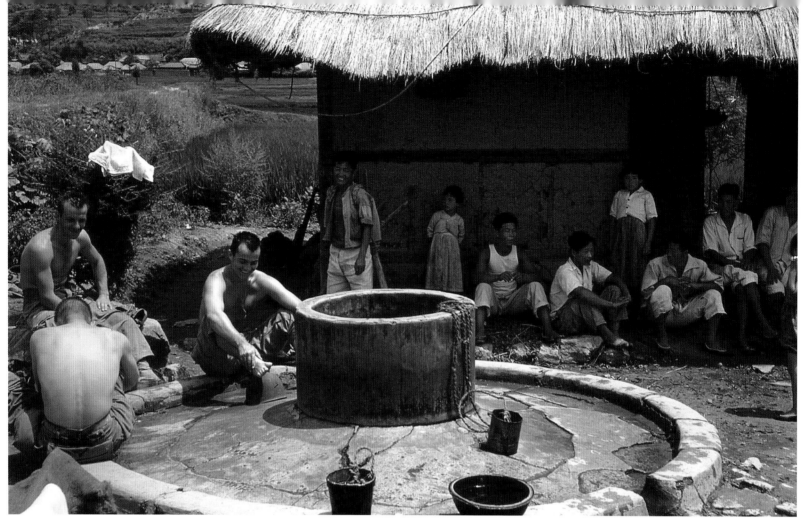

Summertime in the Korean countryside near Busan. GIs cool off by a well, arousing the curiosity of South Koreans.

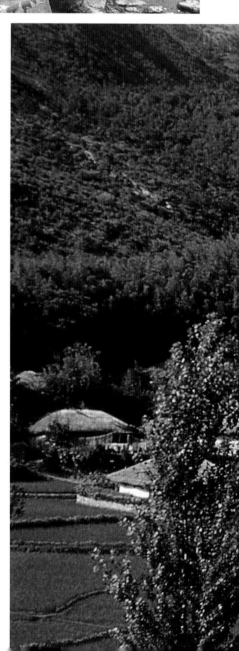

Thatched roof cottages dot a peaceful summer valley in South Korea. This picture captures the traditional beauty of rural South Korea—beauty that is now gone forever in the wake of modernization of the countryside.

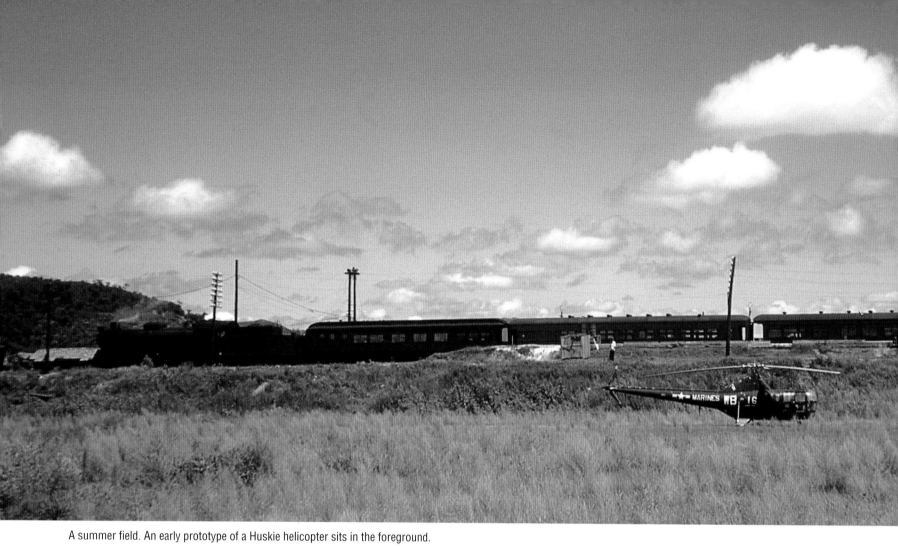

A summer field. An early prototype of a Huskie helicopter sits in the foreground.

Children and adults alike clamor to take a peek at a two-seat light utility US Marine helicopter.

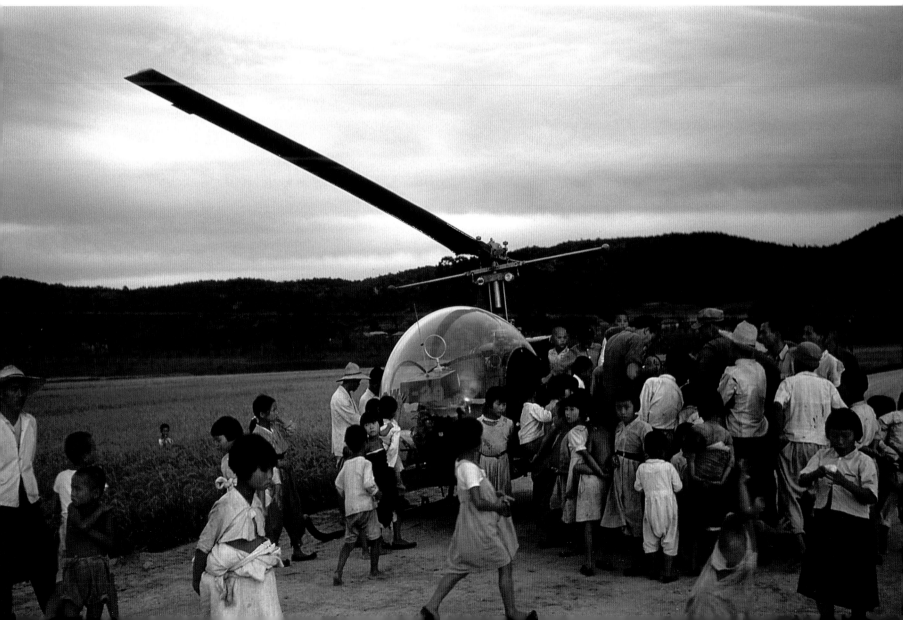

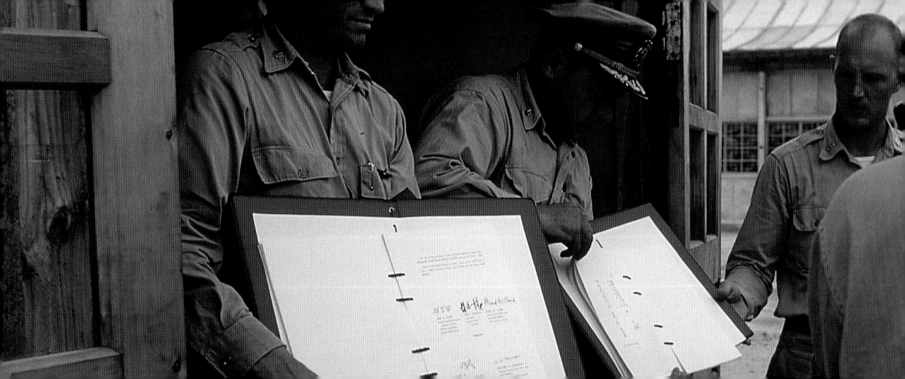

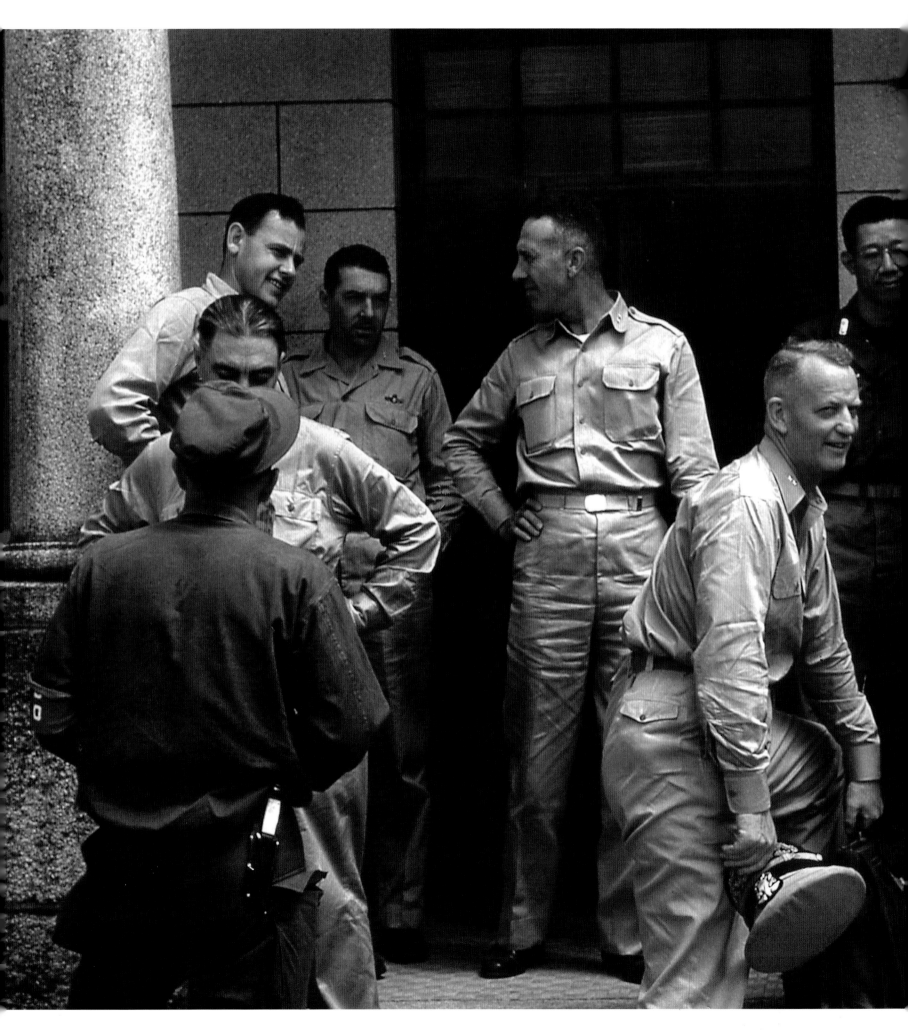

186

Insamgwan in Gaeseong, near the venue where armistice talks were held, was provided as a rest area for the UN Command side.

Generals of the UN Command on the first day of peace talks in Gaeseong, July 1951. The meeting and others to follow would end in stalemate, until the signing of the Armistice in 1953. From right to left, Major General Paik Sun-yup of the Republic of Korea Army, Colonel Lee Soo-young, Rear Admiral Arleigh Burke and Major General Henry Hodes of the 8th Army.

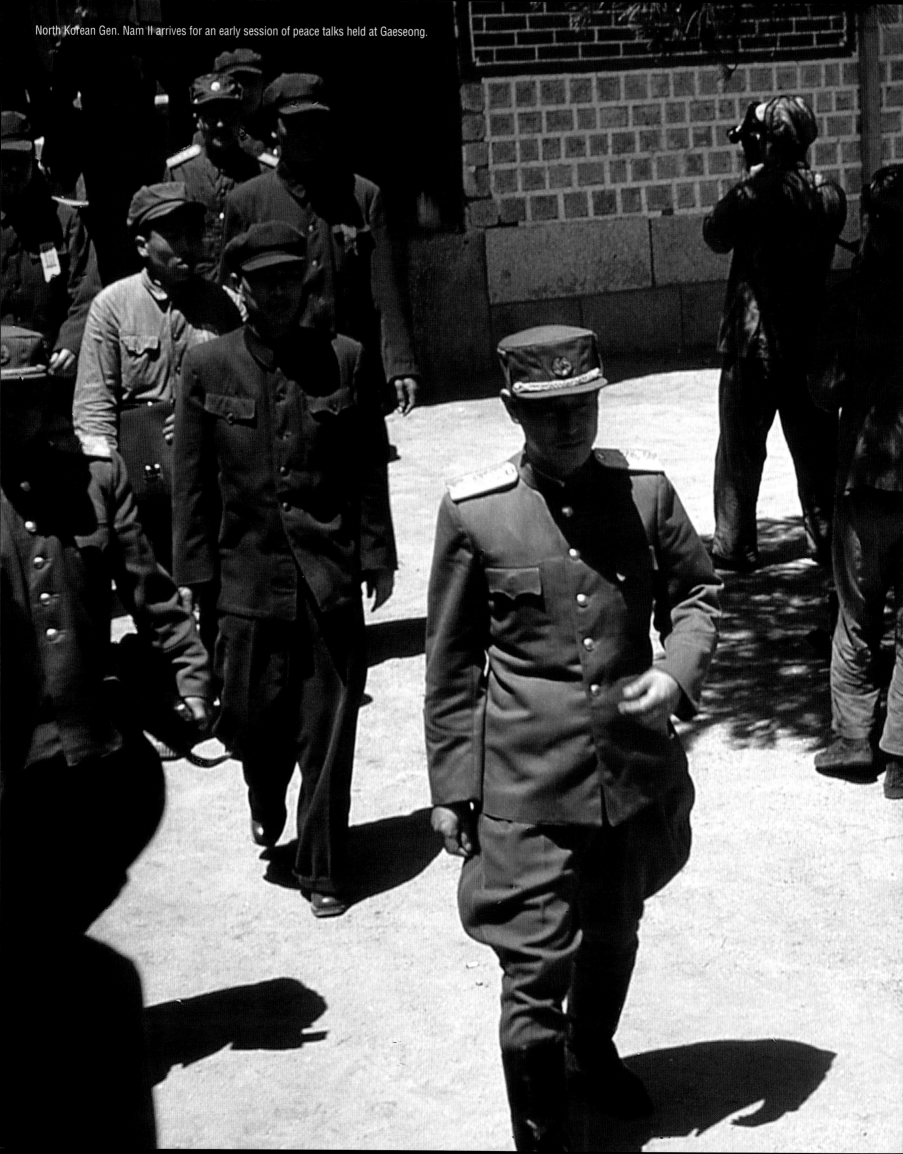

North Korean Gen. Nam Il arrives for an early session of peace talks held at Gaeseong.

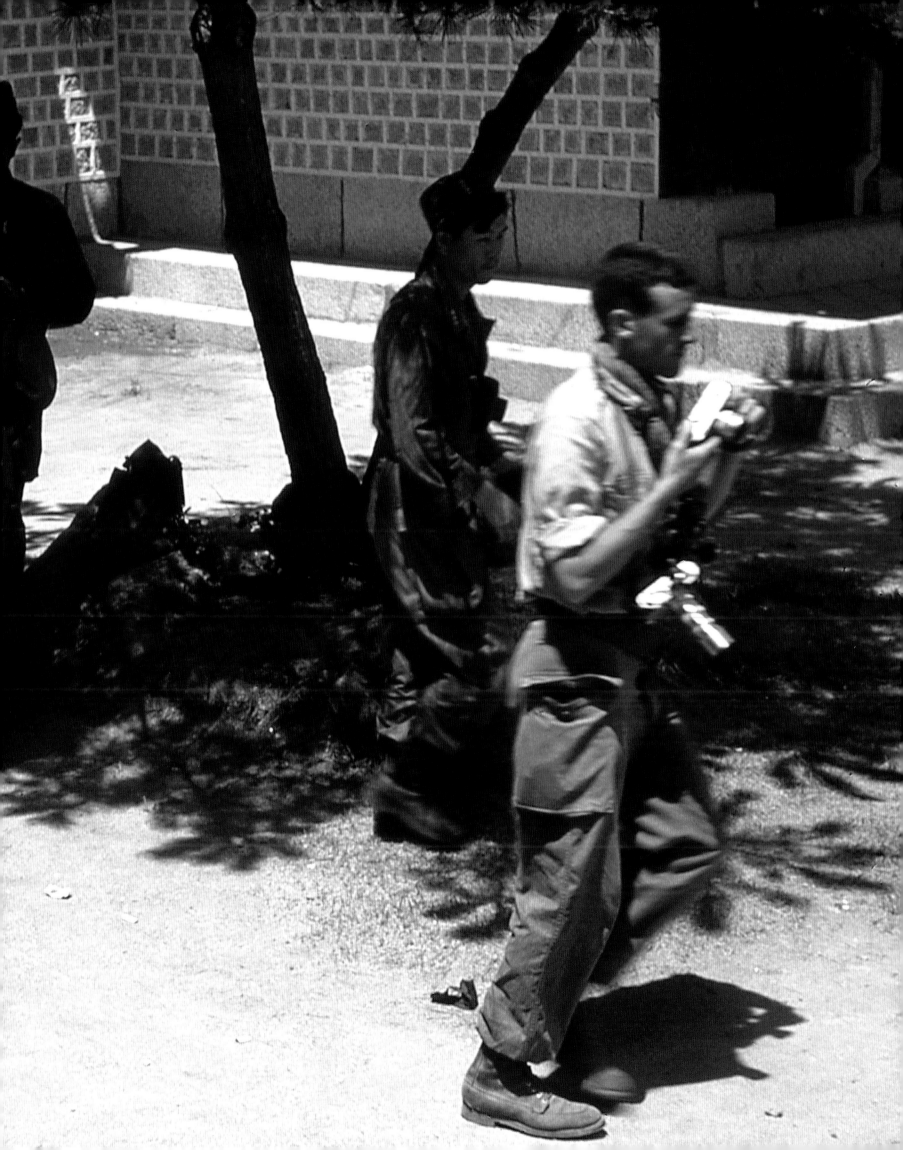

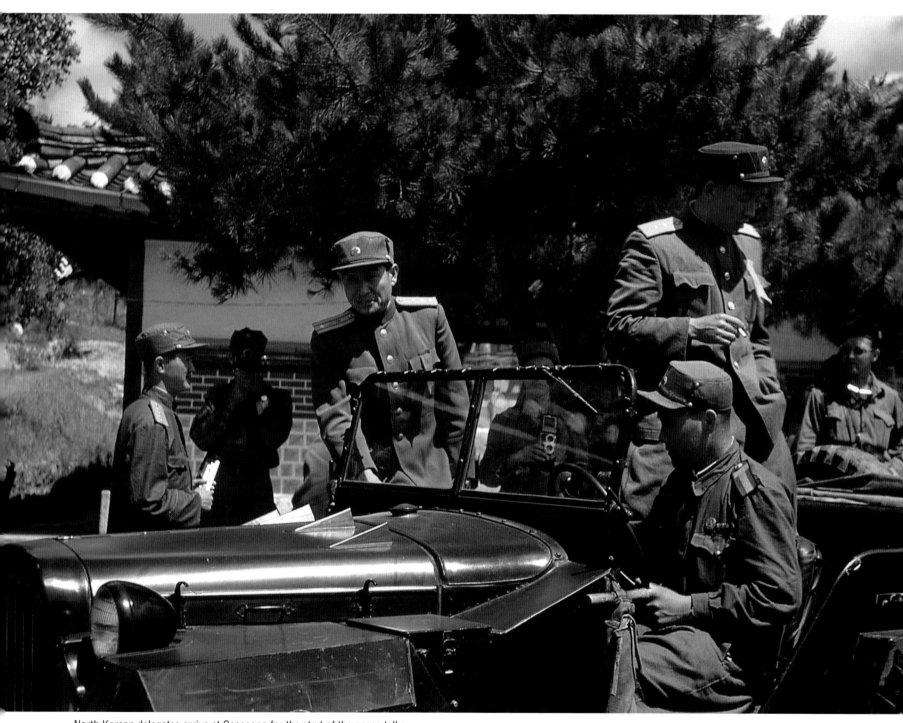

North Korean delegates arrive at Gaeseong for the start of the peace talks.

On August 13, 1951, Vice Admiral Turner Joy arrives in Gaeseong, North Korea. From July 1951 until May 1952 he served as the senior UN delegate to the truce talks. Discussions were beginning on arrangements for a demarcation line, a demilitarized zone, the method of supervising the truce, and the issue of prisoners-of-war.

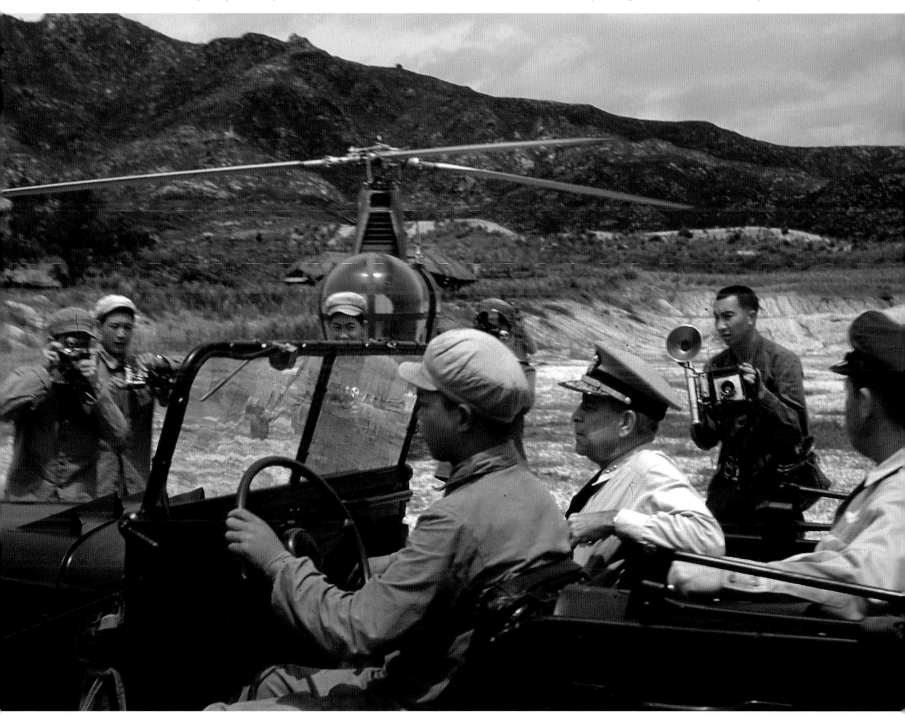

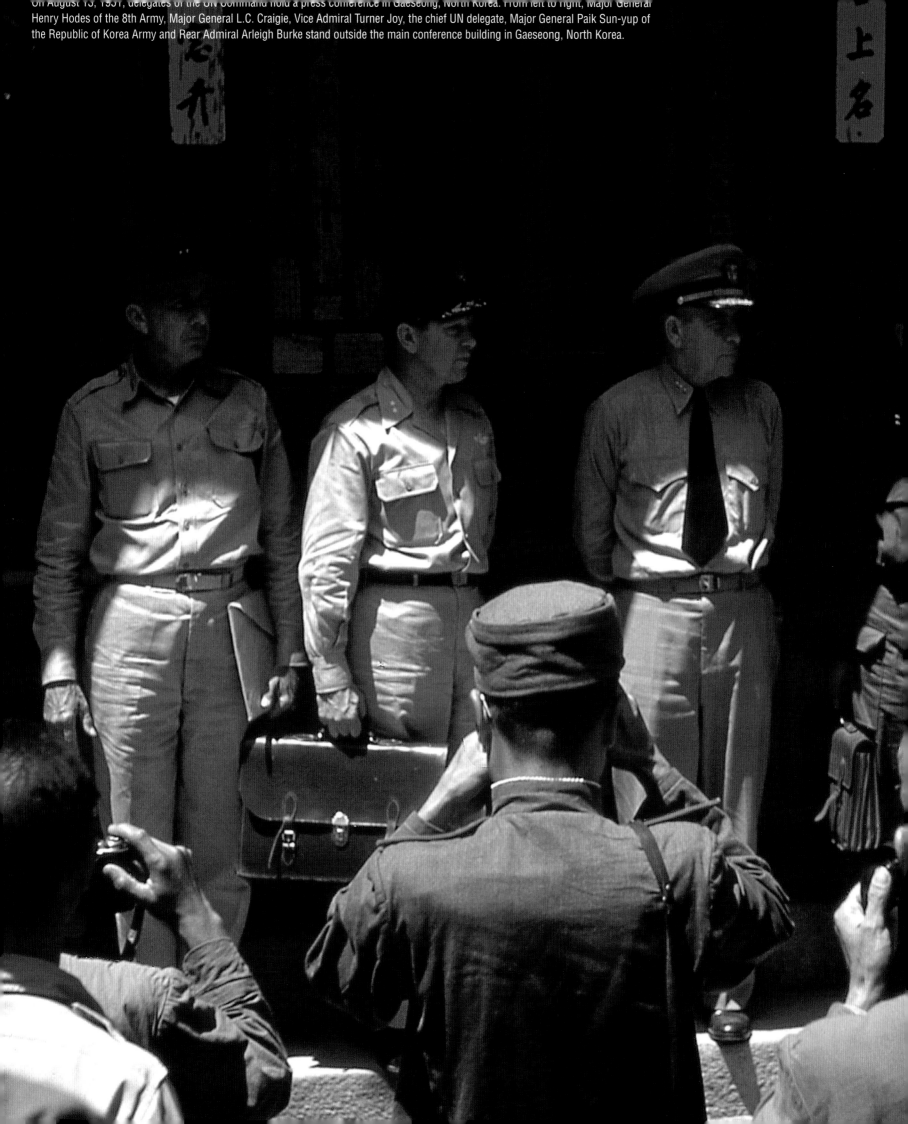

On August 13, 1951, delegates of the UN Command hold a press conference in Gaeseong, North Korea. From left to right, Major General Henry Hodes of the 8th Army, Major General L.C. Craigie, Vice Admiral Turner Joy, the chief UN delegate, Major General Paik Sun-yup of the Republic of Korea Army and Rear Admiral Arleigh Burke stand outside the main conference building in Gaeseong, North Korea.

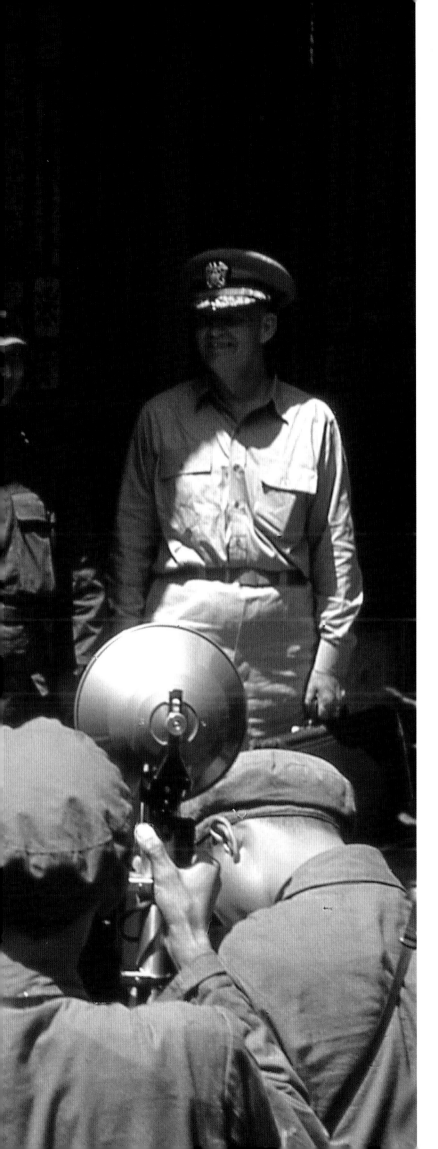

American newsman at the first session of the peace talks at Gaeseong.

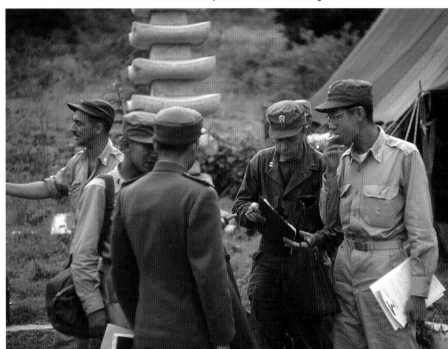

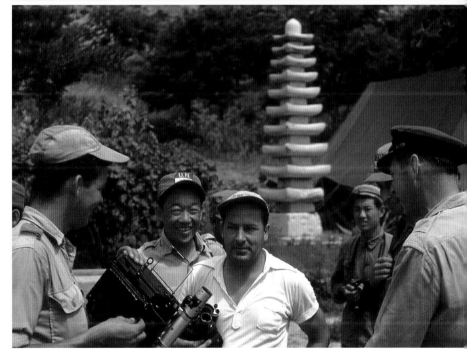

Various reporters standing near the original Peace Pagoda.

On April 20, 1953, wounded North Korean prisoners arrive in Panmunjeom on US military ambulances for a prisoner exchange. Four hundred North Korean and one hundred Chinese prisoners were exchanged that day, in return for fifty South Koreans, thirty Americans, twelve Britons, four Turks, one Canadian, one South African, one Greek and one Filipino. A North Korean medical team crowds around a US military ambulance, ready to escort wounded prisoners.

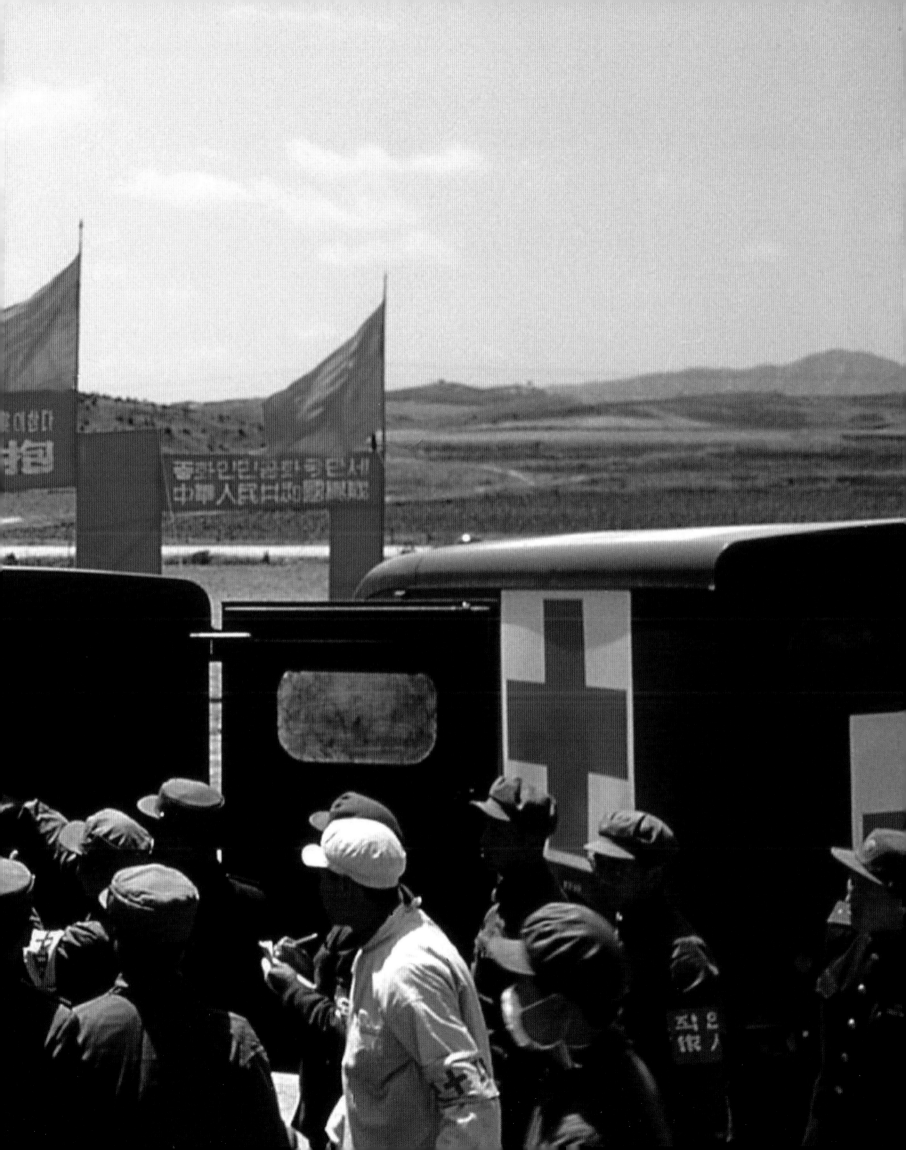

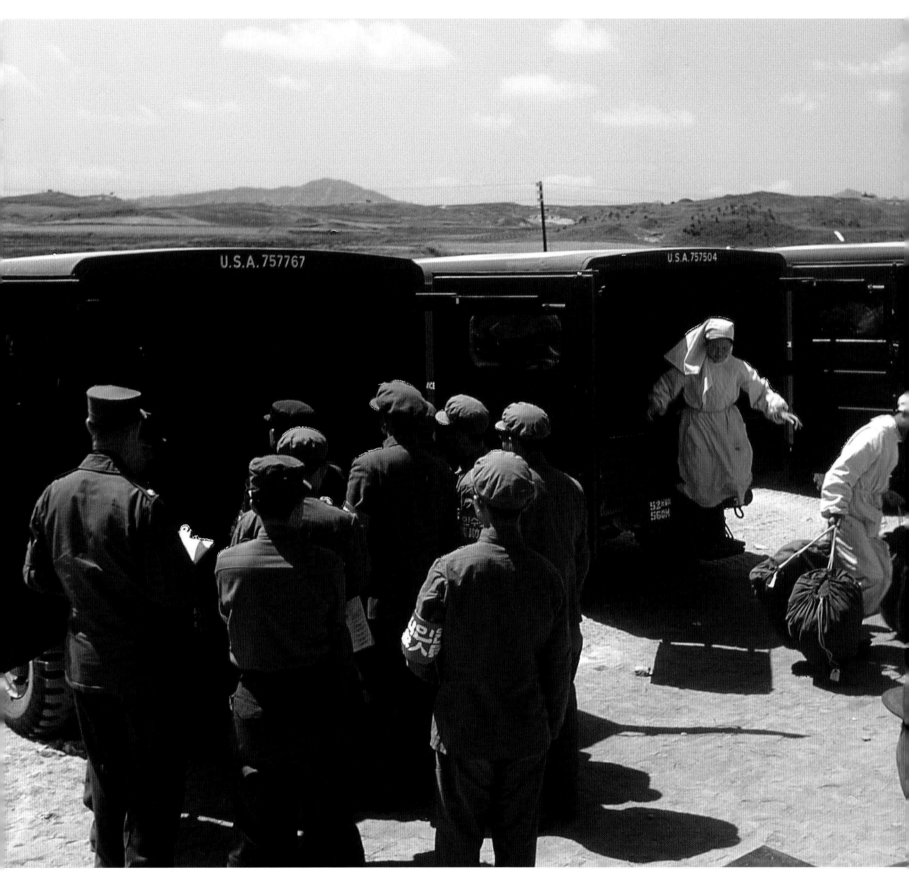

Medical personnel step off a US military ambulance in preparation for the first prisoner exchange at Panmunjeom.

Memories of MASH

"Even today, most Americans can remember a long-running television series called *M*A*S*H*. In the United States, the television version of *M*A*S*H* was a successful and long-running comedy with wisecracking officers and nurses. But the real MASH (Mobile Army Surgical Hospital) I experienced in Korea was very different.

Army doctors in blood-spattered uniforms were working frantically over wounded American soldiers who had just been brought in following a fierce battle on a hilltop where the Americans had been pushed back.

I had a look at the activity and then sat down beside a young soldier who had lost his arm on the hill. The stump of his arm had been bandaged, and he was nonchalantly talking to another soldier from his unit who had come to visit. The conversation went like this: 'Hey, buddy—if you guys recapture that hill, see if you can't find my left arm. I had a favorite ring on that finger and I don't want to lose it.'

Such was the grit of those soldiers. For them, MASH was no joke."

A North Korean medical team assists wounded compatriot prisoners back to the North Korean side of Panmunjeom as South Korean MPs stand guard.

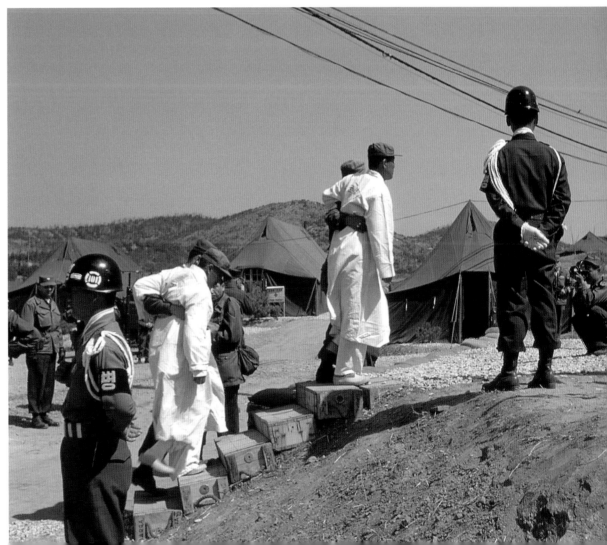

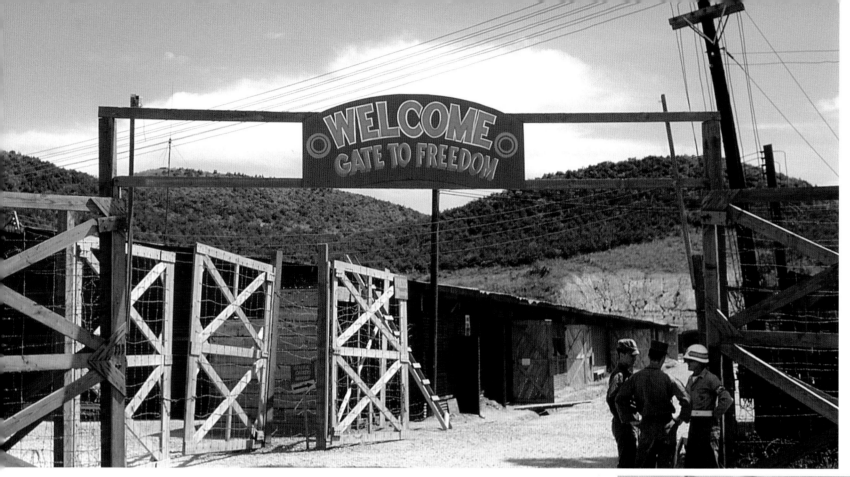

POW camp on Geoje Island. The camp was founded in early 1951 by the UN Command and at one point detained up to 170,000 prisoners in 28 facilities.

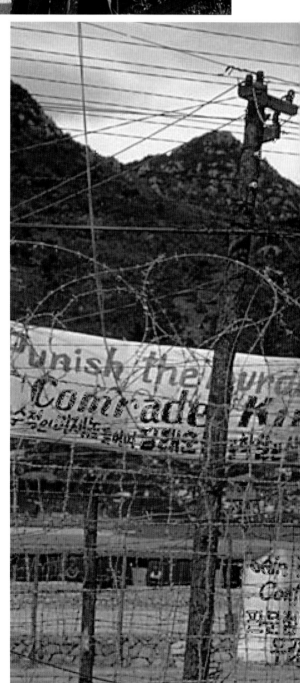

Propaganda banners inside the POW camp after the 1952 North Korean and Chinese uprising. The event culminated in the kidnapping of the US General Francis Dodd, who was later released on conditional terms.

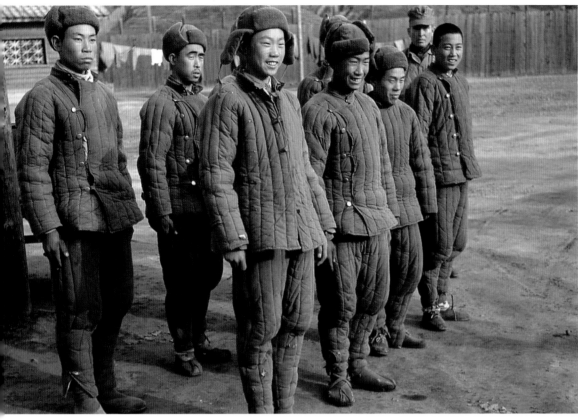

Chinese prisoners.

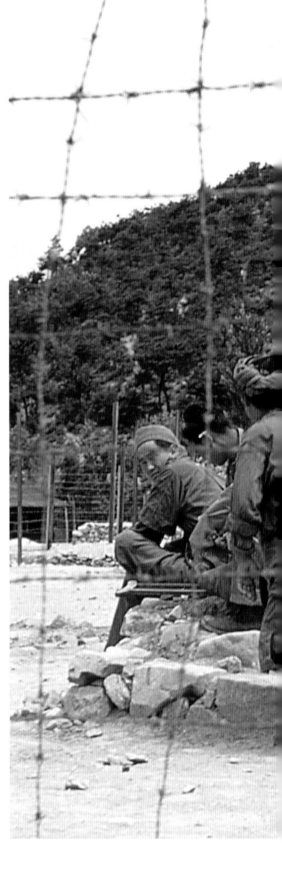

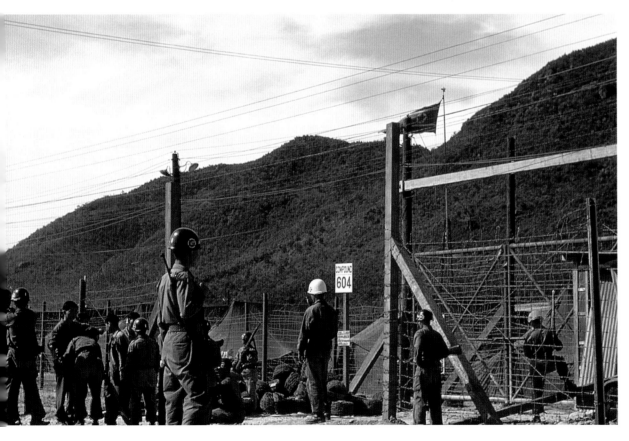

After the quelling of disturbances on Geoje Island, South Korean soldiers inspect prisoners outside a compound. A North Korean flag raised during the rebellion flies above the men.

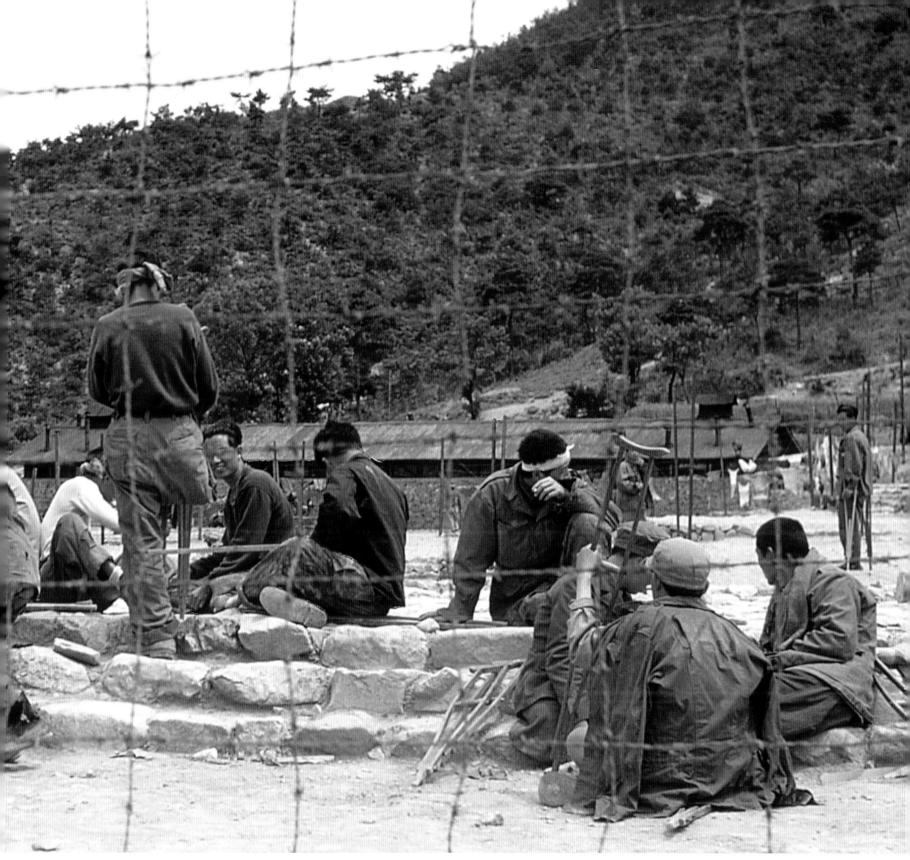

Wounded prisoners inside a camp, after fellow prisoners waged a rebellion against the UN Command.

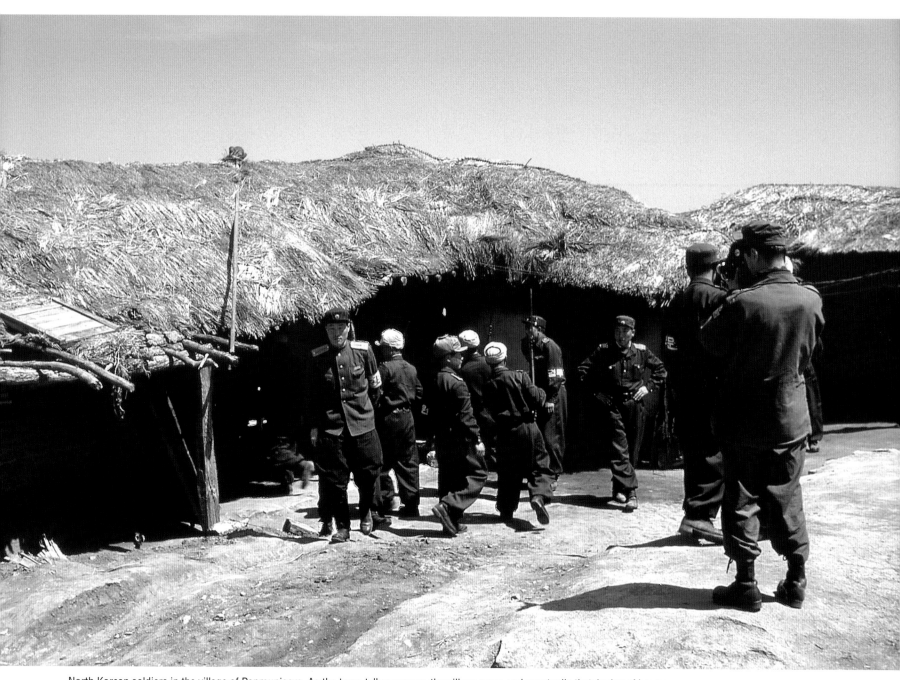

North Korean soldiers in the village of Panmunjeom. As the truce talks wore on, the village grew, and eventually thatched roof houses such as the one pictured here were replaced with modern structures.

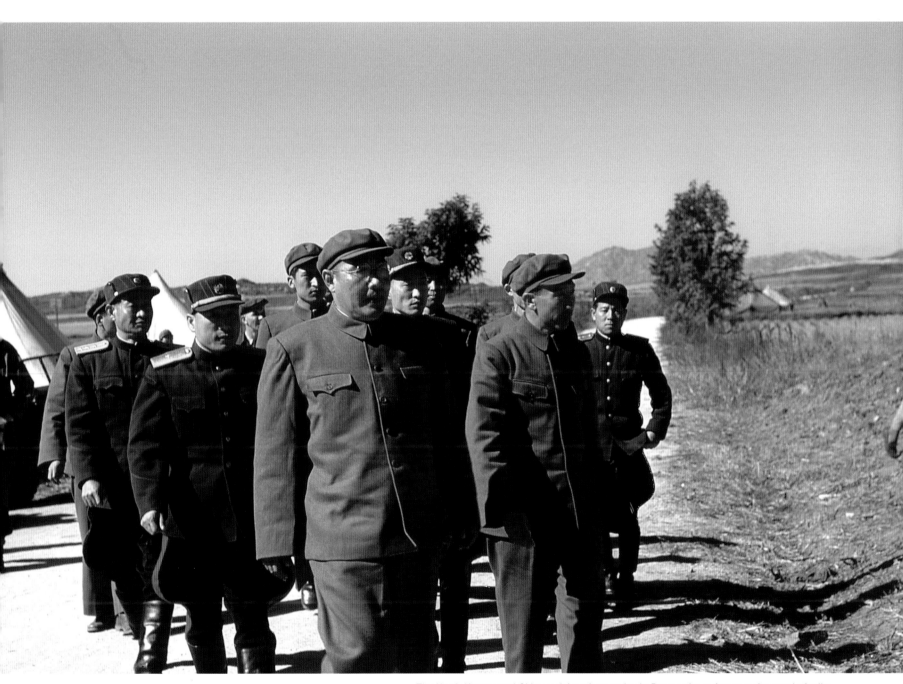

The North Korean and Chinese delegations arrive in Panmunjeom for an early round of talks.

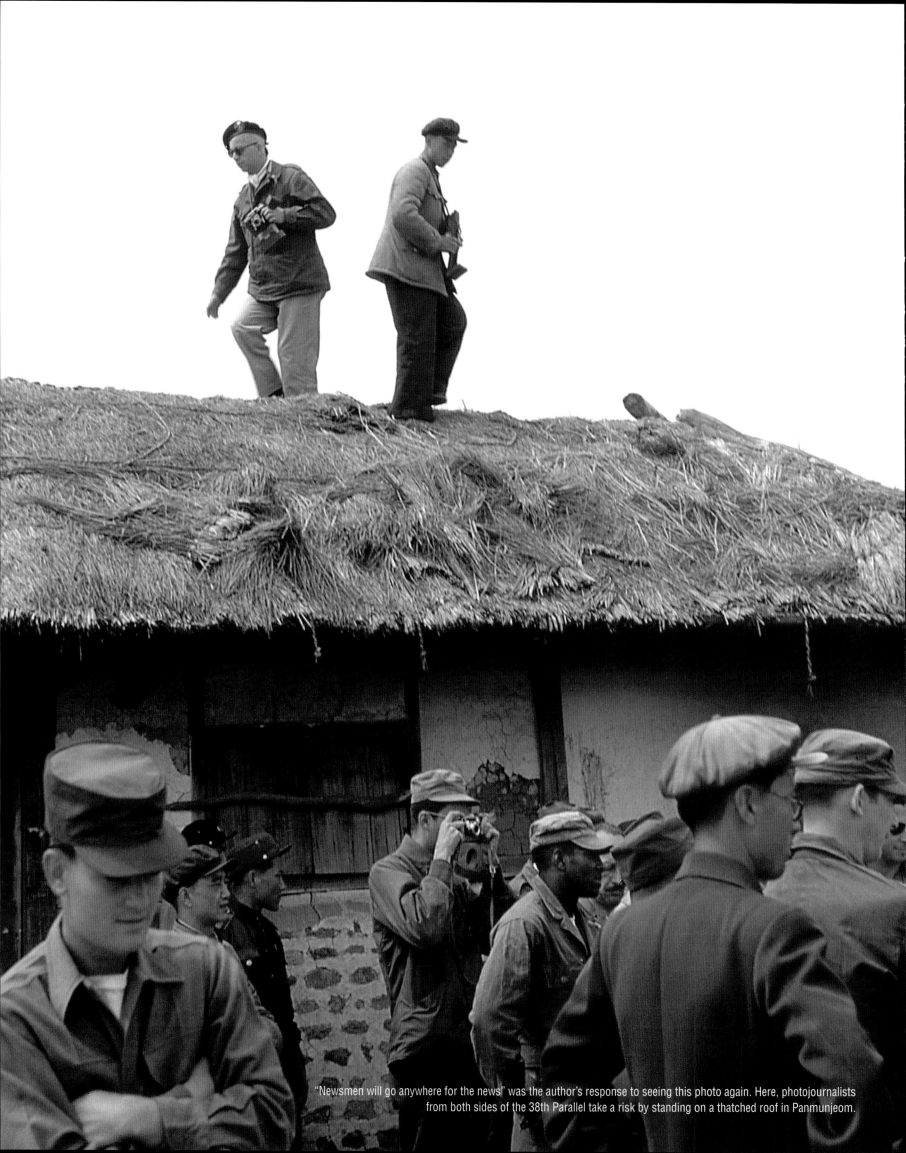

"Newsmen will go anywhere for the news" was the author's response to seeing this photo again. Here, photojournalists from both sides of the 38th Parallel take a risk by standing on a thatched roof in Panmunjeom.

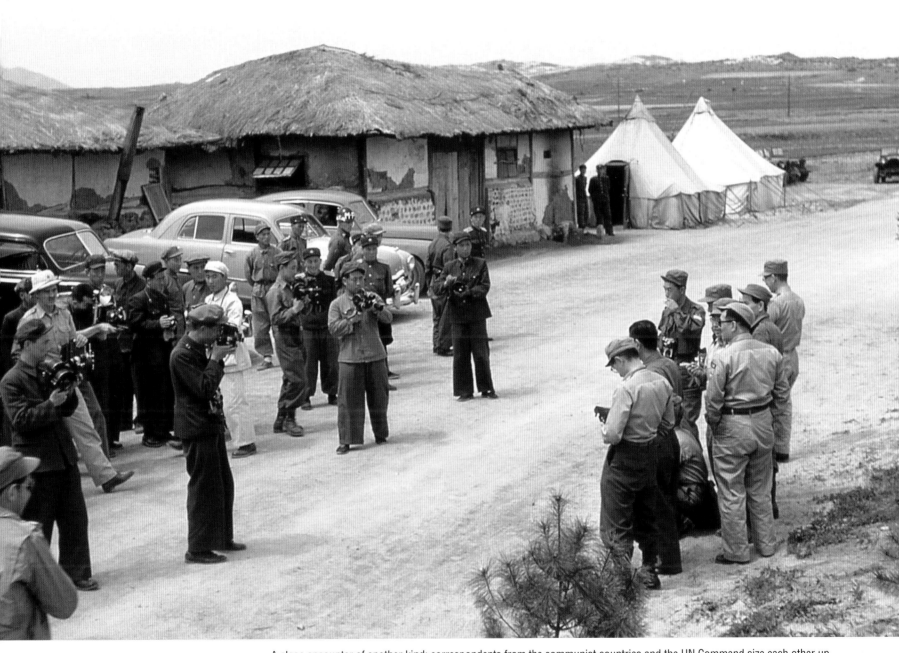

A close encounter of another kind: correspondents from the communist countries and the UN Command size each other up. Friendships were eventually struck across the line, including the author's with the Beijing journalist Chu Chi-ping.

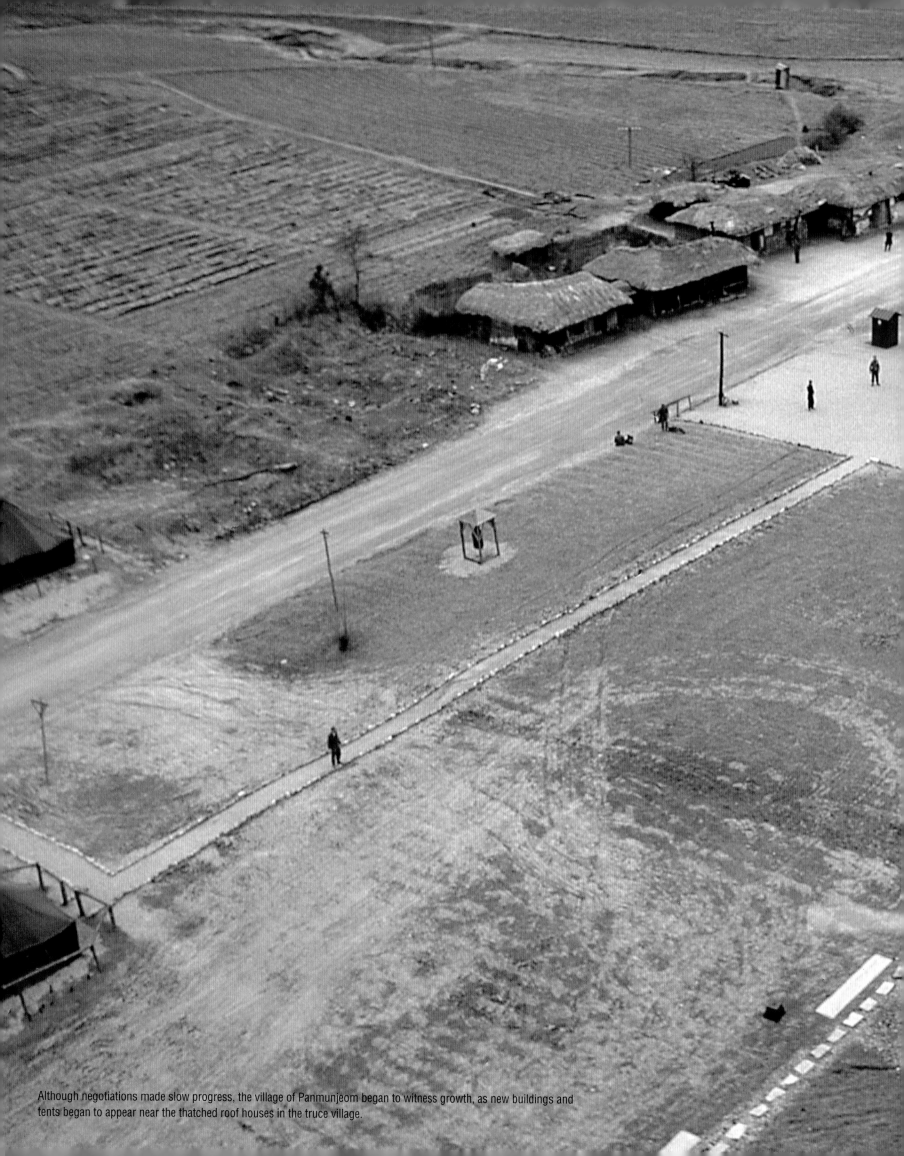

Although negotiations made slow progress, the village of Panmunjeom began to witness growth, as new buildings and tents began to appear near the thatched roof houses in the truce village.

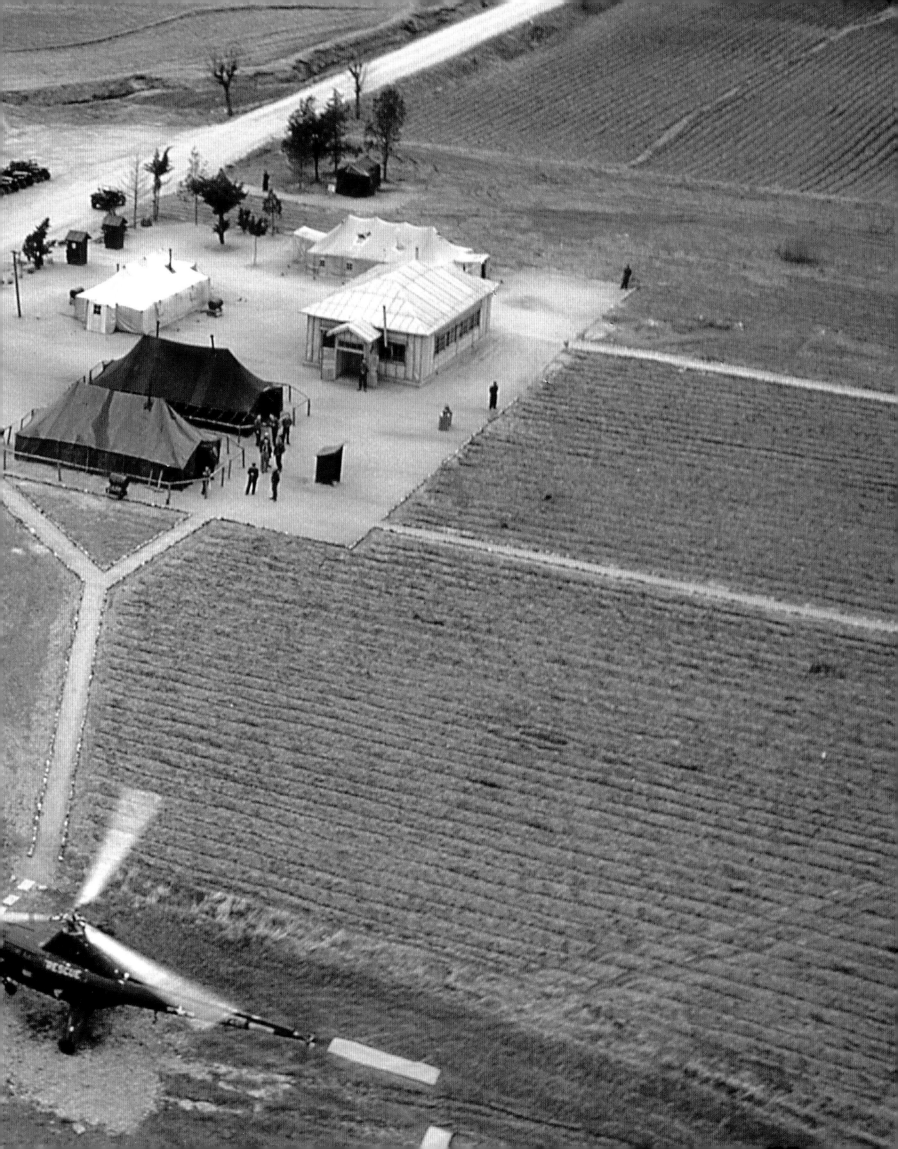

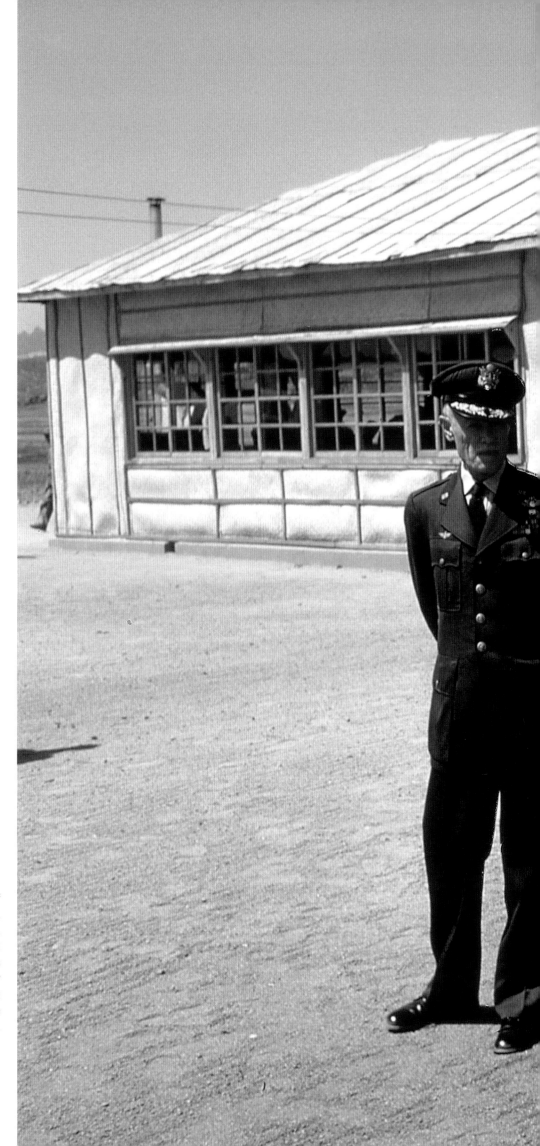

Delegates of the UN Command at Panmunjeom before one of many talks culminating in the armistice. Rear Admiral John C. Daniel stands to the left of General William K. Harrison, center. South Korean Major General Choi Duk-shin and an unidentified American delegate are also pictured. Choi, South Korea's representative on the United Nations armistice team, eventually boycotted the armistice agreement and refused to sign. Although no South Korean ever signed the truce, the terms of the agreement are still observed to this day by the Republic of Korea.

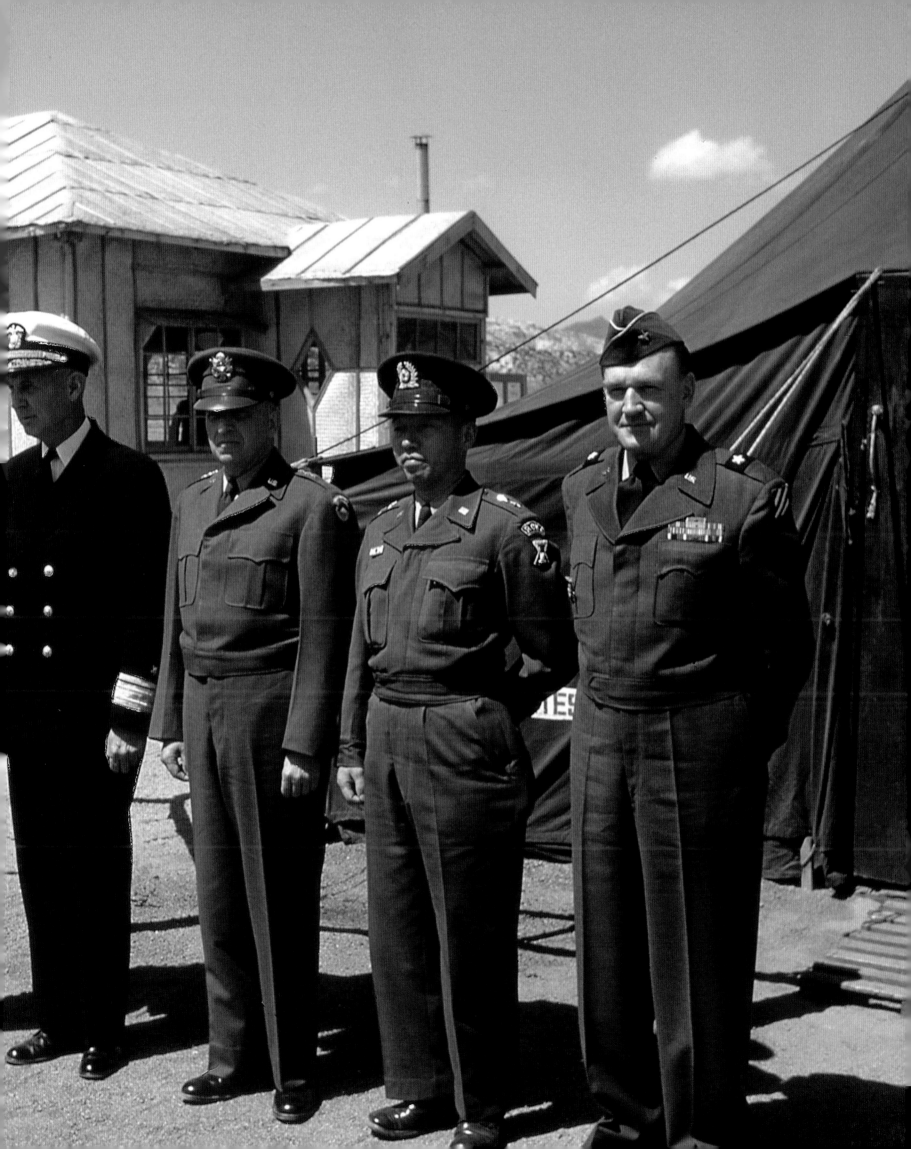

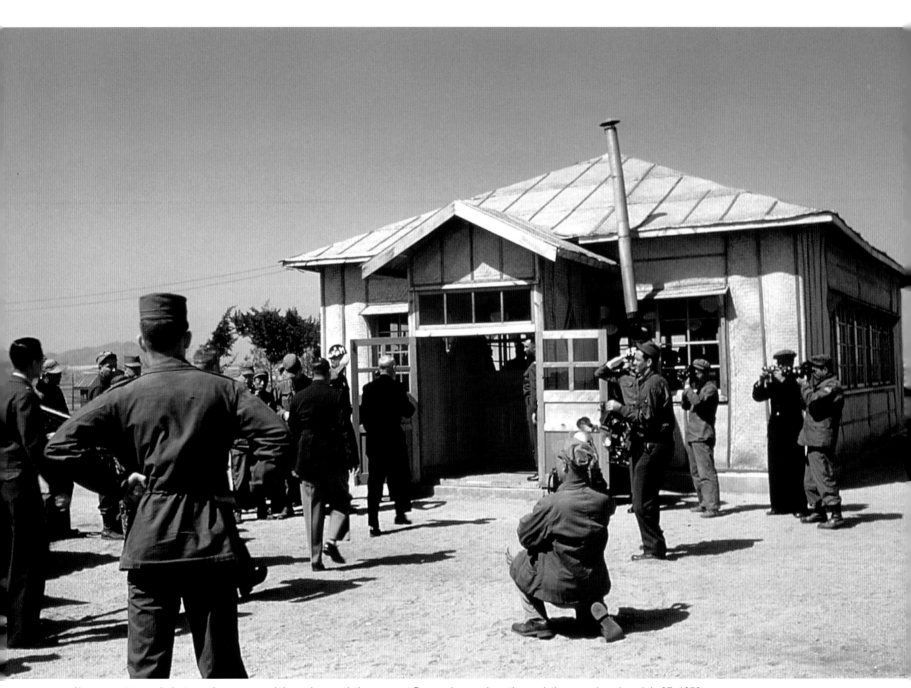

News reporters and photographers surround the main negotiation room at Panmunjeom, where the armistice was signed on July 27, 1953.

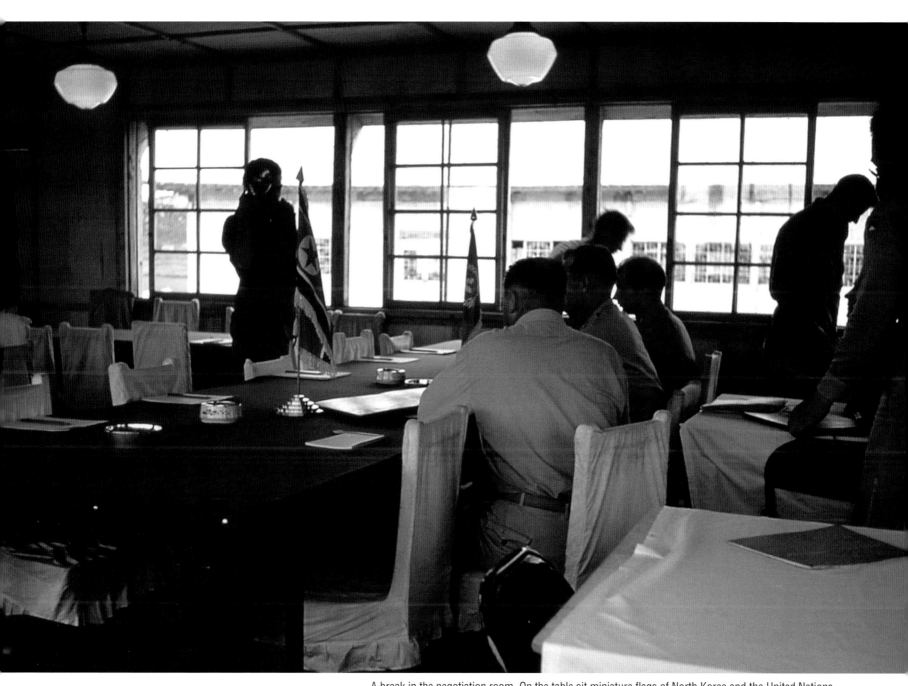

A break in the negotiation room. On the table sit miniature flags of North Korea and the United Nations.

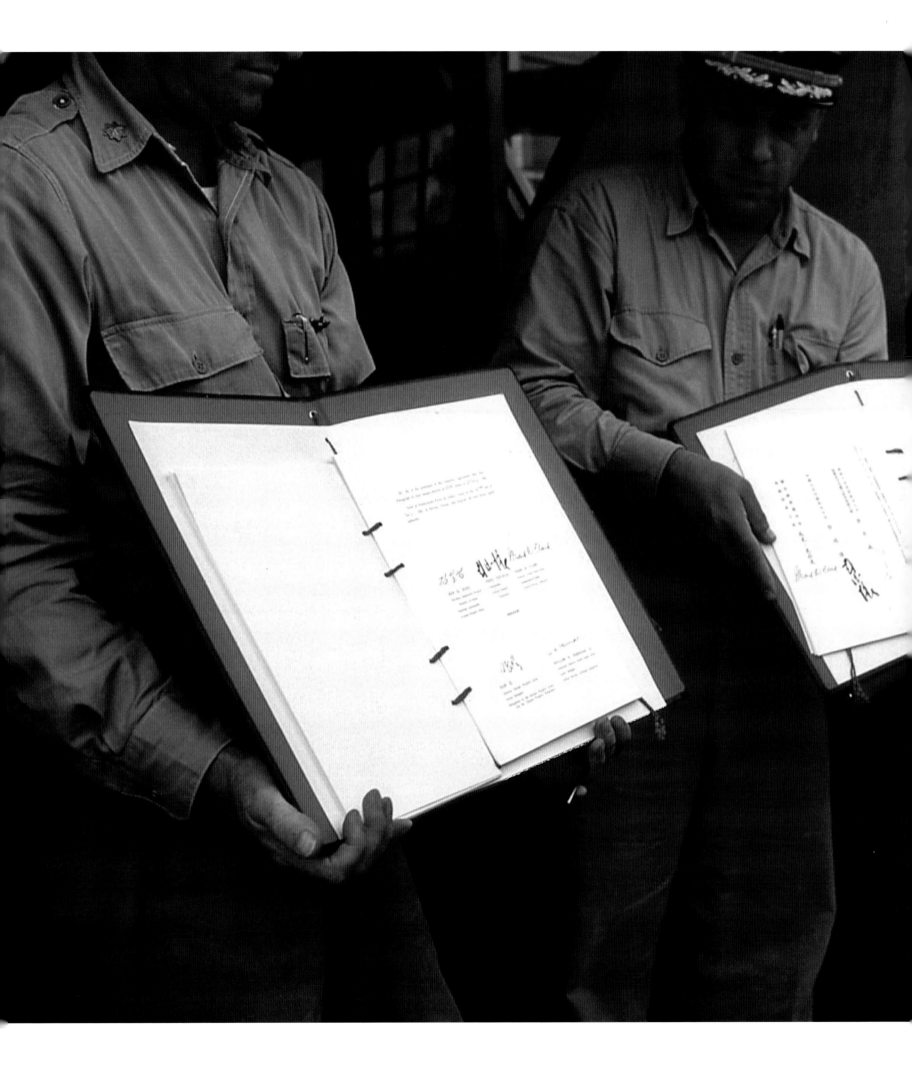

Armistice Signed

"The exchange of the more than one hundred thousand remaining prisoners who wanted to return home went smoothly, and the Korean armistice document was signed at 10 am on July 27, 1953, three years and one month after the North Korean attack. A special phone line was run into Panmunjeom for the first time, and the other radio correspondents and I were able to broadcast an eyewitness account of the signing directly from the 'Peace Pagoda.'

Only later did we learn that a company of American soldiers had been standing by just south of Panmunjeom, ready to come in and rescue us in case of emergency. Right to the end, neither side trusted the other. There was talk in the armistice document about meetings to follow, leading to a full-scale peace treaty. So far nothing has happened. The red-bordered cease fire agreement is the only document holding the guns quiet in Korea, and it has worked more or less successfully for more than half a century."

A closer look at the red-bordered cease fire agreement, signed "in protest" by UN Command General Mark Clark, but also the only document that the author believes "[has held] the guns quiet in Korea successfully for more than half a century." The signature of North Korean leader Kim Il-sung (father of present leader Kim Jong-il) can be seen on the document.

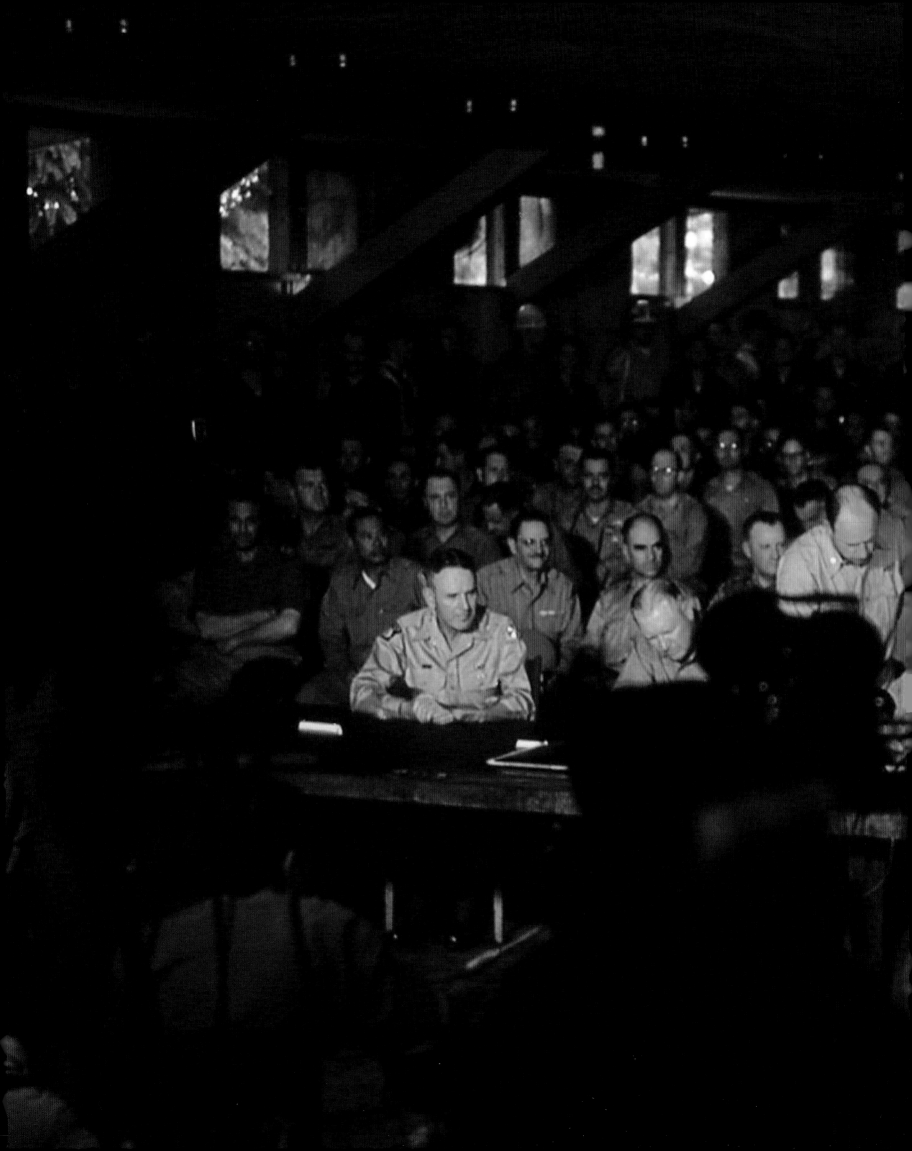

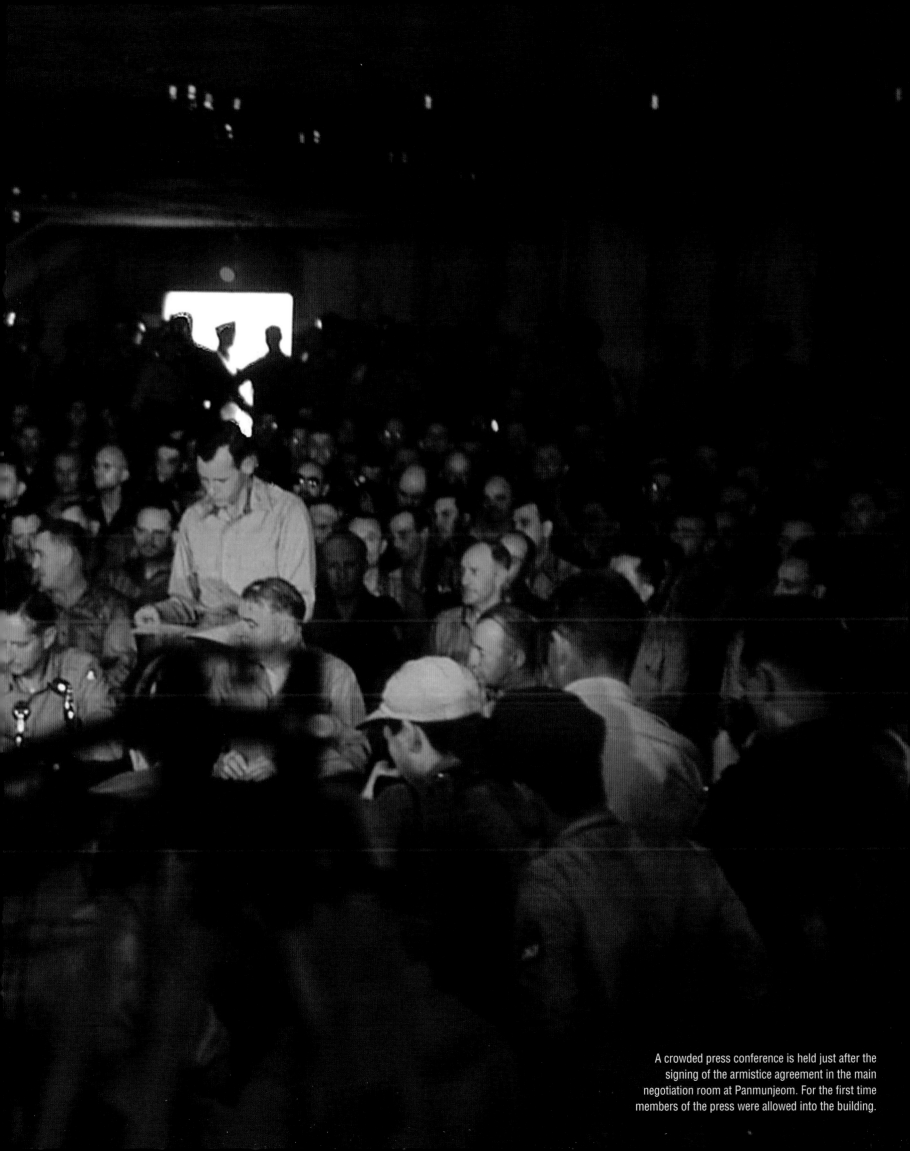

A crowded press conference is held just after the signing of the armistice agreement in the main negotiation room at Panmunjeom. For the first time members of the press were allowed into the building.

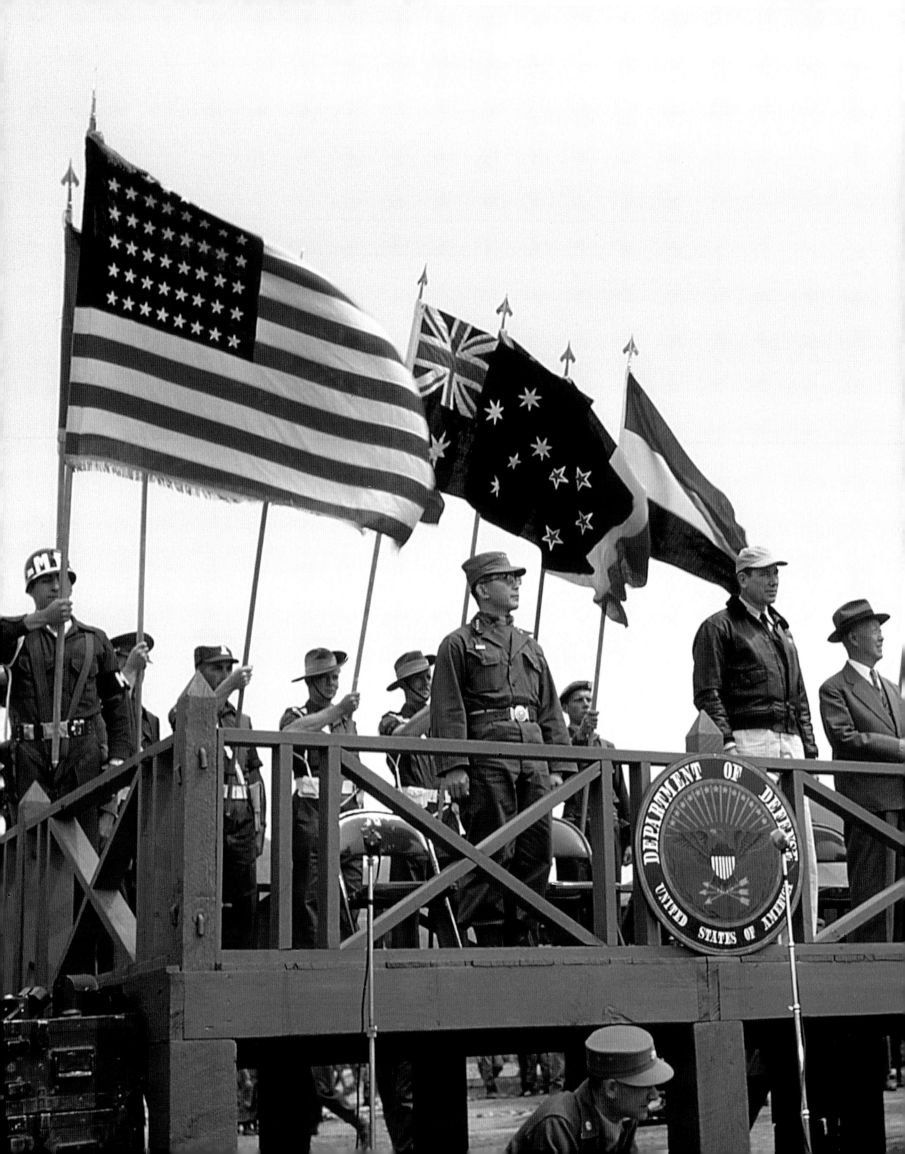

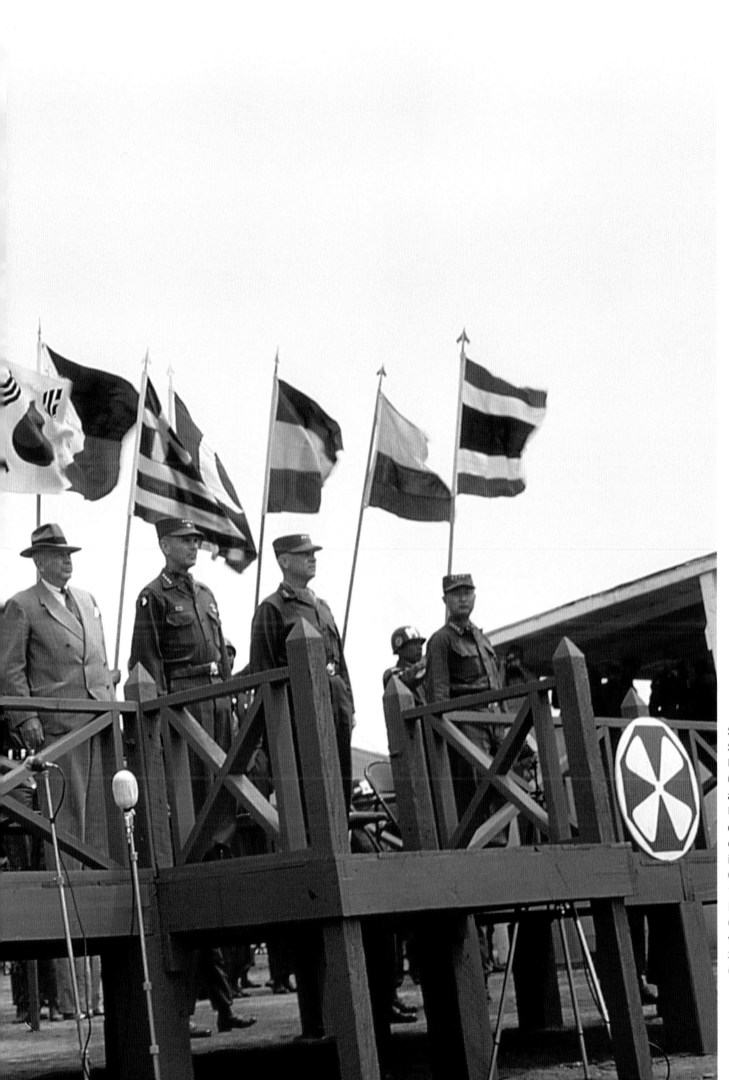

South Korean President Syngman Rhee stands with US 8th Army commander General Maxwell D. Taylor at a ceremony marking the US X Corps' transfer of command and the creation of the ROK 3rd Corps, held in Gwandae-ri, Inje-gun, Gangwon-do in October 1953. At the right end is ROK Army Chief of Staff General Paik Sun-yup, while on the far left is ROK 3rd Corps commander General Kang Moon-bong.

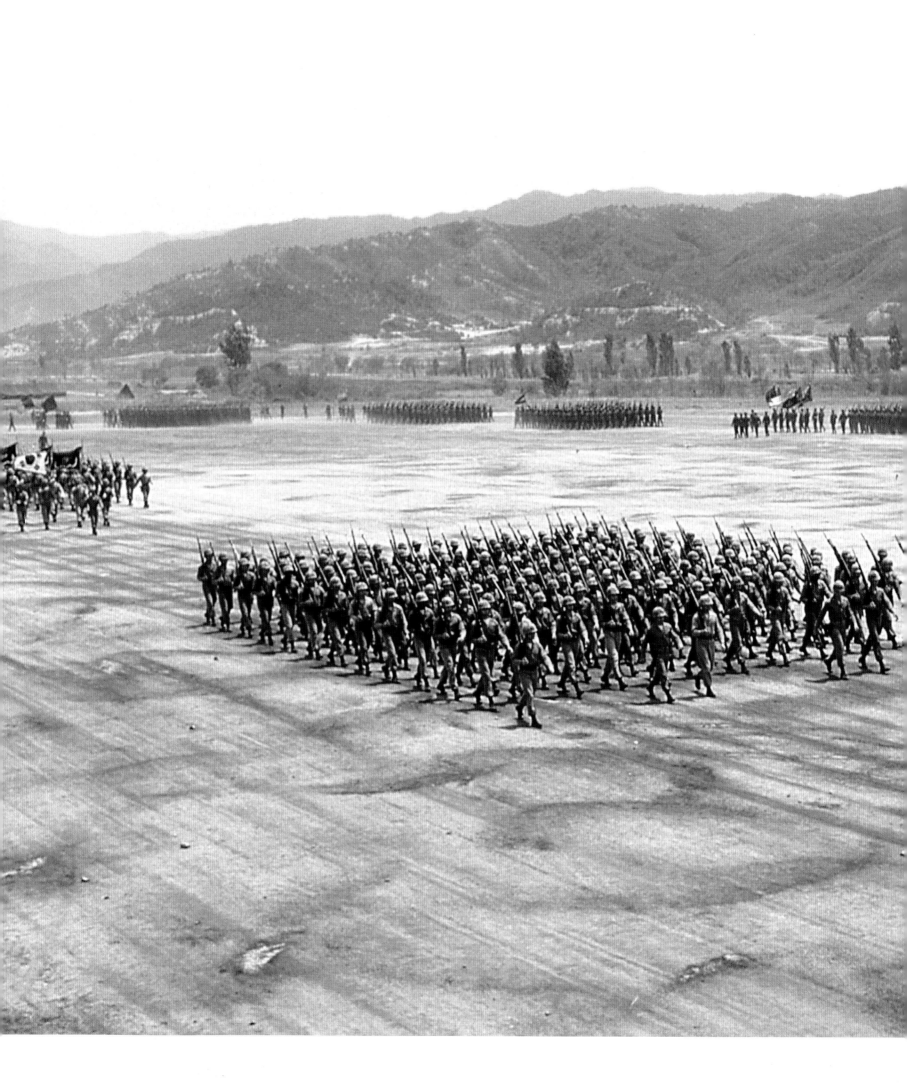

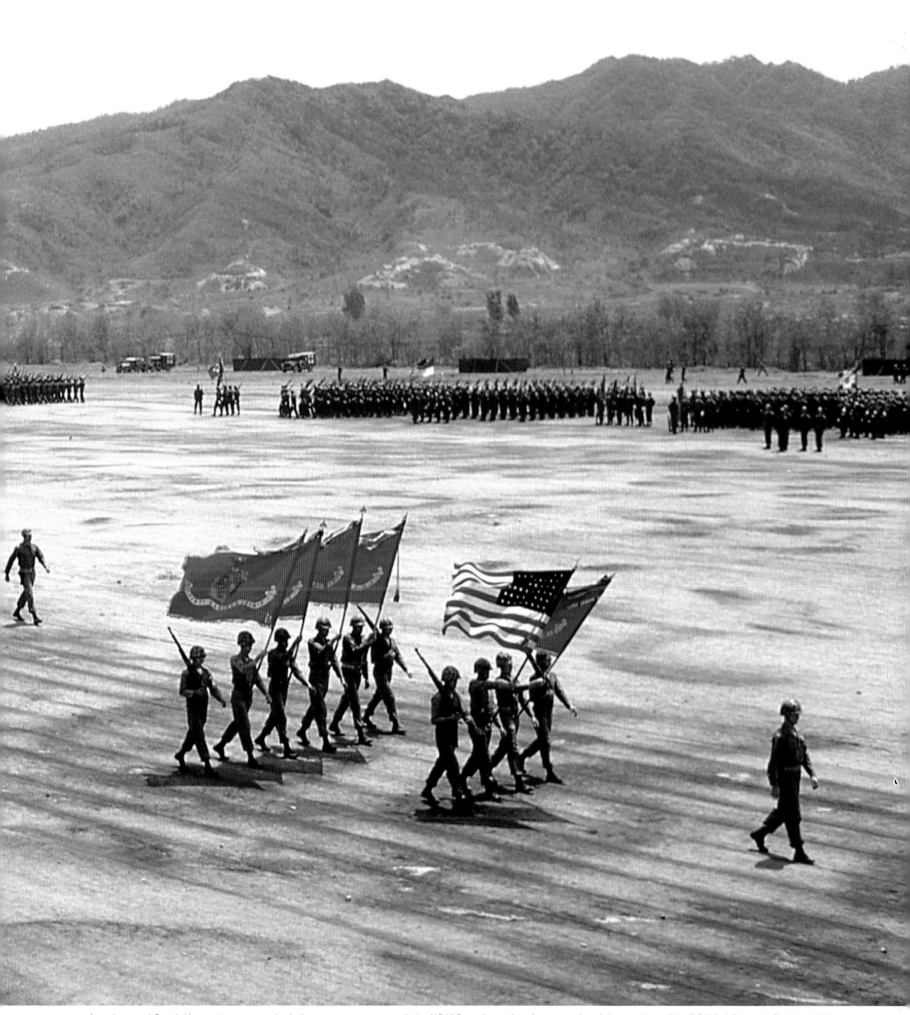

American and South Korean troops parade during a ceremony to mark the US X Corps' transfer of command and the creation of the ROK 3rd Corps in October 1953.

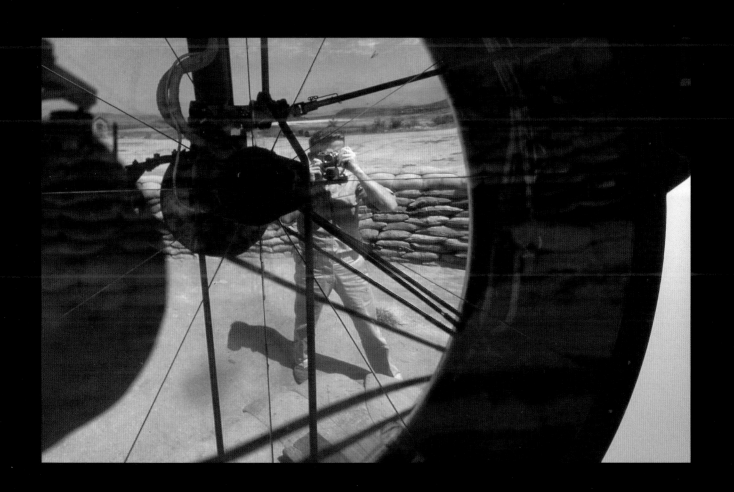

Peabody Award-winning reporter John Rich has participated in or reported on all of America's 20th century wars since World War I. In 1939 he began his news career as a reporter for the daily *Kennebec Journal* in Augusta, Maine and then moved to the *Portland Press Herald* in his hometown of Portland, Maine.

He covered his first war story five weeks before Pearl Harbor, when he interviewed survivors of the US destroyer *Reuben James*, which had sailed north from Portland escorting Lend-Lease cargo for Britain. It was torpedoed and sunk in the icy waters off Iceland by a German submarine. The survivors were brought back to Portland.

In 1942, Rich enlisted in the Navy and studied for a full year at the Naval Japanese Language School at the University of Colorado in Boulder. Upon graduation he joined the US Marine Corps and made four combat D-Day landings during the war, on Kwajalein, Saipan, Tinian, and Iwo Jima.

After the war, he went to work for William Randolph Hearst's International News Service and was immediately sent to Tokyo. There he met and interviewed General MacArthur and traveled with Emperor Hirohito, after the latter had renounced his divinity and, on the advice of MacArthur's occupation officials, began to leave the palace to visit his subjects in many parts of Japan.

The INS sent Rich to Shanghai, where he was reporting when the city fell to the communists. He escaped on an American gunboat down the Huangpu River and spent some days on an American destroyer anchored in the Yangtze River, until he caught a ride on a sea plane flying to Qingdao, which had been completely surrounded by Chinese communist troops. The communists did not try to enter the city while the American fleet was anchored there. Rich eventually returned to Japan on an American cruiser.

John Rich was in Tokyo when the Korean War began and went to Korea the first week of the fighting. For the next three years he covered the war, a longer period than any other American news correspondent. In December 1950 he left INS to join NBC News.

After the signing of the armistice in Korea, Rich spent a year on a fellowship at the Council on Foreign Relations in New York. In 1954 NBC sent him to Europe to head its bureau in the divided city of Berlin. After four years there and some time in Moscow, he was moved to Paris and then, with his wife and four small children, returned to Tokyo. While he was in Tokyo, American efforts to aid the French in Vietnam finally led to full American involvement and the Vietnam War. From his base in Tokyo, Rich was in and out of the Vietnam fighting for a full ten years.

In his final years with NBC he became their Senior Asian Correspondent based in Tokyo. After that, he was appointed a Vice President for the RCA Corporation, which owned NBC News. He now lives in the house, on the coast of Maine, where he was born on August 5, 1917.

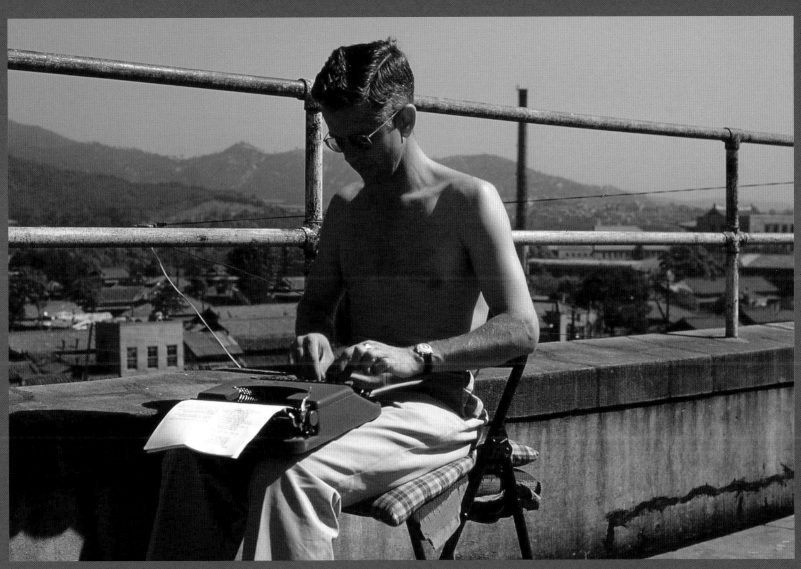

Rich in Seoul shortly after the UN Command's recapture of the capital in 1951. "That's the top of the press building," he pointed out.

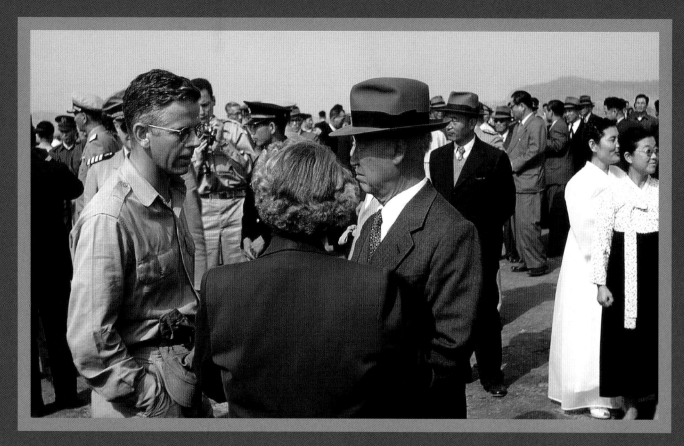

Rich interviews President Syngman Rhee in Busan, seen here with his wife Franziska Donner, the first First Lady of the Republic of Korea.

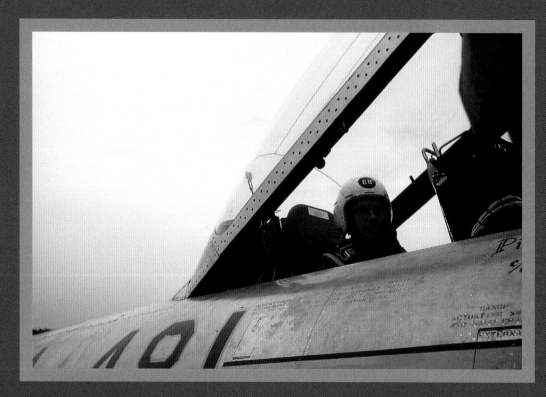

Rich in a small plane, where he would keep a sharp lookout on his side for Russian Yak fighter planes. "I would scan the skies nervously," he recalled.

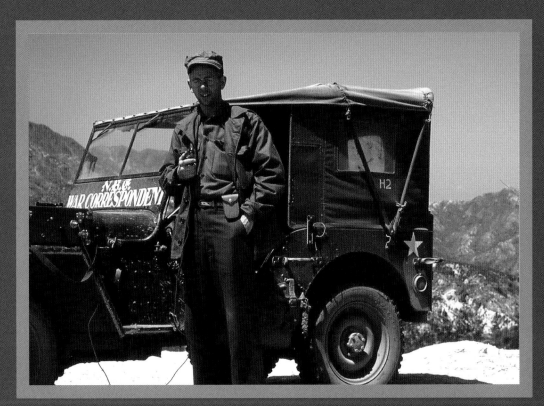

Rich in the mountains north of Seoul, posing by his press jeep. The author was often captivated by the beauty of the Korean countryside as he drove. "It was hard to believe that not too far away, there was a terrible war going on."

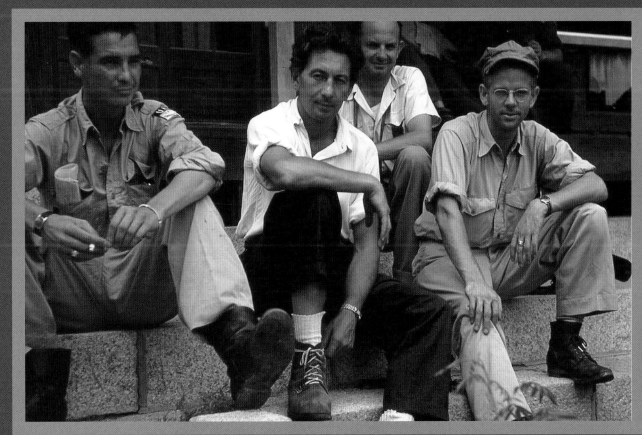

The first Truce Talks of July 1951. Rich (far right) poses with journalists reporting from both sides of the war: from left to right, George McArthur of the Associated Press, Alan Winnington of the *Daily Worker*, and Wilfred Burchett.

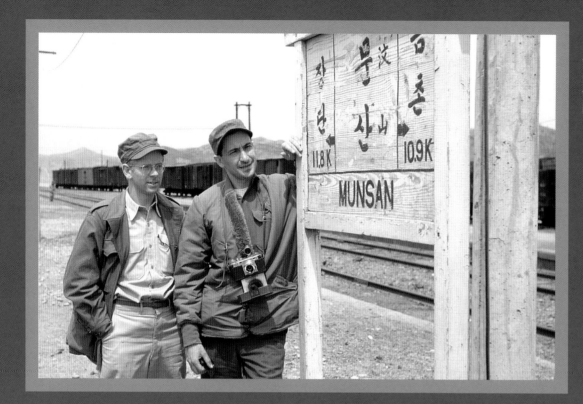

Rich with friend and NBC colleague Irving R. Levine at Munsan Station, then called Munsan-ni. Thanks to its proximity to Panmunjeom, Munsan was where the press congregated to interview key delegates.

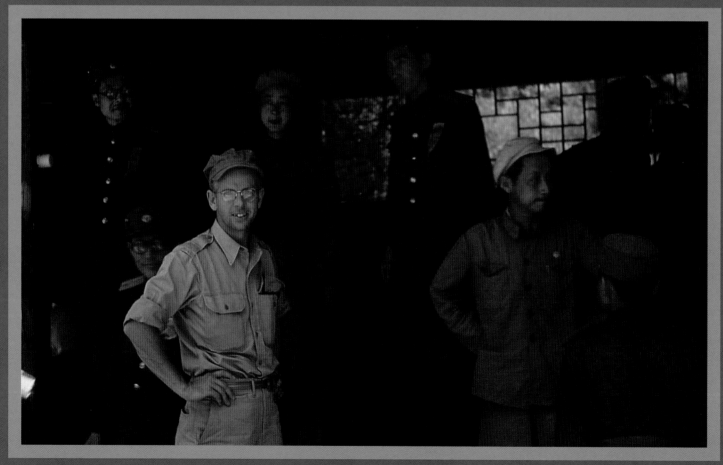

Rich and North Korean delegates at the main conference building in Gaeseong, before talks were relocated to Panmunjeom.

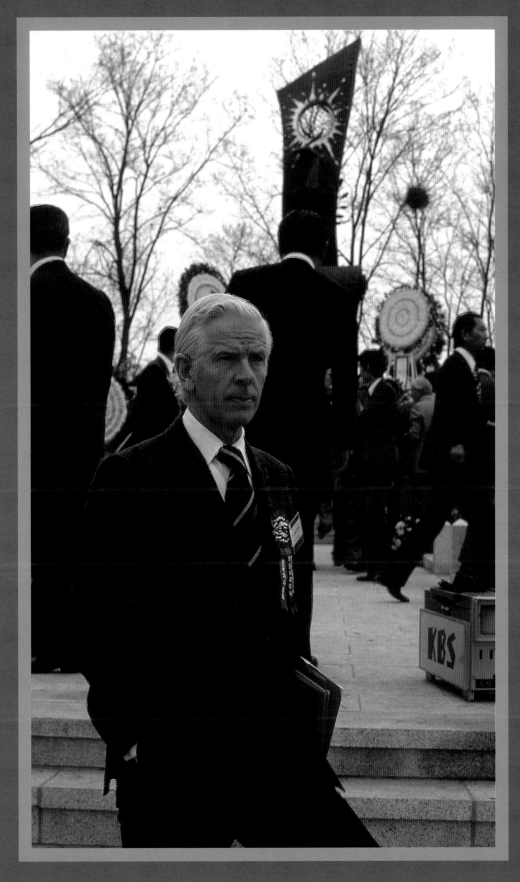

Rich revisiting Korea after a period of absence, to attend a ceremony honoring war correspondents who died during the war.

In His Own Words

An Interview with John Rich

* This interview took place at John Rich's summer house in Vero Beach, Florida, on February 21, 2010.

Your career took you to key locations of 20th century history. How would you summarize the last century in terms of your eyewitness experience?

Very rough, very tough. I was born during World War I. I think I have been in every war—either been in it or covered it as a correspondent—since World War I. I was in World War II and I went to Japan, and the Korean War started shortly thereafter. And then Vietnam followed that. Then, of course, there was trouble in northern India, and I was in Africa, the Congo. So in my own life, I ask, "Now when did that happen? Was that the war in Africa? No, no, that was the Korean War." (*laughs*) So I kind of cover my own history to find what I was doing at a certain time by asking, "What war was I covering?" But yes, it was just war, war, war.

You were a correspondent covering the Korean War during those years of conflict. Where were you located during the war, in chronological order?

Well, I was in the Pacific War as a Marine, and when I got out, I found a job at the International News Service and went right to Tokyo. And then, not so long after I got there, a couple of years, the Korean War broke out. And since I was in Japan, I was the first one from my company to go in. And I went in the very first week of the Korean War and stayed the whole three years! I was there longer than any other American reporter, going back to Japan every couple months for a week or so.

228

When did the first peace talks begin?

When they started talking peace, during the Korean War, it was very rough. Before the talks, they (the communists) drove the Korean and Allied forces right back to around Busan, and we were almost driven off the peninsula. But then we drove back up. And then, around January of '51, there would be these stories about, well, maybe somebody said we'll have to talk peace, in an armistice, something like that. The war was just going on and on.

The Chinese came in quite early in the war, in September 1950, and drove the forces that were there, and captured Seoul. I think Seoul fell twice during the war. I remember they came a little south to Suwon, and I was there one night. I have a picture of dead Chinese—there had been a skirmish in the schoolhouse. So the Chinese came in and pushed back again.

Then General Ridgway—he was a quite a general. He pulled together that American, UN army, and started pushing north. And then they pushed north, and the others, they pushed south. So (*laughs*) that's why the GIs called it the 'yo-yo war.'

This year marks the 60th anniversary of the Korean War, and many observations of the occasion will take place in the Republic of Korea. Could you tell us, for our Korean readers, your general impressions of the Koreans, the South Koreans, during your time in Korea?

I wish we had as much support from other allies as we did from the Koreans. They were wonderful, absolutely behind us. And you know, what's happened in some other countries—they didn't support, and fought against, Americans. But the Koreans were solidly behind us. And I just, well, learned a lot about Korea, and what I learned made me more impressed by the Koreans, the Korean people. They are a good ally to have. Then, of course, when we got into Vietnam, the Koreans sent a division or more to help us in Vietnam. It was quite interesting—in such a short time Korea lifted itself up and made a wonderful army. Very impressive.

These photographs are a relatively recent discovery, because you had kept them in a tea chest for all these years. Could you just tell us the experience of rediscovering the film you took?

I brought color film, and the professionals were not shooting in color film. Their companies at home could not handle it, so they shot it in black and white. So I got in early with my color film, and I just shot it. I'd send it to Kodak, and they'd send back the little yellow envelope with the transparencies in them. I'd look at them, and eventually I put them in a Japanese tea chest, which is tin-lined, and left it there. We took it wherever we went, I can remember how many years! One day I opened it up and the pictures were perfect, not deteriorated at all, fifty years later. That's how they were preserved, and when I got them out, I said, "My God." And it was for all three years of the war, because I was there for the whole three years: the beginning, the middle, fighting, and the long, dragged-out peace talks.

I noticed in your collection of photographs there are a significant number of civilians: women, children, grandfathers. Could you tell me how these everyday people reacted to the camera? Because I'm sure these were earlier times, and cameras were rare.

I don't remember having problems. Once in a while someone would say, "No, no, no, don't take my picture," but it was not a problem. So they certainly got used to it after a while, given the number of cameramen who came into Korea. And, of course, soldiers like to be photographed, show their families what they're doing. It's like sending a letter home.

You took these photographs out of pure interest.

That's right, I took these photographs out of my own interest—not amusement but interest. And I was not a cameraman, but I got this Nikon camera and carried it around with me and snapped away. The collection got bigger and bigger, and I put it in a tea chest. Fifty-five years later they're in perfect shape.

Do you believe you could photograph what interested you because you were not reporting from a photographic perspective?

That's possibly true, but I don't think (professional) cameramen have too much trouble anyway. (*laughs*) Everybody's got a camera now!

When you glance through these photos again, do you relive the experience of the war?

Yes, it brings back images, memories. It's nostalgia, a big check on my life in Korea. My favorite is the first days of peace talks in Panmunjeom. The communist correspondent reporters came down from the north side, and the Korean and UN [ones] came up from the

south. And that first day was the first they (the correspondents) had seen each other, a smaller group of UN correspondents, and a big group from the north. They were just looking at each other, sizing each other up, in a stand-off.

Did someone eventually cross the line and start talking?

Oh, there wasn't a line, but they just kind of gathered on one side, and looked at these guys. Eventually we got very well acquainted with a communist Chinese correspondent, Chu Chi-ping. It was cold up there in Panmunjeom, and they had a little straw hut, about four straw huts, and one of the guys from the North burned a fire in it, so we could duck in and warm up. Chu Chi-ping and I would walk up the road together and walk back. I got to know him very well, and he was a great guy. He had been with the Americans in World War II, but then he became a communist correspondent. But we discussed everything. In fact, I think, through him, myself and some other correspondents as well sent messages to American prisoners being held by the North Koreans. And I think we were able to get a cameraman in the prison camp in the North to take photographs. That's how the pictures got back to the Associated Press.

Otherwise, the truce talks were boring, boring, boring. We were there every day. Outside, we could never hear the peace talks in Panmunjeom. Never got into that room until after the armistice agreement was signed. It nonetheless occurred, but it dragged out so long.

You met several key players of the Korean War, including Syngman Rhee. Could you describe —in your own words—the first President of the Republic of Korea?

I liked him very much, I interviewed him many times, even before the war. He fled south from Seoul, to Busan, by boat and car. And I met him five or six days after the war started, in Busan. I was then stringing for ABC while working for the International News Service. ABC would pay me if I got a broadcast. So I was interested in getting out as many broadcasts as I could to earn money. I went to see President Rhee in Busan shortly after he got there. He wanted to get his words out to the American people, and in his own voice, but I never knew if the broadcast was picked up. Very difficult communications at that time.

What do you remember most about General Douglas MacArthur?

He was a little like Charles de Gaulle. There was a time when de Gaulle would have a press conference and his whole cabinet came. And we'd say, "They've come to find out what's on de Gaulle's mind," because he wasn't communicating with his own cabinet! MacArthur was a similar kind of man. A top man, who knew it all. And of course, his Inchon (Incheon) Landing was a great success. He took a chance and won out.

You didn't see much of him every day. He lived in the American Embassy in Tokyo. And then he'd drive down to the Dai-ichi Insurance building where he had an office on the tenth floor. A couple GIs would run out, salute, and open the doors for him whenever he would leave. He was quite a figure.

What were some of the salient discomforts of the war?

Getting around, you had to have transportation. Fairly early on, I got a jeep. So I brought with me three bottles of whiskey, and I talked to the GI who was working on this beaten-up, broken jeep. So with three bottles of whiskey, I came away with a jeep! It made all the difference. I carried a weapon, blitz cans of water, and some C-rations or something like that, and I'd drive all around. Trouble is, you'd go to the front and you'd get the news there. Then you'd want to move across the front, but you can't go across the front—there were no roads or anything—so you'd have to drive back on various roads until you found another way to drive back up to the front. I did a lot of driving, and I really saw the beauty of the countryside. It was hard to believe that not too far away, there was a terrible war going on. I remember the lovely trees among the hills and rivers. But, of course, you had guerrillas back there too, so I kept my rifle close.

So the dangers of war were always around you, even behind the front?

Even behind the front. Particularly if you were on a jeep alone. They were. They are. In every war.

What values do you hope your readers will extract from your photographs?

They really teach a lesson. It's war in color, and getting right in on it. The color really jumps out at you. You realize how horrible wars are, and what sacrifices soldiers make to fight these wars. They don't have any choice, but they're there, and being shot at, and trying to survive. Brutal.

How did you meet your wife D. Lee Rich in Korea?

We met at the end of the war. She was working at the American embassy, at one of the government agencies there and—(turning to Dee Lee) what were you, I was lifting you out of a jeep, or you couldn't get in a jeep? So, anyways, I picked her up and sat her on the jeep. That was at the Chosun Hotel, where she lived. We were finally married in Europe.

Interviewed by **Elizabeth Shim**
Photographed by **Marc Matsumoto**

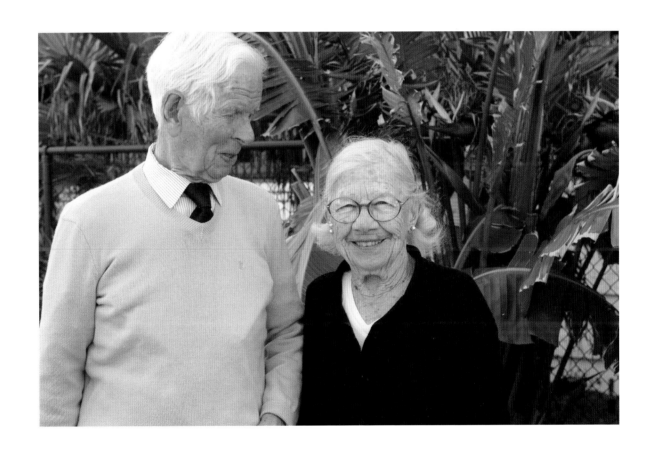

Acknowledgments

Several years ago, the thought of writing a book seemed a remote possibility. I was long retired to my birthplace of Cape Elizabeth, Maine, when I told my neighbor, Jack Kennelly, about the color slides from my Korean years, stored away in a tea chest for close to half a century. Jack was astonished by what he saw, and I didn't understand why until I started reviewing the pictures myself. Today, thanks to ongoing interest and the support of my family and friends, this book of Korean War photographs is finally a reality.

My gratitude goes to Seoul Selection's Kim Hyung-geun, who first suggested this book in 2008, and to my friend Jack, for believing in it. He sparked the first step toward its creation when he suggested I have the images placed in digital format to prevent deterioration, and that I have the collection copyrighted. I am thankful for their confidence and enthusiasm. To my cousin, Dot Brown, for transcribing my memoirs on a word processor. To Lee Jin-hyuk and the entire editorial and design staff at Seoul Selection, for their hard work and help in guiding me through the tedious yet rewarding experience of creating a book. And also to Elizabeth Shim, my publishing liaison in New York, and Marc Matsumoto, my photographer and videographer for this project.

To Andrew Salmon, author of *To The Last Round: The Epic British Stand on the Imjin River, Korea 1951*, for his knowledge and insight into the history of the photographs bound in this volume. Without Andrew, the factual accuracy of the captions would not have materialized. To Robert Koehler, author of a soon-to-be-published Korean War travelogue, for descriptive introductory captions on the Korean War. Though our collaboration took place across an ocean and several time zones, I could not have been in better hands than when I was leaving my work with these experts in military history.

To the memory of the brave soldiers of the UN Command, and especially those representing the flags of the United States and the Republic of Korea. These men fought tirelessly through the sweltering heat and the bitter cold winters, many to their last day. To my then-colleagues in the press corps, whose unswerving dedication to reporting brought America's first cold war to public attention, and whose companionship during those three years I remember to this day.

And finally, to my wife, D. Lee Rich, my partner behind this and almost every major project I have encountered since we met in Korea over 50 years ago to this day. Without her unconditional support and love, this book would have remained a bundle of memories stowed away in a Japanese tea chest.

Credits

Publisher Kim Hyung-geun

Photographs by John Rich
Written by John Rich with Elizabeth Shim, Andrew Salmon, Robert Koehler
Interview by Elizabeth Shim

Edited by Lee Jin-hyuk
Copy-Edited by Colin A. Mouat, Elizabeth Shim

Designed by Jung Hyun-young

Additional photographs by Marc Matsumoto